THE KILLING
OF A PRESIDENT

3-11-95

TO: Tim

May all the truth

be known ---

Soon!

Best Always

Robt Groden

THE KILLING
OF A PRESIDENT

THE COMPLETE PHOTOGRAPHIC RECORD OF THE JFK ASSASSINATION, THE CONSPIRACY, AND THE COVER-UP

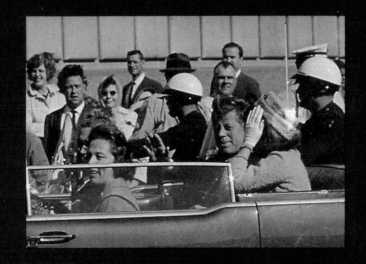

Robert J. Groden

VIKING
STUDIO
BOOKS

VIKING STUDIO BOOKS
Published by the Penguin Group
Penguin Books USA Inc., 375 Hudson Street,
New York, New York 10014, U.S.A.
Penguin Books Ltd, 27 Wrights Lane,
London W8 5TZ, England
Penguin Books Australia Ltd, Ringwood,
Victoria, Australia
Penguin Books Canada Ltd, 10 Alcorn Avenue,
Toronto, Ontario, Canada M4V 3B2
Penguin Books (N.Z.) Ltd, 182–190 Wairau Road,
Auckland 10, New Zealand

Penguin Books Ltd, Registered Offices:
Harmondsworth, Middlesex, England

First published in the United States of America by
Viking Penguin, a division of Penguin Books USA Inc. 1993
Paperback edition published 1994

10 9 8 7 6 5 4 3 2 1

Photograph credits appear on page 223.

LIBRARY OF CONGRESS CATALOGING IN PUBLICATION DATA
Groden, Robert J.
The Killing of a President: The Complete Photographic Record
of the JFK Assassination, the Conspiracy, and the Cover-up
p. cm.
ISBN 0-670-85267-8 (hc.)
ISBN 0 14 02.4003 9 (pbk.)
1. Kennedy, John F. (John Fitzgerald), 1917–1963—
Assassination. I. Title
E842.9.G76 1994
364.1´524—dc20 93–11179

Printed and bound in the U.S.A.
by R. R. Donnelley & Sons Company

Cover design by Neil Stuart
Front cover photograph: John Fitzgerald Kennedy Library, Boston
Handtinting by Ralph Wernli
Handlettering by Dave Gatti

Back cover photographs (clockwise from upper left):
© Phil Willis; AP/Worldwide; National Archives;
Dallas Morning News; Dallas Municipal Archives;
Marie Muchmore; AP/Worldwide; © Phil Willis.

Acknowledgments

There are literally hundreds of people who have helped me, directly and indirectly, in the preparation of this volume. Although I am unable to mention them all here, I want to offer each one my heartfelt thanks.

This project could not have been accomplished without the cooperation and support of my wife, Christine, my sons, Robert, John, and Michael, and my daughter, Melanie.

Special thanks are due not just from me, but from the entire nation and history, to a true American hero. His name is Moses Weitzman. Because of his modesty, Mo has chosen to remain in the background for the past twenty years. If not for Mo, this book and, indeed, the entire Kennedy investigation would have been dead in the water as of 1969. The debt owed to Mo Weitzman can never be repaid.

I would also like to thank my editor, Alison Hood, who crafted my thoughts into words with alacrity and skill.

I am indebted to designer Jon Goodchild and his team—typographer Robyn Benjamin, production assistant Darren Lees, and copy editor Netty Kahan-Kushner—who took on the task of familiarizing themselves with the details of the assassination to produce this volume in record time.

Special thanks go to Michael Fragnito, Publisher of Viking Studio Books, for his belief, support, guidance, and forbearance; to copy editor Paul Busby; and to Marie Timell at Viking Studio Books, whose devotion to making this volume a reality can never be repaid. She selflessly contributed hundreds of hours to the preparation of this book and refused to give up in the face of overwhelming challenges.

My deep gratitude goes to the following:

For their moral and financial support and love, everlasting thanks go to my second family, Wilma and Milton Franck; for his encouragement and artistic genius, Ed Chiarini; for their support, understanding, and patience, Frank and Evelyn Troxell; for their support, deep friendship, and trust, Marc and Cheryl Fruchtman; for his friendship, concern, and totally unselfish assistance, Dr. Leo McCormick, D.C., in Dallas; three generous, tireless, and giving friends, Marshal Evans, Peggy Davidson, and Roger Davidson; to my previous literary collaborators F. Peter Model, who proved to me that I could write, and Barry Sheehy; and for their assistance from the beginning, Dick Gregory, Rep. Thomas N. Downing (D., Virginia), Geraldo Rivera, Sylvia Meagher, Edward Koch, Jerry Policoff, and Robert Saltzman.

Special production thanks to Dorothy Price and Terri Wilson at Unique Photo Lab, Brookhaven, Pennsylvania, and Robert Buckley and his crew, especially Pam Stevens, at Buckley's Photo Lab in Wilmington, Delaware; and to KRON-TV and Guy Morrison.

Thank you also to the hundreds of television and radio talk show hosts and reporters who have been so kind to me and to my work through the years.

And, finally, to those critics of the official fiction who have received and supported my work and research and shared their knowledge with me through the years.—particularly to those who helped me with this book— many thanks: Jack White, Dr. Cyril Wecht, Mary Ferrell, Oliver Stone, Gary Shaw, Larry and Daryll Howard, Larry Ray Harris, Jim Lesar, Josiah Thompson, Jim Marrs, Richard E. Sprague; Carl Oglesby, Harvey Yazijian, Penn and Elaine Jones, Jan Stevens, Jim Garrison, R.B. Cutler, and Robert Johnson.

And finally to my sister and her husband, Susan and Larry Szabo, thank you for your encouragement.

To the dozens of others, including many of the photographers and their families, that space and/or memory disallow, a personal thank you. You know who you are.

Robert Groden, October 1993

There has been
one person who
has never lost
faith in my endeavors to
find the truth about the
assassination of President
John F. Kennedy. She
is a staunch partner, who
for 25 years has given me
her constant enthusiasm,
support, and, most of all,
her love. In the face of
adversity, she had made
the resolve — as did I
— to find the answers
to the crime of the century.
It is to this most remark-
able lady, my wife,
Christine, that this book
is lovingly dedicated.

CONTENTS

x Foreword — *Oliver Stone*

xi Introduction — *Robert Groden*

3 The Assassination

47 Aftermath in Dealey Plaza

73 Medical Evidence: The Cover-up Begins

91 The Framing of Lee Harvey Oswald

113 Johnson's Commission of Inquiry

133 The Garrison Investigation

145 Sabotage and Subterfuge

159 House Assassinations Committee

203 A Conspiracy of Silence

218 Bibliography

220 Index

THE KILLING
OF A PRESIDENT

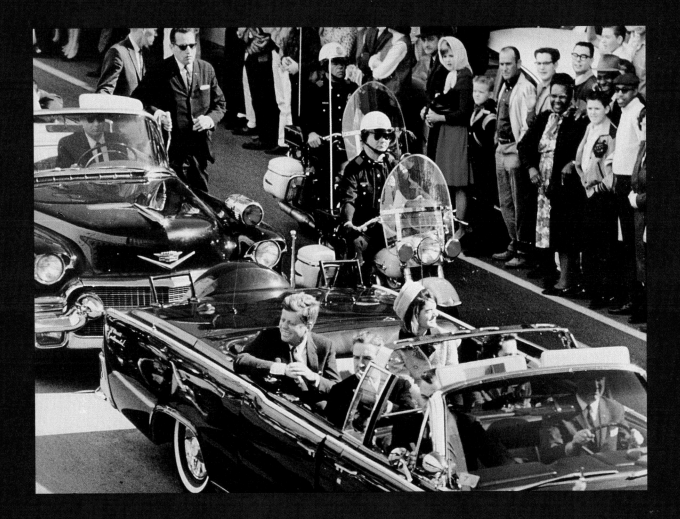

FOREWORD

The assassination of President Kennedy was pivotal in America's history. After the killing in Dallas on November 22, 1963, the world would never be the same. When I began to conceive of the outline for my film JFK, I needed to get a strong visual sense of the scene of the assassination. I spoke to many leading critics of the Warren Report. They all said I should talk to a man named Robert Groden, whose research and writings were to prove crucial in understanding many of the historical issues of the assassination later depicted in JFK.

I first met Robert in Dallas about a year before filming began. I found his overview of the assassination to be quite close to mine, and I asked him to come on board as a consultant for JFK. Robert's contributions to the film, and to the historical archiving of the assassination, have been numerous. He was highly instrumental in ensuring the resulting accuracy of key scenes in Dealey Plaza, the Parkland Hospital trauma room, the Bethesda Hospital autopsy room, and the "single bullet theory" demonstration in the courtroom at the Shaw trial.

Robert assisted the art department in setting up many scenes with his photographs and films — the world's largest collection of visual material relating to the assassination. He gave several film and slide presentations to the cast and crew so they could experience the assassination and develop the same feel for the events in Dealey Plaza that he and I shared.

I'm delighted that Robert is putting together a photographic history of the Kennedy assassination in book form so that there will finally be a visual reference work on the subject. As he has said to me, "May all the truth be known . . . soon!"

—OLIVER STONE *June 1993*

INTRODUCTION

The horror and shock that followed in the wake of the assassination of John Fitzgerald Kennedy are overshadowed only by the even more shocking and ruthless cover-up of the crime. From Lyndon Johnson's issuance of Executive Order No. 11130 on November 29, 1963, a stroke that created the Warren Commission, four separate governmental groups and one independent, nonfederal investigation have undertaken to discern the facts about the killing of the President. These groups include the Rockefeller Commission, the Senate Intelligence Committee, the Garrison investigation, and finally, the U.S. House of Representatives Select Committee on Assassinations (HSCA), commonly known as the House Assassinations Committee, formed in 1976.

After the Warren Commission's report on the assassination was submitted on September 24, 1964, the public breathed a collective sigh of relief. The Commission's findings (now officially disproved) concluded that ". . . on the basis of the evidence before the Commission . . . [Lee Harvey] Oswald acted alone." The Warren Report assured the public that

there had been no conspiracy; the lone assassin who had killed the President had himself been assassinated — nobody had gotten away with this most horrible of acts. The American people needed to believe that the crime of the century had been solved. Indeed, it was that need for resolution that made the cover-up of a possible conspiracy in the killing stay that way— covered up.

A few years later, public signs of dissatisfaction with the Warren Commission findings began to surface. Books such as *Whitewash, Accessories After the Fact,* and *Six Seconds in Dallas*[1] raised legitimate questions as to the Commission's conclusions. In 1963, New Orleans District Attorney Jim Garrison began an investigation that would lead to the 1969 trial of businessman Clay L. Shaw. This was the only prosecution of any suspect in President Kennedy's murder.

After Shaw's trial and acquittal and the successful shutdown of the Garrison probe, it proved very unpopular to speak of the conspiracy. To criticize or raise further questions about the outcome of the Garrison investigation, or any aspect of the assassination, was to attract the derision of the national news media. The years 1969 through 1975 were dark ones in the search for the truth about the events that had led to the brutal killing in Dallas on November 22, 1963.

I turned 18 on the day John Kennedy was killed, and it was a birthday I will never forget. The emotions and sense of trauma I felt about his assassination moved me to become a student of the crime. Fascinated by the assassination's dynamics and cover-up, I set out to discover the facts about it — to try to set the record straight. Deep down, though, I felt unsure

"... cases of murder — whether of the poorest individual or the most distinguished citizen in the land — should be looked at openly in a court of law, where juries can pass on them, and not be hidden, not be buried like the body of the victim beneath concrete for countless years." — Former New Orleans District Attorney Jim Garrison

1. These three books by Harold Weisberg, Sylvia Meagher, and Josiah Thompson, respectively, are among the best of the earlier examinations of the conspiracy and cover-up.

of my role in this process, especially in light of previous investigative work. Hadn't everything possible been done to resolve the case? The answer to my question came in the form of an eventual meeting with a remarkable man named Moses Weitzman.

I met Mr. Weitzman in 1969. The owner of a New York–based motion picture optical house that performed postproduction work on motion picture film, he had in his possession a legitimate, first-generation mechanic's copy of Dallas dress manufacturer Abraham Zapruder's film of the Kennedy assassination.

I went to work for Mr. Weitzman and quickly discovered our mutual interest in the particulars of the Kennedy killing. We spent many hours discussing the assassination, and I shared with him my personal investigations into the crime. After several months, he showed me his pristine copy of the film, which is very shaky; the naked eye cannot move fast enough to follow and interpret the actions captured on it.

Mr. Weitzman gave me the film, also granting me access to an optical printer, a machine used to duplicate and enhance motion picture film. For the first time, I had an ultra-clear copy of Zapruder's film, access to the right equipment to clarify the film's images, and a chance to learn more about the firing of the shots that had killed the President.

I created the first optically enhanced copies of the Zapruder film by stabilizing and enlarging the images, applying several optical techniques to make the film more coherent. First, I rephotographed the film, frame by frame, repositioning the President in each frame so the motions were fluid. I zoomed in, making the images larger within the frame, then used a technique called step framing to slow it down. Now you could see, with a new clarity, what really was happening.

The events of the killing, already captured irrevocably on film, now formed a clear visual equation: from the sequence and directions of the shots, and the differences in the times that President Kennedy and Governor Connally were shot, to the reactions of both men and bystanders to the shots. All of which pointed to — and corroborated — the evidence of at least four shots fired, challenging the Warren Commission's "lone assassin" and "single bullet" theories.

But it wasn't until February 1975 that this information came to the attention of concerned social activists, Warren Commission critics, and eventually, the national news media. Social activist Dick Gregory arranged a press conference for me to announce the showing of my optically enhanced version of the Zapruder film to the Rockefeller Commission (President Ford's commission to examine CIA activities within the United States).

As a result of this media attention, I gave the first national showing of the Zapruder film, including its optical enhancement, on "Goodnight America." Response to the screening was tremendous: The nation was up in arms over the withholding of this crucial evidence for more than 11 years.

Asked to appear before the Virginia Congressional Delegation on April 15, 1975, I presented my films and a series of slides before the assembled congressmen. A few days later, Congressman Thomas N. Downing introduced a resolution to reopen the investigation of the Kennedy assassination. This led to the formation of the U.S. House of Representatives Select Committee on Assassinations, to which I was named staff photographic consultant. The last official verdict on the assassination, released in 1979 by the House Select Committee, stated that "the Committee believes, on

Opposite: National Security Action Memorandum #55.

This memo, which bears the President's signature, is one of several NSAMs from the Kennedy Administration that show the extent of the battle between the White House, the CIA, and the FBI. The President intended to transfer the covert activities of the CIA to military jurisdiction, where they would be subject to clearly defined checks and balances.

H S C A

MYSTERIOUS Death Project

Penn Jones, in his book, *Forgive My Grief,* began to track (as early as 1966) and examine the strange — and often unexplainable — deaths of many of the key witnesses in the JFK assassination. This work came to the attention of the House Select Committee on Assassinations during its investigation of the assassination, and the Committee appointed Jacqueline Hess, Chief of Research, to look into these deaths. The members called this research the "Mysterious Death Project" and examined only 21 of the witnesses on Jones's list. In its final report, the Committee concluded that "available evidence does not establish anything about the nature of these deaths which would indicate that [they were] caused by the assassination of President Kennedy." The complete list includes more than 300 individuals who have died under odd, and often violent, circumstances.

THE WHITE HOUSE

WASHINGTON

DISPATCHED
N. S. C.

JUN 29 3 02 PM '61

June 28, 1961

NATIONAL SECURITY ACTION MEMORANDUM NO. 55

TO: The Chairman, Joint Chiefs of Staff

SUBJECT: Relations of the Joint Chiefs of Staff to the President
in Cold War Operations

I wish to inform the Joint Chiefs of Staff as follows with regard
to my views of their relations to me in Cold War Operations:

a. I regard the Joint Chiefs of Staff as my principal military
advisor responsible both for initiating advice to me and for res-
ponding to requests for advice. I expect their advice to come to
me direct and unfiltered.

b. The Joint Chiefs of Staff have a responsibility for the defense
of the nation in the Cold War similar to that which they have in con-
ventional hostilities. They should know the military and paramilitary
forces and resources available to the Department of Defense, verify their
readiness, report on their adequacy, and make appropriate recommen-
dations for their expansion and improvement. I look to the Chiefs to
contribute dynamic and imaginative leadership in contributing to the
success of the military and paramilitary aspects of Cold War programs.

c. I expect the Joint Chiefs of Staff to present the military view-
point in governmental councils in such a way as to assure that the
military factors are clearly understood before decisions are reached.
When only the Chairman or a single Chief is present, that officer
must represent the Chiefs as a body, taking such preliminary and
subsequent actions as may be necessary to assure that he does in
fact represent the corporate judgment of the Joint Chiefs of Staff.

d. While I look to the Chiefs to present the military factor with-
out reserve or hesitation, I regard them to be more than military men
and expect their help in fitting military requirements into the over-all
context of any situation, recognizing that the most difficult problem in
Government is to combine all assets in a unified, effective pattern.

cc: Secretary of Defense
General Taylor
Mrs. Lincoln
Mr. Smith
McG. Bundy's file ✓

the basis of the evidence available to it, that President John F. Kennedy was probably assassinated as a result of a conspiracy."

Since March 1975, I have received thousands of requests for copies of the photographic evidence in the Kennedy case; the photo collection contained in this book is the response to those requests. Many of these pictures are unpleasant and sensitive in nature but must be published in the interest of historical accuracy. Some of the photography is, admittedly, of inferior quality, and we must remember that many of the photographs were taken by amateurs in rushed or unsettling circumstances. They are true, unaltered reflections of history in the making and are offered here with the intent to keep alive the question of who really killed John Fitzgerald Kennedy.

—ROBERT J. GRODEN *October 1993*

THE WHITE HOUSE

WASHINGTON

~~TOP SECRET~~ - EYES ONLY October 11, 1963

NATIONAL SECURITY ACTION MEMORANDUM NO. 263

TO: Secretary of State
 Secretary of Defense
 Chairman of the Joint Chiefs of Staff

SUBJECT: South Vietnam

At a meeting on October 5, 1963, the President considered the
recommendations contained in the report of Secretary McNamara
and General Taylor on their mission to South Vietnam.

The President approved the military recommendations contained
in Section I B (1-3) of the report, but directed that no formal
announcement be made of the implementation of plans to with-
draw 1,000 U.S. miltitary personnel by the end of 1963.

After discussion of the remaining recommendations of the report,
the President approved an instruction to Ambassador Lodge which
is set forth in State Department telegram No. 534 to Saigon.

 McGeorge Bundy
 McGeorge Bundy

Copy furnished:
 Director of Central Intelligence
 Administrator, Agency for International Development

 cc:
 Mr. Bundy ✓
 Mr. Forrestal
 Mr. Johnson
 ~~TOP SECRET - EYES ONLY~~ NSC Files

Committee Print of Pentagon Papers
by H22 7/15/77

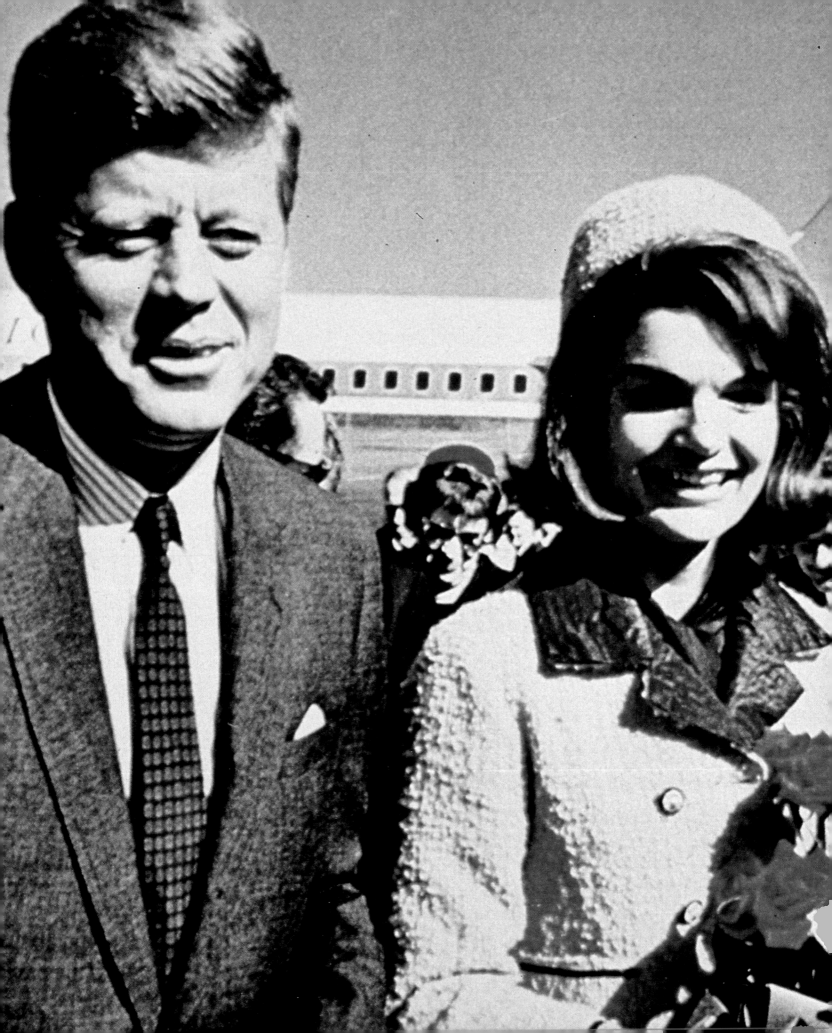

THE ASSASSINATION

O n November 21, 1963, John Fitzgerald
Kennedy, 35th President of the United
States, flew to Texas on a mission to
cement relations between liberal and
conservative elements within that state's Democratic
Party. He also wished to raise and bolster
political support from Texas voters for the
upcoming 1964 election. He had Texan
Lyndon Johnson as his Vice President, but
the state's vote was by no means assured
to John Kennedy.

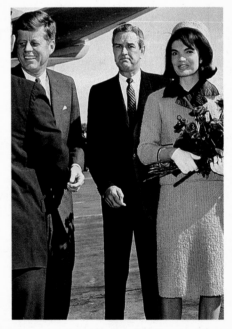

Shortly after disembarking
at Love Field, the President
and First Lady are warmly
received by local dignitaries.

The news of a presidential visit aroused
interest throughout Texas. The Dallas papers
were full of information about the impend-
ing event, which received critical reaction
from the public. City officials, remembering
the hostility encountered earlier in October
by U.S. Ambassador to the United Nations
Adlai Stevenson, wished to welcome the President to
Dallas with dignity and courtesy. Mayor Earle Cabell
wanted the city to redeem itself and asserted that
Dallas had shed its prior reputation as the "Southwest
hate capital of Dixie."

Opposite: Mr. and Mrs.
Kennedy greet well-wishers
at Dallas's Love Field.

The political and emotional climate in Dallas was characterized by hatred and unrest fostered by ultra-conservative factions. According to Dallas Chief of Police Jesse Curry, Dallas was "a city of mixed emotions. As the tension mounted, the small and violent minority were in danger of upsetting the stability of the whole city."[2]

Dallas officials had cause for concern over the President's safety during his visit. Mr. Kennedy had made many formidable enemies within the government and the private sector during his 1,000 days in office. They included FBI Director J. Edgar Hoover, CIA Director Allen Dulles and several powerful factions of the CIA, and the anti-Castro community. The President was angered with the CIA after the Bay of Pigs fiasco and horrified by the Agency's involvement in assassination plots (abetted by Mafia chieftains Santos Trafficante and Carlos Marcello) against Castro. He disallowed a second planned invasion of Cuba, and threatened the Agency, vowing "I will smash the CIA into a thousand pieces."

The President had made an agreement with Soviet Premier Khrushchev at the time of the Cuban missile crisis to cease U.S. assassination attempts against Castro if the Soviets would remove nuclear missile warheads from Cuba. When Mr. Kennedy discovered that CIA top brass had ignored his direct orders to stop all plots against Castro, he sent in the FBI and local law enforcement agencies to break up the Agency's training camps on Florida's No Name Key and on Lake Pontchartrain in New Orleans.

John Kennedy had also antagonized the network of organized crime. The President and his brother, U.S. Attorney General Robert Kennedy, were conducting an intense — and successful — war on the Mob,

Before leaving his Fort Worth hotel on the morning of November 22, the President, special assistant Kenneth O'Donnell, and the First Lady had discussed the inherent dangers of public appearances. Kennedy, who liked outdoor appearances because more people had access to him, commented to O'Donnell that "if anybody really wants to shoot the President of the United States, it's not a very difficult job — all one has to do [is] get [in] a high building someday, with a telescopic rifle, and there would be nothing anybody could do to defend against such an attempt." After having this conversation, the President and First Lady boarded the plane to Dallas.

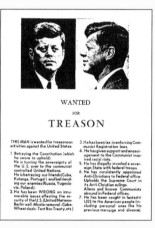

WANTED
FOR
TREASON

THIS MAN is wanted for treasonous activities against the United States:

1. Betraying the Constitution (which he swore to uphold): He is turning the sovereignty of the U.S. over to the communist controlled United Nations. He is betraying our friends (Cuba, Katanga, Portugal) and befriending our enemies (Russia, Yugoslavia, Poland).
2. He has been WRONG on innumerable issues affecting the security of the U.S. (United Nations-Berlin wall-Missile removal-Cuba-Wheat deals-Test Ban Treaty, etc.)
3. He has been lax in enforcing Communist Registration laws.
4. He has given support and encouragement to the Communist inspired racial riots.
5. He has illegally invaded a sovereign State with federal troops.
6. He has consistently appointed Anti-Christians to Federal office. Upholds the Supreme Court in its Anti-Christian rulings. Aliens and known Communists abound in Federal offices.
7. He has been caught in fantastic LIES to the American people (including personal ones like his previous marriage and divorce).

This handbill, the work of the right-wing American Fact-Finding Committee, was being distributed on the streets of Dallas the day of the President's visit.

2. Jesse E. Curry: *JFK Assassination File*.

obtaining indictments, convictions, and deportations. The President's decision not to invade Cuba a second time meant that the Syndicate's highly profitable casinos and prostitution operations, which Fidel Castro had closed down upon coming to power, would remain shut down.

Their very existence and activities threatened, those holding the power in U.S. intelligence agencies and in organized crime hated Kennedy — more than they hated Castro.

On the evening of November 21, the President arrived in Fort Worth on Air Force One. At approximately 11:22 the next morning, the presidential jet left Fort Worth's Carswell Air Force Base on the 13-minute flight to Love Field in Dallas, where the President and his party were met by a large assembly of dignitaries and well-wishers. After greeting officials and acknowledging the crowd, the President, the First Lady, and Texas Governor John Connally and his wife took their seats in the presidential limousine. The motorcade then began its trip to a luncheon at the Dallas Trade Mart, where the President intended to address a group of local business and civic leaders.

The President's trip to Texas was to be a brief, one-day tour with stops in Fort Worth, Dallas, San Antonio, and Houston. Arriving first in Fort Worth, Mr. Kennedy had the opportunity to greet citizens in an outdoor appearance in front of his hotel before flying to Dallas. His original itinerary had not allowed sufficient time for a motorcade through Dallas — until an extra day was added to the visit.

The Dallas Trade Mart, though a new building, presented security problems for the Secret Service. It had numerous entrances and tiers of balconies overhanging the center court below, where the luncheon was to take place. Special Agent Winston Lawson evaluated the security hazards, but eventually decided they could be overcome.

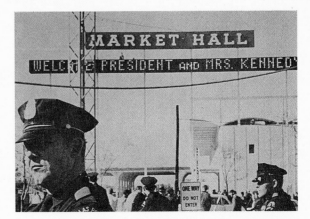

Arrival in Dallas

The President spent the early morning in Fort Worth, then flew via Air Force One to Dallas's Love Field. Met by Texas Governor John Connally, other dignitaries, and a small crowd, he was gratified by the friendly reception. However, Kennedy had not forgotten that his Ambassador to the United Nations, liberal Adlai Stevenson, had been cursed, struck with a placard, and spat upon during his October visit to Dallas. Shortly before Kennedy's arrival, handbills strongly critical of the President began circulating on the Dallas streets.

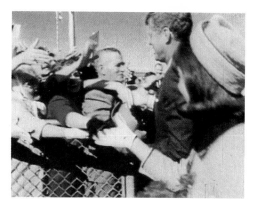

The presidential entourage in Dallas included an individual, dubbed the "Bagman," who carried the apparatus that allowed the President to activate the nation's war machine. In the confusion at Love Field, both the Bagman and Major General Chester Clifton were separated from the presidential party and were inadvertently left at the airport.

Former Vice President Richard Nixon was in Dallas November 22 to meet with Don Kendall, President of Pepsi Cola Bottling Co.

Nixon Predicts JFK May Drop Johnson

By CARL FREUND

Former Vice-President Richard M. Nixon predicted here Thursday that President Kennedy will drop Lyndon Johnson from the No. 2 spot on the Democratic ticket if a close race appears likely next year.

Nixon said Johnson is becoming a "political liability" to the Democratic party.

Nixon, who was defeated by President Kennedy in a close race in 1960, flew to Dallas Thursday for a meeting of Pepsi-Cola bottlers. His New York law firm represents the soft drink company.

Asked if he thought Kennedy would choose a new running mate next year, Nixon replied:

"President Kennedy has stated he intends to keep Lyndon as the vice-presidential nominee. The fact they are coming to Texas together, I believe, indicates the President means what he said.

"But we must remember that President Kennedy and his advisers are practical politicians. I believe that, if they think the race is a shoo-in, they will keep Lyndon. Otherwise, I think, they will choose someone who can help the Democratic ticket.

"Lyndon was chosen in 1960 because he could help the ticket in the South. New he is becoming a political liability in the South, just as he is in the North."

Nixon appeared relaxed as he answered questions and jabbed at the Kennedy administration during an informal press coference in his Baker Hotel suite.

Nixon repeated his statements that he is not seeking the Republican presidential nomination, but sidestepped a question about whether he would accept the nomination if the GOP national convention offered it to him.

"I cannot conceive of circumstances under which that would happen," he said.

The former vice-president said Barry Goldwater is the front-runner now for the Republican nomination, but Gov. Nelson Rockefeller "is a good hand shaker" and could move up quickly.

"Rockefeller will go to New Hampshire and shake every hand there before its residents vote," Nixon said. "If Goldwater doesn't go there and shake some hands, he could lose some of his lead."

Nixon said he sees little chance of a Goldwater-Rockefeller convention deadlock which would throw the nomination to someone who isn't seeking it.

Nixon said he hasn't decided whether he will support a particular contender, although he will attend the GOP convention. He said he would "be in the thick of the fight" to get the nominee elected.

Discussing civil rights, Nixon said the Kennedy administration must share the blame for racial demonstrations.

"Kennedy promised more than he could deliver," Nixon said. "I don't think we should try to out-promise the Democrats. It would be a serious mistake."

Nixon said he would not go so far as Gov. Rockefeller in the civil rights field. On the other hand, Nixon continued, he could not agree with views attributed to Goldwater that the federal governmetnt should leave civil rights to the states.

Nixon, who will leave Love Field two hours before President Kennedy arrives, also said:

1. The two-party system has now become a reality in the South and Republicans appear likely to make more gains.

2. The reputation of the U.S. Senate is at stake in the investigation of Bobby Baker, former secretary to the Democratic majority.

3. The Republican nominee should launch an all-out attack on the administration's record in handling foreign relations and employment, but should avoid a "personality contest" with Kennedy.

DALLAS MORNING NEWS
Early City Ed
Sec. 4 Page
Nov. 22, 196

—Dallas News Staff Photo by Tom Dillard

Richard Nixon ... He sees Barry ahead in GOP, LBJ out as No. 2 Demo.

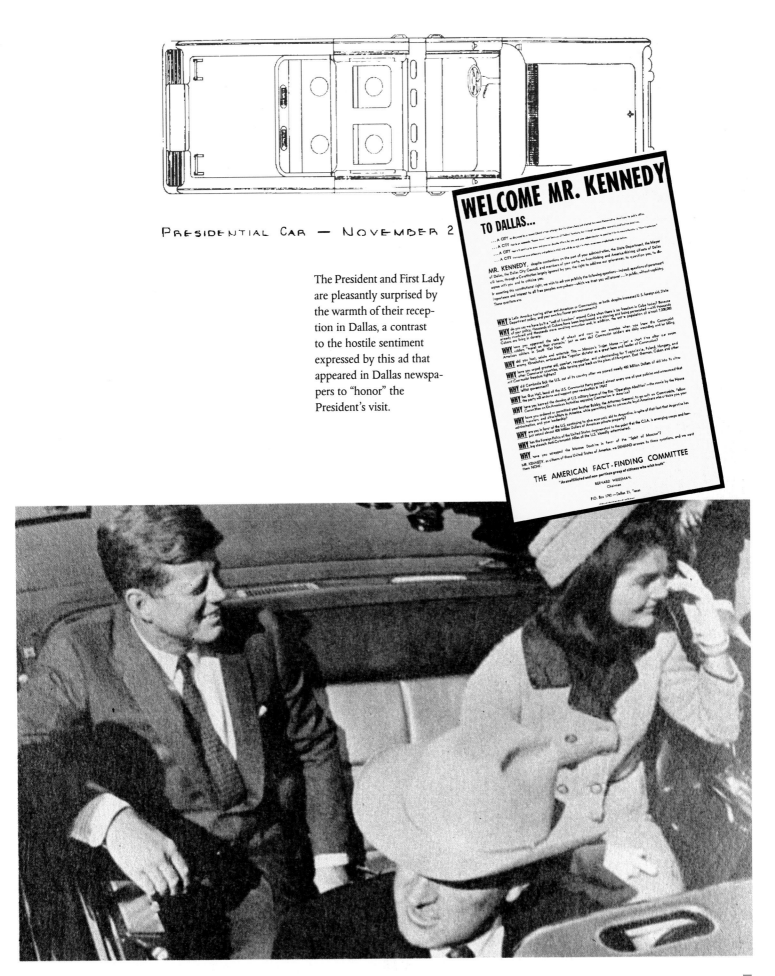

PRESIDENTIAL CAR — NOVEMBER 2[...]

The President and First Lady are pleasantly surprised by the warmth of their reception in Dallas, a contrast to the hostile sentiment expressed by this ad that appeared in Dallas newspapers to "honor" the President's visit.

WELCOME MR. KENNEDY
TO DALLAS...

MR. KENNEDY, despite contentions on the part of your administration, the State Department, the Mayor of Dallas, the Dallas City Council, and members of your party, we free-thinking and American-thinking citizens of Dallas still have, through a Constitution largely ignored by you, the right to address our grievances, to question you, to disagree with you and to criticize you.

In asserting this constitutional right, we wish to ask you publicly the following questions—indeed, questions of paramount importance and interest to all free peoples everywhere—which we trust you will answer ... in public, without sophistry. These questions are:

WHY is Latin America turning either anti-American or Communistic or both despite increases U.S. foreign aid, State Department policy, and your own Ivy-Tower pro-nouncements?

WHY do you say we have built a "wall of freedom" around Cuba when there is no freedom in Cuba today? Because of your policy, thousands of Cubans have been imprisoned, are starving and being persecuted—with thousands already murdered and thousands more awaiting execution and, in addition, the entire population of almost 7,000,000 Cubans are living in slavery.

WHY have you approved the sale of wheat and corn to our enemies when you know the Communist soldiers "travel on their stomachs" just as ours do? Communist soldiers are daily wounding and/or killing American soldiers in South Viet Nam.

WHY did you host, salute and entertain Tito — Moscow's Trojan Horse — just a short time after our sworn enemy, Khrushchev, embraced the "capolar dictator as a great hero and leader of Communism?

WHY have you urged greater aid, comfort, recognition, and understanding for Yugoslavia, Poland, Hungary, and other Communist countries, while turning your back on the pleas of Hungarian, East German, Cuban and other anti-Communist freedom fighters?

WHY did Cambodia kick the U.S. out of its country after we poured nearly 400 Million Dollars of aid into its ultra-leftist government?

WHY has Gus Hall, head of the U.S. Communist Party praised almost every one of your policies and announced that the party will endorse and support your re-election in 1964?

WHY have you banned the showing at U.S. military bases of the film "Operation Abolition"—the movie by the House Committee on Un-American Activities exposing Communism in America?

WHY have you ordered or permitted your brother Bobby, the Attorney General, to go soft on Communists, fellow-travelers, and ultra-leftists in America, while permitting him to persecute loyal Americans who criticize you, your administration, and your leadership?

WHY are you in favor of the U.S. continuing to give economic aid to Argentina, in spite of the fact that Argentina has just seized almost 400 Million Dollars of American private property?

WHY has the Foreign Policy of the United States degenerated to the point that the C.I.A. is arranging coups and having staunch Anti-Communist Allies of the U.S. bloodily exterminated.

WHY have you scrapped the Monroe Doctrine in favor of the "Spirit of Moscow"?

MR. KENNEDY, as citizens of these United States of America, we DEMAND answers to these questions, and we want them NOW.

THE AMERICAN FACT-FINDING COMMITTEE
"An unaffiliated and non-partisan group of citizens who wish truth"

BERNARD WEISSMAN,
Chairman

P.O. Box 1792 — Dallas 21, Texas

The Motorcade

The Secret Service, responsible for all security arrangements for presidential trips, designed the makeup of the motorcade and its route through downtown Dallas to the Trade Mart. The President's limousine, a blue 1961 Lincoln convertible, had collapsible jump seats between the front and rear seats. While the President and First Lady sat in the rear seat, Governor Connally and his wife took the jump seats in front of them. The car was equipped with a removable bubbletop, neither bulletproof nor bullet-resistant, which was removed at the directive of Secret Service agent Winston G. Lawson. Lawson's orders had trickled down from the President.

Dallas Police Chief Jesse Curry asked his Assistant Chief Charles Batchelor to work with the Secret Service to coordinate the security operation for the presidential visit. As part of the advance planning, Batchelor and Special Agents Forrest Sorrels and Winston Lawson covered every inch of the parade route and planned the timing. Batchelor carefully made notes that stipulated a certain number of officers to be stationed at each intersection en route to the Trade Mart. There were no extra police stationed in Dealey Plaza at the time of the assassination.

Dallas County Sheriff Bill Decker assembled his deputies on the morning of the President's visit and instructed them to "take no part whatsoever in the security of the presidential motorcade." The motorcade's route through downtown Dallas had been widely publicized in the local papers, with the result that large crowds turned out to welcome Mr. Kennedy. The original route, however, was changed, so that the motorcade had to make a difficult, slow series of turns in Dealey Plaza.

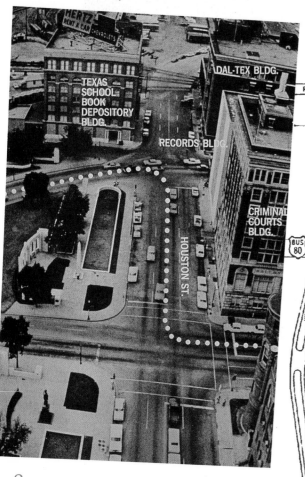

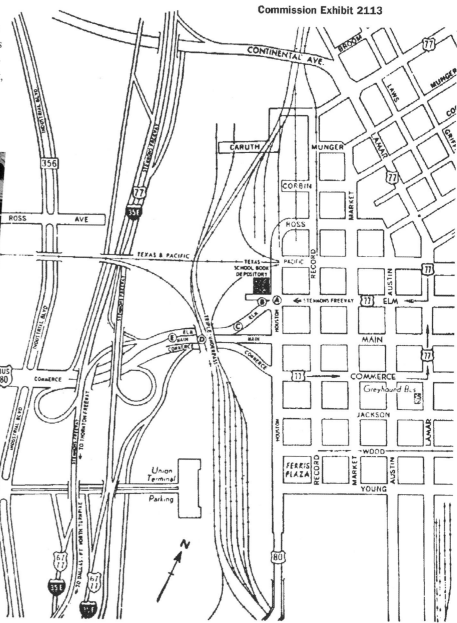

Commission Exhibit 2113

The protocols governing the vehicle arrangement in a presidential motorcade were altered for the procession through downtown Dallas. Police Chief Curry and Sheriff Decker rode in the motorcade's lead car directly in front of the presidential limousine. The limousine, which was supposed to be the seventh in line, could not move faster than the lead car. The press photographers' car, which usually preceded the President's car, was placed eight cars back, negating their purpose—to photograph the president.

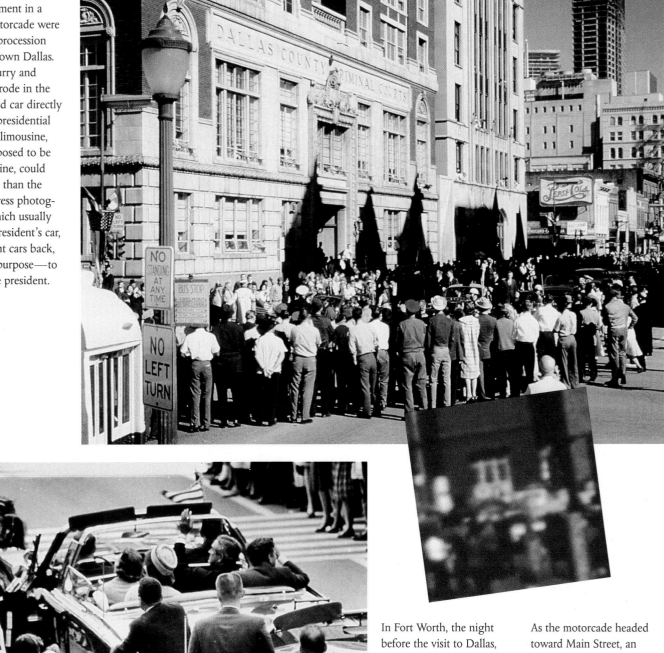

It had been raining earlier in Dallas but in the late morning the weather was fine, with no further threat of rain. The President's press assistant, Bill Moyers, knew that Mr. Kennedy preferred to travel with his car's bubbletop removed, so that he could "see and be seen" by the crowds along the route. Moyers told officials to "get that god-damned bubbletop off unless it's pouring rain."

In Fort Worth, the night before the visit to Dallas, the majority of the President's Secret Service agents had a boisterous party that lasted into the early hours of November 22. The party was held at a local night-club, The Cellar, which was owned by Pat Kirkwood, a friend of another local night-club owner, Jack Ruby. Back at his hotel, the President's protecton was provided by only two unarmed Fort Worth firemen.

As the motorcade headed toward Main Street, an ambulance took away a man who had suffered an apparent epileptic seizure on the corner of Elm and Houston Streets.

Accolades at Houston Street

The motorcade slowed to less than 11 miles per hour as it proceeded toward the crowded intersection of Houston and Elm Streets, the site of the Texas School Book Depository. Elated by the enthusiastic reception, Mrs. Connally turned to Kennedy and said, "Mr. President, you can't say that Dallas doesn't love you." The President's car made the slow, sharp left turn onto Elm Street, moved slowly past the Texas School Book Depository, and started the gradual descent to a triple railroad underpass en route to Stemmons Freeway. The crowd of spectators was sparse along Elm Street, in contrast with the throng that had lined the east side of Houston Street.

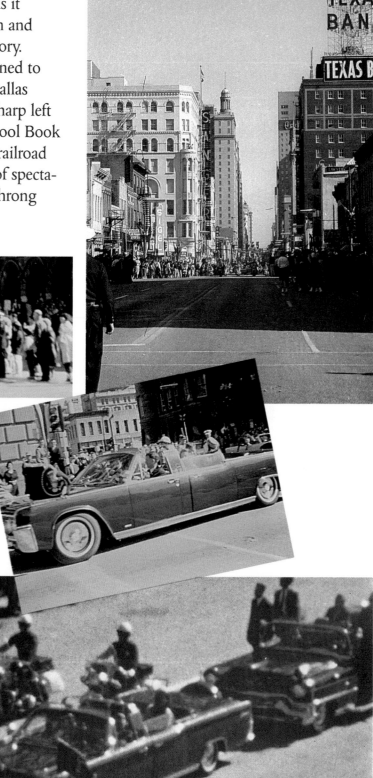

When he later testified to the Warren Commission, Secret Service Special Agent-in-Charge Forrest Sorrels said he had selected the progression along Main to Houston, Houston to Elm, then along Elm through Dealey Plaza because it was "the most direct route to the Trade Mart." According to Sorrels, this route was preferable to going straight down Main Street (in the center of the Plaza), as the motorcade would have had to make a difficult reverse turn to move onto Stemmons Freeway. Apparently, he was not aware that the presidential procession could have used Main Street to move directly onto Industrial Boulevard, which led right to the Trade Mart.

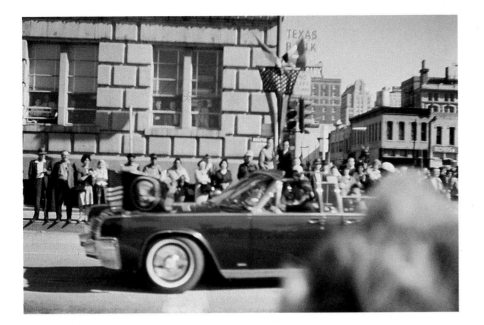

The President's car makes the slow turn onto Houston Street and passes the old Court Building. The zigzag through Dealey Plaza could have been easily avoided if the motorcade had driven directly down Elm Street from start to finish. This would have prevented the need for the President's car to slow down to 11 miles per hour — a terrible security hazard.

The press vehicles in the 15-vehicle motorcade were positioned eight cars back from the President's. The press bus brought up the rear. The ambush took place well away from the eyes of the media.

With Secret Service agents William Greer (driving) and Roy Kellerman in the front seat of the presidential limousine, the car makes the turn at the Main-Houston intersection. This is approximately one minute before the first shot.

The President's car approached the intersection and provided a perfect vantage point for unobstructed firing on the President from the sixth floor of the School Book Depository. Why did the sniper — or snipers — wait until the car had passed the Depository?

The motorcade route from Love Field to the Trade Mart was a long one. Too few Secret Service agents were employed to cover the route, especially when the presidential party reached the wide open space of Dealey Plaza.

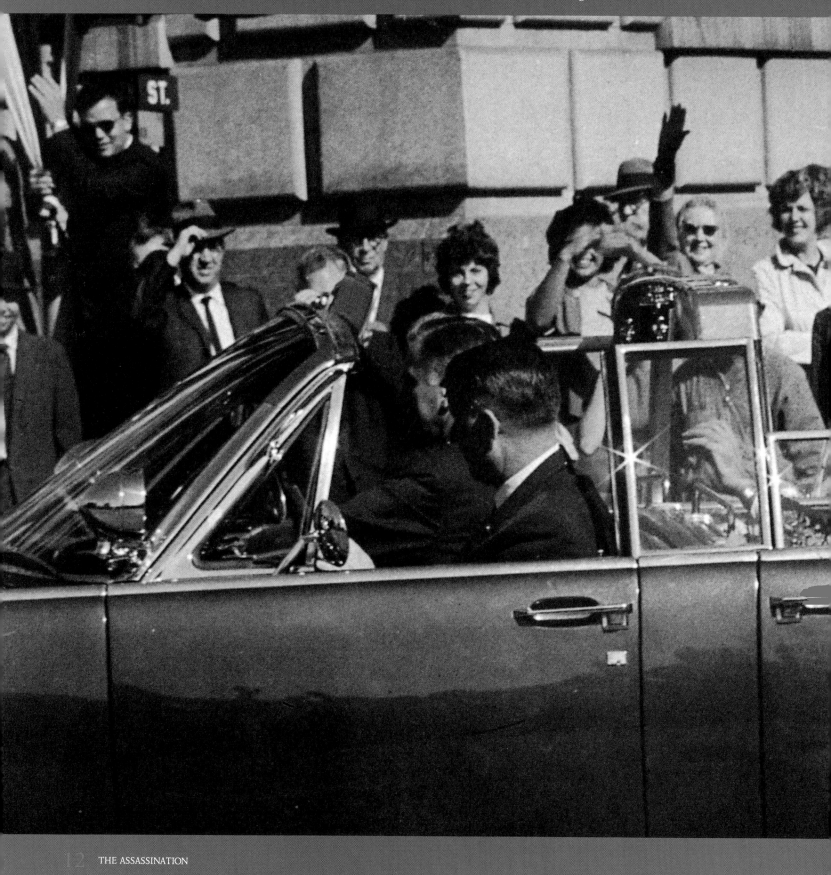

The turn from Houston
Street to Elm Street.

Turning on to Elm Street

The motorcade was a few minutes late arriving at Dealey Plaza. At 12:30 in the afternoon, the President's car made the last, fatal turn, moving at approximately 11 miles per hour, paced by the cars and motorcycles in front. The public had been kept away from lining Elm Street, and the motorcade had come to the end of the large crowds lining Main Street in the center of downtown. Six minutes earlier, bystanders had been distracted by a man apparently having an epileptic seizure on the corner of Houston and Elm Streets. The unidentified seizure victim was taken to Parkland Memorial Hospital, where he promptly disappeared.

The second Secret Service follow-up car succeeded the Vice President's car. The photo at left shows this secret service car — still on Houston Street — with the left-side rear door open. Was opening the door an indication that Johnson's Secret Service agents had been tipped off in advance? Some researchers believe that the car door did not open until the first shot. This photo shows the door open some time before the first shot.

Heading straight down Houston Street to Elm, the President's car turns onto Elm Street. Directly in front of the car is the Texas School Book Depository. As it came down Houston Street, The motorcade was in full view from the sixth floor of the Depository.

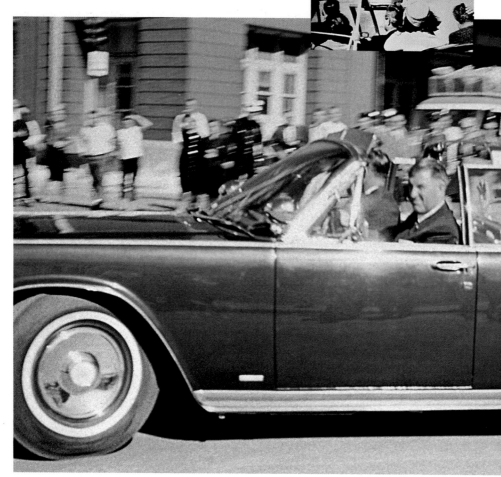

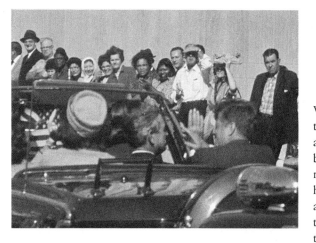

The motorcycle policeman's role within a motorcade is to protect the President from being fired upon, attacked, or approached by crowds of onlookers. Often, this means that motorcycle officers closely flank the presidential limousine, a maneuver that President Kennedy disliked: He felt it separated him too much from people's view.

When Mr. Kennedy decided that his limousine's removable (but not bulletproof) bubbletop should be removed, he was aware that he was exposed and vulnerable to sniper fire. The same thought must have crossed the mind of Secret Service agent Clint Hill who, at least three times during the motorcade's slow progress toward Dealey Plaza, jumped onto the running board of the presidential limousine, hanging on to the handholds welded to the car. When the motorcade reached Dealey Plaza, however, Agent Hill had returned to his position on the running board of the follow-up car.

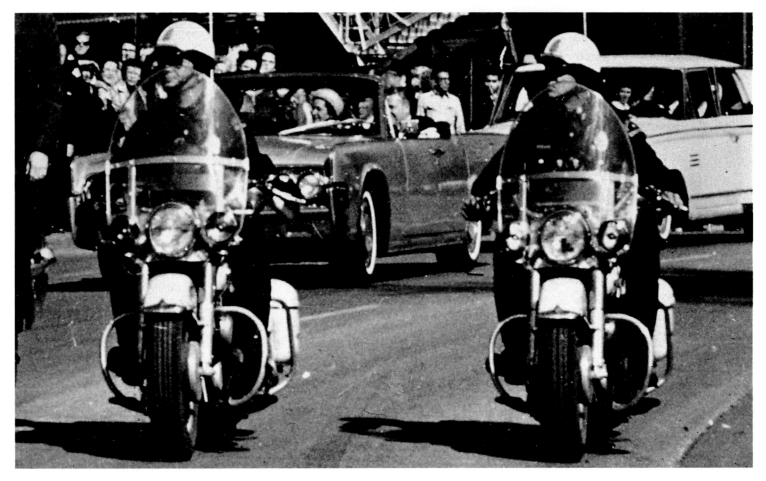

Dealey Plaza

The motorcade's original route had been publicized in the Dallas *Times-Herald* and the *Morning News* and was changed slightly on the morning of the President's visit. The motorcade now was to make a series of slow turns through Dealey Plaza, a park-like area that marked the western end of downtown Dallas. Secret Service agent Forrest Sorrels reported to the Warren Commission that the Elm Street route through Dealey Plaza was the most direct one to the Trade Mart. It was later observed that the motorcade could have traveled a more straightforward route: west on Main Street through the middle of Dealey Plaza, then to Industrial Boulevard and the Trade Mart.

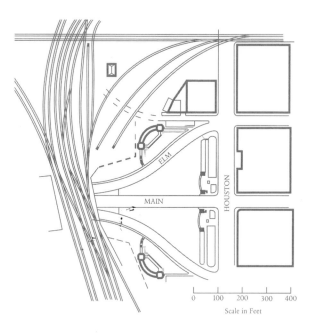

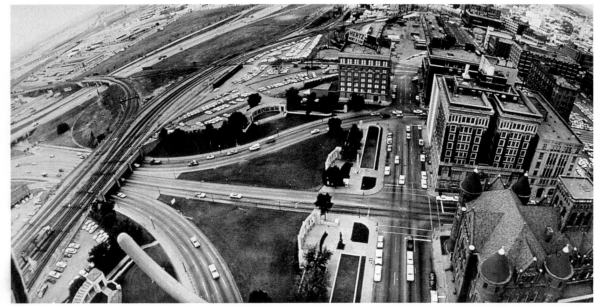

During the motorcade's progress through Dealey Plaza, Sheriff Bill Decker ordered Deputy Harry Weatherford, who was an expert rifleman, to take up a position on top of the Dallas County Records Building, diagonally across from the Texas School Book Depository. Long after the President's assassination, a researcher on the case tried to interview Weatherford, asking him if he had shot at the President. Weatherford replied, "You little son of a bitch, I kill lots of people."

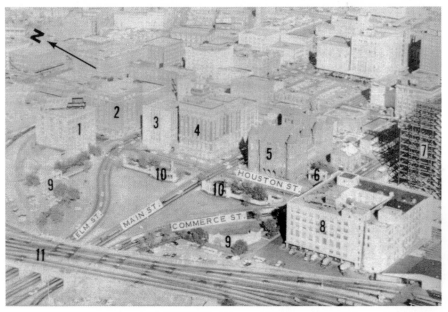

Key: Dealey Plaza
1 – Texas School Book Depository
2 – Dal-Tex Building
3 – Dallas County Records Building
4 – Dallas County Criminal Courts Building
5 – Old Courthouse
6 – Neeley Bryan House
7 – Dallas County Government Center
8 – United States Post Office
9 – Landscaped area: The Pergola, the Cupolas, the Grassy Knoll

Dealey Plaza is a virtual "canyon," a wide open central area with no side streets for egress. Curbing and grass line both sides of Elm Street, disallowing any escape route, and there are adjacent clusters of buildings (*see opposite*) with hundreds of windows. Even with the most stringent of security measures, the Secret Service could never have covered every point in the Plaza to adequately protect the President. The geography of Dealey Plaza is, in itself, a massive security breach.

The motorcade had to slow down to almost five miles per hour to negotiate the sharp zigzag turn onto Elm Street. In addition, the motorcade's lead car, the motorcycles, and the follow-up car behind the presidential limousine all boxed in the President's car, making escape from the assassination scene nearly impossible.

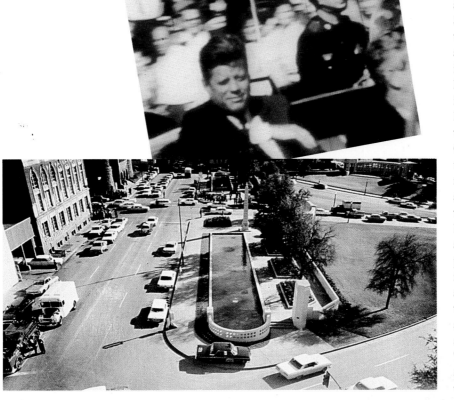

Just before the turn from Houston Street onto Elm, any killer positioned in the alleged "sniper's nest" on the sixth floor of the Texas School Book Depository would have had an unobstructed view of the President's car as it moved slowly toward the Houston-Elm intersection (*center*). FBI Director J. Edgar Hoover was asked by the Warren Commission to comment upon why the assassin did not choose this time and angle for firing, rather than waiting as he did until the President's car was moving away on Elm. Hoover replied, "The reason for that is, I think, the fact that there are some trees between this window on the sixth floor and the cars as they turned and went through the park." There was no tree in this area to obstruct an assassin's view.

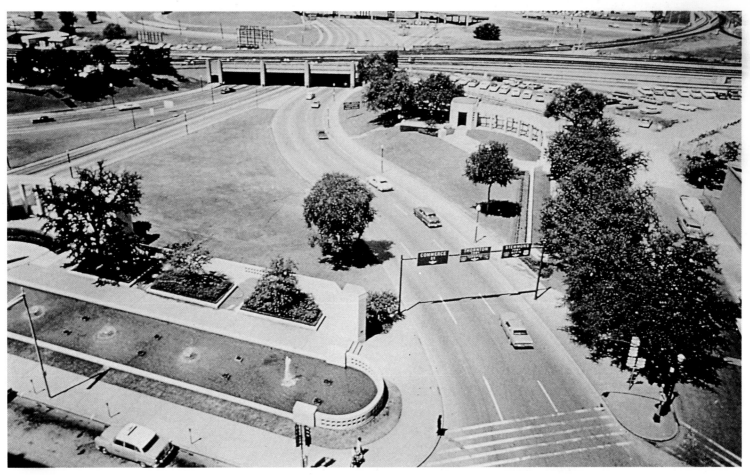

The Ambush

The clock atop the School Book Depository read 12:30 p.m. as the first shots rang out — and kept coming for the next nine seconds. Bystanders said that a barrage of shots was fired, appearing to come from several directions around the President's car. The first bullet missed. The next shots struck Mr. Kennedy in the throat and back. The President's driver, Secret Service agent William Greer, did not react except to turn — with his foot on the car's brake — and stare over his right shoulder until the President was hit in the head, at which point Greer sped up the car. One of the motorcycle policemen left his microphone open, recording the shots on a Dictabelt back at police headquarters.

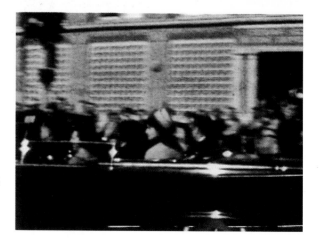

The motorcade was due to reach Dealey Plaza at 12:25 p.m. The President and his entourage were late by approximately five minutes, as Mr. Kennedy had unexpectedly taken extra time to shake hands and speak with numerous well-wishers at Love Field. By this time the President's assassin would have been positioned and ready in the Depository window. Carolyn Arnold, a secretary at the Depository, spotted Lee Harvey Oswald in its second floor lunchroom at approximately 12:25 p.m.

Dealey Plaza provided ideal vantage points and cover for an assassination. The drawing below, and its repetition on the following pages, illustrates the probable firing positions and shot originations in relation to the movement of the President's car down Elm Street. As the motorcade slowly passed the Depository on its way toward the triple railroad underpass, there were at all times at least four perfect firing points from which to ambush the President.

Tina Towner, standing on the corner of Elm and Houston Streets, took an 8-mm movie of the motorcade as it turned on to Elm Street. This frame (*above*) shows the side of the President's car.

While watching the motorcade in Dealey Plaza, bystander Arnold Rowland and his wife observed two men and what appeared to be a rifle in the east corner window on the sixth floor of the School Book Depository at approximately 12:15 p.m. He commented to his wife that they must be Secret Service agents. Mrs. Rowland reached into her purse for her glasses and looked up. But she did not see them — the men had backed away into the shadows.

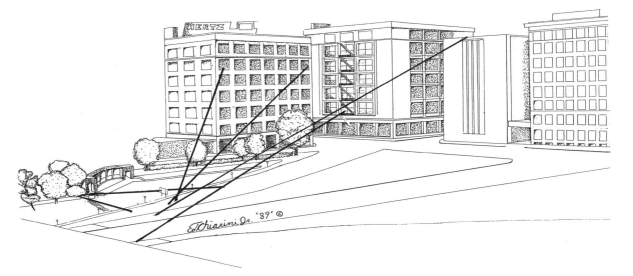

Above: These are the known and suspected firing positions in Dealey Plaza and the possible trajectories of the shots.

Re-enactment of the view from the "sniper's window" on the sixth floor of the Depository. This is the target two seconds before the first shot just as the limousine disappears behind the oak tree.

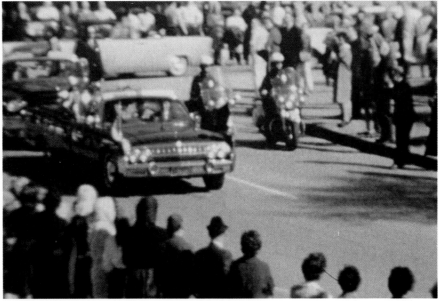

One second before the first shot is fired.

Dallas dress manufacturer Abraham Zapruder photographed the entire assassination, continuously filming the President's car as it approached and passed down Elm Street and out of Dealey Plaza. He stood on top of a short cement pedestal near the Grassy Knoll.

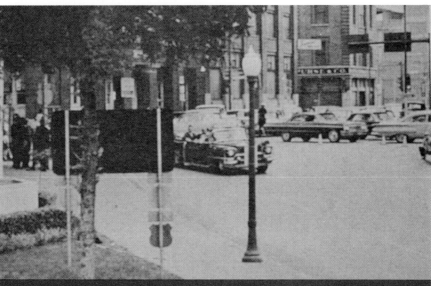

RE-ENACTMENT

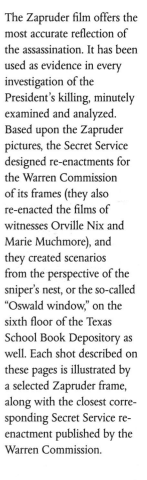

The Zapruder film offers the most accurate reflection of the assassination. It has been used as evidence in every investigation of the President's killing, minutely examined and analyzed. Based upon the Zapruder pictures, the Secret Service designed re-enactments for the Warren Commission of its frames (they also re-enacted the films of witnesses Orville Nix and Marie Muchmore), and they created scenarios from the perspective of the sniper's nest, or the so-called "Oswald window," on the sixth floor of the Texas School Book Depository as well. Each shot described on these pages is illustrated by a selected Zapruder frame, along with the closest corresponding Secret Service re-enactment published by the Warren Commission.

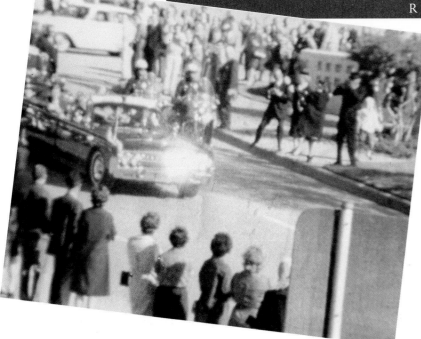

The Warren Commission hired a surveyor, Chester Breneman, to take measurements, based upon the Zapruder film, of the distances between the President's car (and his position within the car) and the firing point from the Depository's sixth floor sniper's window. Breneman later stated that the Commission had ignored his findings and had changed his measurements in the final report.

Shot #1

Abraham Zapruder's film is a relentless "clock" of the assassination. It not only gives a visual record of the reactions to and the sources of the gunshots, but also represents a device to verify the timing between shots, which occurred in an incredibly short time span — less than nine seconds.

The first shot fired missed the car, but both the President and Connally reacted to it. Connally turned around to his right to look at the President. John Kennedy stopped waving, turned his head 90 degrees to the right, looked directly toward Grassy Knoll, and lowered his hand. Jacqueline Kennedy, who had been looking to her left, did not realize the noises she heard were gunshots until hearing John Connally yell, "Oh no, no, no!" Then she turned to her right.

Above: The first shot that was fired missed the car completely and hit the pavement. This was corroborated by at least two witnesses. Why did it miss? There is speculation that the gunman was anxious, pulling the trigger too soon.

Just before the first shot was fired, the President is looking to his left. He hears the gunshot and turns to his right to look at the Grassy Knoll, as shown here in Zapruder frame 153 (the actual firing would have occurred around frames 150, 151, or 152).

Below: The President's car from the south side of Elm Street, looking northwest toward the Grassy Knoll and the pergola. Abraham Zapruder can be seen standing in the background on the short cement block next to the pergola.

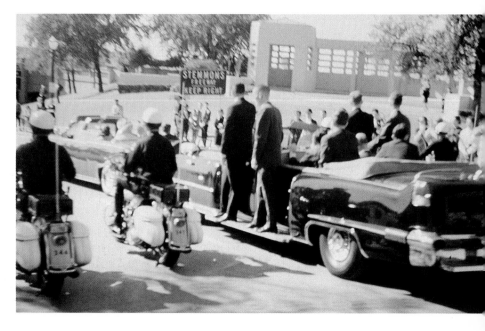

Government Re-enactment

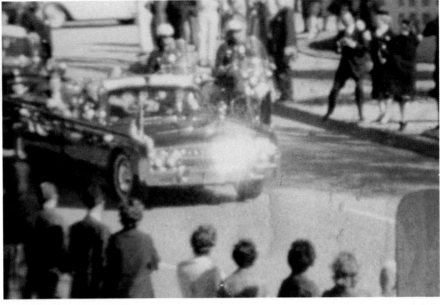

John Kennedy resumes waving to the crowd, while Governor Connally reacts to the first gunshot, turning to look over his right shoulder. Connally later testified that he was not struck by the first shot.

When the first shot was fired, the view of the President's car from the sixth floor Depository window was blocked by an oak tree. A more likely firing position would have been from the Dal-Tex building, where an unidentified man was seen in a second floor window behind the fire escape.

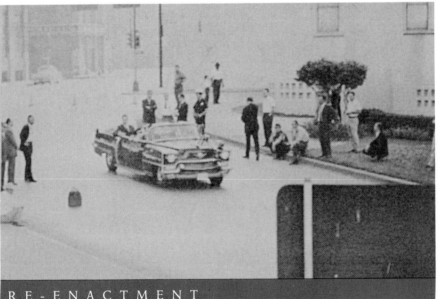

RE-ENACTMENT

When the first shots rang out, they came close together, one after the other. When the first bullet was fired, it startled Abraham Zapruder, causing his hand to jump in reaction. The film begins to blur at about frame 155. Zapruder's surprise at each subsequent shot is reflected in the repeated blurring of his film.

The Warren Commission's investigation used only a selected few of the Zapruder re-enactments. Curiously, those they did cite as "evidence" to support their findings were chosen only to fit with the actions of a lone, crazed assassin.

Shown here are the closest re-enactments to match the selected Zapruder frame at top.

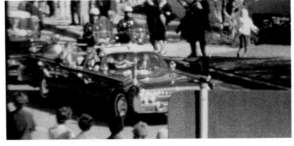

The presidential limousine as seen on Elm Street prior to the second shot, which wounded President Kennedy in the throat.

Shot #2

The next shot came from the front and struck the President in the throat, causing him to quickly grab his throat. His wife turned to look at him, later stating, "All I remember is seeing my husband, he had this sort of quizzical look on his face, and his hand was up. . . . I remember thinking he just looked as if he had a slight headache. I just remember seeing that. No blood or anything." Had his driver accelerated the car at this moment, the President's life could have been saved.

Above: The second shot, which struck the President's throat was the first to hit. It had to come from the front, with the most logical point of origination being the Grassy Knoll.

The President resumed waving to the crowd after the first shot; he probably did not realize a gunshot had been fired. At Zapruder frame 188, he is struck in the throat from the front, his upper torso pushed rearward. Viewed through Zapruder's camera, the President's right hand appears to move forward slightly when, in fact, it is his upper body that is being thrown to the rear. The film shows the changing position of the President's hand in relation to his head: His hands and arms start to drop, then come up to his throat. This motion continues until after the President disappears behind the Stemmons Freeway road sign.

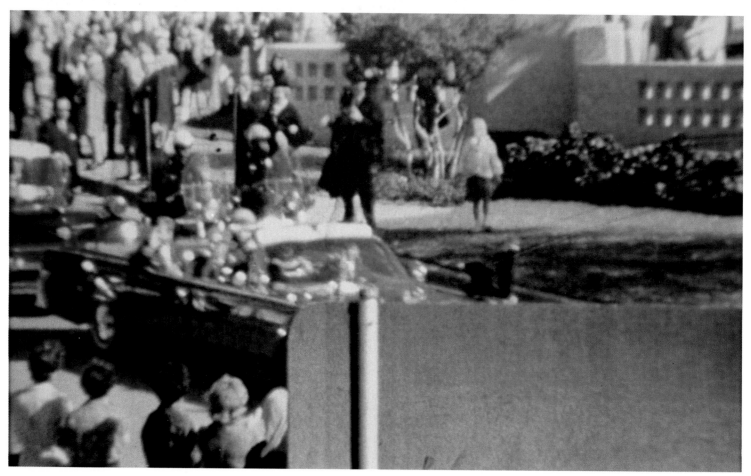

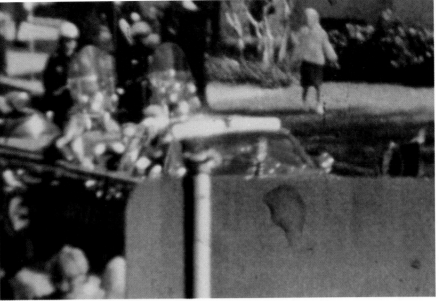

Frame 193

The film shows that a second bullet was fired and hit at approximately frames 188 through 191. This conclusion is supported by the President's clearly visible reaction, as well as subsequent acoustical analysis of the shot. At this point the film again blurs as Zapruder is startled by the sound of gunfire. The President stops waving and starts to turn toward the front. Governor Connally realizes at this point that a shot has been fired and begins to look over his right shoulder at the President.

The gunshots were recorded on tape (via the motorcyle officers' live microphone channels) back at Dallas police headquarters. These first two shots occurred at a point on Elm Street when a large oak tree was still blocking the view from the "assassin's window" on the Depository's sixth floor, as shown by the government re-enactment above.

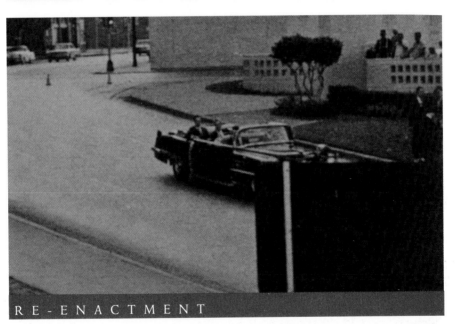

RE-ENACTMENT

The President's throat wound was a minor one. Had William Greer, who was driving the limousine, accelerated the car, Mr. Kennedy's life could have been saved. Greer, like many of his fellow agents in the motorcade that day, was curiously slow to react.

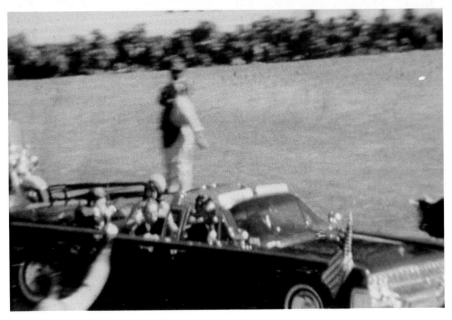

Frame 238 clearly shows the President's response to being hit in the throat. He brings his hands to his throat in a protective motion.

By Zapruder frame 200, the President's right hand has stopped waving, and the next few frames show the succession of rapid head movements from right to left. This is evidence of President Kennedy's reaction to the throat shot.

A prominent publishing concern purchased the Zapruder footage on November 24, 1963, securing all rights to the film. When the Warren Commission volumes were published in late 1964, they contained many of the Zapruder frames (154 through 334), but frames 208 through 211 were missing from the Commission's evidence. Assassination researchers who bought the Warren Report raised the question of why those frames would be gone. It was subsequently stated that while the film was being enlarged for transparencies to be used for publication, a junior lab technician had inadvertently closed the film gate on top of the film, cutting it. These missing frames had shown the President, after the first two shots, disappearing behind the Dealey Plaza freeway sign.

Bystander Phillip Willis takes a picture from behind the limousine at the moment of the second shot. He captures two mysterious images, but neither is noticed or identified until years later. In the center foreground, to the right of the President's car, is a man holding an opened umbrella. Behind him and to the left on the Grassy Knoll is the dark shape of a man crouched behind the cement wall. These images later become known as "Umbrella Man" and "Black Dog Man."

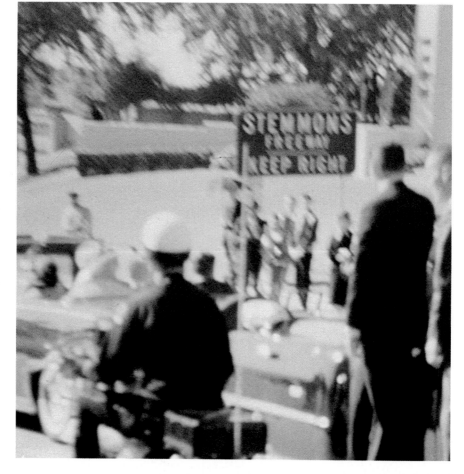

The view looking toward the Grassy Knoll shortly following shot #2 clearly shows "Umbrella Man." Since the umbrella is a blur, we can deduce that it is rapidly moving vertically. The witnesses in the foreground are running to catch a glimpse of the President from their previous viewing position on Houston Street.

Shot #3

Governor Connally heard the first shot, but he apparently did not hear the second shot, which was fired approximately two seconds later. He looked back to his right to check on the President, he started to turn to his left, then he was battered by a high-powered bullet. This shot narrowly missed John Kennedy, struck the Governor in the back, coursed through his chest, and exited by the right nipple.

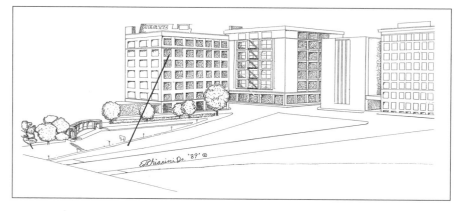

Above: The third shot, fired from the western end of the depository, struck Governor Connally from behind. It entered by the right armpit, passed through his chest and exited below the right nipple at an angle far too steep to have come from the so called "Oswald" window.

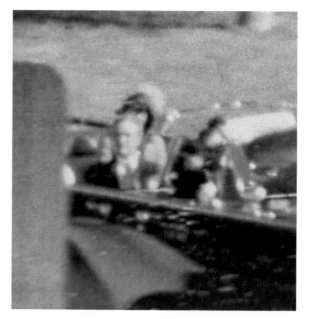

Frame 224

As shot #3 strikes Governor Connally in the back and the bullet exits his chest, it forces the right front of his jacket away from his body and blocks our view of his shirt *(bottom left and close-up, bottom right)*. Mrs. Kennedy, in the background, is turning to look quizzically at the President. Mysteriously, Governor Connally's suit was cleaned that day; as a result, the jacket's value as evidence was diminished.

Frame 225

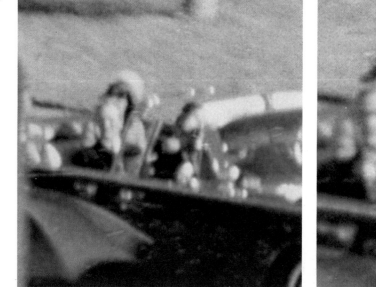

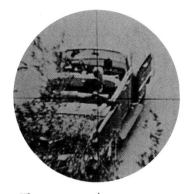

The government's re-enactment shows clearly that a single bullet could not have hit both men.

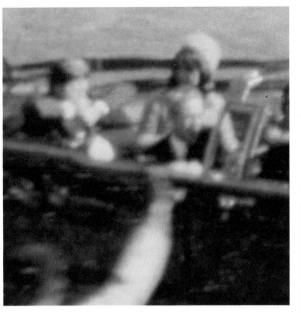

" . . . I felt the blow from something, which was obviously a bullet, which I assumed was a bullet, and I never heard the second shot . . . I didn't hear but two shots. I think I heard the first shot and the third shot."
— *former Texas Governor John Connally*

Above: As Connally is struck, there is a severe drop of his right shoulder and the puffing out of his cheeks.

After being struck, Connally's body continues turning to the left at an accelerated rate, and his right shoulder begins to drop. The Governor's right hand flinches and his Stetson hat moves almost out of his grasp but he keeps hold of it. The beginning of this shoulder drop movement, which was thought to have appeared only around Zapruder frames 237-238 (after Mr. Kennedy had been struck in the back), was actually *continued* in those frames. This new information confirms that Governor Connally was hit *before* the President sustained a wound to his back.

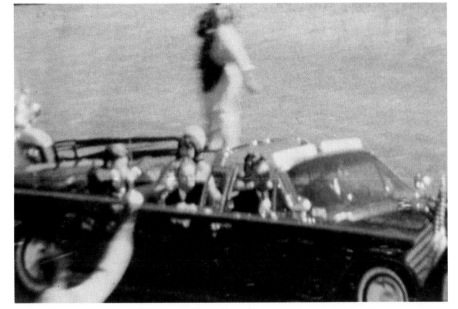

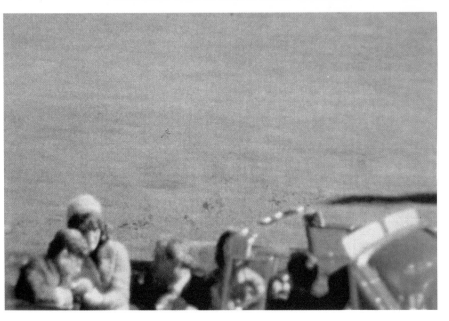

Note that at frame 274 (*left*), 2.7 seconds after the third bullet struck and after the fourth shot struck the President, there is no damage to Connally's wrist, as evidenced by the fact that Connally is still holding his Stetson hat in his right hand. This proves that Governor Connally was struck by two bullets—shot #3 and an unaccounted-for later shot.

Shot #4

The fourth shot struck the President in the back, six inches below the shoulder line to the right of his spinal column. He still sat erect, held up by his back brace. This fourth shot (the third bullet to actually strike a human target) is supposed to have traveled through the President's body and exited his throat, entered Connally's back by his right armpit and exited his chest by the right nipple, then struck him in the right wrist and embedded itself in his left thigh. This is the path of the remarkable "magic bullet," part of the three-shot theory — the "single bullet" theory — developed by the Warren Commission.

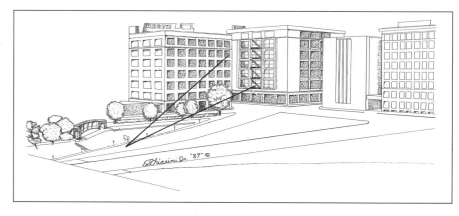

Above: The fourth shot came from behind, possibly from the so called "Oswald" window, but more probably from the second floor of the DalTex building. It struck the President in the back pushing him downward and forward instantly.

The sound of the third shot (and all succeeding shots) is not on the tape that was being recorded back at police headquarters. At the exact moment of the gunshot, someone keyed a radio microphone, which caused a heterodyning effect — or an electrical beat — that interrupted the recording.

Frame 224 (*far left*)
The President is sitting erect against the rear seat of the car. As bullet #4 strikes him in the back (frame 228, *near left top*), it pushes him downward and forward violently. His forwardmost position is shown in frame 236 (*below*).

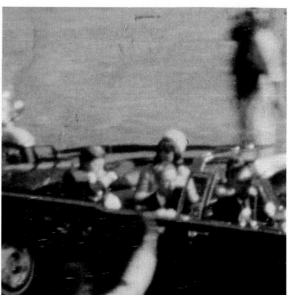

Government re-enactment

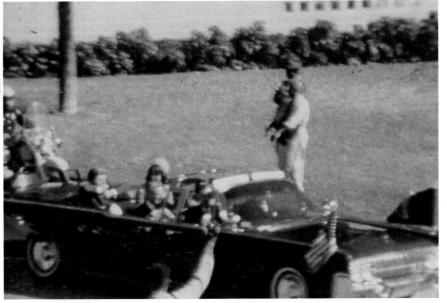

Frame 232

The President is hit in the back from behind. The gunshot most likely came from a near horizontal position, rather than higher up.

The "single bullet" (or magic bullet) concept was developed to explain the effects of the third shot, laying further groundwork to support the lone assassin theory. The Warren Commission claimed that this bullet caused *seven* separate nonfatal wounds in the Governor's and the President's bodies. Why? One (obviously) separate shot shattered Mr. Kennedy's head. Another succeeding shot caused the ricochet that wounded bystander James Tague in the cheek (this was public evidence the Commission could not ignore). Hence, the third shot had to have caused the remainder of the wounds.

The two men shown in this re-enactment are not sitting in the original positions taken by Governor Connally and the President (Connally was seated more to the right, Mr. Kennedy was seated farther left). The seating positions shown here were set up to support the "single bullet" theory, demonstrating that a single (or "magic") bullet could have passed through the President and the Governor.

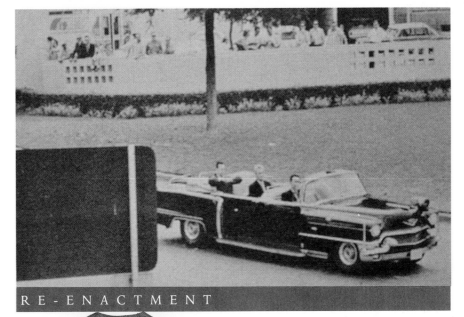

RE-ENACTMENT

The Warren Commission investigation was predicated on the theory that one lone assassin fired three separate shots from a rifle that wounded John Connally and killed the President. The lone assassin theory *had* to be supported in order to rule out the existence of more than one gunman — which would have indicated a conspiracy.

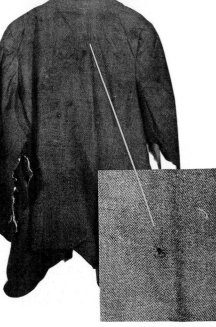

This photograph of the President's jacket, with the inset indicating the bullet hole, shows the exact point of impact of shot #4—the President's back, approximately 6 inches below the shoulder line.

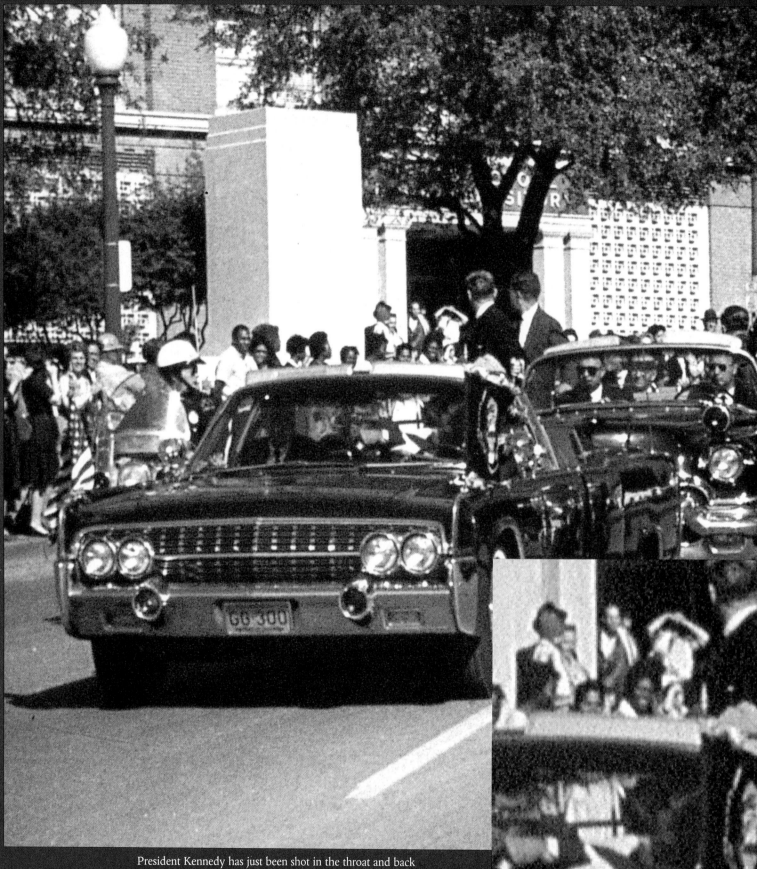

President Kennedy has just been shot in the throat and back
and has slumped forward slightly with his hands up at his neck.

See pages 186–187.

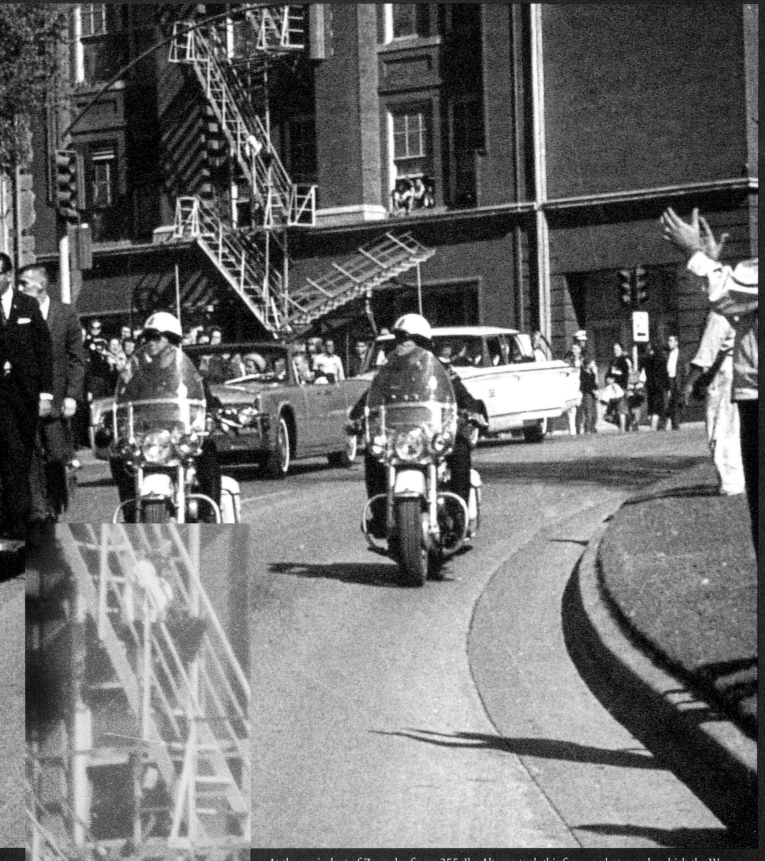

Meanwhile, The attention of the Secret Service agents on the left side of the follow-up car and of the motorcycle police focuses on President Kennedy.

The window of a second floor broom closet behind the fire escape (*inset*) of the Dal-Tex bulding is open. See pages 184–185. Later analysis shows that there is a figure in the window.

At the equivalent of Zapruder frame 255, Ike Altgens took this famous photograph, which the Warren Commission severely cropped.

Shot #5

The fatal fifth shot struck the President in the head, and the power of the frontal impact threw his body rearward and to the left. The motorcycle officers flanking the President's car knew instantly that he had been badly injured: Officer Bobby Hargis, riding on Mrs. Kennedy's side of the motorcade, was struck in the face by a sheet of blood and brain tissue from the President's shattered head.

Above: The fifth shot, from behind the stockade fence on the knoll, struck the President in the right temple, causing massive fracturing, and forcing his head and upper torso violently rearward and to the left. The bullet exited from the rear of the head in the occipital region, leaving a wound the size of a grown man's fist.

A young serviceman, Gordon Arnold, tried first to film the motorcade from behind the picket fence on the Grassy Knoll. A man showing CIA credentials accosted him and told him to get away. Arnold moved to a different spot, close to the stairs on the Grassy Knoll, and resumed filming. He suddenly felt a shot whine past his left ear, and he dropped quickly to the ground. Then a second shot was fired over his head. Moments later, Arnold was kicked by a man in a blue policeman's uniform (who was hatless and had dirty hands). The man demanded to know if Arnold was filming, then took the film from Arnold's camera before disappearing behind the stockade fence.

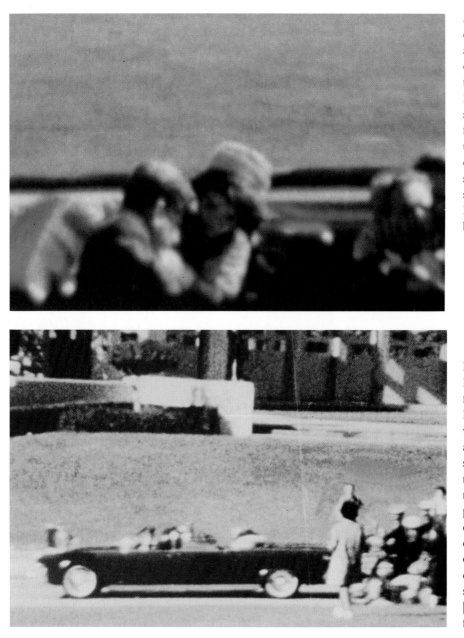

Right: Dealey Plaza eyewitness Orville Nix caught the moment of the head shot on film. His original footage disappeared in 1978 after it was returned to UPI by the House Assassinations Committee.

At least 80 percent of the eyewitnesses in Dealey Plaza asserted that a gun was fired on the President's car from the crest of the Grassy Knoll. At the time of the shooting, the Knoll was in front of the car. It is highly unlikely, as our examination of the medical evidence will show, that the fatal head shot came from the Depository, which was behind the President.

Bystander S. M. (Sam) Holland claimed that the fifth bullet "hit part of [the President's] face." Other eyewitnesses would later testify along similar lines. Their stories matched the first news reports of the assassination, both televised and printed (later news reports distorted or completely changed the facts from these original stories). That same day, an NBC News report stated that "a bullet struck [Mr. Kennedy] in front as he faced the assailant."

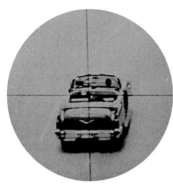

Government Re-enactment

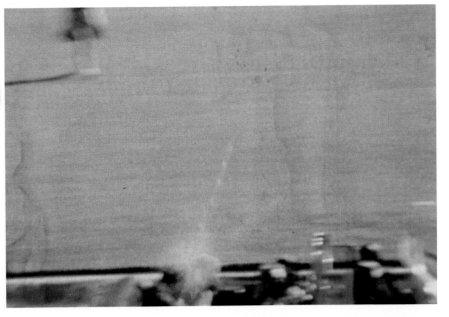

Frame 313

The fatal head shot, coming from in front of the President's car, rapidly pushes his head and body rearward and to the left. The limousine is now barely moving. Critics of the conclusion that the head shot came from the Grassy Knoll maintain that the President's body was pushed back by the acceleration of the limousine. However, the car did not accelerate until several seconds after the head shot.

After the first volley of four shots, Secret Service agents William Greer and Roy Kellerman, both in the front seat of the President's car, turned simultaneously toward the center of the car to look at the President. Greer, the driver, looked over his right shoulder, Kellerman over his left. Then they both turned forward at the same time.

While Kellerman picked up the car radio microphone and spoke into it, Greer turned around again (contradictory to his subsequent testimony to the Warren Commission) to look directly at Mr. Kennedy. This is within one second before the fifth — and fatal — shot.

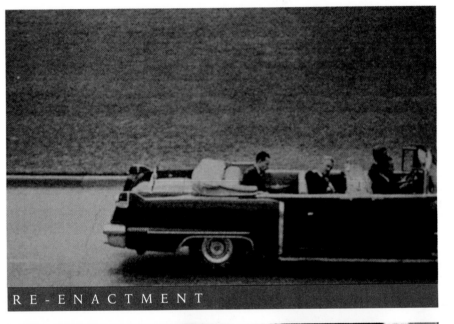

RE-ENACTMENT

Associated Press photographer Ike Altgens saw the fifth shot hit the President. He later stated that the impact was so great that he thought the shot exited from the left side of Mr. Kennedy's head. Said Altgens, "There were flesh particles that flew out of the side of his head in my direction where I was standing [on the south side of Elm Street], so much so that it indicated to me that the shot came out of the left side of his head." In fact, the exit was from the rear.

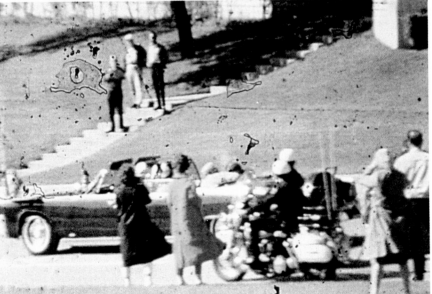

Abraham Zapruder was one of several individuals photographing the motorcade in Dealey Plaza. Orville Nix was standing across the street from Zapruder and caught a view of the President's left side. His film also shows the President being hit from the front and thrown rearward. The Polaroid (*below*) was taken by Mary Ann Moorman seconds after the fatal shot to the President's head. Like Nix, Moorman was across the street, but she was much closer to the President. More than 40 witnesses later informed the Warren Commission that they were aware of shots fired at the President from the Knoll.

A young man named Billy Harper found a piece of bone from the President's head lying on the ground. A pathologist later identified the material (now known as the "Harper Fragment") as a piece of occipital bone, which comes from the back

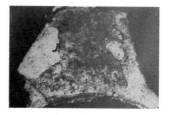

of the head. The bone was found in a spot determined to have been 35 feet behind and to the left of the Presi-

dent's car at the time of the head shot. While the Plaza was being searched after the shooting, Deputy Constable Seymour Weitzman also discovered fragments of bone on the grass and curb to the left of where the President's car had been.

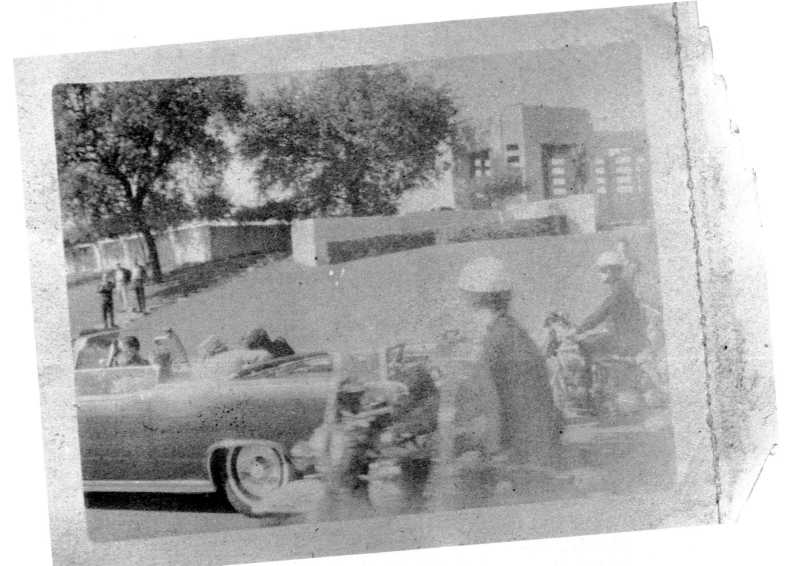

The Warren Commission manipulated the Zapruder film to fit their investigative process. They reversed certain frames so that the President could be seen being pushed forward, which would indicate a shot from behind (fired from the Depository by a single gunman). This distortion of hard evidence proved to be futile, as there were several other photographs taken at the scene that all showed the backward motion of the President's body.

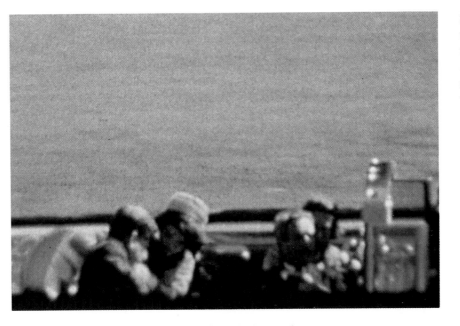

Frame 312 (*left*), one-eighteenth of a second before the head shot, and frame 321 (*below left*), showing the rearwardmost position of the President.

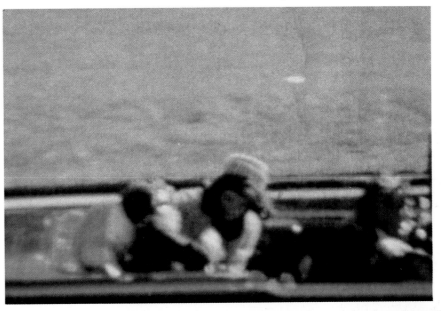

Major Phillip Willis, his wife, Marilyn, and their daughter Linda saw the damage to John Kennedy's head. The three were standing at close range when the head shot hit the President. Said Willis, "I'm very dead certain at least one shot came from the front." The Willises maintained strongly that they saw the back part of the President's head blown away.

Frames from the Nix film (*below*), in which the camera faces north toward the Grassy Knoll, show the movements of the President's body, pushed to the rear and left, after the fifth shot. These are the same body motions captured by the Zapruder film.

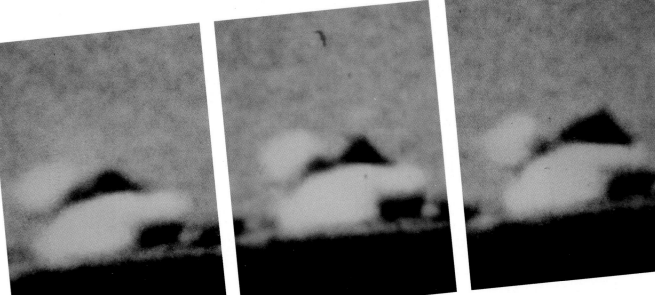

Shot #6

Six-tenths of a second after the fatal head shot, a sixth bullet shattered a large bone in Governor Connally's wrist and embedded itself in his left thigh just above the knee. Secret Service agent Clint Hill ran to the President's car and jumped on it. He approached Mrs. Kennedy, who had climbed up from her seat and was trying to retrieve a skull fragment from her husband's head that had landed on the rear of the car.

Above: A half second after the shot to the President's head, a sixth bullet struck Governor Connally in the right wrist.

Taken by Ike Altgens just after the first four shots, the photo (right) shows the windshield of the President's car with no sign of damage from gunfire. Next came the fatal head shot, followed a half second later by a sixth bullet that hit Connally from the rear. It appears that a fragment cracked the windshield. The photo below was taken by the Secret Service soon after the assassination.

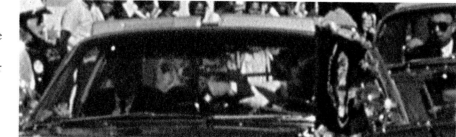

Senator Ralph Yarborough was riding with Vice President and Mrs. Johnson two cars behind the President. He was troubled by the Secret Service agents' reactions to the shooting, saying that "all of the Secret Service men seemed to me to respond very slowly with no more than a puzzled look. Knowing something of the training that combat infantrymen and combat marines receive, I am amazed at the lack of instantaneous response by the Secret Service when the rifle fire began." Senator Yarborough had also observed the reaction of serviceman Gordon Arnold, a Grassy Knoll witness. Arnold immediately dropped to the ground, responding to a shot that came from over his shoulder behind the stockade fence.

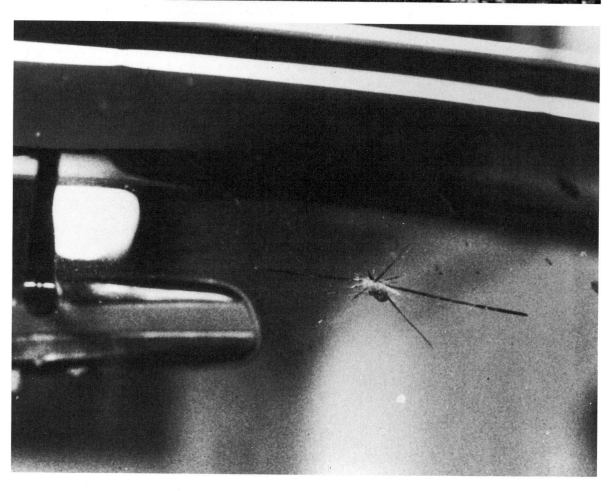

A story was later circulated that Secret Service agent Rufus Youngblood, riding in the Vice President's car, reacted immediately to the barrage of shots by jumping over into the back seat and covering Lyndon Johnson with his body. The truth is that after the fatal head shot, Johnson dropped to the floor of the car and stayed there, as did Agent Youngblood, who remained in the front of the car.

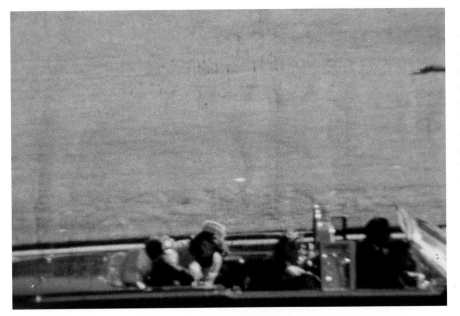

The sixth shot hits Governor Connally after the shot to the President's head. Pushed rapidly forward, the Governor then collapses in his wife's lap. Driver William Greer (*below*) turns to see the impact of the fatal shot. This shows that Connally was hit by two separate bullets.

While in the hands of UPI, Marie Muchmore's original film was cut or mutilated at the frame that showed the moment of the head shot. This frame, and the ones surrounding it, were preserved by optical effects specialist Moses Weitzman in 1973.

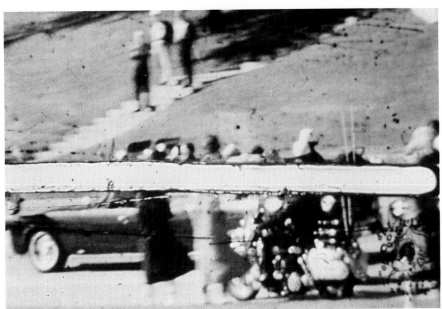

Once it was realized that gunshots were being fired, several people, like the Newman family (*right*), hit the ground and protected children.

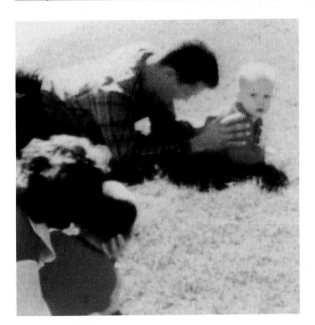

Witness Beverly Oliver (also called the "Babushka Lady" because of the scarf she wore on her head that day) stood close to the President's car during the shooting. She filmed the entire assassination at close range, but her film was later taken from her by Regis Kennedy of the FBI. It was never seen again. Oliver, who knew Jack Ruby and was employed at a Dallas nightclub next door to Ruby's Carousel Club, later married a local mobster.

"... And my husband never made any sound. I turned to the right. And all I remember is seeing my husband, he had this sort of quizzical look on his face, and his hand was up, it must have been his left hand. And just as I turned and looked at him, I could see a piece of his skull and I remember it was flesh colored. I remember thinking he just looked as if he had a slight headache. I just remember seeing that. No blood or anything.

And then he sort of did this, put his hand to his forehead and fell in my lap. I cried: 'They have killed my husband, I have his brains in my hand.'

"And then I just remember falling on him and saying, 'Oh, no, no, no.' I mean 'Oh, my God, they have shot my husband,' and 'I love you, Jack.' I remember I was shouting. And just being down in the car with his head in my lap. And it just seemed an eternity.

"And finally I remember a voice behind me, or something, and then I remember the people in the front seat, or somebody, finally knew something was wrong, and a voice yelling, which must have been Mr. Hill, 'get to the hospital,' or maybe it was Mr. Kellerman, in the front seat. But someone yelling. I was just down and holding him.

"I was trying to hold his hair on. But from the front there was nothing. I suppose there must have been, but from the back you could see, you know, you were trying to hold his hair on, and his skull on." — *Jacqueline Kennedy's testimony to the Warren Commission*

anything. I was just down hr—
...mber a voice behind me, or something, and then I remember
the pr... the front seat, or somebody, finally knew something was wrong,
and a voice yelling, which must have been Mr. Hill, "Get to the hospital,"
or maybe it was Mr. Kellerman, in the front seat. But someone yelling. I
was just down and holding him. [Reference to wounds deleted.]
 Mr. RANKIN. Do you have any recollection of whether there were one or
more shots?
 Mrs. KENNEDY. Well, there must have been two because the one that made
me turn around was Governor Connally yelling. And it used to confuse me
because first I remembered there were three and I used to think my husband didn't
make any sound when he was shot. And Governor Connally screamed. An—
then I read the other day that it was the same shot that hit them both. Bu—
I used to think if I only had been looking to the right I would have seen th—
first shot hit him, then I could have pulled him down, and then the second sh—
...have hit him. But I heard Governor Connally yelling and tha—
...turned to the right my husband was doin—
...bullet. And those

There are two stories that have sprung up to interpret Mrs. Kennedy's actions on the rear of the limousine. The first states that Mrs. Kennedy was trying to escape the scene. The second reasons that she was reaching out to help Secret Service agent Clint Hill get onto the trunk of the car. Both explanations are myth.

Mrs. Kennedy could not have escaped off the trunk of the limousine. Where would she go? Where could she escape to? The gunshots were converging on the car from different directions, with no sheltered place nearby in which to find cover. Escape was virtually impossible.

That Mrs. Kennedy was trying to help Agent Hill onto the car is highly unlikely. Hill never touched her. The Zapruder film shows that when she began to climb out onto the trunk, the First Lady never turned around to look over her shoulder to know that Hill was approaching. She was too intent on retrieving a piece of her husband's shattered head, which she held on to until giving it to Dr. Marion Jenkins at Parkland Hospital.

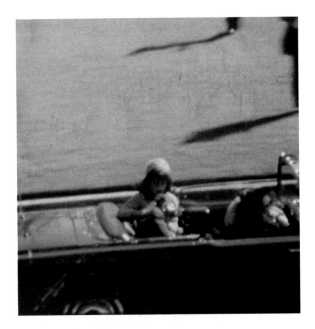

Mrs. Kennedy, in her panic and shock, turns in her seat and begins to climb onto the trunk of the limousine to recover a piece of the President's skull. Though she would later testify that she had no memory of doing so, her actions were deliberate. She climbs up out of her seat, braces herself with her left hand, reaches with her right hand for the head fragment, picks it up, and carries it back into the car. She said, "I have his brains in my hands."

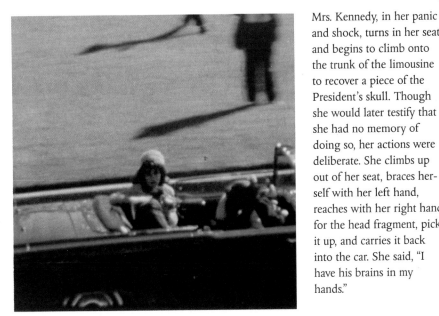

Opposite: The Warren Commission's censorship of Mrs. Kennedy's testimony. The "reference to wounds" is printed in full to the left.

Secret Service agent Clint Hill finally reaches the rear of the President's car after running — and almost falling — in his first attempt to catch up with the accelerating vehicle. Said Agent Hill, "Mrs. Kennedy had jumped up from the seat and was, it appeared to me, reaching for something coming off the right rear bumper of the car. . . . I noticed a portion of the President's head on the right rear side was missing and he was bleeding profusely."

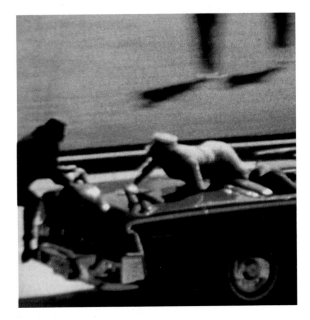

Additional Shots

There were at least two other shots fired in Dealey Plaza that day, perhaps even four more. Three (apparent) bullet marks were found at various places in the Plaza the afternoon of the killing: one by the south curb of Elm Street, one on the north sidewalk of Elm Street, and one by the south curb of Main Street. The latter mark was caused by a bullet that hit the curb and splintered. A fragment of metal and some concrete struck bystander James Tague on the cheek while he was standing near the triple railroad underpass.

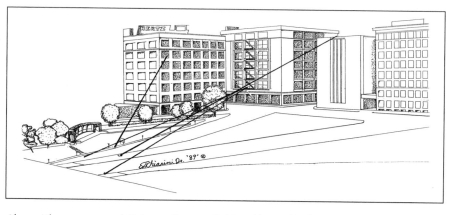

Above: There were two definite, and one probable, additional bullet hits on the ground in Dealey Plaza, and a definite bullet hit on the metal frame above the limousine's windshield.

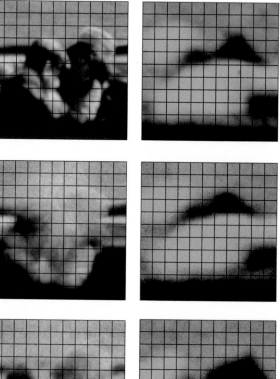

South curb of Elm

Immediately after the shooting, police and sheriff's deputies found a bullet lying in the grass by the south curb of Elm Street. An alleged FBI agent picked up the bullet to examine it, then pocketed it. The bullet has never been recovered (see page 68).

North curb of Elm

This alleged bullet mark on the sidewalk, if it was from an assassin's gun, lines up exactly with the window at the western end of the School Book Depository.

Zapruder/Nix frames

If there was a simultaneous companion shot to the one that shattered the President's head, it would have been an additional shot coming from the sixth floor Depository window, from behind the President's car. It could have been a tangential shot, striking somewhere on the right side of the head, rather than a direct hit to the back of the head, which would have exited on the left side of the President's face (where there was no damage).

The side-by-side frames here represent opposite angle views of a slight forward movement of the President's head in response to a possible additional gunshot just before the more violent rearward movement.

South curb of Main

The bullet that struck the curb on the south side of Main Street splintered, and fragments of metal and concrete hit James Tague in the cheek. It could have come from the Dal-Tex Building or the Depository.

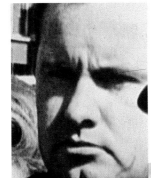

The public's awareness of James Tague's cheek wound impelled the FBI to examine the spot where the bullet struck the south curb of Main Street (about eight feet from where Tague stood). When they went to investigate the curb, the spot where the bullet struck had been paved over. (The FBI never admitted this.) The pen points to the new paving, which is a different color from the original. The FBI later had that curbing removed from the Plaza.

Mark on North Elm curb

The mark found in the north sidewalk of Elm Street may or may not have come from an assassin's bullet. It was not examined on the afternoon of the shooting, because a police car was parked over it during the search in Dealey Plaza. When the section of sidewalk was removed and tested (by a nonfederal agency) approximately 15 years later, no traces of bullet metal were found.

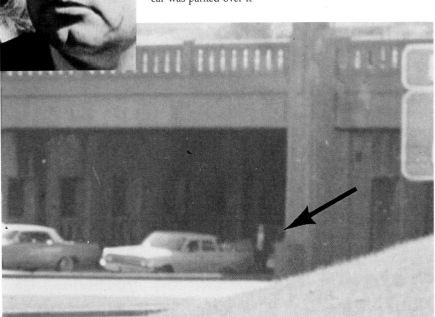

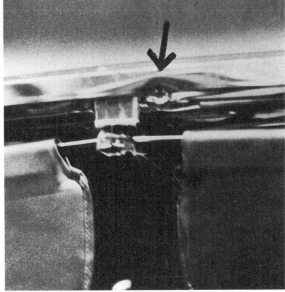

The manhole

A shot that hit near a manhole cover in the Plaza probably came from the roof of the Dallas Records Building, where Deputy Harry Weatherford was stationed, as the angle of the bullet mark cannot be aligned with a trajectory from the School Book Depository. A bullet was found by this spot only minutes after the assassination.

The windshield

An additional bullet, which missed both the President and the Governor, slammed into the windshield frame of the President's limousine above the rear-view mirror, as can be seen in this photo (*above right*) taken by the Secret Service. Fired from behind the car, this shot most likely came from the Dal-Tex Building. The Warren Commision's reconstruction of the crime ignored this evidence. The government's response to the existence of what clearly appears to be damage from a bullet was that it occured prior to Dallas.

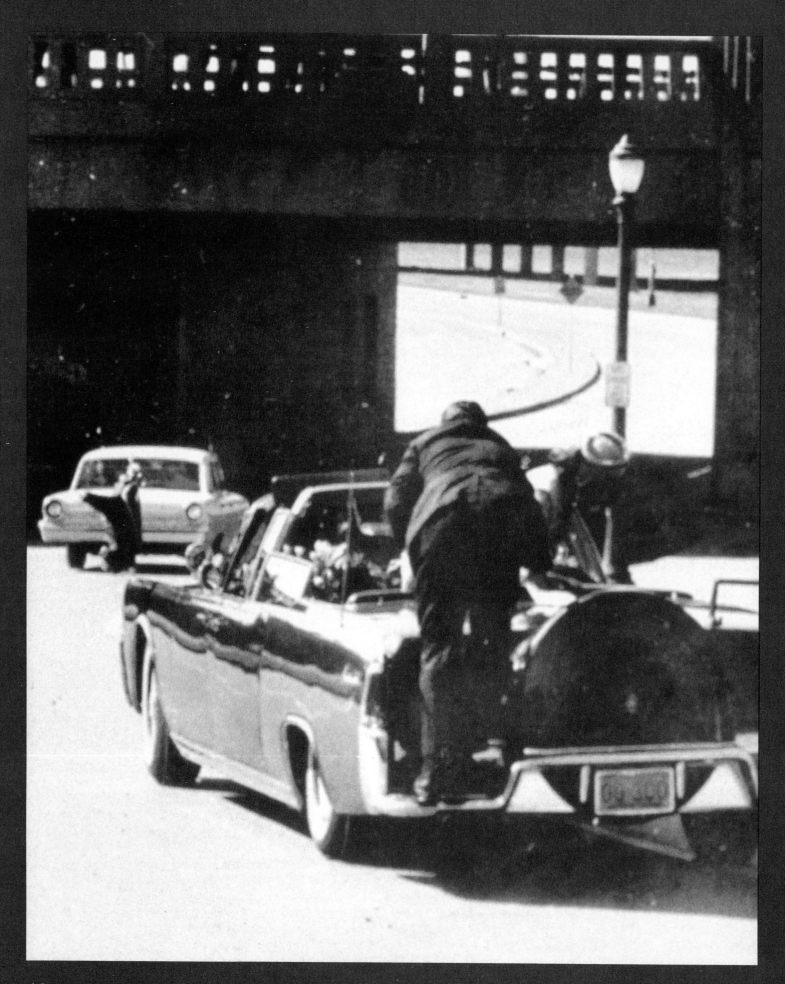

Flight to Stemmons Freeway

Seconds after the President was hit in the head, Secret Service agent Clint Hill had jumped onto the rear of the limousine and was covering Mrs. Kennedy and the wounded President. The limousine's driver, William Greer, reacted and sped up the car. Agent Roy Kellerman, in the front seat with Greer, radioed to the lead car, which sent an urgent message to nearby Parkland Memorial Hospital. In a press car toward the back of the motorcade, reporter Merriman Smith relayed the first news story of the assassination.

The getaway (clockwise from left): Photographers Orville Nix, Mark Bell, and Jack Daniel, each standing in a different spot in the Plaza, captured the escape from Dealey Plaza from opposing angles.

Less than three minutes after the assassination, the telephone lines in Washington, D.C., were discovered to be out of service. The official explanation for this later stated that because too many people were trying to use their telephones to relay news of the shooting, the telephone system went down. Since it has been documented that the breakdown occurred almost at the moment of the shooting, it is unlikely that masses of people would have been trying to call the capital at that time.

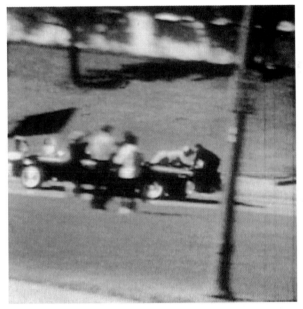

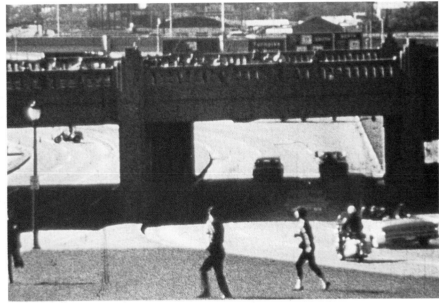

Opposite: The last seconds in Dealey Plaza. Secret Service agent Clint Hill clings to the back of the President's car before crawling toward the back seat. Said Hill, "Just about as I reached [the car], there was another sound, which was different from the first sound . . . as though someone was shooting a revolver into a hard object — it seemed to have some type of an echo."

The majority of the President's Cabinet were en route by airplane to Japan when the assassination took place. When news of the killing was radioed in, officials discovered that the code book that would help them access a secured radio channel to decipher the message was missing. Cabinet members, who were astounded that this crucial handbook was gone (an unprecedented violation of all federal protocols), did not know what information to believe, so they turned around and flew back to Washington.

Ed Hoffman, a deaf-mute who was standing on the overpass near the Stemmons Freeway on-ramp, had a direct view (from between 50 and 75 feet away) into the President's car as it moved toward the freeway entrance. The car had stopped there for about 30 seconds to receive directions from the lead car, which they had passed moments earlier. While William Greer waited for the lead car to catch up, Hoffman looked into the presidential limousine. He saw that the entire rear of Mr. Kennedy's head

was gone. (Other eyewitnesses' testimonies corroborate this observation—see page 86.) When later interviewed, Hoffman wrote down that the President's head looked like "blood jello."

S. M. (Sam) Holland watched the assassination from the Stemmons Freeway overpass. He said in subsequent testimony that he heard and saw four shots fired. Holland stated that he thought the third shot came from the stockade fence on the Grassy Knoll, which was to the right front of the President's car. Holland's story perfectly matched the confirmed shots on the Dallas Police Department's Dictabelt recording of the gunshots. He also told federal investigators that he saw a Secret Service agent standing up in the follow-up car (behind the President's car). Holland asserted that the agent was holding a machine gun. The investigators thought this statement was absurd and made light of Holland's entire testimony.

The high-speed flight along Stemmons Freeway to Parkland Hospital begins. The lead car and the presidential limousine arrive at Parkland Hospital's emergency entrance at approximately 12:35 p.m.

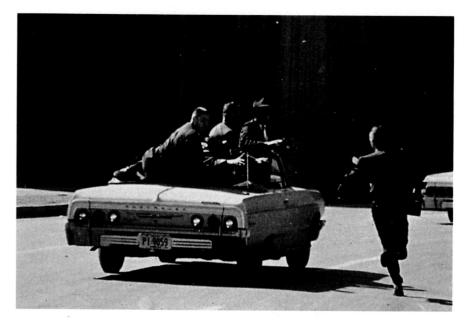

Below: The presidential limousine races toward the Stemmons Freeway on-ramp. In the follow-up car is a man, a Secret Service agent, standing up with a machine gun in his right hand. This picture would later be a key piece of evidence in the House Assassinations Committee investigation, proving that eyewitness Sam Holland's testimony about the number and source of gunshots — and that he saw a man with a machine gun in the follow-up car — was not exaggerated.

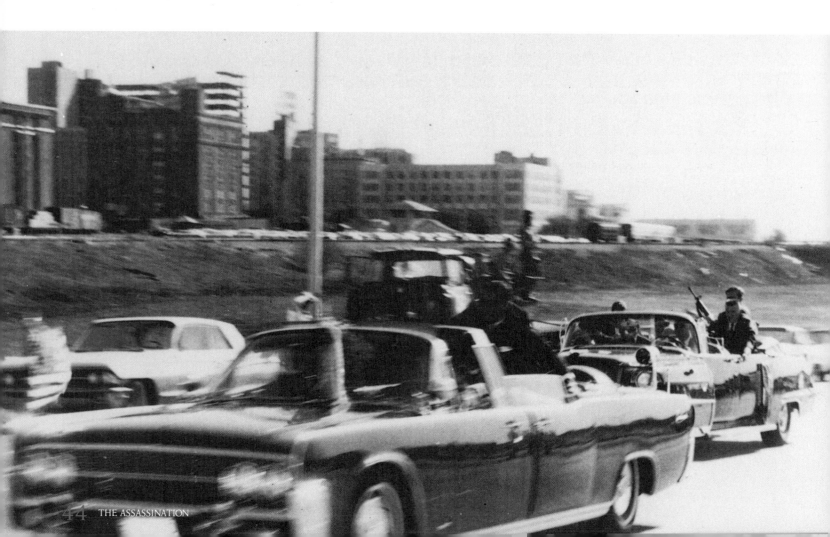

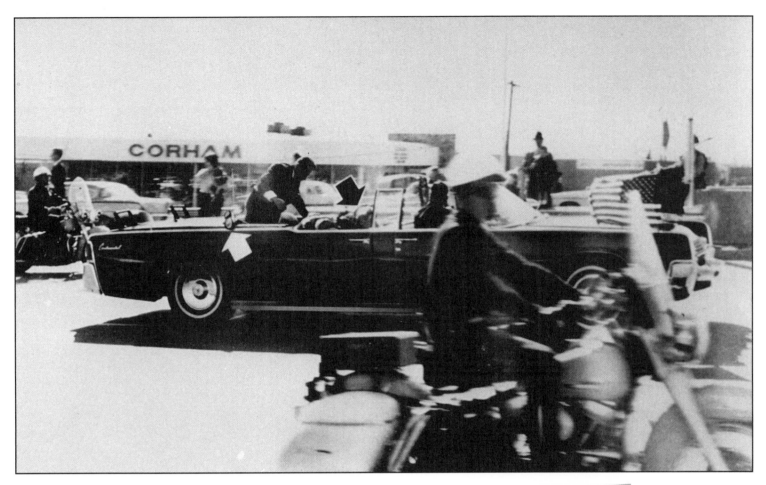

National newswire reporter Merriman Smith, riding in one of the motorcade's press cars, radioed in his story about the assassination as the last shots were fired. Perhaps intent on filing an exclusive report, Smith yanked out the radio's microphone, preventing anyone else from using it. This also delayed any information from Dallas.

With press cars keeping pace, the motorcade moves off Stemmons Freeway onto Harry Hines Boulevard, speeding at about 70 miles per hour. Just a few blocks from Parkland Hospital, Agent Hill, with his foot hanging over the edge of the car, is still positioned over the President and First Lady, on the alert for possible further attack.

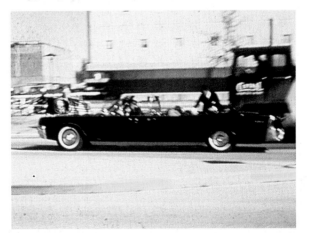

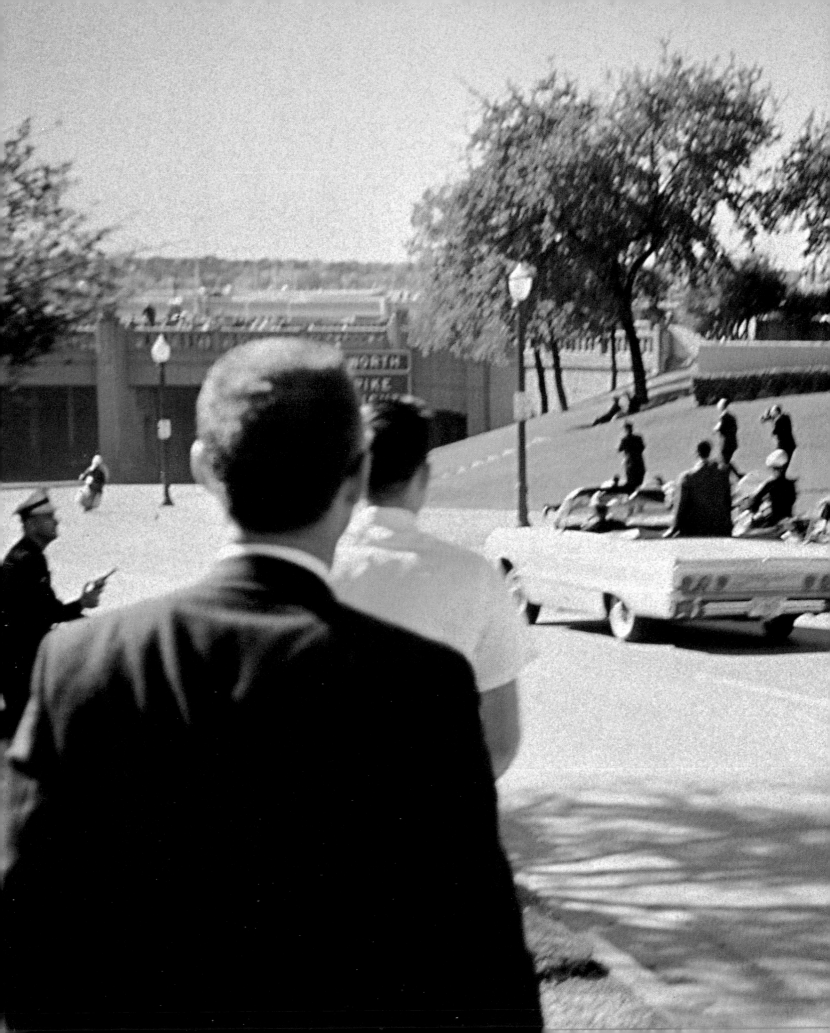

AFTERMATH IN DEALEY PLAZA

As the echoes of gunshots were fading in Dealey Plaza, the crowd of onlookers and Dallas police reacted spontaneously, running up the short slope of a hill now known as the "Grassy Knoll." The police officers who rushed the Knoll in response to the shots were aware that the fatal shot had come from the top of the hill. A crowd of more than 200 went along with them to help pursue the assassin, but all were met and turned away at the top of the Knoll by men flashing Secret Service badges.

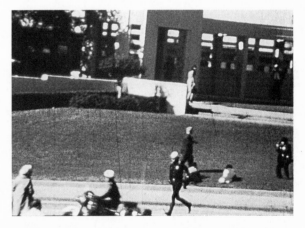

The immediate response of several motorcycle police officers was to jump from their bikes and rush up the Knoll.

Why these people would put themselves in jeopardy and attempt to chase an armed killer into the parking lot at the top of the Knoll is best summed up by Dealey Plaza witness Jean Hill. Hill had been standing directly across from the Grassy Knoll. She stated, "I only knew that this man had shot the President. He had to be stopped. I didn't have time to even think of my own safety."

Motorcycle officer Bobby Hargis, riding to the rear passenger side of the President's car, had been

Opposite: Stunned by what they have just seen, police and onlookers seem momentarily frozen, their attention on the Grassy Knoll. Within the next second, people ran frantically up the Knoll in pursuit of an assassin.

47

splattered with the President's bloody tissue from the fatal shot to the head. Feeling sure that the shot must have come from the top of the Grassy Knoll, he and other colleagues and eyewitnesses ran there.

Witnesses' observations about audible impressions of shot number and direction tended to vary, but the majority (more than 80 percent) of eyewitnesses were drawn immediately by the sounds of gunfire originating from behind a stockade fence and a cement retaining wall on top of the Grassy Knoll.

Numerous photographs show the police in Dealey Plaza surrounding and entering the Texas School Book Depository soon after the shooting. They did so in response to the statements of witnesses Howard Leslie Brennan and Amos Euins and following the lead of Dallas motorcycle patrolman Marrion L. Baker. Baker had heard the shots and observed pigeons scattering into the air from their perches on the Book Depository; he rushed into the building to investigate. He was met by building superintendent Roy Truly, and together they ran up the stairs to the second floor and encountered Depository employee Lee Harvey Oswald. Oswald left the Depository within minutes of this meeting and boarded a westbound city bus. On the sixth floor, a "sniper's nest" with a gun and bullet shells was not discovered until later that afternoon.

About one-half hour after the shooting, the police continued a protracted search of the railroad yard area behind the Knoll. This led to the arrest of three men, the so-called "tramps." The oddity about these alleged tramps is that almost no record was made of their

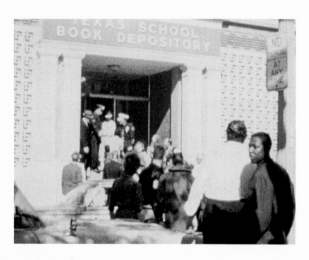

A person who some later thought was Lee Harvey Oswald watched the assassination from the Depository's front entrance (see pages 30 and 186). This man stayed in the doorway after the shooting, and was eventually pressed into service running the Depository elevator for the police while they searched the building.

One of the "tramps" arrested in the railroad yard resembled E. Howard Hunt, a CIA operative involved in earlier assassination plots against Fidel Castro, leading to speculation years later of a direct Dallas-Watergate link involving Hunt.

arrests, they were clean-shaven, and they wore clothing and shoes in good condition. They were held in custody until Monday, November 25, then released.

The debate over the number of shots fired, their points of origin, and the number of gunmen still continues, but this discussion pales against the realization that even a *single shot* fired from the Knoll proves a conspiracy in the killing of the President.

If there were gunmen firing from both the front and the rear, as indicated by eyewitnesses' reactions and the ensuing photographic evidence, the killing was a classic military style, or triangulated fire, ambush.

Immediately after the shooting, police and bystanders run toward the railroad overpass, which adjoins the stockade fence at the top of the Grassy Knoll. Newsman Robert MacNeil, standing next to the officer, stares backward over his left shoulder. The man standing next to the tree, wearing a fedora hat, black suit, and white socks, closely resembles—and may very well be—Jack Ruby. Ruby was dressed identically when he shot Lee Oswald two days later.

Newsman Robert MacNeil came down off the Grassy Knoll and ran over to the Texas School Book Depository. At the entrance, he accosted a stranger in the crowd and asked him if there were a telephone nearby. The man barely replied, saying that there was one inside if he'd just go in and look for it. Not until years later did MacNeil realize that the man he'd spoken to was, in fact, Lee Harvey Oswald, who was just about to leave the building.

Responding to the Gunfire

The scene in Dealey Plaza erupted as bystanders, Dallas police, and those in the presidential motorcade witnessed and heard the evidence of gunfire. Eyewitness Mary Ann Moorman saw the President slump down and she screamed, "My God, he's shot!" There were those who ran to the Grassy Knoll in pursuit of an assassin, while others rushed to the Texas School Book Depository Building. But, oddly, those individuals crucial to the President's protection, the Secret Service agents, did not react. With the exception of Agent Clint Hill, they did very little.

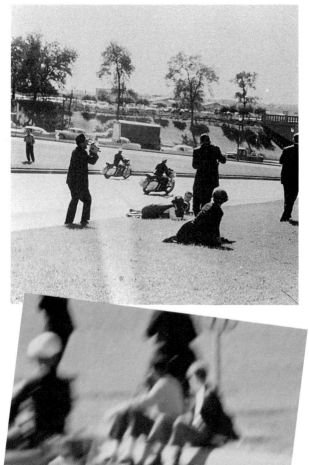

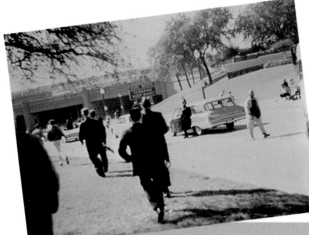

Top, right: One man, still standing, gazes after the motorcyles speeding to catch up with the departing motorcade. He holds a crude cardboard sign that he has just flashed at the presidential limousine. It says "S.O.B. Jack Kennedy."

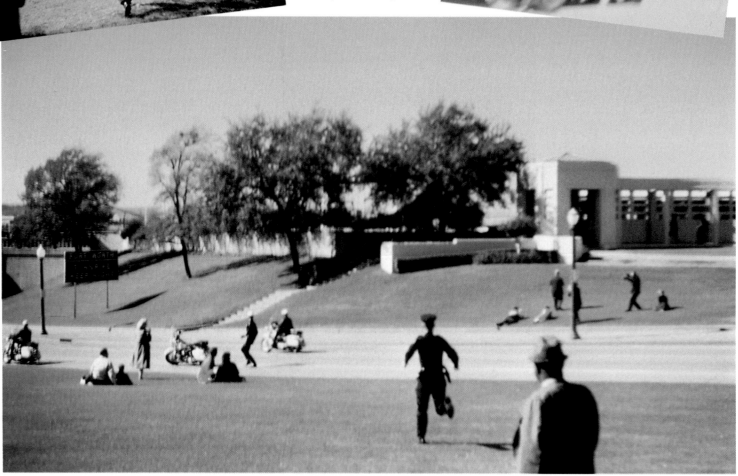

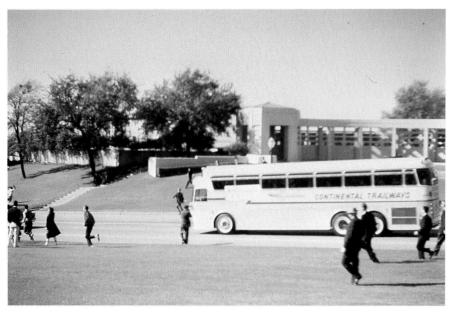

As the motorcade made its escape toward the Stemmons Freeway, officers and other eyewitnesses, still in shock, look toward the Grassy Knoll.

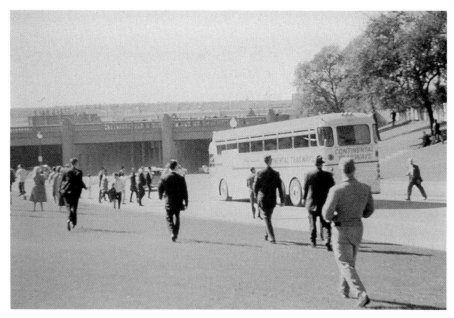

Eyewitness Jim Hicks (*foreground, above*), who later claimed to be a radio coordinator for the gunmen, looks after the press bus as it follows the motorcade to Parkland Hospital. Hicks, walking toward the Knoll, has something in his back pocket resembling a radio with an antenna.

A small group of people chased a man who ran from behind the cement wall, up the Knoll and across the railroad yard. This alleged assassin appears in photographs as a dark figure behind the wall seen on the right (see pages 54-57).

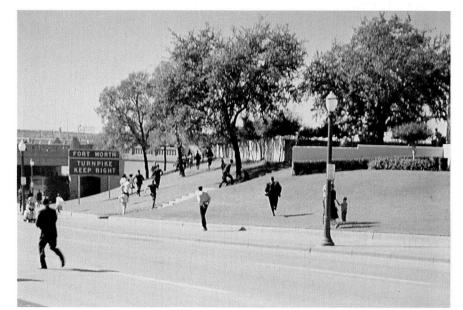

The Police Response

The transcript from the Dallas Police Department Dictabelt recording. Seconds after the shooting, Police Chief Jesse Curry and Sheriff Bill Decker radioed instructions to their men to immediately investigate the top of the Grassy Knoll and the railroad yard behind it. These orders, given quickly in response to the gunfire, indicate that both Curry and Decker were convinced that the shots came from the Knoll. Their car was directly in front of it when the shooting began.

The all-points bulletin goes out on the alleged assassin (*opposite page, last paragraph*). Police got a description from eyewitness Howard Brennan, who had seen a man through a dirty sixth floor window of the Texas School Book Depository.

Brennan was nearsighted and wasn't wearing his glasses at the time. His description bears little resemblance to Lee Harvey Oswald, who was younger and had a slighter build. How could the police have recognized Oswald from this report, especially as they had not yet received Brennan's description when they circulated the bulletin?

Caller	Conversation
212 (Patrolman L. W. Spradlin)	On Mockingbird near Denton.
Dispatcher (Henslee)	It will probably be after 2:30 p.m.
5 (Deputy Chief of Police George L. Lumpkin)	1 (chief of Police Jesse E. Curry), crowd on Main Street in real good shape. They have them back off of the curb
1 (Chief)	Good shape. We are just about to cross Live Oak.
Dispatcher	12:22 p.m.
1 (Chief)	1 (Chief) to escort - drop back. We will have to go at a real slow speed here on now.
1 (Chief)	1 (Chief) to Motorcycle - hold up escort. O.k. move along.
1 (Chief)	Check and see if we have everything in sight. Check with the rear car.
Dispatcher	1 (Chief) who is in the rear car?
158 (Patrolman L. S. Davenport)	Everything is O.K.
Dispatcher	1 (Chief), 158 advise O.K., 12:26 p.m.
1 (Chief)	Crossing Lamar Street.
Dispatcher	10-4. Pretty good crowd there, 12:28 p.m.
1 (Chief)	Big crowd, yes.
5 (Deputy Chief)	Notify Captain Souter of the location of the convoy now.
Dispatcher	15/2 (Captain J. M. Souter), now on Main, probably just past Lamar.
1 (Chief)	Just crossing Market Street (12:28 p.m.)
4 (Deputy Chief N. T. Fisher)	125 (Captain P. W. Lawrence), what traffic personnel do you have on Mockingbird?
1 (Chief)	Headed to Parkland. Something's wrong with channel 1.
5 (Deputy chief George L. Lumpkin)	1 (chief) what do you want with these men out here with me.
1 (Chief)	Just go on to Parkland Hospital with me.
83 (Patrolman R. L. Gross)	Dispatcher on channel 1 seems to have his mike stuck.
1 (Chief)	Get those trucks out of the way. Hold everything. Get out of the way.
Dispatcher	Unknown motorcycle - up on Stemmons with his mike stuck open on channel 1. Could you send someone up there to tell him to shut it off? (12:34 p.m.)

Caller	Conversation
125 (Captain Lawrence)	"On Mockingbird at Cedar Springs," is the question?
4 (Deputy Chief)	10-4. It's moving out of this lot very slow.
125 (Captain Lawrence)	I am at the Trade Mart now headed out that way.
4 (Deputy Chief)	That is all right - I'll check it.
1 (Chief)	Approaching Triple Underpass.
Dispatcher	12:30 p.m. KKB 364.
1 (Chief)	Go to the hospital - Parkland Hospital. Have them stand by.
1 (Chief)	Get a man on top of that triple underpass and see what happened up there.
1 (Chief)	Have Parkland stand by.
Dallas 1 (Sheriff J. E. Decker)	I am sure it's going to take some time to get your man in there. Pull every one of my men in there.
Dispatcher	Dallas I repeat, I didn't get all of it. I didn't quite understand all of it.
Dallas 1 (Sheriff)	Have my office move all available men out of my office into the railroad yard to try to determine what happened in there and hold everything secure until Homocide and other investigators should get there.
Dispatcher	10-4. Dallas 1 - Station 5 (Dallas County Dispatcher) will be notified.
Dispatcher	1 (Chief) any information whatsoever?
1 (Chief)	Looks like the President has been hit. Have Parkland stand by.
Dispatcher	10-4. They have been notified.
4 (Deputy Chief)	We have those canine units in that vicinity, don't we?
22 (Patrolman Hill)	I have one guy that was possibly hit by a ricochet from the bullet off the concrete and another one saw the president slump.
Dispatcher	10-4.
137 (Patrolman E. D. Brewer)	We have a man here who says he saw him pull the weapon back through the window from the southeast corner of that depository building.
Dispatcher	295 (Patrolman William Price), do you know the extent of the injury?
295 (Patrolman Price)	It's not for me to say, I can't say. (12:41 p.m.)
5 (Deputy Chief Lumpkin)	Give me a squad to Elm Houston.

Caller	Conversation	Caller	Conversation
190 (Sergeant S. Q. Beliah)	Do you still want me to hold his traffic on Stemmons until we find out something?	15/2 (Captain Souter)	Did they advise they have the suspect?
1 (Chief)	Keep everything out of this emergency entrance.	Dispatcher	No, they do not have the suspect.
Dispatcher	Did you get all that information 136 (Patrolman B. W. Hargis)	9 (Inspector J. H. Sawyer)	We need some more men down at the Texas School Book Depository. We should have some on main if we could get someone to pick up and bring them down here.
136 (Patrolman Hargis)	10-4		
142 (Patrolman C. A. Haygood)	I just talked to a guy here who was standing close to it and the best he could tell it came from the Texas School Book Depository Building here with that Hertz renting sign on top.	250 (Sergeant W. A. Simpson)	I will start down Elm Street and pick up as many as I can on the way (12:43)
		190 (Sergeant Baliah)	We can release this traffic here? We can go down there or stay here and hold it.
Dispatcher	10-4. Get his name, address, telephone number there - all the information that you can from him. 12:35 p.m.	Dispatcher	Release the traffic and report Code 3 (Emergency-red lights and sirens) to Elm and Houston, 12:43 p.m.
15/2 (Captain Souter)	Captain advise have all emergency equipment - have 283 (Patrolman C. R. Hamilton) cut the traffic at Hines and Industrial. Have all emergency units on South Industrial.	15 (Captain C. E. Talbert)	Are you having them contain that block or 2 block area?
		Dispatcher	Yes, we are trying to seal off that building until it can be searched.
531 (Sergeant Henslee)	283 (Patrolman Hamilton), cut traffic Hines and Industrial.		
Dispatcher	Attention, do not use Industrial Blvd. 12:36 p.m.	15 (Captain Talbert)	More than that building. Extend out from that building so it can be searched.
260 (Sergeant D. V. Harkness)	I have a witness that says that it came from the 5th floor of the Texas Book Depository Store.	267 (Patrolman J. H. Caldwell)	Do you want me to head south?
Dispatcher	220 (Sergeant W. R. Russell), keep all emergency equipment off the entrance to Parkland and all of the emergency equipment there off of Industrial Boulevard.	Dispatcher	Yes, 12:44 p.m.
		9 (Inspector)	The type of weapon looked like a 30-30 rifle or some type of winchester.
		Dispatcher (Henslee)	9 (Inspector), it was a rifle?
Unknown	We have the emergency entrance secured. 12:37 p.m.	9 (Inspector)	A rifle, yes.
125 (Captain Lawrence)	We have the emergency entrance to Parkland secured.	Dispatcher	9 (Inspector) any clothing description?
22 (Patrolman L. L. Hill)	Get some men up here to cover this school depository building. It's believed the shot came from, as you see it on Elm Street, looking toward the building, it would be upper right hand corner, second window from the end.	9 (Inspector)	About 30,5'10", 165 pounds.
		Dispatcher	Attention all squads, the suspect in the shooting at Elm and Houston is supposed to be an unknown white make approximately 30, 165 pounds, slender build, armed with what is thought to be a 30-30 rifle.-repeat, unknown white male, approximately 30, 165 pounds, slender build. No further description at this time or information 12:45 p.m.
Dispatcher	10-4. How many do you have there?		

The supposed Secret Service men guarding the top of the Grassy Knoll could have been intelligence agents ordered to special security detail for the day. If that were true, why would they prevent Dallas police from joining the search for the assassin? No record of extra protection has been established to account for Secret Service men on the Knoll. Were these men part of an intricately planned assassination?

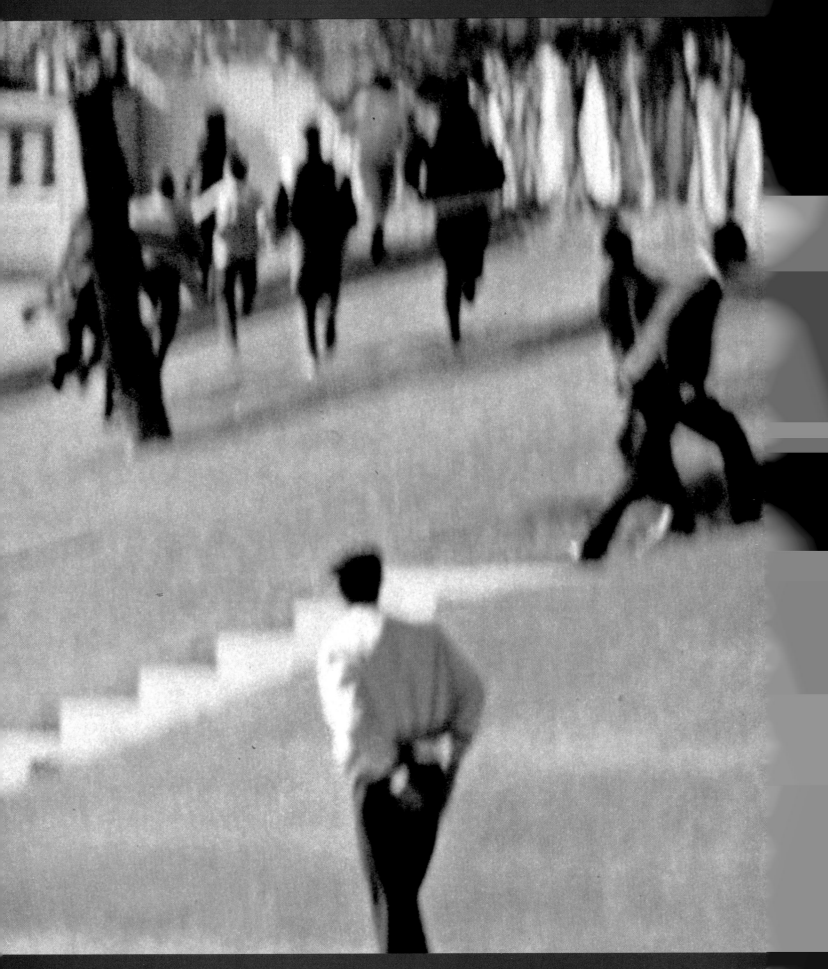

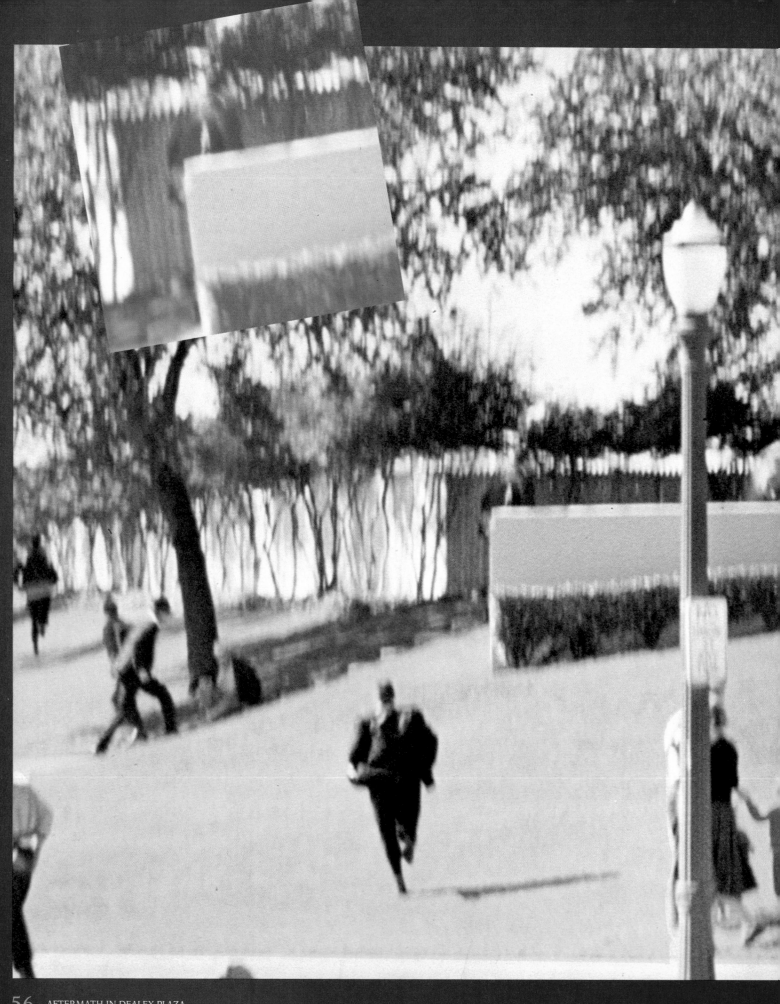

Dealey Plaza witnesses pursue a man who had been standing, with only his upper body visible in photographs, behind the corner of the cement wall on the Knoll. Moments after the last gunshot, the man fled, leaving a Coke bottle on the ledge (*see inset at upper left*). The bottle (with a possible assassin's fingerprints) was probably found but discarded and never presented as evidence.

Another man (*see bottom inset*), moving so rapidly that he appears only as a blur, runs to look over the stockade fence.

The first man to reach the stockade fence jumps onto a cement pedestal attached to the pergola structure and scans the parking lot beyond the fence (*top*). If anyone alive saw what happened to the assassin, this man did. He was neither identified nor questioned and has never come forward.

Chaos at Parkland Hospital

Racing along Stemmons Freeway, the President's car reached Parkland Hospital at approximately 12:35 p.m., followed closely by the Vice President's car. The scene at the hospital entrance was chaotic with physicians and other hospital personnel rushing to the President's car. At first, Mrs. Kennedy would not release her husband. Governor Connally, who had regained consciousness upon arrival at the hospital, tried to stand and get out of the car, but collapsed. Finally, with difficulty, Agents Kellerman, Greer, and Lawson lifted the President onto a stretcher. Admiral George Burkley, the President's physician, arrived three to five minutes later, as he had mistakenly gone on to the Trade Mart.

Parkland Hospital orderly Darrell Tomlinson found a bullet on the floor near a stretcher in the hallway outside the Trauma Room. The bullet, which had a pointed nose, was turned over to the Secret Service.

However, the bullet later used as evidence in the Warren Commission investigation was not the same bullet that Tomlinson found. The bullet placed in evidence had a rounded nose.

Though it has been proven that Jack Ruby was present at Parkland when the President was brought in, it is not known whether Ruby planted the bullet. When called later to testify before the Warren Commission, Darrell Tomlinson was asked to identify the bullet (Commission Exhibit 399). He said it looked completely different from the original bullet he had found.

After the race to the hospital, the majority of the entourage and the press were kept outside near the entrance to the Emergency Room. Senator Ralph Yarborough, who had arrived with Vice President Johnson, was prevented from going inside. Still in shock, he walked aimlessly around the parking lot.

Someone, perhaps Agent Clint Hill, put a jacket over the President's shattered head to conceal his wounds from the press. As they carried the President inside, Mrs. Kennedy accompanied them into the Trauma Room, still holding on to the piece of the President's head she had retrieved from the rear of the limousine.

While the President was being attended to, a rumor started circulating within the stunned and saddened crowd outside that the President was already dead. A priest, Father Oscar Huber, was called.

Trauma Room One

Dr. Malcolm Perry took over the President's treatment after Dr. Charles Carrico, a surgical resident, had attempted to improve Kennedy's breathing by putting him on a respirator. Perry performed a tracheotomy, assisted by Dr. Robert McClelland, while the rest of the medical team tried to stabilize the President's vital signs and stop the massive bleeding. When noting the absence of any neurological, muscular, or heart response, the doctors, including the President's physician, concluded that attempts to save the President were hopeless. Father Oscar Huber administered the last rites, and John Kennedy was pronounced dead at approximately 1:00 p.m.

Surrounded by Secret Service Agents, Vice President Johnson is hurried out of the hospital to Police Chief Curry's squad car for the drive to Love Field.

When she entered Trauma Room One, Mrs. Kennedy went up to Dr. Marion Jenkins, nudged him and said, "Here, will this help?" She opened up her hand and gave Dr. Jenkins the piece of her husband's head that she had recovered off the trunk of the car.

Doris Nelson, the supervising Emergency Room nurse, got a good look at the President's wounds. She and other nurses washed and prepared his body for the coffin. Said Nelson, ". . . we wrapped him up . . . and I saw his whole head. . . . There was no hair back there.

. . . It was blown away. Some of his head was blown away and his brains were fallen down on the stretcher." When Parkland Doctor Paul Peters was interviewed about the President's wounds, he said: "He had a large — about 7 cm — opening in the right occipital-parietal area. A con-

siderable portion of the brain was missing there, and the occipital cortex — the back portion of the brain — was lying down near the opening of the wound. Blood was trickling out."

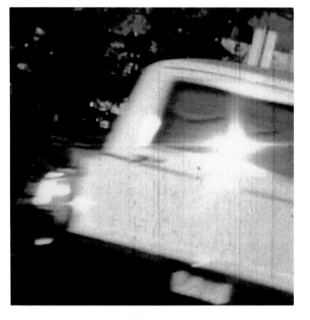

The announcement of the President's death by acting secretary Malcolm Kilduff. Kilduff points to the spot where the bullet entered the right temple.

Storming the Knoll

Witnesses who charged up the Knoll after the escaping gunman were reacting spontaneously to their convictions that the gunshots had been fired from the top of the slope in front of the President's car. But the area encompassing the Grassy Knoll, the Pergola, parking lot, and large railroad yard was a maze of potential escape routes. To catch an assassin would have been extremely difficult. Also, witnesses —and even police—were deterred from the chase by men who claimed to be Secret Service agents.

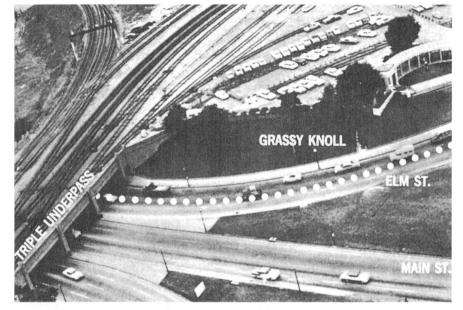

A press cinematographer ran up the Knoll in the midst of the crowd, his camera continuously filming the chase. This frame shows the spontaneous response of the hundreds of witnesses in the Plaza who rushed the Knoll.

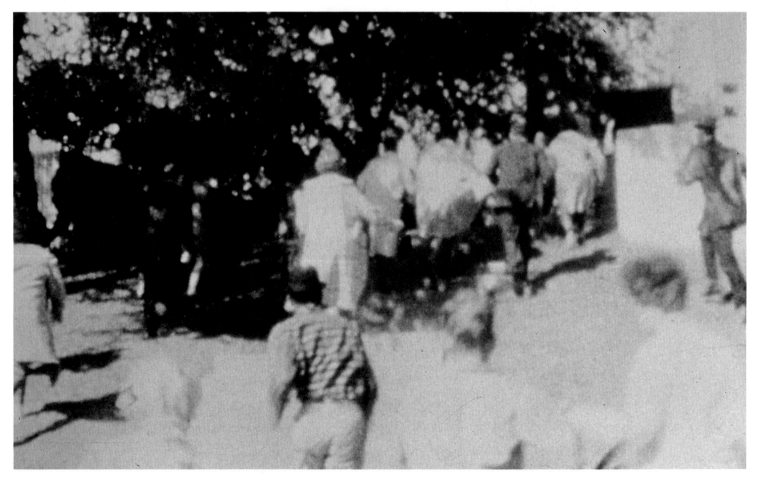

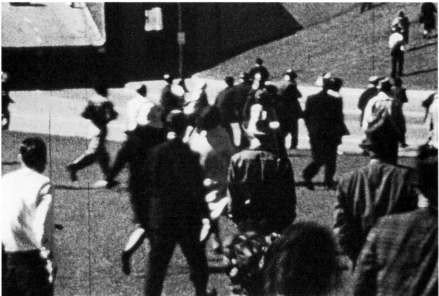

Railroad dispatcher Lee Bowers was sitting in the railroad tower that overlooked the yard and parking lot when a flurry of activity near the stockade fence attracted his attention. Unsure of whether he had seen smoke, a quick flashing of light, or if he heard something, Bowers stared at the fence from his position behind it. Shortly afterward, Bowers noticed a train (the departure of which he had not authorized) pulling out of the yard and transmitted an order to stop it. Three men, supposedly tramps or hobos, were later pulled off the train and arrested.

Just before the assassination, Bowers had seen a car, with out-of-state license plates and a political bumper sticker, drive into the parking lot. The car drove around the lot and left, then returned and left again. The car came back a third time, parked, and two or three people got out and walked to the stockade fence. When Bowers was called to testify before the Warren Commission, he tried to describe what he had seen in the parking lot. Each time he started to give them this particular information, the interviewer led him away from the subject. He later told other researchers that "there was some unusual occurrence — a flash of light or smoke or something which caused me to feel like something out of the ordinary had occurred there."

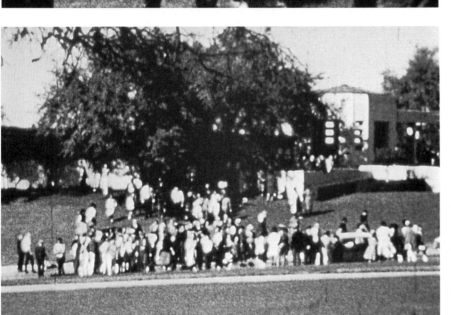

The Depository Investigation

After hearing the crack of a high-powered rifle shot, Officer Marrion Baker's attention was attracted to the Depository by the startled flight of pigeons from the roof. He left the motorcade to investigate, pushing his way through the spectators at the Depository entrance. Gun drawn, Baker and building superintendent Roy Truly ran up one flight of stairs to the second floor, where they encountered employee Lee Harvey Oswald in the lunchroom, drinking a Coke. Oswald, moments later, calmly left the Depository and boarded a bus. Twelve minutes passed before the Depository was sealed off for investigation.

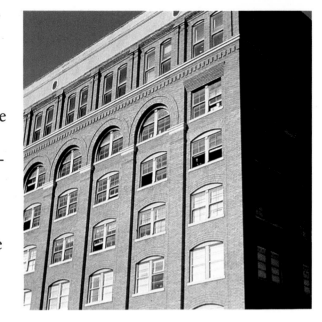

Richard Randolph Carr had watched the motorcade from the new Dallas County Government Center. During the assassination, Carr caught sight of a heavyset man, who was wearing a tan sport jacket, as well as a hat and glasses, on the sixth floor of the Depository. When the shooting stopped, Carr saw two men run from the vicinity of the Depository, jump into a Rambler station wagon, and drive north on Houston Street. After he left his vantage point, Carr saw the man in the tan coat hurriedly leave the Plaza.

Opposite: The view from the "sniper's nest," the easternmost window on the sixth floor of the Texas School Book Depository.

When Deputy Sheriff Roger Craig encountered Lee Harvey Oswald at the Dallas police headquarters after Oswald's arrest, he thought he recognized him right away. Craig told Captain Will Fritz (who was questioning Oswald at the time) that he had seen a man resembling Oswald walking down the Grassy Knoll after the shooting. He got into a green Rambler station wagon, which drove away. Oswald bristled and told them that the car belonged to Ruth Paine, and to "leave her out of this."

The man in the white shirt under the road sign is the man Craig said was Lee Oswald leaving the Depository. The station wagon on the right is the car that stopped to pick him up. This may be Oswald or one of the several Oswald look-alikes whom others mistook for Oswald.

H S C A
MYSTERIOUS
Death Project

Key eyewitness Richard Randolph Carr was never called upon to testify. But police and other officials repeatedly came to his house outside Dallas to intimidate him into silence. Carr suffered death threats and coercion at the hands of the FBI who told him, "If you didn't see Lee Harvey Oswald in the School Book Depository with a rifle, then you didn't see anything."

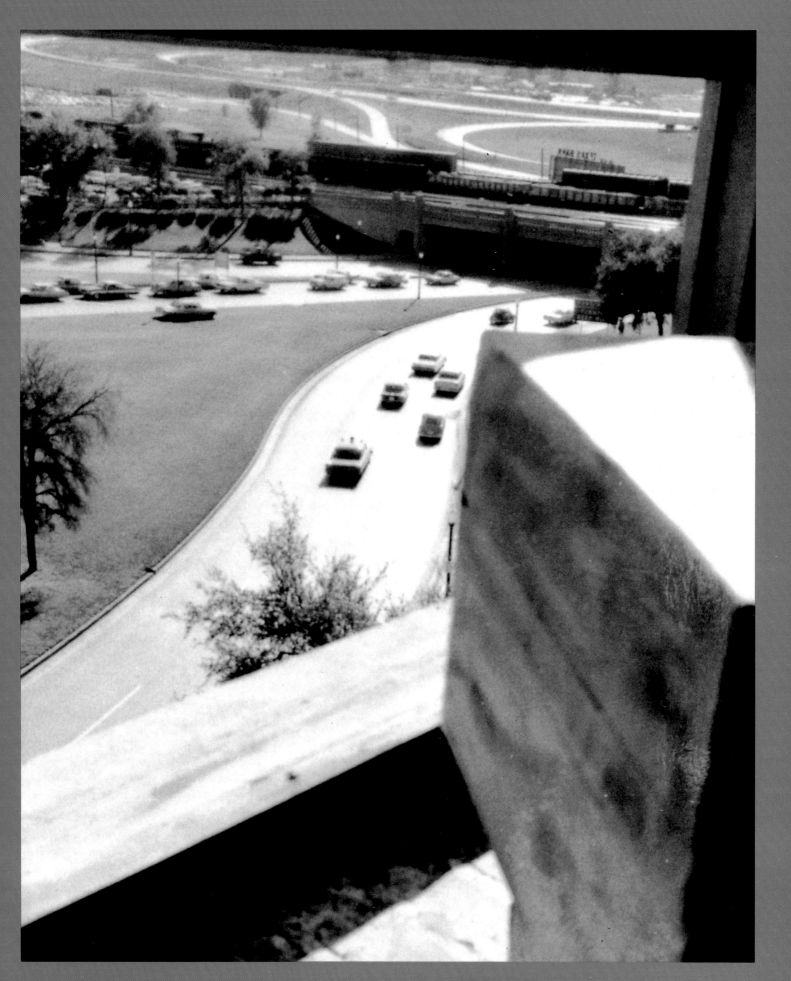

Five minutes before the President was shot, Carolyn Arnold, a secretary for the Depository, passed by the second floor lunchroom and saw Lee Harvey Oswald sitting there eating his lunch. He was alone, and Arnold did not stop to talk with him.

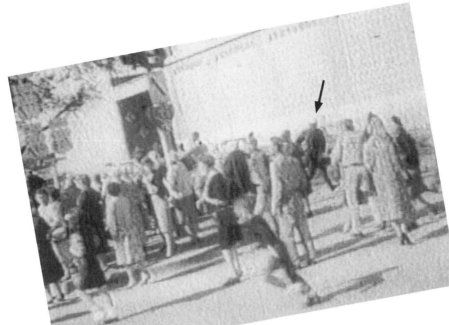

Only a few witnesses in the Plaza paid attention to any activity in the Texas School Book Depository at the time of the shooting. After Officer Marrion Baker entered the Depository and encountered Oswald on the second floor he asked building superintendent Roy Truly, "Does this man work for you?" When Truly verified that Oswald was an employee, Baker continued searching the upper floors of the Depository.

When they began to search the Depository, Deputy Sheriffs Roger Craig, Eugene Boone, and Seymour Weitzman found a rifle — which they all described as a 7.65 Mauser with a scope — near the west side of the sixth floor. Later police reports changed this information, stating that the rifle was a 6.5 Mannlicher-Carcano.

Deputy Sheriff Roger Craig criticized the official handling of the Kennedy assassination from the beginning. He spoke out about how Sheriff Bill Decker had instructed his deputy sheriffs not to participate in the President's protection. Craig suffered many attempts on his life after the assassination. Unknown assailants forced his car off the road. Mysterious attackers shot at him. In constant pain from injuries sustained in the car crash, he allegedly shot himself.

As yet, the police had no real suspect in the killing. They put out an all-points bulletin to pick up an "unknown white male, approximately 30 years old, 165 pounds, slender build." Police supposedly had gotten this description from eyewitness Howard Brennan. There was no further description. This profile could have described thousands of young males.

On November 22, Oswald met with neighbor Buell Wesley Frazier, who drove him to work. Oswald had a long, thin brown paper package. When Frazier asked him what was in the package, Oswald replied, "Curtain rods."

Dallas Police Captain Will Fritz wrote a letter dated June 9, 1964, to the Warren Commission discussing the three empty bullet shells found on the sixth floor of the Depository. In 1967, the National Archives said that the letter was missing.

There is photographic evidence of someone appearing in the sixth floor "sniper's window" approximately 30 seconds after the assassination (see page 208). If Lee Harvey Oswald had been in the window then, he would have had between 42 and 60 seconds to run down four flights of stairs to the second floor lunchroom. When Officer Baker and Roy Truly saw Oswald there moments after the shooting, they saw no evidence of Oswald's being in a hurry or out of breath.

The sixth floor of the Depository was crowded with cartons of books and would have been difficult to negotiate with great speed. This maze of boxes would have prevented Oswald's rapid flight to the second floor.

The Rifle

Officer Baker had stated that during the shooting he heard the distinct report of a high-powered rifle. Parkland Hospital doctors, later commenting on the President's wounds, verified that he had been shot with a high-powered rifle. The official search of the Depository yielded conflicting reports about the type of gun actually found. First reports claimed the gun was a 7.5 Mauser. There was also a report that police and deputies had found an additional rifle, a British .303. When the final report was written, it described the gun found on the sixth floor as a 6.5 Mannlicher-Carcano, which is not a high-powered rifle.

Ballistics test results showed that the scratches on the three empty bullet shells found in the sniper's nest could have been made by the Mannlicher-Carcano. In subsequent investigations, officials test-fired the Mannlicher and found that this rifle takes a minimum of 2.3 seconds to fire two shots in succession.

No shot from the Depository window could have been fired before Zapruder frame 210 because an oak tree blocked the view. But Governor Connally is struck at frame 227, which represents an elapsed time span (for firing) of less than one second.

The Mannlicher-Carcano 6.5. was supposedly purchased via mail order by someone named Alek J. Hidell (Lee Oswald's alias), shipped to a post office box, and never signed for in script — only block letters.

Two policemen reportedly handed down this rifle (*left*) from the roof to the seventh floor fire escape, and examined it on the street. This gun is not a Carcano, and has never been placed into evidence.

Did Oswald's brown paper package contain curtain rods, as he had claimed? The FBI ascertained that the package was made from materials used at the Depository, but the paper bag showed no traces of gun oil or any creases that matched the outlines of a Mannlicher-Carcano, either intact or broken down into components.

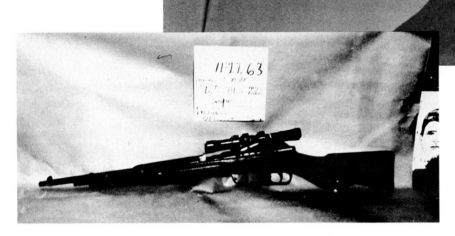

The Plaza

Though Dealey Plaza was a sprawling, open space, the areas most likely to yield evidence and clues were within the smaller radius of the Grassy Knoll, the parking lot (owned and used by the Dallas police), the railroad yard, and the Texas School Book Depository. Given the lesser area of ground that police and sheriff's officials had to search, it was remarkable that — even when the initial shock had subsided — there was no cohesive effort to the investigation. Police and deputies in the railroad yard did not even look inside the cars parked there, and they allowed bystanders to come and go freely. And it was almost 15 minutes before the School Book Depository was sealed off. Sweeping arrests were made in the Plaza, resulting in a haphazard roundup of citizens.

Larry Florer was arrested coming out of the Dal-Tex building, reportedly drunk; he was held for questioning and later released.

Eyewitnesses in Dealey Plaza were panicked by what they had seen. Many were hushed up, intimidated, and badgered after they had given testimony to the FBI and the Warren Commission. Those witnesses who had claimed that the fatal gunshots came from the front of the President's car had their lives threatened and their testimonies suppressed. Those who believed the shots all came from the rear were left alone.

Fifteen-year-old Amos Euins, who had helped to alert police to the School Book Depository as a possible source of the gunshots, was taken in for questioning. He claimed he had seen an assassin, in a window of the Depository, lowering his head as if to shoot a rifle. Secret Service agents later decided that Euins' description of the man he had seen was not accurate — Euins was confused — but that his assertion that he had seen a rifle sticking out of the window was true.

Immediately after the shooting, the police went back into the parking lot behind the Grassy Knoll. They took down license numbers, and people in the lot were allowed to leave, but the officers never searched the cars.

Lee Bowers, who had been sitting in the railroad tower, had seen two men standing near the wooden stockade fence before and during the shooting. He described one of them as heavyset and middle-aged, the other he thought was in his twenties and wearing a plaid shirt or coat. Just before the shooting, Bowers spied a car moving along the back of the fence, driven by a man speaking into a radio.

While examining the grass and curbing near Elm Street, Deputy Buddy Walthers found a bullet. He turned it over to someone he believed was an FBI agent, who immediately pocketed it. The bullet disappeared.

Other Evidence

While the police were searching the Plaza and the surrounding areas, Lee Bowers, still in the tower, saw a train pulling out toward the railroad overpass. He knew it did not have clearance to depart, so he stopped the train and called the police. They found three tramps and arrested them. At police headquarters the tramps were fingerprinted and had mug shots taken. The mug shots and fingerprints have disappeared, and the arrest records were missing for 27 years. The only proof of the tramps' arrest is a series of seven photographs taken in Dealey Plaza that day.

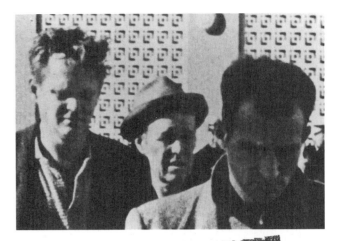

The three tramps arrested near Dealey Plaza on November 22, 1963, have been the subject of a great deal of speculation. The shorter, older one appears to have a listening device in his right ear (*left*). One of the arresting officers has an identical device in his ear (*left*). Was this a coincidence?

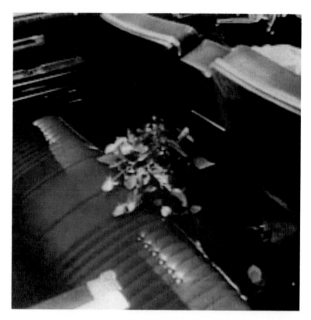

Lady Bird Johnson abandoned the bouquet of yellow roses that she had received at Love Field (right).

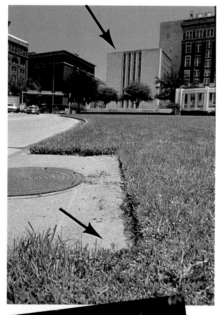

Police carefully examined the bullet strike by the Elm Street manhole cover (*above left*). The mark was aligned with the Dallas County Records building, not the Depository. They also found foot-prints and evidence of activity behind the picket fence corner nearest to Elm Street.

While the President's car (*above*) was still at Parkland's entrance, Secret Service men started to wash it out, destroying valuable evidence. At Lyndon Johnson's request, the car was later removed, stripped, then totally rebuilt.

Leaving Dallas

Before President Kennedy's body could be removed, Dallas officials told members of the President's staff that it was illegal to move the body before an autopsy could be performed by the Dallas County Medical Examiner, Dr. Earl Rose. Despite this, the casket was transported to Air Force One for takeoff to Andrews Air Force Base in Maryland. Vice President Johnson and his wife were taken to the airport in separate vehicles and boarded Air Force One. Even though Johnson was in a hurry to leave Dallas, he delayed the departure of the plane until he could formally be sworn in, at 2:38 p.m., with Jacqueline Kennedy and Mrs. Johnson standing at his side.

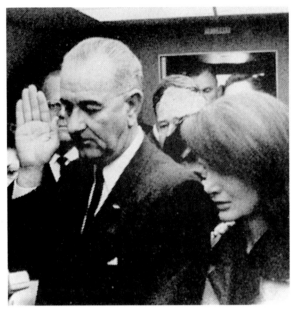

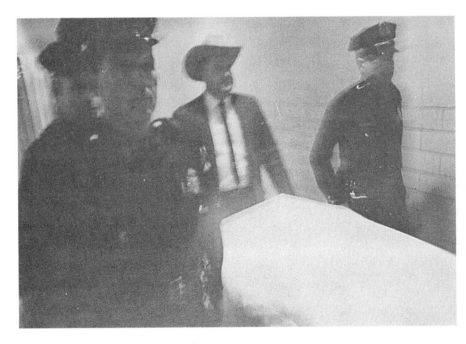

By Texas law, the President's body could not be removed from Parkland until Dr. Earl Rose performed an autopsy. But Lyndon Johnson had given orders that the body was to be put on Air Force One immediately for departure to Washington. When the Secret Service men began to wheel the coffin holding the President's body out of the hospital, a desperate and horrible fight took place in the corridor outside Trauma Room One. Agents threatened Rose, saying, "You'd better get out of the way if you don't want to be run over."

The departure from Dallas was immediate; however, before the plane took off, Johnson took care to be sworn in as the new President.

Air Force One's passengers (Kennedy's widow, friends and staff, press and Secret Service) were subdued and in shock over the day's events. In the bottom right photo, the new President turns to look at Rep. Albert Thomas (D., TX), who winks at Johnson.

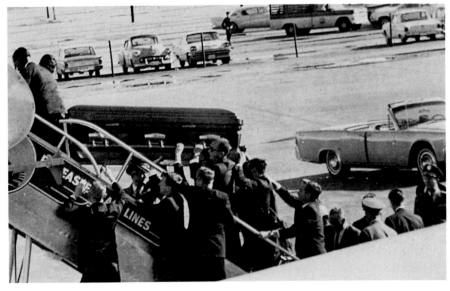

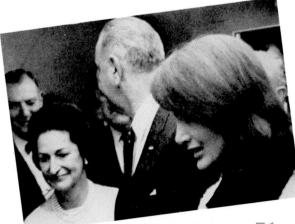

THE MEDICAL EVIDENCE: THE COVER-UP BEGINS

Naval Admiral Dr. George Burkley, the President's personal physician, arrived at Parkland Memorial Hospital while doctors were performing emergency treatment on the President. Burkley concluded that "my direct services to him at that moment would have interfered with the action of the team that was in progress." Dallas doctors were concentrating their efforts on controlling the massive bleeding of the President's head wound and reconstructing an airway to his lungs. But shortly before 1:00 p.m., doctors concluded that all attempts to revive Kennedy were hopeless. This was immediately verified by Dr. Burkley, who signed the President's death certificate, stating (ambiguously) on it that "the President was struck in the head."

Burkley was later present at Maryland's Bethesda Naval Hospital for the autopsy.

A military autopsy was performed on President Kennedy the evening of the assassination at Bethesda. What should have been —

Every Dealey Plaza witness and all Parkland Hospital employees who observed Kennedy's wounds firsthand stated unequivocally that they saw a massive exit wound in the rear of the President's head (see page 86). The only individuals to deny this were the three autopsy physicians, Drs. James Humes, J. Thornton Boswell, and Pierre Finck.

from a point of historical significance — a most complete and thorough medical-legal autopsy ended up as a sham. Performed exclusively by military personnel, the procedure fell far short of even minimum military guidelines. More than three dozen procedures required by the armed forces autopsy manual were either incomplete or not performed. This hastily organized, unprofessional autopsy was to yield findings — both accurate and inaccurate — that gave shape to the intricate web of complicity in the killing of the President.

Dr. James J. Humes was the physician officially in charge of the autopsy, but other higher level personnel present exercised their authority over how the autopsy was actually carried out. Humes was not a forensic pathologist, nor had he ever before performed an autopsy involving gunshot wounds. During the procedure, Dr. Burkley ordered Humes not to track the path of the bullet wounds through the President's body. He also authorized him to destroy the original notes made of the autopsy, requiring Humes's written certification that this had been done. Humes, in later testimony, stated that "the original notes, which were stained with the blood of our late President, I felt, were inappropriate to retain."

The autopsy photographs taken at the outset of the procedure were supposed to be the official permanent record of the President's wounds. The photographs were poorly done, tampered with, and forged. They and the report have been suppressed — with evidence missing or destroyed — by the government since the day of the assassination. The autopsists were put under threat of courts-martial with the following edict not to reveal any of the autopsy findings: "You

X-ray films taken of Kennedy's body were supposedly presented as evidence for use in the Warren Commission investigation, then later turned over to the National Archives for cataloging and storage. The photographic evidence included a roll of 120 film that had been processed, but the images were extremely underexposed.

The subsequent investigation, conducted by the House Assassinations Committee, discovered that roll of film and examined it (they later refused to acknowledge this evidence). The film shows approximately five images of the body's left side, from about mid-leg to the top of the head. The photographs were taken from the perspective of body level, looking slightly up toward the President's head.

are reminded that you are under verbal orders of the Surgeon General, U.S. Navy, to discuss with no one events connected with official duties on the evening of 22 November – 23 November, 1963 . . . an infraction of these orders makes you liable to Court Martial proceedings. . . ."

When I was serving as staff photographic consultant to the House Assassinations Committee early in 1976, I discovered major discrepancies between the Dallas doctors' original descriptions of the wounds and the images in the autopsy photographs.

The phony photos are clear evidence of a deliberate attempt to mislead the investigators of the crime. But beyond the issue of the fakery of evidence lies the question of its existence: Many items listed in the official inventory of autopsy materials are now missing, or have been withheld or destroyed. Several large skull fragments were recovered in Dallas and photographed. Microscopic slides were prepared for the study of tissue samples from around the President's wounds. Both the fragments and the slides are missing from the National Archives.

The President's brain was removed during the autopsy and placed in a stainless steel container filled with a formalin solution so that it could be sectioned and examined a short time later. These key tests would have shown the trajectory of the bullet(s) through the brain; however, there is no record or indication that this critical work was ever done. If the tests on the brain *were* performed, and the results confirmed either a shot from the front or the existence of two separate shots to the head, those authorities with the power to suppress the evidence concealed this irrefutable proof of conspiracy by stealing the brain and skull fragments.

This illustration drawn for the House Assassinations Committee investigation shows their version of the damage to the President's brain.

The Throat Wound

The President's throat wound has long been the subject of controversy. Was it an entrance or exit wound? Few medical personnel viewed the wound in its original state before it was obliterated by a tracheotomy procedure. Parkland doctors Charles Carrico and Malcolm Perry, the first to examine the President, noted that the President had "a small bullet wound in the front lower neck." Perry perceived the throat wound to be one of entrance, as did Parkland nurse Margaret Henchliffe. Carrico had hooked the President to a respirator, after which Dr. Perry performed a tracheotomy to open an airway to the lungs. When asked later by Warren Commission Assistant Counsel Arlen Specter if the wound could have been considered one of exit, Henchcliffe testified: "I have never seen an exit bullet hole . . . that looked like that."

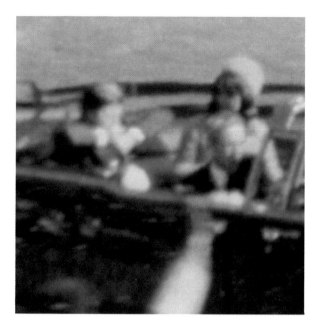

Sketch from the autopsy face sheet showing the location of the throat wound.

San Francisco Chronicle,
November 23, 1963.

Doctor's Report

Two Wounds--- Throat and Head

Dallas

President Kennedy was shot through the throat and head, possibly by the same bullet, his attending surgeon said yesterday.

Dr. Malcolm Perry, 34, said "there was an entrance wound below his Adam's apple. There was another wound in the back of his head."

Two of the ten physicians in attendance on the President said it was possible that ͏͏ the throat ͏͏

with other members of the surgical staff.

"They arrived immediately, but at his point, the President's condition did not allow complete resuscitation.

"He was critical and moribund. Dr. Clark assisted respiration with oxygen, an anesthetic machine and an endo-tracheal tube. A tracheotomy was performed."

FLUIDS

The President's throat was opened.

"Blood and fluids were given," Perry said.

Dr. Malcolm Perry (*above*) described the original throat wound as "a very small injury [3 to 5 mm], with clear cut, although somewhat irregular margins of less than a quarter inch, with minimal tissue damage surrounding it on the skin." He was adamant that it was an entry wound. When interviewed in 1979, he still maintained that the bullet had entered the President's throat from the front, but has since refused to go on record with this information.

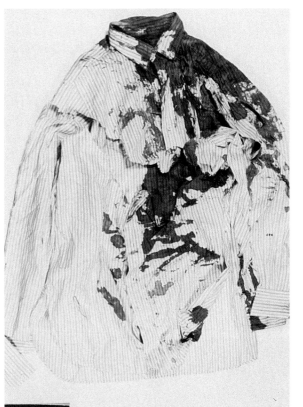

The President's shirt collar has a small slash cut made by a scalpel. This slit was made when medical personnel rushed to take off the necktie so that the shirt could be removed. The fact that this is not a bullet hole confirms the observation of Dr. Charles Carrico that the wound was in the lower neck above the shirt collar.

According to eyewitnesses' reports, the throat wound was a small and inconspicuous one before the tracheotomy procedure obliterated it.

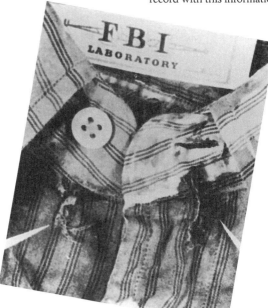

The Bethesda doctors did not consult their professional colleagues who had attended the President at Parkland Hospital. Nor did the autopsy procedures include a full examination, dissection, or accounting of the wounds, though the autopsy records imply that the procedure was complete. The final autopsy report was never dated, and the original notes for it were destroyed, either under Dr. Burkley's orders or with his okay.

Dr. Humes, who autopsied the President's body, consulted with Parkland's Dr. Perry only *after* the autopsy. Humes did not even know that there was a bullet wound in the throat, as it had been distorted and enlarged by the tracheotomy.

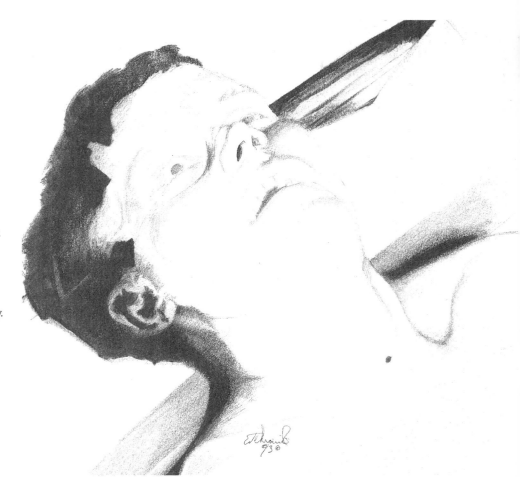

The Back Wounds

The single bullet theory, developed to support conjecture that Oswald had acted alone to kill the President, hangs on the location of the source of this shot. The exact moment of impact, the location of the back wound, and the trajectory are key points in the debate. The Warren Commission and House Assassinations Committee investigations both "adjusted" the position of Kennedy's back wound. The Warren findings, developed to support the "magic bullet" theory, had the President's back wound placed in the back of the neck, while the HSCA report (which used the Warren Report as its starting point) found it to be down on "the upper right of the back."

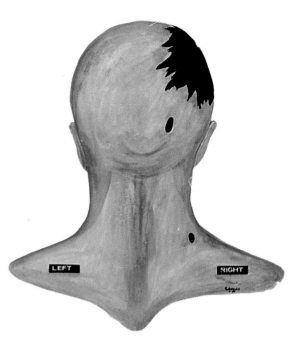

As this drawing shows, the Warren Commission "moved" the President's back wound to support the autopsy findings. This "evidence" is at odds with the content of an earlier discussion from the January 27, 1964, Executive Session of the Commission:

"**Mr. Rankin:** Then there is a great range of material in regard to the wounds . . . and that all has to be developed much more than we have at the present time . . . We have an explanation . . . in the autopsy that probably a fragment came out the front of the neck, but with the elevation the shot must have come from, and the angle, it seems quite apparent now, since we have the picture of where the

This autopsy photograph (*left*) shows the wound to the President's back clearly below the shoulder line. As the photo was taken by lifting the head and shoulders, instead of turning the body facedown, the perspective of the wound's position is distorted.

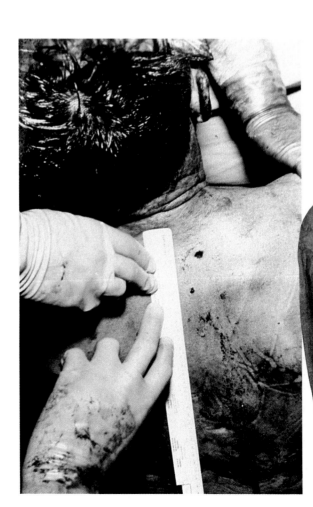

The back of the President's jacket and shirt provide uncontested evidence of the entrance location of the shots.

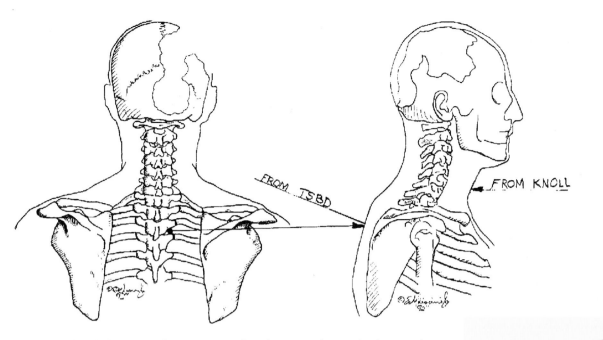

FROM TSBD

FROM KNOLL

FBI agents Frank O'Neill and James Sibert signed a receipt stating they were in receipt of a "missile" (not a fragment) that was removed from the President's body. This "missile" was an entire bullet, a fact confirmed by Admiral Calvin Galloway, who was present at the autopsy and saw the bullet. This bullet was never submitted as evidence in any investigation.

bullet entered in the back, that the bullet entered below the shoulder blade to the right of the backbone, which is below the place where the picture shows the bullet came out in the neckband of the shirt in front, and the bullet, according to the autopsy, didn't strike any bone at all, that particular bullet, and go through. So . . . how could it turn . . .

"**Rep. Boggs:** I thought I read that bullet just went in a finger's length." The diagram above notes the disparity of the location of the wounds and the single bullet theory: The President's back wound was placed much lower in the body than the (frontal) neck wound. It would have been difficult for one bullet to cause both wounds.

The President's personal physician, Dr. George Burkley, drafted the death certificate on November 23, 1963. It stated that the non-fatal back wound was "in the back, at about the level of the third thoracic vertebra." The next day, Burkley signed the autopsy face sheet, which verified the same information. He knew this information was reported correctly — he had been present at the autopsy. Further, the wound's location, as stated on these two documents, corresponds to the bullet holes in the President's clothing.

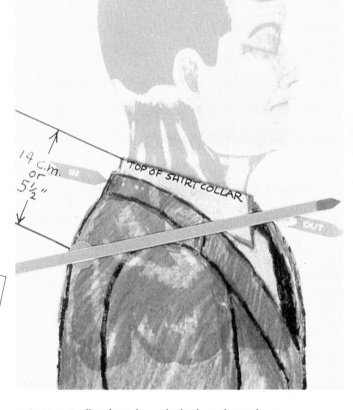

14 c.m. or 5½"

TOP OF SHIRT COLLAR

Artist H. A. Rydberg's medical illustration, published by the Warren Commission, shows the President's back wound placed in the back of the neck, not farther down

the back, as the marks on his clothing indicated. The real position gives a very different trajectory, which is shown in blue.

CERTIFICATE OF DEATH
NAVMED N (REV. 4-58) FRONT

COPY

The White House, Washington, D.C.

President John Fitzgerald Kennedy

President of the United States

May 29, 1917

NAVMED N (Rev. 4-58) BACK

John Fitzgerald Kennedy

President John Fitzgerald Kennedy, while riding in the motorcade in Dallas, Texas, on November 22, 1963, and at approximately 12:30 p.m., was struck in the head by an assassin's bullet and a second wound occurred in the posterior back at about the level of the third thoracic vertebra. The wound was shattering in type causing a fragmentation of the skull and evulsion of three particles of the skull at time of impact, with resulting maceration of the right hemisphere of the brain. The President was rushed to Parkland Memorial Hospital, and was immediately under the care of a team of physicians at the hospital under the direction of a neurosurgeon, Kemp Clark. I arrived at the hospital approximately five minutes after the President and immediately went to the emergency room. It was evident that the wound was of such severity that it was bound to be fatal. Breathing was noted at the time of arrival at the hospital by several members of the Secret Service. Emergency measures were employed immediately including intravenous fluid and blood. The President was pronounced dead at 1:00 p.m. by Dr. Clark and was verified by me.

Front Entry Wound

Zapruder frame number 337 shows the damage to the President's head: A full one-third of Kennedy's head was shot away at the moment of impact (note the volcano-shaped exit wound in the rear of the skull). A motorcycle officer, riding to the rear of the President's car, and other eyewitnesses have testified to observing an explosion of brain tissue and blood caused by a shot coming from in front of the President's car.

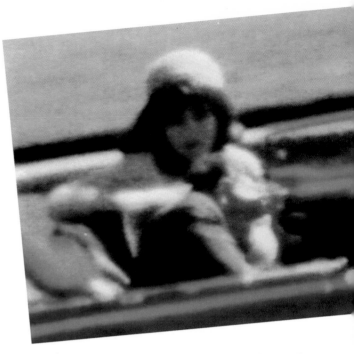

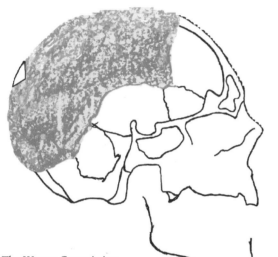

Referring to the head wound, the autopsy report says,"... situated in the posterior scalp approximately 2.5 cm laterally to the right, and slightly above the external occipital protuberance [the small bump on the back of the skull] is a lacerated wound measuring 15 x 6 mm ..." Was the language "slightly above" a deliberate change from what could have originally read "slightly below"?

The Warren Commission established the President's head wound as one of entrance from the rear, with the bullet traveling slightly right of the midline and just above the hairline. In order to achieve this type of wound, the bullet would have had to travel along a right-to-left path, and would have exited in the area of the lower left portion of the President's face (where there was no damage). Perversely, the Commission's drawings also show an exit wound on the right side of the head, which could only result from a bullet traveling on a left-to-right trajectory. This is doubly puzzling when you consider that the Texas School Book Depository, from where the shot is supposed to have originated, was to the right rear of the car.

When a speeding missile enters a mass, such as a human body, the entry mark must be smaller than the exit. As the missile, or bullet, moves forward through the body, material is pushed outward along the edges of the wound, causing a cone-shaped widening corresponding to the direction from which the shot was fired. The sculpted model (at right) shows the effects of the bullet's path, which ends with a wide volcano-shaped exit wound at the rear of the President's skull.

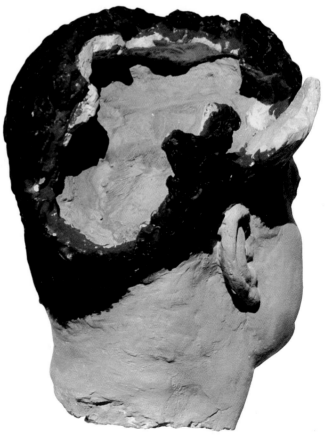

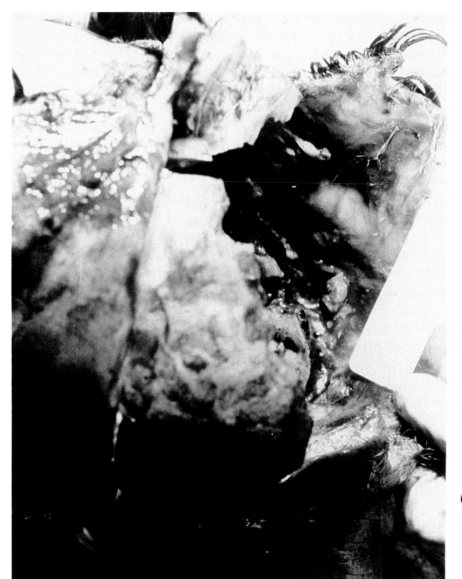

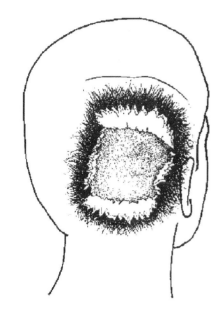

Dr. Robert McClelland drew this depiction of the exit wound in 1966. It shows the size, location, and nature of the wound with the skull fragments blasted out. This drawing exactly matches the volcano image appearing in Zapruder frames 335 and 337.

Commander Humes was interviewed by a panel of physicians for the House Assassinations Committee investigation and was asked to verify the entry location of the head wound. His questioner asked him, "Where is the point of entrance?" Humes replied that it "... didn't show. It's below the external occipital protuberance. . . . It's to the right and inferior to the external occipital protuberance . . . and . . . there was a virtually identical wound in the occipital bone." Just as someone had altered the autopsy report to state that the wound's entry point was "above" the protuberance (so it could follow the path of the Warren Commission's "magic" bullet), a mysterious "someone" also changed Jacqueline Kennedy's original testimony to the Commission, deleting her statement, "I was trying to hold his hair on. But from the front there was nothing. I suppose there must have been. But from the back you could see, you know, you were trying to hold his hair on, and his skull on."

The wound shown in the top left photograph is larger than what appears in the Warren Commission's diagrams and drawings. The photo at the bottom right, which is supposed to be an official autopsy photograph, shows the head to be totally intact. How can this be? Zapruder frames 335 and 337 show the damning evidence. Exposed just over a second after the head shot, they show a skull flap that pivots downward and forward, appearing in the film as a white mass in front of the President's right ear.

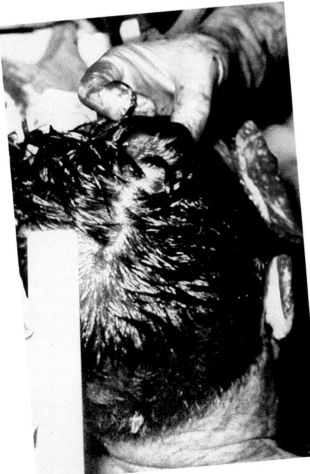

The Missing Evidence

Floyd Riebe, a medical photographic technician who took the pictures of the body at Bethesda, said that the President had "a big gaping hole in the back of the head." This is more damage than could have been done by a military jacketed bullet; the bullet was probably the explosive, or frangible, type. Riebe was shown the official autopsy photographs, and strongly disagreeing with them, he said, "The two pictures you showed me are not what I saw that night." With regard to the X-rays, which show the face shot away, Riebe said, "It's being phonied someplace. It's make believe." The evidence that could corroborate Riebe's statement — the President's brain — is missing.

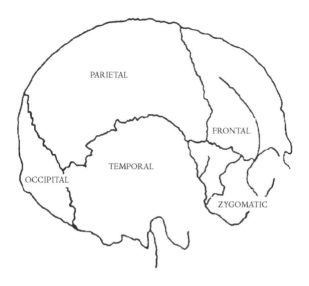

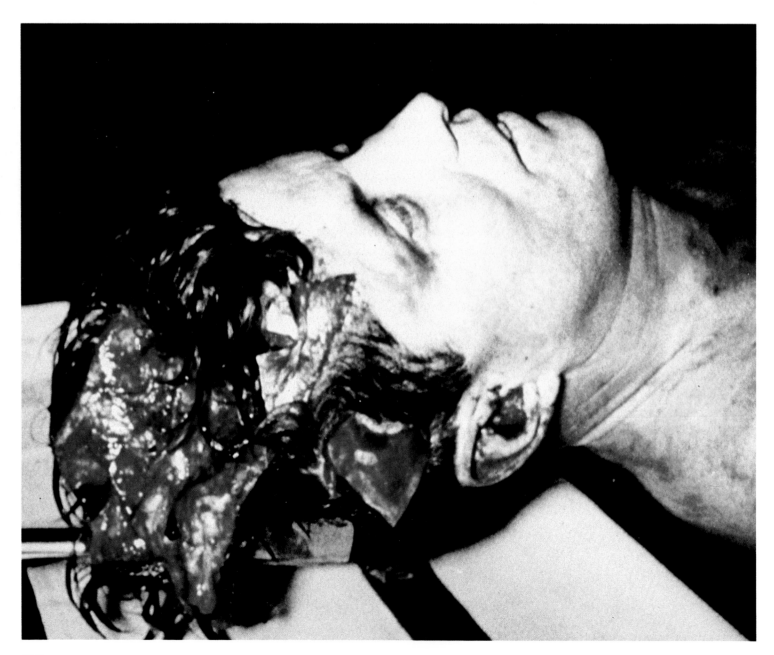

Opposite left: Severe damage to the right side of the President's head extended from the frontal temporal area across the top and into the occipital region. Here, the piece of skull still barely attached to the head has been laid back along the head in a closed position. This flap (area at top of photo) was still attached to the body during the autopsy until, at one point, it became detached from the head. This fragment should be in the National Archives, but is missing.

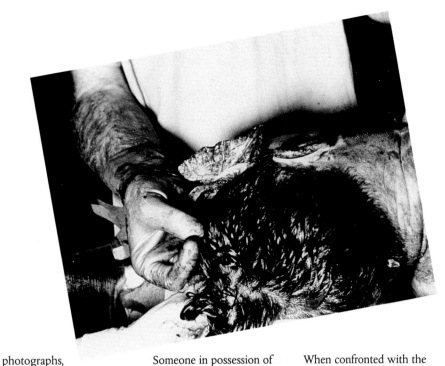

Reporter Sylvia Chase interviewed Jerrol Custer, the Bethesda Hospital technician who took the X-rays of the President's head. She asked him, "Is this the X-ray picture you took, and is this the wound you saw on the President?" Custer replied, gesturing to the back of his head, "No. This area [here] was gone. There was no scalp there." Custer, along with Parkland's Dr. Robert McClelland, has denied the authenticity of these X-rays.

The X-rays of the anterior-posterior and lateral views of the President's skull. Neither of these X-rays matches up with the wound in the photograph. The X-rays were taken at the same time — and in the same place — as the autopsy photographs, on November 22, 1963, at Bethesda Naval Hospital.

Someone in possession of the actual autopsy photos created a faked photo (above) of the back of the President's head. This, however, was done at a different time (and possibly by different parties) from the faking of the X-rays. Thus, the conspirators' efforts did not produce coinciding fakeries — there probably was too little time.

When confronted with the official autopsy photographs (the ones released for use as evidence), Bethesda autopsists Drs. James Humes and J. Thornton Boswell told the medical investigative panel for the House Assassinations Committee that the entrance wound on the President's head was at — or adjacent to — the occipital protuberance. They asserted that there was a large hole "through which you could see the brain." The "official" photographs showed an intact scalp and skull in that area.

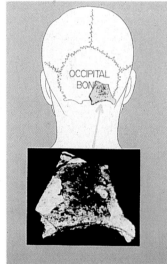

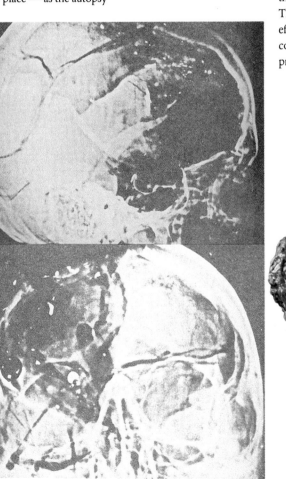

This skull fragment, 2.5 inches wide, was found by Billy Harper on the grass in the Plaza, 35 feet to the left and rear of the point of impact, directly in line with the shot from the Knoll. This is a piece of occipital bone from the extreme rear of the head.

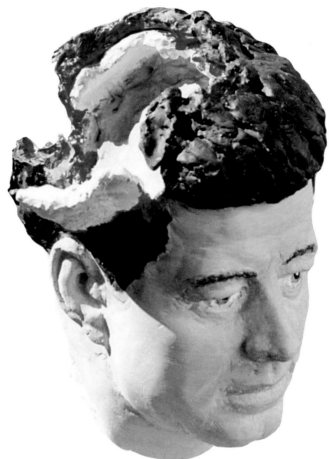

The evidence of the position and effect of the President's head wound was obvious to all civilian and medical eye-witnesses: The wound was a large hole in the right rear of the head. The autopsists also described the wound as such, but larger. Dr. McClelland, who had been called to the Trauma Room when Mr. Kennedy was admitted to Parkland Hospital, said that the cause of death was attributable to "a massive head and brain injury from a gunshot wound of the right temple." In succeeding pages you will see how the Warren Commission refuted and ignored this — and other — testimony.

Not all of the real autopsy photographs were destroyed or forged. Those conspiring to hide the evidence could not eliminate all of it, perhaps fearing that some future executive order or investigation would require producing it for examination. Instead, those in possession of the photos and other evidence could, and did (as succeeding chapters will show), control who had access to the photographic and medical evidence.

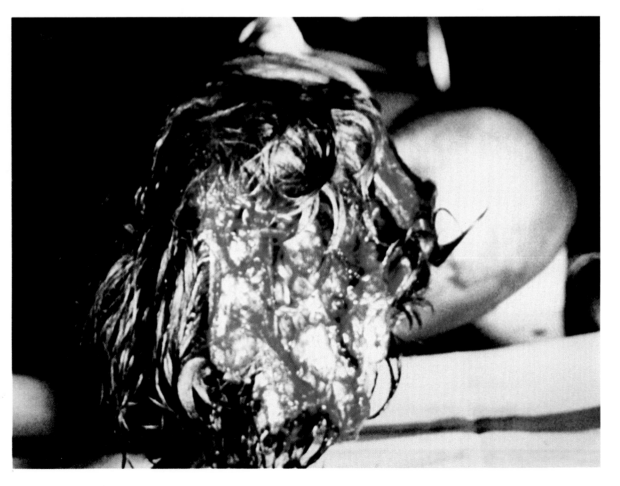

The drawing (*below*) clarifies the jagged, outlined area of the top of the head, which shows the magnitude of the wound. The President's brain was totally exposed, as seen in the actual autopsy photo below.

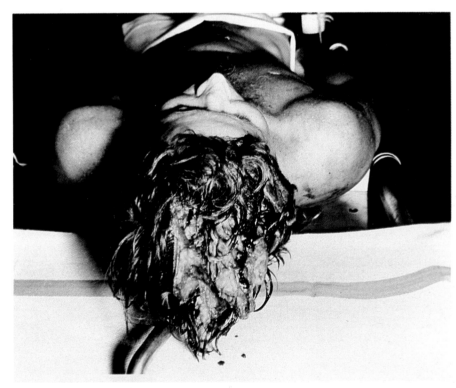

These pieces of photographic film are called soft edge mattes. They illustrate the technique of matte insertion. A composite picture is made by sandwiching the black core matte (*near left*) with the original picture (i.e., the back of the President's head with a large exit wound). This is exposed onto a new piece of film. Next, the clear core matte (*far left*) is sandwiched with the picture of what you want to insert (i.e., the back of an intact head). This is then exposed onto the same piece of new film. The result is a single image that appears to be the intact rear of the President's head (see page 81, bottom right).

From the front view drawing of the skull (*top*), you can see how far forward the wound extended. The original photo of the President's head wound clearly indicates the extent of the massive wound. The fabricated X-rays show the wound and skull damage (*above*) extending further forward to just above the eye socket.

The Doctors' and Other Witnesses' Stories

The House Assassinations Committee was never allowed to see the autopsy photographs of the inside of the President's chest cavity. The Parkland Hospital doctors were the best eyewitnesses to the President's wounds. They had at least 20 minutes, and some had longer, to examine the President's injuries immediately after the shooting. The doctors' oral and written statements provided the only reliable clues to the snipers' locations and bullet trajectories. This evidence of the extent and nature of the wounds was distorted in subsequent investigations.

False Real

Beverly Oliver: "The whole back of his head went flying out the back of the car."

Phillip Willis: "It took the back of his head off."

Dr. Charles Crenshaw: "The wound was the size of a baseball."

Dr. Ronald Jones: "My impression was there was a wound in this area of the head." When shown the faked autopsy X-ray, Parkland Hospital's Dr. Jones said, "There was no damage to the face that was visible. . . . The X-rays are incompatible with the photographs, which show no injury to the face."

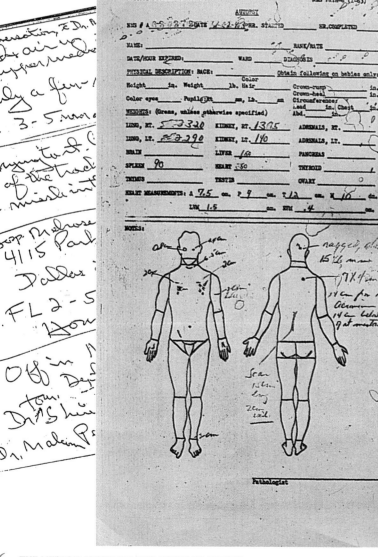

These notes (*far left*) were made by Dr. Humes during a conversation he had with Parkland Hospital's Dr. Malcolm Perry the morning after the autopsy. Humes had not been aware that there was a gunshot wound in the President's throat.

The autopsy face sheet was filled in by Dr. Boswell, and shows the back entry wound well down from the neck.

Marilyn Willis:
"A red 'halo.' Matter [was] coming out the back of his head."

Ed Hoffman:
"The rear of his head was gone, blasted outward."

Dr. Robert McClelland:
"It was in the right back part of the head — very large . . . a portion of the cerebellum fell out on the table as we were doing the tracheotomy."

Dr. Paul Peters:
". . . right there, occipital parietal."

Dr. Kenneth Salyer:
"This wound extended into the parietal area."

Dr. Charles Carrico:
"There was a large — quite a large — defect about here [pointing] on his skull."

Dr. Richard Dulany:
"It was up in this area."

Nurse Audrey Bell:
"There was a massive wound at the back of his head."

The autopsists neither dissected nor examined the President's brain, but simply placed it in a preserving solution. Only an examination of the brain could have yielded irrefutable evidence of how many shots to the head had been fired, where they had come from, and what type — or types — of bullets were used. The President's brain is missing from the National Archives.

The original autopsy notes, which Dr. Burkley authorized to be destroyed, would have given a more accurate record of Kennedy's wounds and of the number of bullets and their trajectories.

Bethesda lab technician Paul O'Connor drew this version of what he saw during the autopsy.

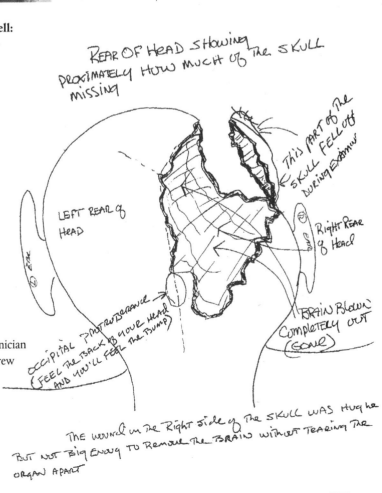

REAR OF HEAD SHOWING PROXIMATELY HOW MUCH OF THE SKULL MISSING

THIS PART OF THE SKULL FELL OFF DURING EXAM

LEFT REAR OF HEAD

RIGHT REAR OF HEAD

OCCIPITAL PROTUBERANCE (FEEL THE BACK OF YOUR HEAD AND YOU'LL FEEL THE BUMP)

BRAIN BLOWN COMPLETELY OUT (GONE)

The wound in the Right side of the SKULL WAS Huge BUT NOT BIG ENOUGH TO REMOVE THE BRAIN WITHOUT TEARING THE ORGAN APART

Theran Ward
"[It was] right back here."

Aubrey Rike
"You could feel the sharp edges of the bone at the edge of the hole in the back of his head."

Jerrol Custer
"From the top of the head, almost to the base of the skull, you could see where that part was gone."

Paul O'Connor
"[There was] an open area all the way across into the rear of the brain."

Floyd Riebe
". . . a big gaping hole in the back of the head."

Frank O'Neill
". . . a massive wound in the right rear."

The diagram, below, of the top of the head clarifies the details of the original sketch made by Dr. Boswell during the autopsy.

ASSASSINATION MYTHS, #4

There is a theory, one that I disbelieve, that Kennedy's body had been kidnapped (and had false wounds inflicted upon it) while being transported from Dallas to Maryland for the autopsy. Those who supposedly participated in this dubious scheme had the body removed from the coffin as soon as it was placed on Air Force One. They stowed the President's body into the hold of the plane, then smuggled it off at Andrews Air Force Base, somehow avoiding all press cameras. The body was then taken by helicopter to an undisclosed location, where wounds were placed on it to make it appear as if all the gunshots had come from behind the President's car. This theory, highly improbable, originated from a comparison of the testimonies of Dallas ambulance driver Aubrey Rike and Bethesda lab technician Paul O'Connor. Rike claimed the body was wrapped in sheets when it was placed in the coffin. O'Connor stated that the President's body was in a body bag when he took the body to the autopsy room. While the body's wrappings could have been changed, certain individuals were with the President's body for the entire time it was on the plane enroute to Maryland. Dave Powers, the President's closest friend, stated that he was with the body throughout its transfer from Parkland to Bethesda; he never left the body for a single moment. FBI agent Frank O'Neill told me in an interview that he was present when the body was off-loaded at Andrews Air Force Base, and that he, and fellow agent James Sibert, followed the ambulance straight to Bethesda Hospital. O'Neill was present when the body was removed from its bronze coffin.

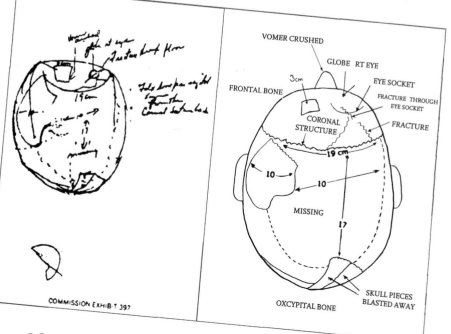

Trajectories: Real & Created

All the evidence of the bullets' trajectories (or flight paths) and resulting wounds has been obscured in every investigation of the President's killing. Medical experts' analyses and testimonies pointed to shot origination and wounding that did not conform to the single bullet and lone assassin theories. The covering up of crucial medical evidence began in earnest when the President's body was illegally removed and hastily (and incompletely) autopsied. The rush to hide the revealing elements that would have proved the nature of the bullets' trajectories was largely successful: To this day, the President's brain and skull fragments are missing — "lost" or stolen — from the National Archives.

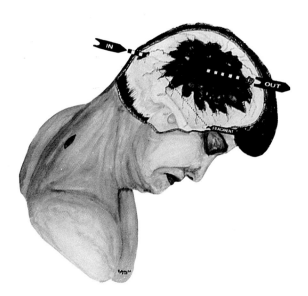

The FBI and Secret Service created re-enactments of the crime that would fit neatly with the single bullet theory. However, this re-creation (below) indicates otherwise and shows that the bullet entering the President's back could not have caused the throat wound and Governor Connally's back wound.

Both of the two illustrations here were drawn for the Warren Commission by H. A. Ryberg, and designed to conceal actual autopsy evidence.

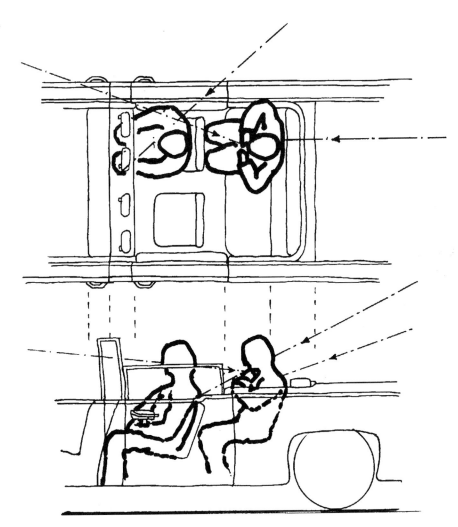

FBI agents Frank O'Neill and James Sibert stated in their report on the autopsy that "Dr. Humes located an opening which appeared to be a bullet hole that was below the shoulders and two inches to the right of the middle line of the spinal column. This opening was probed by Dr. Humes with the little finger, at which time it was determined that the trajectory of the missile entering at this point had entered at a downward trajectory of 45 to 60 degrees. Further probing determined that the distance traveled by this missile was a short distance inasmuch as the end of the opening could be felt with the finger." The report also verifies that they received a "missile" taken from the President's body by Dr. Humes. The FBI and other intelligence officials have denied that any bullet was discovered and catalogued.

In 1968, Attorney General Ramsey Clark convened a "hush-hush" panel of doctors (the Clark Panel) to examine the faked autopsy photos and X-rays. The panel, led by Dr. Russell Fisher (who had ties with the Armed Forces Institute of Pathology), concluded that the head wound rear entry point was actually inches higher up than the position ascertained by the Warren Report. The wound was now properly in line with a trajectory from the sniper's nest on the sixth floor of the Book Depository.

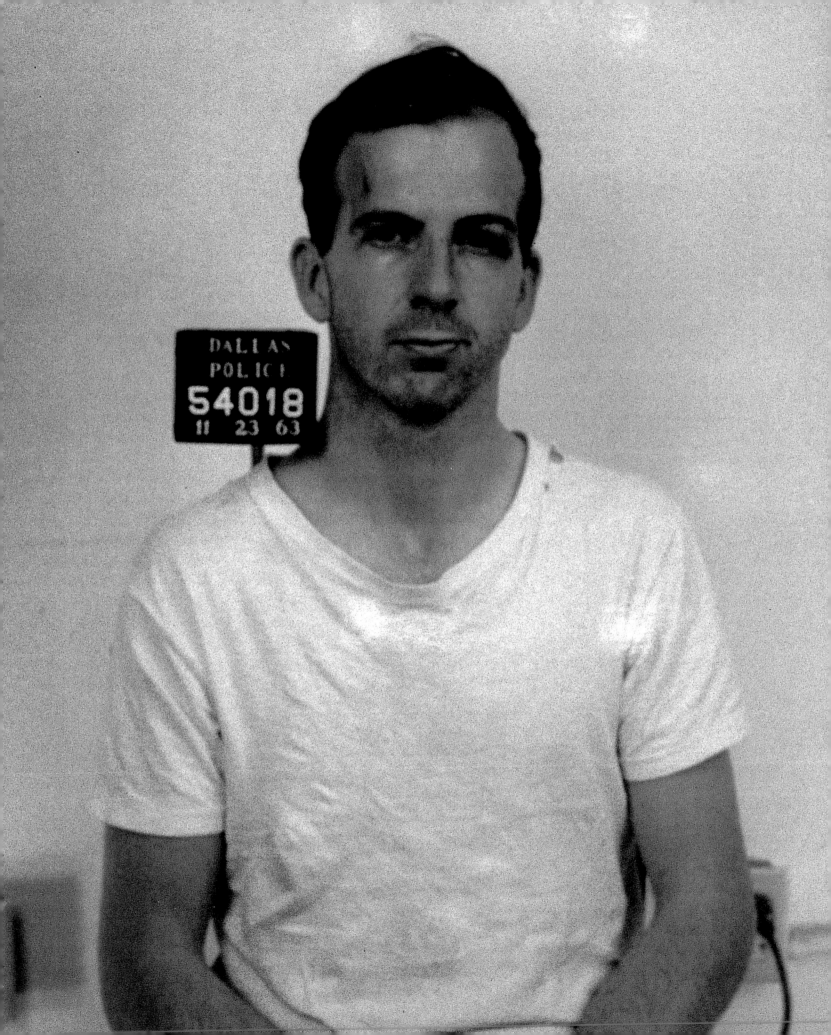

THE FRAMING OF LEE HARVEY OSWALD

Did you shoot the President?"

"I didn't shoot anybody, no sir . . . I'm just a patsy."

Lee Harvey Oswald's involvement in the killing of John Kennedy will remain one of history's greatest question marks. His participation in a conspiracy is highly unlikely, and there is only the thinnest circumstantial evidence against him. He is unlikely to have fired a shot at the President, but was set up as a "fall guy." The framing of Lee Harvey Oswald as a violent killer, loner, and unintelligent malcontent was crucial to the success of the conspiracy.

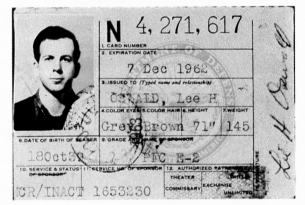

Lee Harvey Oswald's Marine Corps ID card. Where did his loyalties lie? During the early days of the Warren Commission investigation, a vast majority of evidence revealed that Oswald had been employed by at least two different U.S. intelligence services. He became an official FBI informant beginning in September 1962.

A curious aspect of the case against Oswald is the total lack of any discernible motive on his part to commit the murder. There is no known or recorded incident of Oswald expressing dislike or hatred of President Kennedy. What has been documented are his comments to the contrary: He publicly stated his liking for the President and his family.

From the time of his arrest in the Texas Theatre to

his death at the hand of Jack Leon Ruby, Lee Oswald was stripped of his civil rights and firmly caught in a frame-up for murder. Although he publicly asked for "legal assistance," Oswald was taken into custody, denied legal representation, and interrogated by Dallas police Captain Will Fritz. No official recording of the interrogation was intended, but Fritz secretly tape recorded the session (it is rumored that these tapes still exist). Subsequent government inquiries would have us believe that no recordings or notes were made of the interrogation. Even if this were the case, why should Oswald be questioned if whatever he said would not be recorded for use in some way?

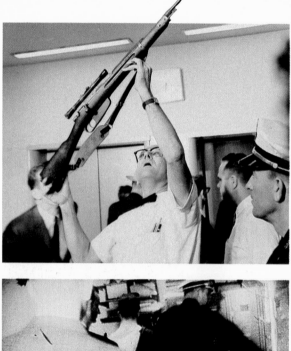

Oswald (shown here with his back to the camera) is now under arrest. He is being led past his co-worker, Billy Lovelady (see page 186), who has been brought in for questioning. This is the only known photograph of the two men together.

Left: Police displaying the alleged assassin's gun and Lee Harvey Oswald to the press at police headquarters. Officials were anxious to let it be known that this Mannlicher-Carcano rifle was the murder weapon. The very next day, officials had access to a photograph of Oswald, holding the same rifle in his hand, taken in the backyard of his former residence on Neely Street in Dallas.

There was no trial — Oswald was not allowed to live long enough. Had Oswald been tried, a distinct profile of the man would have emerged — one far different from the Warren Commission's portrait of him as a disgruntled and dangerous loner. Research has shown that Oswald was patriotic and intelligent — and was deeply involved with U.S. intelligence operations until his death on November 24, 1963. The true circumstances of Oswald's military service, defection to the Soviet Union, and activities within the intelligence community may forever remain buried within the mountainous files of the CIA and FBI.

Forty-eight hours after the President's assassination, Oswald himself was assassinated by Dallas night

Dallas police captain Will Fritz said that the case against Lee Harvey Oswald was "cinched." "This man killed President John F. Kennedy," he insisted.

Oswald confronts the press for the first time after his arrest. During the press conference he requested that someone come forward and give him — or help him procure — legal representation.

club owner Jack Ruby. Ruby stepped through a crowd of reporters at Dallas police headquarters on Sunday morning, November 24, and shot Oswald to death on live national television. Was Ruby, a known associate of organized crime figures, acting on impulse? Or was he also part of the conspiracy?

Ruby was tried and convicted of shooting Oswald. More than five months after the assassination — on June 7, 1964 — the Warren Commission finally interviewed Ruby in the interrogation room of the Dallas County Jail. Ruby pleaded for three hours with Earl Warren and at least ten others to be taken to Washington so that he could tell what he knew, asserting that he wasn't safe in Dallas. When his repeated pleas were ignored, Ruby told Warren, "I won't be around for you to come and question me again."

Ruby was later granted a new trial by Judge Joe Brown. But Brown was dead within days, and Ruby died before a second trial could take place. To the end believing that he had been injected with a cancer-causing substance, Jack Ruby died in jail (reportedly of cancer) on January 3, 1967. The information he wanted to share about the conspiracy died with him.

When he suddenly shot Oswald amid a crowd of police and press, Jack Ruby created an unbelievable fracas, which appeared on live national television. Here, the murder weapon has just been wrestled away from Ruby by L. C. Graves, a detective with the Dallas Police Department.

Oswald's Trail

Lee Harvey Oswald's movements before, during, and after the assassination were curiously nonchalant for a man who had planned, and was about to execute and escape, a murder scenario. Carolyn Arnold saw Oswald sitting alone in the second floor Depository lunchroom between 12:15 and 12:25 p.m., but she did not talk to him. The motorcade was due to arrive at 12:25 p.m. Shortly after the shooting, Officer Baker and Roy Truly saw Oswald on the second floor, still in the lunchroom, but did not detain him. Oswald then left the Depository, not by a closer rear exit, but through the front door. He boarded a bus to go home, but the traffic was heavy. He switched to a taxicab, arrived home, changed his shirt, and pocketed his revolver. Oswald left his house about 1:04 p.m., reputedly walked eight-tenths of a mile, and killed Dallas police officer J. D. Tippit at approximately 1:12 p.m. He then went to the Texas Theatre, where police soon burst in and arrested him.

When the Depository was being searched, employees were excused to go home. Most employees were already outside of the building, and many went back inside. Oswald, however, did the opposite, leaving the building minutes after the shooting. When questioned, most Depository employees could account for where they had been during and after the assassination. However, the Book Depository was not sealed off and considered a restricted area until at least 15 minutes after the shooting.

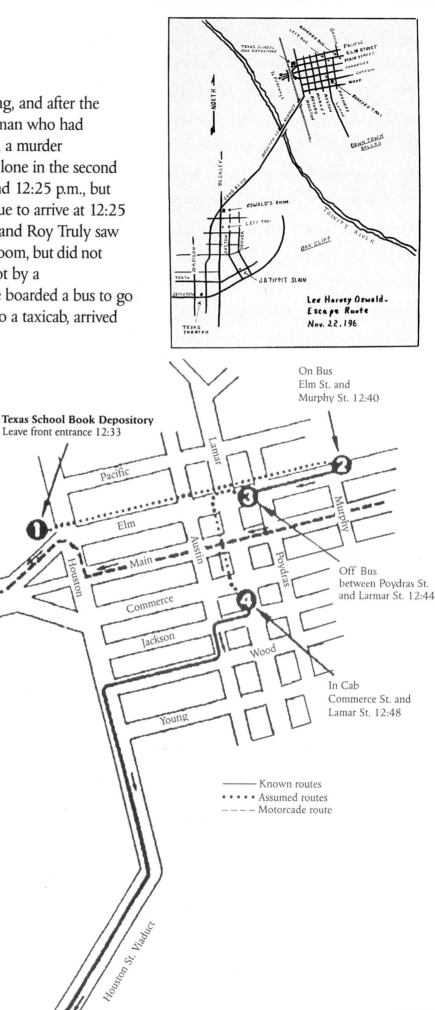

On Bus
Elm St. and
Murphy St. 12:40

Texas School Book Depository
Leave front entrance 12:33

Off Bus
between Poydras St.
and Larmar St. 12:44

In Cab
Commerce St. and
Lamar St. 12:48

——— Known routes
• • • • Assumed routes
– – – – Motorcade route

Lee Harvey Oswald-
Escape Route
Nov. 22,196

Though Depository secretary Carolyn Arnold saw Oswald on the second floor five minutes before the President's car started down Elm Street, she was never asked to submit this testimony to the Warren Commission.

Two views of the second floor Depository lunchroom, where Oswald sat calmly eating his lunch right before the assassination. He did not watch the motorcade, nor was he likely to have been up on the sixth floor when it passed by the Depository.

Oswald's bus transfer and Post Office box key, which were found in his pockets when he was arrested.

Curiously, the bus that Oswald boarded when he left the Depository was not traveling away from that site, but back toward it. When the bus became mired in traffic, Oswald abandoned it in search of a taxicab. He went to the Greyhound bus station where he saw a free cab, but he gave it up to someone else waiting there and took the next available one.

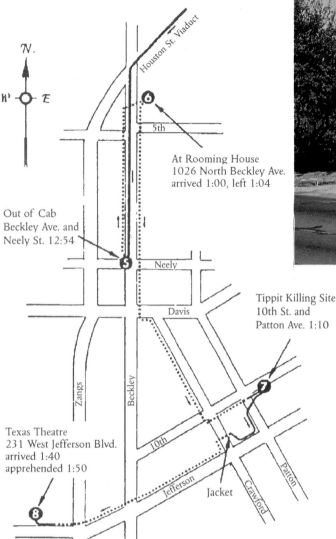

N.

W' — E

Houston St. Viaduct

5th

6

At Rooming House
1026 North Beckley Ave.
arrived 1:00, left 1:04

Out of Cab
Beckley Ave. and
Neely St. 12:54

5

Neely

Davis

Zangs

Beckley

Tippit Killing Site
10th St. and
Patton Ave. 1:10

7

Texas Theatre
231 West Jefferson Blvd.
arrived 1:40
apprehended 1:50

10th

Jefferson

Jacket

Crawford

Patton

8

Oswald's Dallas rooming house at 1026 North Beckley. Shortly after the President's murder, Oswald's landlady, Mrs. Earline Roberts, saw a police car in front of the house. The driver sounded the horn briefly, then drove away. Could the driver have been Officer Tippit, who was thought to have been acquainted with both Jack Ruby and Lee Oswald?

Oswald left William Whaley's cab, which stopped at Beckley Avenue and Neely Street, and bypassed his rooming house at 1026 North Beckley (not far from Jack Ruby's home). Back-tracking to his house, he entered and saw Roberts, who was watching TV news reports of the assassination. She said to Oswald, "Isn't that terrible about the President?" According to Roberts, Oswald barely replied, responding with a noncommital grunt.

Oswald carried a long brown paper package to work with him on the morning of November 22. He told his friend Buell Frazier, who drove him to work, that the package contained curtain rods. The night before, Oswald had returned to Irving, Texas, where his wife was living with Ruth Paine, in order to pick up the rods for his room at Earline Roberts' house in Dallas. Here, Mrs.

Roberts supervises as the rods are being hung in Oswald's room (this was done after Oswald's arrest — Mrs. Roberts apparently wanted the room to look presentable for those who might see it).

The Death of J. D. Tippit

Less than 45 minutes after the assassination, Dallas police officer J. D. Tippit was shot to death in the Oak Cliff area at 10th Street and Patton Avenue, several miles from Dealey Plaza. Tippit was hit four times. Officer Gerald Hill, who had custody of the .38 revolver supposedly found on Oswald at the time of his arrest, testified to the Warren Commission that he had discovered six live rounds in the gun's chamber. He also found two empty cartridges at the murder scene that came from an automatic weapon, not a revolver. (Revolvers do not discharge shells after firing.) The evidence suggests that Oswald never fired that gun — or shot anyone — that day.

Officer Tippit was shot and killed in front of 404 10th Street while standing by his squad car. Three shots were fired across the hood of the car; the assailant then came around to where Tippit lay and fired a fourth shot into his head. One bullet struck a button on Tippit's uniform and stuck there; it fell off in the ambulance en route to the hospital. This evidence was never recovered.

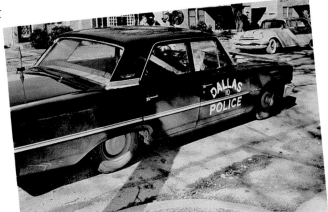

Map showing eyewitnesses to the Tippit murder. All of these individuals' original statements asserted that the man who had fired upon Tippit did not resemble Lee Harvey Oswald. In their later testimonies to the Warren Commission, most eyewitnesses changed their stories, stating that Tippit's killer did, indeed, look like Oswald. Both Aquilla Clemmons, who was admonished by the Dallas police and FBI to keep silent, and Jack Tatum, frightened by what he had seen, never gave statements to the Dallas police or to the Commission. (Tatum later testified before the House Assassinations Committee in 1976.) As a result, these two names do not appear on the map.

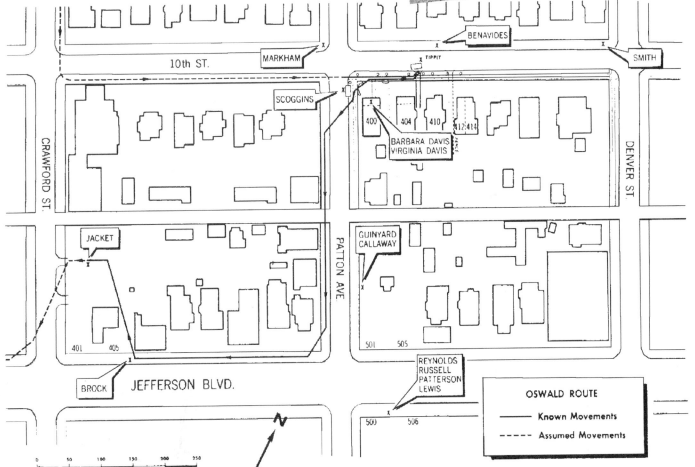

After Officer Tippit was shot to death, the killer headed toward Jefferson Boulevard, dropping his jacket at Jefferson and Crawford Streets. The jacket was recovered and found to bear certain laundry marks, which later could not be linked with or traced to Oswald.

This jacket was later used in the Warren Commission's investigation (Exhibit 162). Commission Assistant Counsel David Belin questioned Domingo Benavides, a witness to Tippit's killing, about the jacket. When he asked Benavides if it bore any similarity to the jacket he had seen the killer wearing Benavides replied, "I would say this looks just like it." Belin, however, had mistakenly shown him the wrong jacket, a blue one that had been found in the Depository (that belonged to Oswald). When Belin discovered that the witness had identified the wrong jacket, he changed the jacket's exhibit (evidence) number to make it look as if Benavides had identified the correct jacket.

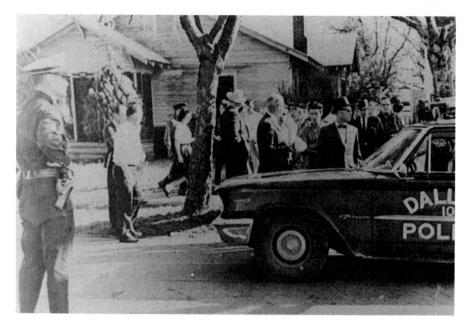

Each morning, Officer Tippit would stop in at the Dobbs House, a restaurant. According to a woman who worked there, Lee Oswald came in one time when Tippit was there. She did not know if the two knew each other.

The official (Warren Commission) version states that Oswald was walking east on 10th Street. However, several witnesses claimed that Tippit's assailant was walking west on 10th Street, which would have been toward the direction of Oswald's house.

The Dallas police report claimed that Tippit had been killed with an automatic weapon. When Officer Gerald Hill, who had custody of Oswald's .38 revolver, was questioned by CBS News as to what kind of weapon was used and how many shots were fired, he replied, "A .38 snub-nose [revolver] that was fired twice."

This map, evidence from the Warren Commission volumes, shows the various positions of the cameras that recorded the photographic evidence of the killing.

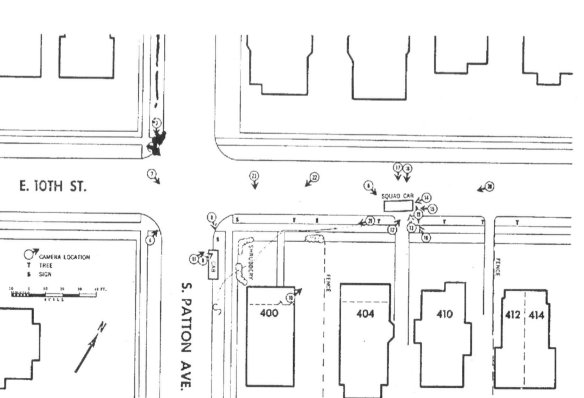

E. 10TH ST.

CAMERA LOCATION
T TREE
S SIGN

S. PATTON AVE.

SQUAD CAR

SHRUBBERY

FENCE

FENCE

400 404 410 412 | 414

Aquilla Clemmons was the only eyewitness to the Tippit killing who saw two men at the crime scene. She described the man who fired upon Tippit as heavyset, with short hair. She did not say the man looked like Oswald. She never changed her story, even after men came to her house and warned her to do so, saying that "she'd better keep her mouth shut if she didn't want to get hurt." Clemmons was never called to testify before the Warren Commission.

The police arrived at the scene of Tippit's murder after his body had been taken to Methodist Hospital (all the photos taken at the site were after the body's removal). There are no photographs of the body and how it fell, but reports indicate that he was shot in front of his police vehicle, slightly toward the driver's side.

Officer Hill testified to the Warren Commission that he had taken Oswald's revolver into custody. When questioned by Assistant Counsel David Belin, Hill stated that a fellow officer, Bob Carroll, had handed him the gun at the scene of Oswald's arrest at the Texas Theatre. Belin asked him what he did upon receiving the gun. Hill replied, "I broke the gun open to see how many shells it contained and how many live rounds it had in it. There were six . . ."

Ted Callaway saw a man run by on Patton Avenue, approximately one block away from the Tippit murder scene. As the man passed by, Callaway heard him mutter under his breath, "Poor dumb cop."

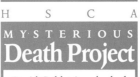

MYSTERIOUS Death Project

David Goldstein, who had assisted the FBI in tracing the revolver used in the Tippit killing, died in 1965 of seemingly natural causes.

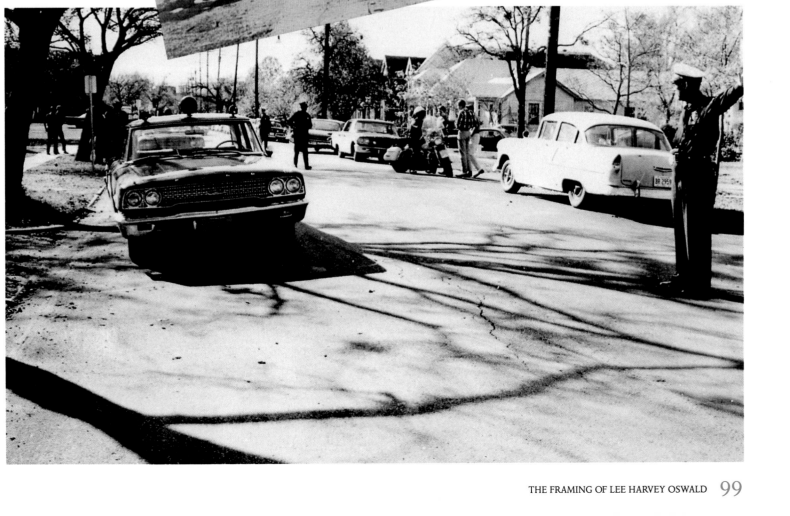

Commission Exhibit 524

Helen Markham was running to catch her bus, which was due at 1:16 p.m. She was about to cross 10th Street at Patton Avenue, heading toward Jefferson Boulevard. As she began to step into the street, Officer Tippit's car passed through the intersection, preventing her from crossing. From a short distance away, she saw Tippit stop his car and get out of it, only to be fired upon by a gunman, who then ran off down Patton. Presuming she was on time, the killing would have had to take place between 1:10 and 1:14 p.m.

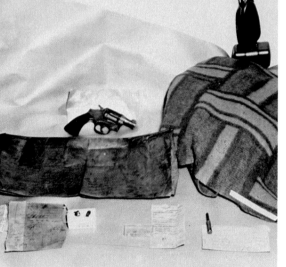

Four bullets taken from Oswald's revolver.

Johnny Calvin Brewer, who was a shoe salesman at the Hardy Shoe Store on Jefferson Boulevard (east of the Texas Theatre), heard police sirens out in the street. His attention was drawn there just as Lee Harvey Oswald — or someone resembling him — entered the doorway to the store. Brewer recognized the man, whom he had seen a week earlier when he had come into

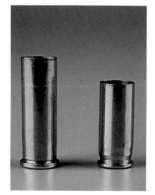

The short shell is from an automatic weapon, the long one from a revolver. Note the groove in the base of the automatic shell, in contrast with the flange at the base of the revolver shell. The ammunition, though of the same caliber, is not interchangeable between the two guns. According to the police radio report the shells found at the scene were from an automatic pistol and could not have been fired from Oswald's gun.

the shop to buy shoes. Apparently, Oswald (or his "look-alike") had been a difficult customer, which is why Brewer remembered him. Brewer then followed "Oswald" to the Texas Theatre.

Only three bullets were taken from Tippit's body, but four shots were fired at him. According to the FBI report on the murder, two of these bullets were manufactured by Winchester Western, the third by Remington Peters. Two of the bullets were from .38 specials. Oswald supposedly owned a .38 special Smith and Wesson revolver.

The Arrest of Lee Oswald

Lee Harvey Oswald was arrested in the Texas Theatre on Jefferson Boulevard in the Oak Cliff Section of Dallas, several miles from the Texas School Book Depository. He had been walking on Jefferson Boulevard when police cars, with their sirens screaming, passed him. It is possible that a man who resembled Oswald drew attention to himself by sneaking into the theater without paying for a ticket (adequate money for a ticket was later found in Oswald's pockets). The cashier called the police, who quickly arrived in force and arrested Oswald within moments. Donald Wayne House, who looked just like Oswald, was also arrested in Fort Worth for possible involvement in the assassination but was released after Oswald was arrested.

The police were called and descended upon Oswald. They dragged him — kicking, shouting, and fighting — from the Texas Theatre. One witness claimed an arresting officer yelled, "Shoot the President, will you!" Oswald reportedly knocked Officer Nick McDonald out cold and received a gash on his right temple in the scuffle. Oswald was yelling, "I am not resisting arrest! Police brutality!" This was ten hours before he was formally charged with the President's murder. Supposedly he was being arrested for the murder of J. D. Tippit, or for sneaking into the movie theater without paying for a ticket.

Why Oswald would go to a movie theater at this time is perhaps explained by his background as an intelligence operative. It is common practice for agents to arrange clandestine meetings at such places, where they can exchange information, then leave, without raising suspicion. Who was Oswald to meet? What was his assignment, if any?

Officer Gerald Hill had found the spent cartridges on the sixth floor of the School Book Depository during the search (this find, however, was attributed to Deputy Sheriff Luke Mooney in the official police report). Later, he arrived on the scene of the Tippit killing, accompanied by Assistant District Attorney William Alexander. Then, he was called to the Texas Theatre, where he was present for Oswald's arrest and came into possession of Oswald's revolver.

Why would Alexander, an assistant district attorney, accompany Hill to the scene of the Tippit murder? Reputed to be hot-tempered, Alexander, after Oswald's arrest, called him a "goddamn Communist" and wanted to accuse him of being part of an international conspiracy to kill the President. Alexander allegedly once threatened a man, perhaps in the course of trying to extract testimony or a confession, by holding a gun up to the man's head and exclaiming, "You son of a bitch, I will kill you right here!"

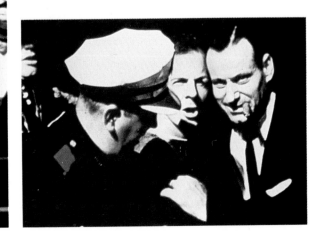

The Perfect Patsy

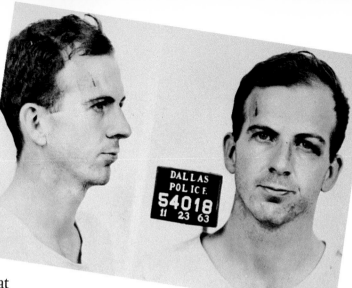

The countdown to Oswald's murder began the moment the President was shot. From his actions immediately after the assassination, it appeared that Oswald realized — too late — that he was being set up as a patsy to take the blame for the killing. When he was arrested at the Texas Theatre, instead of trying to escape (providing the police with a "perfect" opportunity to shoot him), Oswald tried a desperate ploy to save his life by shouting, "I am not resisting arrest!" It has been theorized that Oswald was, from the moment he returned to the United States after his defection to the Soviet Union, subtly manipulated and deceived by the intelligence community for which he worked. His was one of the first "strange deaths" of numerous eyewitnesses and co-conspirators in the Kennedy case.

Oswald in custody. Was he guilty of taking part in any aspect of the President's assassination? The police had found a Mannlicher-Carcano rifle (with one intact bullet still in the gun) on the sixth floor of the Depository — this supposedly was the same rifle that Oswald, under the alias of Alek Hidell, had purchased through mail order.

Captain Will Fritz, who interrogated Oswald after his arrest, secretly recorded the questioning (during which Oswald may have admitted to being involved with the intelligence community). Though he may have taken notes during the session, Fritz testified to the Warren Commission that there were no notes. Assassination researcher Mary Ferrell learned that sometime in the 1970s, Fritz had mentioned to a friend that President Lyndon Johnson had called him on November 23, 1963, and said, "You've got your man, the investigation is over." The tapes of the interrogation are said to still exist, but in an unknown location.

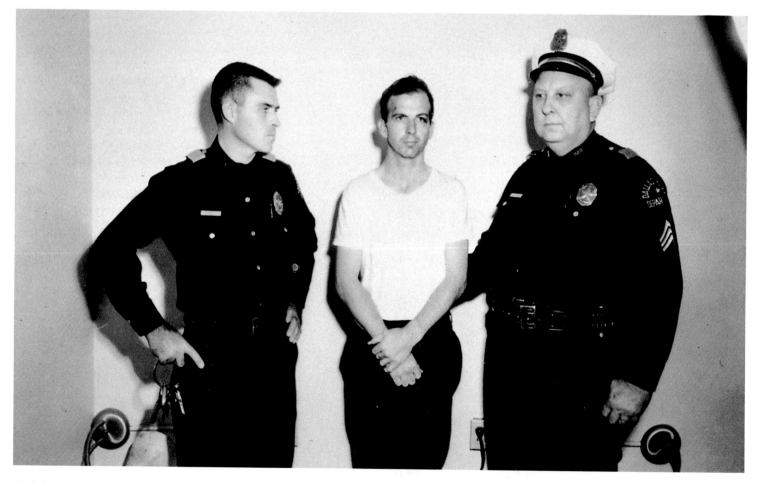

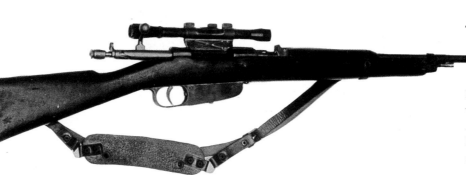

Dallas Police Chief Jesse Curry (*below*) did not think Oswald acted alone. Oswald was known to be a poor marksman during his tenure in the Marine Corps, and would have had little chance to improve his marksmanship

in civilian life. Said Curry, "We don't have any proof that Oswald fired the rifle, and never did. Nobody [has] yet been able to put him in [the Depository] with a . . . gun in his hand."

Oswald was given nitrate tests to his cheeks and hands to determine whether he had fired the rifle. His cheeks tested negative for traces of nitrate, but a slight residue was found on his hands, deposits that he could have gotten while handling newspaper or other materials present in the Depository. The positive test results on his hands could have meant that Oswald had not bothered to wash his hands. The cheek test proves his innocence.

The bolt of a Mannlicher-Carcano is extremely difficult to work. No one (including the professional marksmen who later tried to duplicate the firing of three successive shots with the Carcano) could have fired even two shots in 1.6 seconds and hit a target — especially a moving target. It is highly unlikely that Oswald was the marksman. Police, when searching through Oswald's possessions after his arrest, found no bullets for the 6.5 Mannlicher-Carcano rifle.

Oswald was put into a police lineup with men that, even from a distance, did not approximate his physical stature or condition. He specifically protested this. When he was being led to stand in one of the lineups he said, "They've had me in this [same torn T-] shirt for days, and they're going to pick me out [of the lineup], right?"

Ten days before the assassination, Lee Oswald delivered a "threatening note" to Dallas FBI Headquarters. It was addressed to Special Agent James Hosty, Jr., who had been keeping Oswald and his Russian-born wife, Marina, under surveillance. Two hours after Jack Ruby killed Oswald, Dallas FBI head Gordon Shanklin ordered Hosty to destroy the note: Hosty flushed it down the toilet.

Not until October 1975, three months after a story about this note hit the press, did the FBI make a statement about it. They claimed the note said, "Let this be a warning. I will blow up the FBI and the Dallas Police Department if you don't stop bothering my wife." Hosty, who after the incident with the note found himself demoted within the FBI, said that the note was not so violent; he said that it merely stated that "if you don't cease bothering my wife, I will take appropriate action and report this to the proper authorities."

What was so damning about such a note (that seemingly made no threat on John Kennedy's life) that it had to be so hastily — and secretly — destroyed? The note perhaps contained information Oswald may have discovered about the plot to kill the President.

The Stalking of Lee Oswald

Jacob Rubenstein, alias Jack Ruby, had been involved in organized crime since his childhood in Chicago, working for Al Capone, Jake "Greasy Spoon" Guzik, and Frank "The Enforcer" Nitti. Involved in the murder of union official Leon Cook in Chicago, Ruby eventually moved to Dallas, where he still worked for the Mob. Following the assassination, Ruby started stalking Oswald. On Friday night, November 22, Ruby was seen — and photographed — at Dallas police headquarters. On Saturday night, he anonymously called Officer Billy Grammer (who the next day realized the caller had been Jack Ruby) at police headquarters and warned him that, if the police moved Oswald as planned the next morning, "we will kill him."

Oswald runs the gauntlet of police and press. One of the officers made the comment that Oswald didn't act like someone who had just shot the President. In fact, officials noticed that Oswald, who was certainly on his own in a desperate situation, was amazingly calm and self-assured.

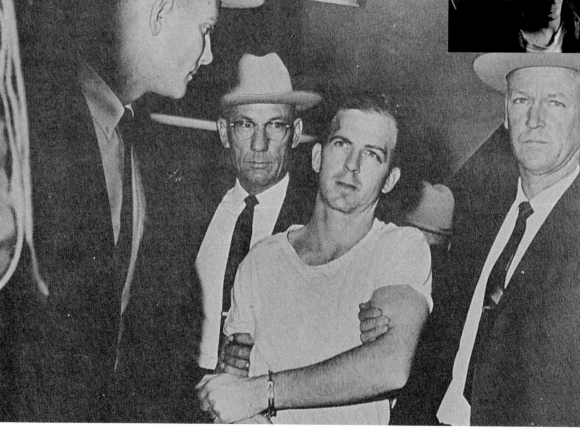

It is likely that Lee Oswald was never supposed to leave the Book Depository or the Texas Theatre alive. Because he survived through the assassination, the Tippit killing, and his arrest at the theater, police now had a suspect who could probably prove his own innocence (and pass a lie detector test). Any conspirators in the President's murder had a great deal to gain by silencing Oswald, who could have had advance knowledge of at least portions of an assassination plot. Jack Ruby, perhaps under orders from the Mob, was ordered to keep Oswald (permanently) quiet.

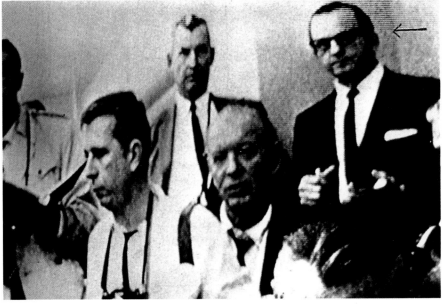

Left: Jack Ruby at the midnight press conference on November 23, 1963. When Oswald was brought before reporters, Police Chief Curry made reference to him as a member of the "Free Cuba Committee." Ruby shouted out the correct name of the organization as the "Fair Play for Cuba Committee." How well did Jack Ruby know Lee Oswald?

Jack Ruby distributed cards that advertised the attractions of his Carousel Club to police and newsmen over the weekend of the assassination.

For extra protection, Oswald was to be transferred from Dallas Police Headquarters to the county jail by armored car. The transfer was standard procedure; usually prisoners in custody did not remain overnight at headquarters. Oswald's two-night stay there, which included a midnight press conference, reinforced his guilt in the eyes of the press — and of the nation.

Below: Jack Ruby waits, gun in hand, to kill Oswald. How was Ruby convinced to murder Oswald? Was he being monetarily compensated? Ruby, though, was reluctant to do the job; he waited until a full hour after the planned time of Oswald's transfer before finally arriving in the basement at police headquarters. Curiously, Oswald's transfer was held up until Ruby arrived.

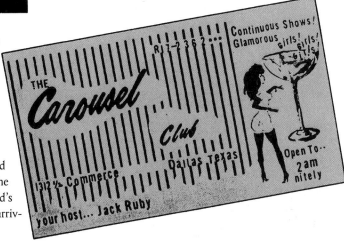

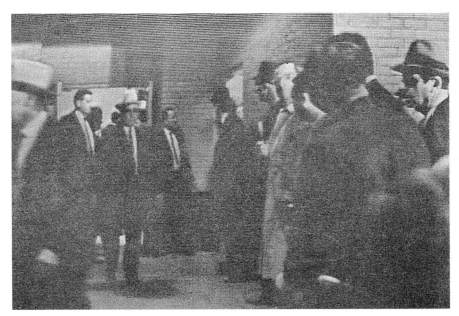

The Second Assassination

It was highly possible that Jack Ruby had direct orders from Mob superiors to kill Oswald. His warning call to Grammer was perhaps an attempt to create a situation where he would not have access to Oswald and would not have to kill him. This tactic, which might have cleared Ruby with the Mob, did not work. Still trying to avoid a confrontation with Oswald, Ruby showed up at the jail one hour past the prisoner's scheduled transfer time, but the authorities held up moving Oswald, perhaps coincidentally, until Ruby arrived.

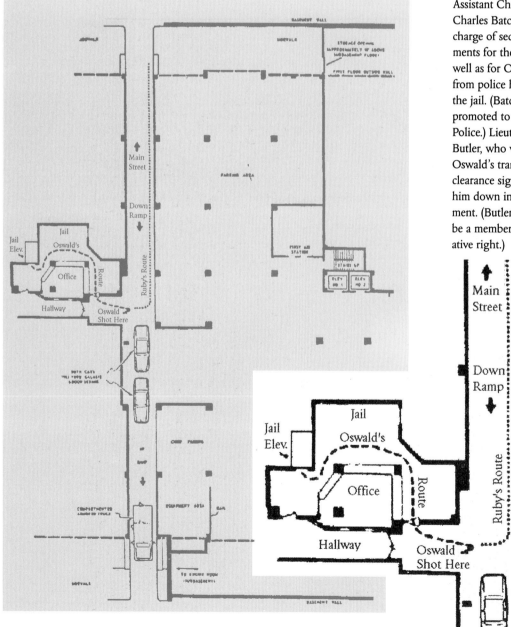

Assistant Chief of Police Charles Batchelor was in charge of security arrangements for the motorcade, as well as for Oswald's transfer from police headquarters to the jail. (Batchelor was later promoted to Chief of Police.) Lieutenant George Butler, who was supervising Oswald's transfer, gave the clearance signal to bring him down into the basement. (Butler was reputed to be a member of the conservative right.)

In its investigation, the House Assassinations Committee concluded that Ruby probably was assisted in entering the basement. When someone began a double-check and search of the basement before the transfer, Charles Batchelor ordered it stopped. Officer Roy Vaughn supposedly let Ruby in, and Officer Napoleon Daniels said he saw Ruby come down the ramp.

Ruby walked to the area near the bottom of the ramp and ducked under the metal handrails, joining the crowd of reporters. Two police cars were parked on the ramp below the armored car at the ramp's exit point. There is a theory that a series of four beeps, sounded by someone in one of the cars, provided an audible signal of Oswald's movements through headquarters, perhaps alerting Ruby to the moment when Oswald would finally appear.

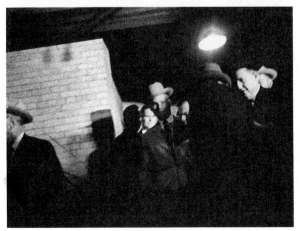

In the bottom right photo, Jack Ruby's attire and posture are simular to the dress and pose of the man standing near the tree on the Grassy Knoll in the photo on page 49. They appear to be the same man.

Police Chief Curry was about to leave his office in the headquarters building to watch Oswald's transfer. While he was preparing to leave, Curry received a telephone call from Mayor Earle Cabell (left), who kept him engaged in a conversation that lasted until Ruby had shot and killed Oswald.

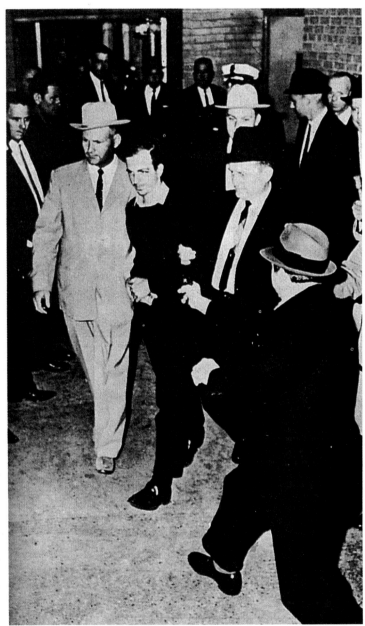

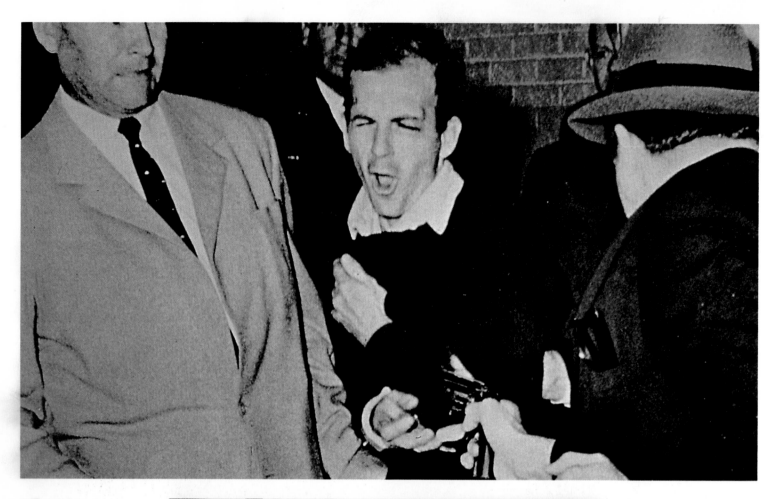

Suffering from a severe abdominal wound, but still alive, Oswald was taken by ambulance to Parkland Hospital. While en route to the hospital, Oswald received external cardiac massage, a procedure known to aggravate abdominal bleeding. Once at the hospital, Oswald's vital signs were stabilized for a brief time. But Oswald died a short time later.

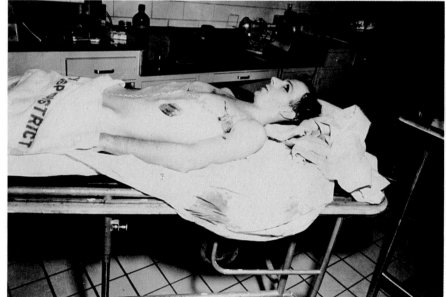

Tom Howard, Jack Ruby's first defense lawyer, circulated a story that Ruby had killed Oswald in order to spare Jacqueline Kennedy the grief and strain of testifying at a murder trial.

The "Assassin's" Assassin

The morning of November 24, 1963, Jack Ruby moved to the front of a crowd of reporters and shot Lee Harvey Oswald on live national television. Later, in custody, Ruby said, "I walked into a trap when I walked down there. I wasn't clean enough. It was my destiny. I'd taken 30 antibiotic and Dexedrine pills. They stimulate you." Beverly Oliver, who worked in the Colony Club, next door to Ruby's Carousel Club (and who was also a witness to the events in Dealey Plaza), has stated that Ruby had introduced her to Oswald at the club two weeks before. She said that Ruby presented Oswald as "Lee Oswald from the CIA."

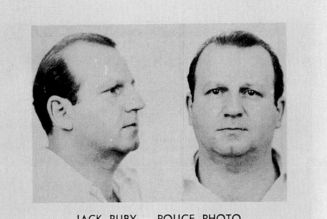

JACK RUBY — POLICE PHOTO

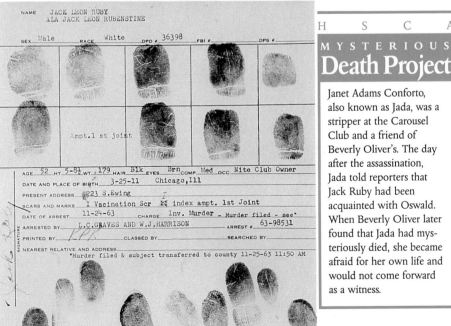

H S C A
MYSTERIOUS
Death Project

Janet Adams Conforto, also known as Jada, was a stripper at the Carousel Club and a friend of Beverly Oliver's. The day after the assassination, Jada told reporters that Jack Ruby had been acquainted with Oswald. When Beverly Oliver later found that Jada had mysteriously died, she became afraid for her own life and would not come forward as a witness.

Ruby allegedly gained access to the "killing zone" in the basement by walking down this ramp. Officer Roy Vaughn swore, until the day he died, that Ruby never passed him on the ramp. It is doubtful that Vaughn was telling the truth.

Moments after the shot was fired, one of the two police cars on the ramp backed up into the basement into the crowd, and struck Ruby on the back of his left leg, knocking him off balance. Was this to prevent Ruby from firing a second shot?

Ruby's Connections

The FBI, in its investigation of the assassination, reported to the Warren Commission that they could find no apparent connection between Jack Ruby and organized crime. A later examination of Ruby's telephone bills for the weeks and hours preceding the assassination revealed dozens of calls to Mob figures. From his jail cell in Dallas, Ruby later told journalist Tom Johnson that "it is the most bizarre conspiracy in the history of the world. It'll come out at a future date." Ruby, a very reluctant fall guy in the Kennedy killing, would never live to reveal his knowledge of the conspiracy. He "developed" cancer and died in 1967.

Lee Harvey Oswald's brother, Robert, said that Lee and Ruby knew one another. Other individuals who frequented and worked at the Carousel Club also made this claim. David Ferrie (see page 134), Lee Oswald's superior officer when he was in the Civil Air Patrol in New Orleans, also was said to have managed the Carousel Club at one time; he and Oswald were often seen together. Beverly Oliver asserted that she had observed Oswald and Ferrie at the Club numerous times.

H S C A
MYSTERIOUS
Death Project

Thomas Hale Howard, a friend of Jack Ruby, was at a gathering of Ruby's friends at his apartment on the night Oswald was shot. Howard, Ruby's first lawyer, died of a supposed heart attack early in 1964.

H S C A
MYSTERIOUS
Death Project

Some of Jack Ruby's friends met at his apartment the evening of Oswald's death. Ruby's roommate, George Senator, is the only one of these who did not die under strange circumstances. Jim Koethe was killed in September 1964, in a lethal karate attack. In April 1964, Bill Hunter was shot through the heart while in a police station in Southern California.

MYSTERIOUS
Death Project

Before John Kennedy came to Dallas, two men who worked for Jack Ruby threw stripper Rose Cherami out of a speeding car and abandoned her by the side of the road. She claimed that she knew of a plan to kill the President, and in a later statement she also said that Jack Ruby and Lee Oswald were involved in a sexual liaison. Cherami was killed in a hit and run accident in 1965.

After Fidel Castro had taken over the Cuban government in 1959, Jack Ruby traveled there to meet with various Mob figures whom Castro had imprisoned. On one trip, Ruby reportedly met with mobster Meyer Lansky, also known (to Ruby) as "Mr. Fox."

MYSTERIOUS
Death Project

Beverly Oliver's husband, George McGann, was murdered in the home of a man named Ronny Weeden. Convicted killer Charles Harrelson, who knew Weeden from prison, claimed that Weeden had killed McGann, and that he "had a reputation as a hit man."

MYSTERIOUS
Death Project

Hank Killam, the husband of one of Jack Ruby's strippers, Wanda Joyce Killam, was found with his throat slashed in March 1964. Before his death Killam had said to his brother, "I am a dead man, but I have run as far as I am going to run."

MYSTERIOUS
Death Project

Karyn Kupcinet, the daughter of Jack Ruby's Chicago friend, Irv Kupcinet, was murdered two days after the Kennedy assassination. She allegedly had advance knowledge of the assassination plans — a telephone operator claimed to have overheard her discussing the killing.

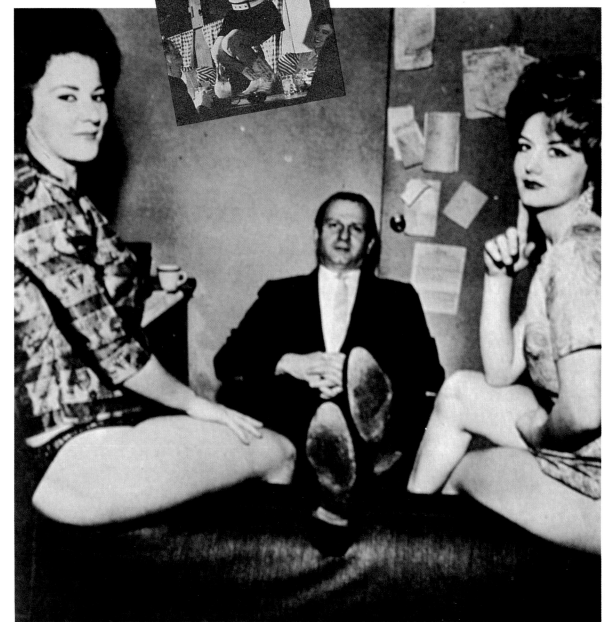

MYSTERIOUS
Death Project

Reporter Dorothy Kilgallen was the only member of the press to gain an interview with the jailed Jack Ruby. She had taken a great interest in the case and attended Ruby's trial. She purportedly told a friend of hers that she wanted to "break the assassination mystery wide open." Kilgallen was found to have accidentally overdosed on barbiturates (the autopsy report showed that she had enough drugs in her system to kill at least ten men). Her death was termed a suicide.

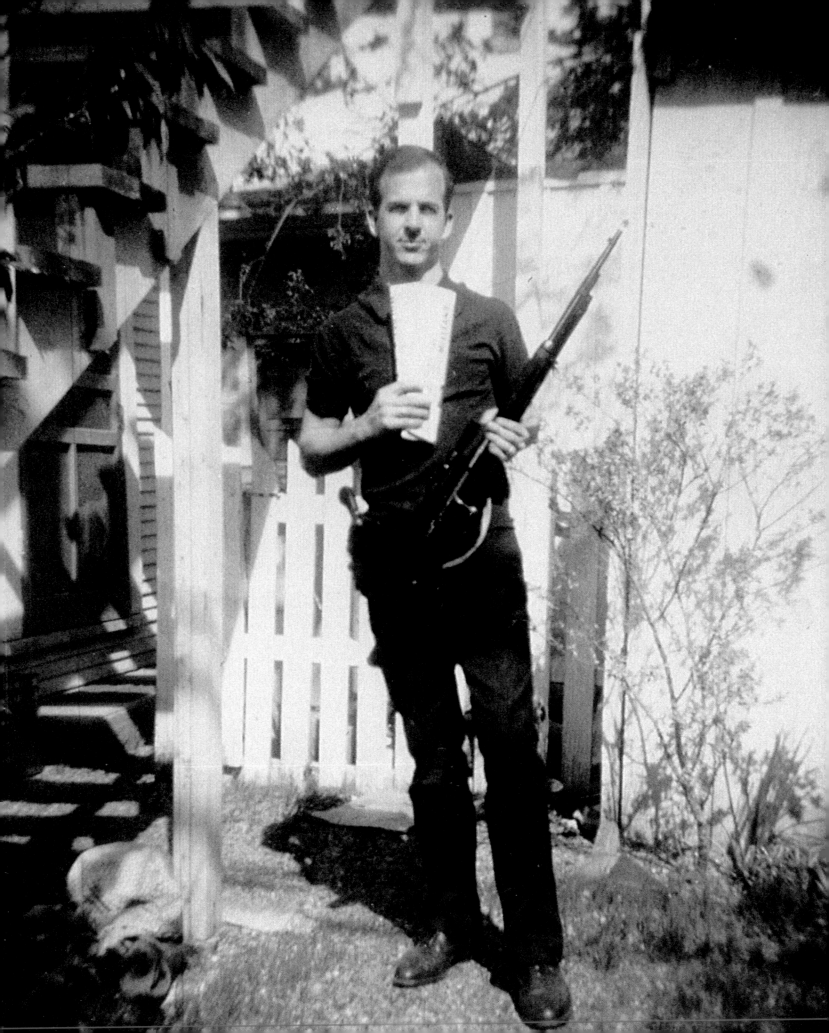

JOHNSON'S COMMISSION OF INQUIRY

O
n November 29, 1963, one short week after the killings in Dallas, President Lyndon Johnson issued Executive Order No. 11130 empowering a presidential commission to investigate the assassination. The Commission's seven members were hand picked by Johnson. Five were Republicans and two were conservative southern Democrats.

The Commission never hired any independent investigators during its ten-month investigation and relied entirely upon the FBI and the CIA to do all its investigating. The reason given for the existence of the Warren Commission was to uncover the facts of the Kennedy assassination. But upon the release of its final report on September 24, 1964, it seemed that the Commission's true mandate was instead to allay the growing rumors of conspiracy and U.S. intelligence entanglement with the assassination.

President Johnson was finding these rumors — especially those involving him — increasingly difficult to live with. All too quickly, the Texas State Attorney General's office was uncovering evidence of links between Oswald and U.S. intelligence agencies.

Opposite: The Warren Commission believed that the backyard portraits were truthful representations. They were used to establish Oswald's violent nature.

3. CBS Reports, "The American Assassins" (Part 2), November 26, 1975.

President Johnson said of Oswald, "He was quite a mysterious fellow, and he did have a connection. . . . The extent of the influence of those connections on him I think history will deal with more than we're able to now."[3]

Johnson was already deeply implicated in several illegal activities involving such individuals as business crony Bobby Baker. He had the additional pressure of knowing — as did others — that Kennedy might have dropped him from the 1964 re-election ticket. Former Vice President Richard Nixon had been quoted in the November 22, 1963, edition of the *Dallas Morning News* as saying, "Johnson is becoming a 'political liability' to the Democratic party. Kennedy has stated that he intends to keep Lyndon as the vice presidential nominee. But we must remember that Kennedy and his advisors are practical politicians . . . if they think the race is a shoo-in, they will keep Lyndon. Otherwise, I think, they will choose someone who can help the Democratic ticket."

Critics of the Warren Commission, even early on in the investigation, were hounded and harassed, often referred to as Communists. Since Oswald was a supposed pro-Castro Communist, anyone who did not believe he killed John Kennedy was certainly suspect. Chief Justice Earl Warren (perhaps influenced by those Commission members with loyalties to the intelligence community) had a persistent band of critics put under watch, and both the CIA and FBI circulated internal memoranda detailing how to counteract such criticism in the press by using what they called "propaganda assets" in the media.

Besides firing Allen Dulles from his post as Director of the CIA, John Kennedy had also fired two other top CIA men, General Charles Cabell (brother of Dallas Mayor Earle Cabell, (*top left*) and Richard Bissell (*above*), Deputy Director of Plans, for their involvement in the Bay of Pigs incident.

In light of such statements, the new President did not want to be implicated in or connected to the assassination in any way.

Given the new emotional and political tensions created by the assassination, Johnson needed the appearance of a solid investigation into Kennedy's murder: He was finding it impossible to govern amid the growing rumors that he had been involved in an assassination plot or its cover-up. Johnson also needed a group of investigators who would write a politically acceptable report to quell any rumors of conspiracy, more than to determine the actual truth about the killing. The appointment of Allen Dulles and Chief Justice Earl Warren ensured the success of this latter goal.

Former CIA Director Allen Dulles had hated John Kennedy and was now in a position to con-

President Kennedy with former CIA Director Allen Dulles and Dulles's successor, Kennedy appointee John McCone.

trol the flow of information so vital to a thorough and honest investigation. It was widely known that Kennedy and the CIA had been at odds since the bungled Bay of Pigs invasion of Cuba in 1961. Dulles, whom Kennedy had forced to resign as CIA Director after the Bay of Pigs, knew the details of the CIA's assassination plots and attempts against Castro, but never shared this knowledge with the Commission. This information could have had major impact in establishing the possibility of a conspiracy to kill the President. Dulles also repeatedly violated his secrecy oath as a commissioner, systematically informing the CIA of internal secrets from within the Commission.

Dulles was not the only Commission member engaged in this activity. Gerald Ford, then a junior congressman from Michigan, continuously leaked information to the FBI during the Commission's investigation.

There have been many criticisms raised of the Warren Commission findings. One of the most common is that the investigation began with the premise that Oswald was the lone assassin. The directives of the investigation all related to Oswald — there never was any other suspect. The improbable single bullet theory was developed by Warren Commission Assistant Counsel Arlen Specter to support the lone assassin theory (and was championed by Gerald Ford). When the Warren Commission released its report, which was instantly backed by the vast majority of the working press, it successfully — but temporarily — obscured the existence of conspiracy.

The Commission Convenes

President Johnson asked Chief Justice Earl Warren to head a special commission to investigate the assassination. Warren was reluctant to accept the appointment; Johnson finally persuaded him to do so, arguing that Warren's participation would expedite the Commission's authority to quell rumors of a possible foreign conspiracy. None of the seven members of the Warren Commission had any previous investigative experience; they relied upon J. Edgar Hoover and the FBI's investigative report on the assassination. But by the time of the Commission's first session on December 5, 1963, they still had not received the FBI report. Throughout the Commission's life, Hoover continually used delaying tactics, waiting until the Commission was under deadline pressure to submit their report, then providing more material than the Commission could possibly evaluate. When the Commission released its final report, it was accompanied by 26 volumes of "supporting evidence and testimony."

Earl Warren later concluded that never in our lifetimes would we know the entire truth of what happened in Dallas.

Allen Dulles, a formidable opponent of John Kennedy, clearly intended to keep information about Oswald's connections with the CIA and FBI from becoming public knowledge.

The Commission at work, in an official formal portrait. From left to right: Mr. Allen Dulles, Rep. Hale Boggs, Sen. John Sherman Cooper, Chief Justice Earl Warren, Sen. Richard B. Russell, Mr. John J. McCloy, Rep. Gerald R. Ford.

Congressman **Hale Boggs,** a conservative on the panel, was intimidated by those members with strong CIA ties. At first, he bought the single bullet theory, but he later changed his mind, believing that the questions had not been adequately answered.

About the President and Connally being hit with the same bullet, Senator **John Sherman Cooper** said, "I, too, objected to such a conclusion; there was no evidence to show both men were hit by the same bullet."

Senator **Richard Russell** did not believe that Oswald could have planned out and executed the assassination on his own.

John McCloy, a close associate of Nelson Rockefeller's, was a strong supporter of the single bullet theory and of the Commission's findings. He denied any existence of a conspiracy to kill John Kennedy.

Chief Justice **Earl Warren** (wearing glasses) is shown stepping into one of the official cars after leaving the Texas School Book Depository building, where he visited the spot from which the bullets had been fired. Warren later met with Jack Ruby.

Gerald Ford was FBI Director Hoover's eyes and ears on the Warren Commission. Ford, in his book about the assassination called *Portrait of the Assassin,* boldly excerpted sections of a top secret document (transcripts from a closed executive session of the Commission), then later claimed he had not realized he had done so. The federal government later exonerated him by declassifying the document.

General Counsel **J. Lee Rankin** headed up the Commission's investigation and served as a liaison to both the CIA and FBI. Rankin carefully fended off any staff or members' criticism of the evidence in the case, and at one point stated, "No more memorandums. The report has to be published."

Arlen Specter, Assistant Counsel for the Commission, went to great lengths to develop and support the single bullet (also known as the "magic bullet") theory. Richard Nixon, when being prosecuted for his role in the Watergate scandal, asked Specter to take charge of his legal defense (Specter eventually turned down the job).

Leon Jaworski, Special Counsel to the Commission, went to Dallas with Earl Warren and Gerald Ford to question Jack Ruby. In charge of investigating Lee Oswald's CIA and FBI connections in Texas, Jaworski reported to the Commission that there was no truth to the allegations that Oswald had worked for the intelligence community.

A Top Secret

In a closed executive session of the Commission on January 27, 1964, members discussed Lee Harvey Oswald's probable involvement with the FBI and CIA and were dismayed about the implications. The Commission also expressed its awareness that the location of the President's back wound was far lower than the throat wound. However, when the final report was published, it included diagrams of the President's back wound placed a full six inches higher than its real location.

Mr. Rankin.

That he also knew the number that was assigned by the F.B.I. to Oswald which was No. 179, and he knew that he was on the payroll or employed, I think that is the way he put it, employed by the F.B.I. at $200 per month from September of 1962 up to the time of the assassination.

That was all that he knew about it. He didn't...

...consider any substantial proof of this rumor.

We do have a dirty rumor that is very bad for the Commission, the problem and it is very damaging to the agencies that are involved in it and it must be wiped out insofar as it is possible to do so by this Commission.

So it seemed to me in light of that the way I would treat it ...were in their pos... ...one approach me, ...much more th...

We have an explanation there in the autopsy that probably a fragment came out the front of the neck, but with the elevation the shot must have come from, and the angle, it seems quite apparent now, since we have the picture of where the bullet entered in the back, that the bullet entered below the shoulder blade to the right of the backbone, which is below the place where the picture shows the bullet came out in the neckband of the shirt in front, and the bullet, according to the autopsy didn't strike any bone at all, that particular bullet, and go through.

So that how it could turn and --

Rep. Boggs. I thought I read that bullet just went in a finger's length.

Mr. Rankin. That is what they first said. They reached in ...uld feel where it came, it didn't go any further

Talking with Ruby

Chief Justice Warren and Gerald Ford journeyed to Dallas to interview Jack Ruby. Under close watch by Dallas officials (among them Sheriff Bill Decker) during the questioning, Ruby was agitated and said, "I may not live tomorrow to give any further testimony. . . . I can't say it here . . . it can't be said here. . . . It can be said, it's got to be said amongst people of the highest authority. . . . Gentlemen, if you want to hear any further testimony, you will have to get me to Washington soon, because it has something to do with you, Chief Warren. . . . I want to tell the truth, and I can't tell it here." Ruby pleaded with Warren for almost three hours to take him back to Washington, but to no avail.

JACK RUBY — PO

Said Ruby, "I have been used for a purpose, and there will be a certain tragic occurrence happening if you don't take my testimony and somehow vindicate me. . . ."

"But we have taken your testimony," answered Earl Warren. "We have it here. It will be in permanent form for the President of the United States and for the Congress of the United States, and for the people of the entire world. It is here. It will be recorded for all to see. That is the purpose of our coming here today. We feel that you are entitled to have your story told."

Representative Ford asked,: "Is there anything more you can tell us if you went back to Washington?"

"Yes. Are you sincere in wanting to take me back?"

"We are most interested in all the information you have."

". . . I am used as a scapegoat. . . . But if I am eliminated, there won't be any way of knowing. Right now . . . I am the only one that can bring out the truth to our President. . . . I know that your hands are tied [and that] you are helpless," said Ruby.

Though Warren could have arranged to do so, he told Ruby that they couldn't take him to Washington, saying, "Well, the public attention that it would attract, and the people who would be around. We have no place there for you to be safe when we take you out, and we are not law enforcement officers, and it isn't our responsibility to go into anything of that kind."

Resigned, Ruby replied, "You have lost me though. You have lost me, Chief Justice Warren."

Jack Ruby, with his links to various Mafia figures and their money-making enterprises (especially gambling), had made high-level political connections among some of Texas's millionaire gambling aficionados. This group helped support the yearly holidays that FBI Director Hoover (who loved to gamble) would take at the Del Mar Racetrack in Southern California.[4] Ruby alluded to these connections in his testimony to Warren, but the Chief Justice was confused by what appeared to be the ramblings of a paranoid man.

4. Peter Dale Scott: *Crime and Cover-up*, p.45

The Surveyor's Report

The Warren Commission attempted to make a strong case against Oswald and created painstaking re-enactments of the assassination. They hired Chester Breneman (later to become the surveyor of Eastland County, Texas) and Dallas County surveyor Bob West to take measurements and help re-create the crime scene in Dealey Plaza. Breneman and West, who had participated in re-enacting the scene in 1964 for the FBI and Secret Service, again measured the Plaza and the distances from the Book Depository, then matched the results against the stills of the Zapruder film. At the end of the day's work, both Breneman and West agreed that no one man could have fired all the shots. When the Warren Commission published its report, which included the figures from the re-enactment, Breneman and West were astounded to find that the published figures did not match theirs — nor did they match the figures taken in the 1964 re-enactments.

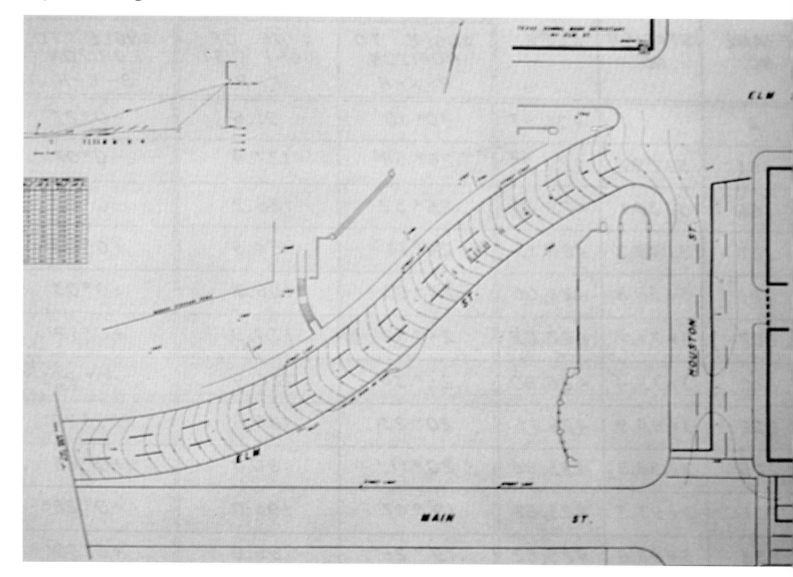

Lone Assassin Theory

The Commission's agenda (reinforced by J. Edgar Hoover's belief in Oswald's guilt) was to prove that a "lone nut," a violent malcontent, killed the President. Warren Commission Assistant Counsel Arlen Specter developed the single bullet theory to support the claim that Oswald had acted alone. Throughout the investigation, the Commission never considered any other suspect in the killing, ignored the hard medical evidence of Kennedy's wounds, and discounted or distorted Dallas doctors' testimonies by publishing their own drawings of the President's wounds. Oswald's culpability was a foregone conclusion.

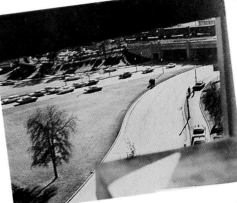

The Commission had the most difficult task of finding a possible motive for Oswald's having killed the President. They found that "many factors were undoubtedly involved in Oswald's motivation for the assassination, and [the Commission] does not believe that it can ascribe to him any one motive or group of motives. . . ."

When they investigated the nature of Oswald's employment at the Texas School Book Depository, the Commission found that he worked primarily on the first and sixth floors of the building. The assassination occurred at 12:30 p.m., and there were no eyewitness accounts placing Oswald above the second floor after 12:00 p.m.

TEXAS SCHOOL BOOK DEPOSITORY, SECOND FLOOR, OSWALD'S MOVEMENTS

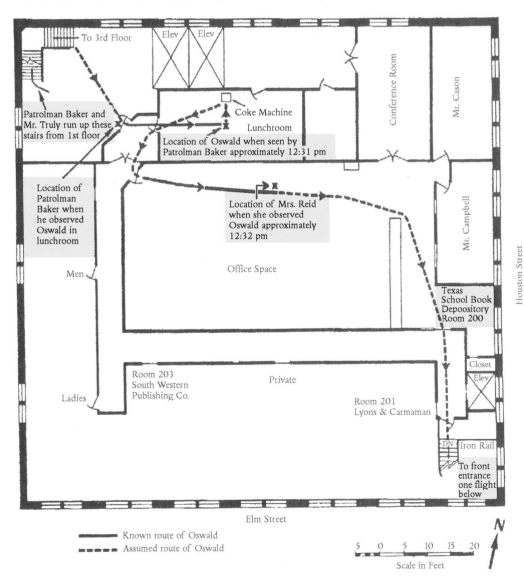

To 3rd Floor

Elev | Elev

Conference Room

Mr. Cason

Coke Machine

Patrolman Baker and Mr. Truly run up these stairs from 1st floor

Lunchroom

Location of Oswald when seen by Patrolman Baker approximately 12:31 pm

Location of Patrolman Baker when he observed Oswald in lunchroom

Location of Mrs. Reid when she observed Oswald approximately 12:32 pm

Mr. Campbell

Men

Office Space

Texas School Book Depository Room 200

Houston Street

Room 203 South Western Publishing Co.

Private

Closet

Elev

Ladies

Room 201 Lyons & Carmaman

DN | Iron Rail

To front entrance one flight below

Elm Street

———— Known route of Oswald
- - - - - Assumed route of Oswald

N

5 0 5 10 15 20
Scale in Feet

Oswald asserted that he did not kill John Kennedy, saying, "I don't know what you're talking about. My wife and I like the presidential family. . . . They are interesting people." His wife, Marina, and his close friend George DeMohrenschildt both corroborated this statement. After the assassination, the FBI never formally threatened Marina Oswald with deportation, but made it clear to her that she should cooperate with them if she wanted to remain in the United States. Her testimony to the Warren Commission was crucial to their investigation, but yielded somewhat puzzling results. Her statements, as reported by the commission, were often vague and incomplete.

When Dallas police searched Ruth Paine's home in Irving, Texas, where Marina Oswald and the children were living, they found a series of mysterious photographs among Oswald's possessions. The pictures showed a man, supposedly Oswald, standing in his backyard in various poses, holding a rifle and pro-Communist literature. Marina Oswald testified that she had taken one photograph of her husband in a similar pose; however, when the Commission showed her two pictures, she stated that she had never seen the photo after she'd taken it, and that she may have taken two pictures. During Oswald's interrogation by Will Fritz, he was shown one of the photos and claimed that the pictures showed his head, but not his body. Oswald, who had done photo work before, said he could prove they were fakes, but he never got the chance to do so.

The Commission's belief that Oswald had shot the President with the Mannlicher-Carcano was challenged by the assertions of Oswald's 19-year-old neighbor Buell Wesley Frazier. Frazier drove Oswald to work on the morning of the assassination. He had observed the way Oswald was carrying a paper package that he said contained curtain rods. Frazier stated that Oswald held the bottom of the package in the cup of his hand, with the top resting under his armpit; Frazier maintained that the parcel was far too small to contain a rifle. Frazier himself owned a British .303 rifle, the type of weapon that news reports said was first found on the Depository roof. He was arrested that afternoon and held for questioning, but he was later released.

The Warren Commission believed that Oswald was, in fact, the owner of the Mannlicher-Carcano rifle, the supposed murder weapon (though Dallas police, knowledgeable about weapons and ammunition, testified that they had found a German Mauser in the Depository). The Dallas police report first stated that the weapon was a Mauser. The report was changed later, stating that it was a Mannlicher-Carcano.

The Commission leaked the photograph below to a prominent national magazine, a maneuver that helped solidify Oswald's public image as the dangerous lone assassin.

The Warren Commission made every effort to prove that the backyard photos were genuine, but critics noted shadow inconsistencies between the body, ground, and head, a composite line in the photos between the mouth and the chin, and mismatching head and body proportions.

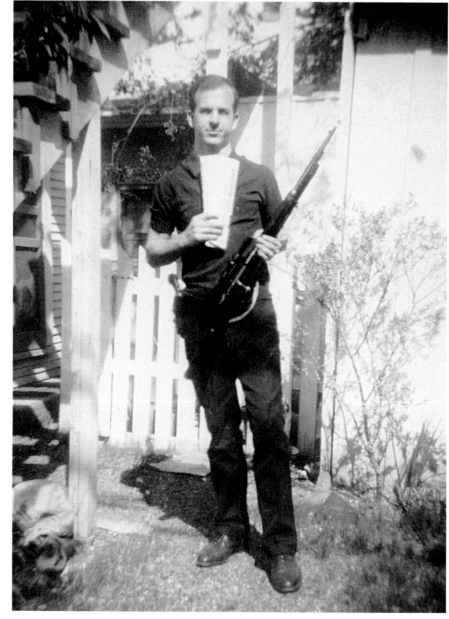

Dallas police took a palm print from the barrel of the Mannlicher-Carcano, which was identified as a latent (or scarcely visible) palm print of Oswald's. The Commission then considered the brown paper case as a piece of valuable evidence, as it also retained Oswald's latent palm print. The second print contained blanket fibers that were found to match the fibers of a blanket in which Oswald had supposedly wrapped the rifle. The blanket was still in Ruth Paine's garage when police later searched her house.

The Warren Commission wanted to establish that only three bullets had been fired, and that each had been fired from Oswald's 6.5 Mannlicher-Carcano rifle from the sixth floor Depository window. Though Oswald may have purchased the rifle under his operative alias, Alek Hidell (for unknown purposes), it has not been established that he ever fired the gun. In the initial search of the Depository, police found a Mauser rifle, but this discovery was quickly suppressed. The Mannlicher-Carcano rifle (which officials found in the west end of the sixth floor with one bullet still in it) was an unwieldy, low-precision weapon. Was it planted to implicate Oswald?

In 1976, The National Archives revealed that two internal letters written by Warren Commission assistant counsel David Belin and staff attorney Burt Griffin to Chief Counsel Lee Rankin were missing from its collection. These two documents discussed Oswald's interrogation by the Dallas Police Department after his arrest, as well as other questions that needed to be addressed and answered by various governmental or official agencies. Among the questions needing resolution was the puzzle of the unidentified fingerprints that were found on the cartons on the sixth floor of the Texas School Book Depository.

A Violent, Dangerous Man

Based upon the strange patchwork of evidence that included a brown paper package supposedly containing a rifle, the secretive purchase of that rifle under an assumed name, and the mysterious "backyard" photos, the Commission formed the opinion that Oswald was a violent and dangerous individual. Further information surfaced when Marina Oswald testified to the Commission that her husband had perhaps used the Mannlicher-Carcano to shoot at retired army general Edwin A. Walker, an associate of powerful oilman H. L. Hunt. In spite of this testimony, Oswald was never conclusively linked to the shooting. The police had reported that a 30.06 caliber steel-jacketed bullet had come from the gun fired at Walker. This bullet, though, could not have been fired from a Mannlicher-Carcano.

General Walker examined the bullet that was shot into his house and found that it was severely damaged. When he compared it to the bullet that was later used as evidence during the House Assassinations Committee investigation, he stated that it was not the same bullet: The one he had discovered in his house had been so badly mangled that it did not even look like a bullet.

Jesse Curry, in his book, *JFK Assassination File,* published a picture taken of Oswald's possessions. In the shot is a photo of Walker's house with the Chevy parked in the driveway. The license plate is intact. Marina Oswald, when she

Dallas police found a photograph of General Walker's house among Oswald's belongings. When it was given to the Commission for evidence, there was a hole cut in the picture, excising the license plate of the car parked in Walker's driveway. Whose car was this, and what was its connection with Walker? One of Walker's men reported seeing the 1957 Chevrolet (shown in the photo) being driven around the neighborhood a few days before the assassination. The driver was believed to be Cuban or Latin.

first saw the picture, told the Commission that the photo had not originally been cut. How and why was the photo damaged before its submission to the Warren Commission?

Behavior of the Single Bullet

The Commission's mandate was to find a total absence of conspiracy in the assassination of the President. To do this, they needed to prove that one assassin had fired three shots from behind the President's car. Thus, the Commission developed the "lone assassin" and "single bullet" theories. The single bullet theory states that only three shots were fired that day in Dealey Plaza. One shot missed its target, and one struck the President in the head and killed him. One other shot hit the President in the back of the neck, went through his body, exited his throat, continued on to strike Governor Connally by the right armpit, fracturing his fifth rib and collapsing his lung, exiting his chest by the right nipple, entering and exiting his right wrist, and then burying itself in his left thigh. This undamaged "magic" bullet later fell off Governor Connally's stretcher at Parkland Hospital. The validity of the single bullet theory dissolves in the face of the hard physical evidence.

Government testing of the Mannlicher-Carcano rifle alleged to have been used by Lee Oswald proved that the rifle could not be fired twice in less than 2.3 seconds (which did not include time for aiming the gun). The Zapruder film shows both men reacting to being shot three-quarters of a second apart — far too short a time span for separate shots from the Mannlicher-Carcano. Rather than admit to the logical conclusion of a second gunman, the Warren Commission chose to accept the concept of the "magic bullet."

Single Bullet Theory

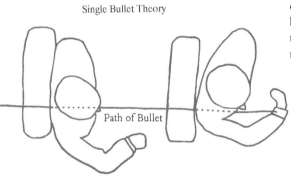

Path of Bullet

The single bullet theory, when depicted in pictures or diagrams, can seem plausible; the effect of angle or trajectory can be easily manipulated or obscured.

Bottom: Arlen Specter holds the tip of the probe against the location of Governor Connally's back wound. In order for the bullet's trajectory to have passed through the President and entered Connally, the President's wound needed to be six inches higher than its actual location, which is shown by the white spot on the jacket, below Specter's hand.

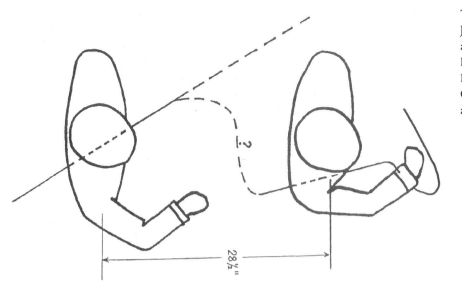

The nature and location of John Connally's wounds as noted (*below right*) by Dr. Robert Shaw of Parkland Hospital, who had attended Connally on the day of the assassination.

Arlen Specter asked the President's autopsist, Dr. Humes, whether the "magic bullet" could have been the same one that was embedded in the Governor's thigh. Humes replied, "I think that extremely unlikely. The reports [from Parkland] tell of an entrance wound on the lower mid-thigh of the Governor, and X-rays taken there are described as showing metallic fragments in the bone, which apparently by this report were not removed from . . . Governor Connally's thigh. I can't conceive of where they came from this missile." Drs. Pierre Finck and J. Thornton Boswell, also present at the autopsy, concurred with this statement.

The notes (*below left*) by autopsist Dr. J. Thornton Boswell show the exact location of Kennedy's back and head wounds. Note the small upward arrow drawn in a right-to-left direction next to the head wound entry point. If the head shot had come from the downward, rear-to-front trajectory and traveled in the direction of the arrow, then it could not have exited on the right side of the head, as the autopsists claimed and as the photographic evidence shows.

One of the Parkland Memorial Hospital doctors who treated Governor Connally stated that the bullet that had injured Connally "behaved as though it had never struck anything but him."

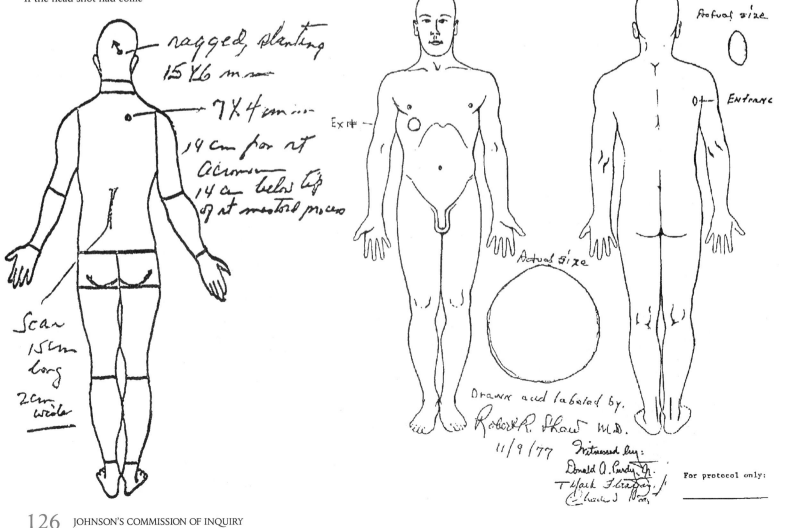

Dr. Milton Helpern, former Chief Medical Examiner of New York City, commented, "The original, pristine weight of this bullet before it was fired was approximately 160–161 grains. The weight of the bullet recovered on the stretcher in Parkland Hospital was reported by the Commission at 158.6. This bullet wasn't distorted in any way. I cannot accept the premise that this bullet thrashed around in all that bony tissue and lost only 1.4 to 2.4 grains of its original weight. I cannot believe either that this bullet is going to emerge miraculously unscathed, without any deformity, and with its lands and grooves intact . . . You must remember that next to bone, the skin offers greater resistance to a bullet in its course through the body than any other kind of tissue . . .

This single bullet theory asks us to believe that this bullet went through seven layers of skin, tough, elastic, resistant skin. In addition . . . this bullet passed through other layers of soft tissue; and then shattered bones! I just can't believe that this bullet had the force to do what the Commission has demanded of it; and I don't think the Commission has really stopped to think out carefully what it has asked of this bullet."

The somewhat oval shape of the wound in Governor Connally's back perhaps indicated that the bullet had started to tumble or move side-to-side before entering the body. An ovoid-shaped wound is typical of those caused by a bullet that has gone through or glanced off an impeding object. However, Connally's back wound was not extremely ovoid, which indicated that the bullet had not struck anything before hitting him. Governor Connally's physician, Dr. Robert Shaw, testified to the Commission that the hole at its longest point was six-tenths of an inch, which matched the hole in the Governor's jacket, which measured .25 by .65 inches. It is more likely that the bullet entered from a nonperpendicular angle.

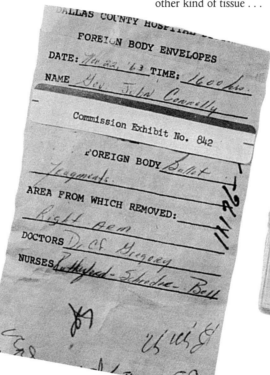

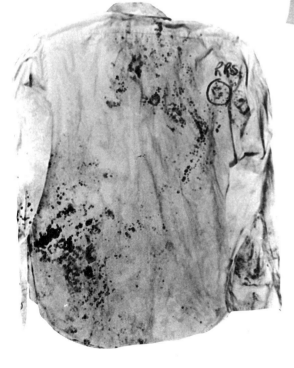

The total estimated weight of the fragments in Governor Connally's wrist (based upon his X-rays), added to the fragments removed from his wrist at the time of the assassination and those that remained in his thigh, is far greater than the weight missing from the single pristine bullet, which is between 160 and 161 grains. This would indicate that at least some of the fragments came from at least one other bullet.

Audrey Bell, an Emergency Room nurse supervisor at Parkland Hospital, said that she had observed and held at least four or five bullet fragments that were extracted from Governor Connally's wrist. She stated, "The smallest was the size of the striking end of a match, and the largest [was] at least twice that big. I have seen the picture of the magic [pristine] bullet, and I can't see how it could be the bullet from which the fragments [that] I saw came."

The inward bend in the lip of the bullet shell (*right*), which was found near the Depository window, was caused by a malfunction of the rifle some time during the shooting. This type of dent would have been caused by an empty shell hitting the front of the gun's receiver after the bolt had been slammed forward. If this had occurred during the firing process, it would not have been possible to fire two shots within anywhere close to the normal 2–3 second minimum firing time of the Mannlicher-Carcano. The time span would be substantially increased.

One of the autopsists, Dr. Pierre Finck, commented on the single bullet theory, saying that it was impossible "for the reason that there are more grains of metal still in Governor Connally's wrist than there are missing from that bullet. That bullet could not have done it."

This test bullet, which was fired into a wrist bone only, exhibits more damage than the pristine bullet, which was supposed to have caused at least seven separate wounds and shattered two dense bones.

This pointed-nosed bullet is the same type that was found in the Parkland Hospital corridor adjacent to a stretcher. All the bullets allegedly used in the assassination had rounded noses, as did the "magic bullet."

The nose and base of a bullet weighing 4.46 grains and 21 grains, respectively, were found in the front seat compartment of the presidential limousine, which indicated a more horizontal flight path. A bullet fired from the sixth floor of the Depository would have landed in the rear seat compartment. These fragments are far too large to have come from the pristine "magic" bullet, Commission Exhibit Number 399.

Fragments of the bullet taken from Governor Connally's wrist. Some are now missing or destroyed by the neutron activation analysis performed as part of the ballistics testing. The Warren Commission believed that the two or three bullet fragments they had in evidence could have come from the pristine bullet, but that this was doubtful because of those fragments' collective weight. FBI Director Hoover, in a secret memorandum directed to the Commission dated July 8, 1964, discussed the spectrographic analysis of the fragments and said that there were only "minor variations" between the fragments. Hoover sought to encourage the Commission's belief in the power of the "magic" bullet, but some Commission members remained skeptical. The presence of any variation in the fragments, no matter how minute, indicated that different bullets probably had been used.

Bullet flight path

11°31'

President

#399 zigs, yaws & zags

Direction of travel

Governor

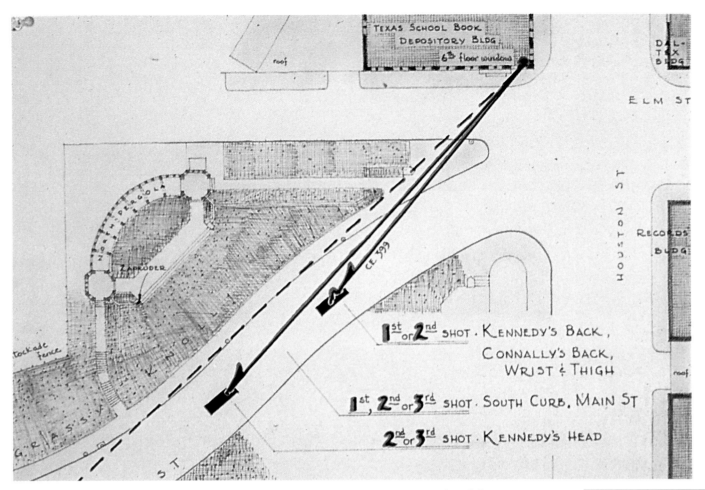

Within the diagram:
TEXAS SCHOOL BOOK DEPOSITORY BLDG
6th floor windows
DAL-TEX BLDG
ELM ST
HOUSTON ST
RECORDS BLDG
roof
PERGOLA
ZAPRUDER
stockade fence
GRASSY KNOLL ST
CE 399

1st or 2nd SHOT · KENNEDY'S BACK,
CONNALLY'S BACK,
WRIST & THIGH

1st 2nd or 3rd SHOT · SOUTH CURB, MAIN ST

2nd or 3rd SHOT · KENNEDY'S HEAD

Above: A diagram of the Warren Commission's final conclusion regarding the trajectories of the three bullets. The first or second shot was considered to be the shot that did all the damage: the "magic bullet" theory. Interestingly, the FBI's "official version" was different: Their theory stated that the first shot struck the President, the second struck Connally, and the third struck the President in the head.

Spectrographic analysis on the bullet fragments was suppressed by FBI Director Hoover and two Attorneys General, Ramsey Clark and John Mitchell. Also hidden were neutron activation analyses by the Atomic Energy Commission.

After all the examination and analysis of the evidence, there were Commission members who could not believe the single bullet theory. Senator Richard Russell reportedly was hesitant about signing a report that touted such a concept; he wished to include a footnote recording his dissent in the final report. Earl Warren vetoed this. Russell, thinking that there probably was a conspiracy involved in the assassination, stated, "We have not been told the truth about Oswald by federal agencies." He was correct.

H S C A
MYSTERIOUS
Death Project

Commission member Congressman Hale Boggs did not believe the single bullet theory and said, "I had strong doubts about it." In a speech in 1971, Boggs accused the FBI of tapping his telephone (as well as other congressmen's telephones) and publicly denounced the Bureau's "gestapo tactics." Boggs disappeared, never again to be found, while on a flight to Alaska.

Portrait of Lee Harvey Oswald

Lee Oswald was born in New Orleans on October 18, 1939, to Marguerite Claverie Oswald. The youngest of three siblings, Lee had an unsettled family life, with no father and a mother who once placed him in an orphanage when he was very young. Throughout Oswald's youth, his mother moved the family to Texas, New York, and back again to New Orleans. Lee grew to be a quiet, intelligent loner, a self-styled intellectual who developed a strong interest in Marxism and the Communist party while a teenager. Also as a teenager, he participated in the New Orleans Civil Air Patrol under David Ferrie, who later had close ties with former FBI and military intelligence agent Guy Banister (a private eye in civilian life) as well as with New Orleans Mafia boss Carlos Marcello.

At seventeen, Oswald joined the Marine Corps. Shortly after applying for a hardship discharge due to the illness of his mother, he defected to the Soviet Union in the fall of 1959. When Oswald returned from the Soviet Union in 1962, he brought with him a Russian-born wife, Marina Prusakova, and the first of their two children. The family settled in the Dallas area, and Oswald went to work later that year as an FBI informant, perhaps slightly disillusioned about his status within the CIA and/or the ONI, or Office of Naval Intelligence

In the summer of 1963, Lee moved to New Orleans, ostensibly to find work, leaving Marina and their child behind. In New Orleans he became active trying to start a local chapter of the Fair Play for Cuba Committee, and renewed his acquaintance with Ferrie and others involved in covert activities. Only a few months later, Marina joined him in New Orleans, where she gave birth to their second child. Shortly thereafter, the family returned to Dallas.

At the time of his death, Lee Oswald, a husband and the father of two, was twenty-four years old.

Above: A teenaged Oswald in the Civil Air Patrol.

Right: Marina Oswald.

When Lee and Marina Oswald settled in Irving, Texas, in 1962 they developed a series of interesting relationships. It has been speculated that the Oswalds' landlady in Irving, Mrs. Ruth Paine, and George DeMohrenschildt (a member of the "White Russian" community in the Dallas area) were involved with the CIA, but this has never been proven. Oswald became closer to Paine and DeMohrenschildt through his young, Russian-born wife; Paine helped him procure a job at the Texas School Book Depository through her neighbor Linnie Randle, whose brother was Buell Wesley Frazier. Frazier drove Oswald to work (with the infamous curtain rods) from Ruth Paine's house (*right*) on the morning of the assassination.

Oswald (*below right*) with an unidentified friend; in Minsk (*below*) with a group of his fellow factory workers; and with Marina (*right*).

THE GARRISON INVESTIGATION

In November 1963, New Orleans District Attorney Jim Garrison learned through a televised report that Lee Harvey Oswald had been in New Orleans for three months prior to the Kennedy assassination. Oswald was keeping company during that time with his former superior officer in the Civil Air Patrol, David W. Ferrie. Ferrie had participated in the 1961 Bay of Pigs invasion, and was still deeply involved with the anti-Castro movement. Oswald and Ferrie's relationship would lead Garrison to prosecute New Orleans businessman Clay L. Shaw as a co-conspirator in the Kennedy assassination.

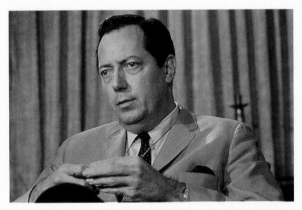

Former New Orleans District Attorney Jim Garrison. Garrison showed Abraham Zapruder's film of the Kennedy assassination to the jurors for the Clay Shaw trial. Never publicly shown before, the film shocked and stunned all those present in the courtroom.

Garrison's investigation initially began and ended with David Ferrie. He brought Ferrie in for questioning on Monday, November 25, 1963, because one of his informants had reported seeing Oswald and Ferrie together. When the results were not conclusive, Garrison turned over the questioning to the FBI, which immediately cleared Ferrie of any involvement in the assassination.

Ferrie died of a supposed brain hemorrhage on February 22, 1967, in his apartment. It was strewn with empty pill containers — one or more of which had contained Proloid, a drug known to cause brain hemorrhage — and two typed, unsigned suicide notes.

Ferrie's autopsy photos later revealed several contusions inside his lower lip, perhaps caused by extreme pressure to the mouth, as if someone had forced him to ingest something. It seemed as if Ferrie, who was the link to the high-level members of the conspiracy, had been silenced before he could break under the strain of Garrison's persistent inquiry.

Two portraits of David Ferrie. Ferrie, an expert pilot, was involved in the CIA's military training of anti-Castro exiles for a second invasion of Cuba.

Garrison's investigation of Ferrie continually turned up the name Clay Bertrand as a business associate of Ferrie's. This man was nowhere to be found until Garrison's investigative team discovered that Clay Bertrand was an alias used by prominent New Orleans businessman Clay L. Shaw. Under this name, Shaw had hired New Orleans attorney Dean Andrews to defend Lee Harvey Oswald soon after Oswald's arrest.

Garrison's case had been stronger against Ferrie, but his only option now was to pursue Clay Shaw. He was unsure of Shaw's connection to the assassination but believed that Shaw was involved, and he brought him in for questioning on Easter Sunday in 1967. Garrison knew that Shaw was lying about not knowing Ferrie and Oswald — too many witnesses had seen them together — as well as about his association with the CIA. Shaw's lies moved Garrison to become more suspicious: What else was he covering up, and why?

A government is a great deal like a human being. It's not necessarily all good, and it's not necessarily all bad. We live in a good country. I love it and you do, too. Nevertheless, the fact still remains that we have a government which is not perfect.

There have been indications since November the 22nd of 1963 — and that was not the last indication — that there is excessive power in some parts of our government. It is plain that the people have not received all of the truth about some of the things which have happened, about some of the assassinations which have occurred — and more particularly about the assassination of John Kennedy.
— Jim Garrison's closing statement at the trial of Clay Shaw

Garrison brought charges of conspiracy against Shaw because he believed that Shaw, a contract agent for the CIA, was using his international connections in the gunrunning market on behalf of local anti-Castro groups.

Shaw was tried but was acquitted with the CIA's intervention. Garrison knew at the time of the trial that there were at least three CIA infiltrators on his investigative staff. It has now been established that no fewer than nine infiltrators and agents-provocateur had sabotaged the prosecution. They leaked evidence to Shaw's defense attorneys and sent bonafide Garrison staff out to follow hundreds of false leads: This effectively depleted the resources of Garrison's understaffed and underfunded investigation.

Clay L. Shaw held a prominent place in New Orleans business and society circles. Under the guise of owning and operating an international importing business, Shaw purportedly used his contacts to procure and run guns for CIA operations.

With a not guilty verdict returned on Shaw, the press — influenced by the CIA's media "propaganda assets" — turned its guns on Garrison to discredit him. The press reported that because Shaw had been cleared of conspiracy charges, no conspiracy existed.

The jurors were convinced that Shaw was guilty of multiple counts of perjury and that Garrison had laid a strong foundation for a conspiracy, but a definitive connection could not be proven.

Jim Garrison's investigation and prosecution of Shaw was a calculated risk, a means to achieve a two-fold end. His purposes were to keep the public awareness of the conspiracy alive and to keep Clay Shaw from getting away with his involvement in it.

Before his death on October 21, 1992, Garrison would see the story of his investigation told in the film *JFK*. Nearly three decades after the Shaw trial, the press would yet again attack his efforts.

The New Orleans Connection

In the summer of 1963, Lee Oswald went to New Orleans without his family, perhaps at the directive of his superiors in the intelligence network. He posed as a pro-Castroite Communist, undertook to start a local chapter of the Fair Play for Cuba Committee (he was the only member), and canvassed for his pro-Castro cause on the streets of New Orleans. This activity, though in keeping with his pro-Castro cover, was a bit puzzling to the FPCC, who wrote in response to Oswald's request for assistance: "It would be hard to conceive of a chapter with as few members as seem to exist in the New Orleans area. [I] have gone through our files and find that Louisiana seems somewhat restricted for Fair Play activities. However, with what is there perhaps you could build a larger group if a few people would undertake the disciplined responsibility of concrete organizational work."[5] While in New Orleans, a gradual picture of Oswald's purported character took shape, an image later used to implicate him as President Kennedy's assassin. He appeared to be a rather unstable loner with violent tendencies—in short, the perfect assassin.

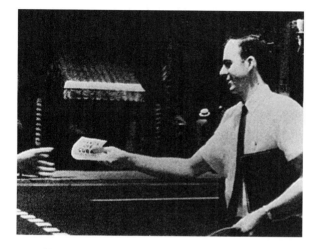

Oswald at work on the New Orleans streets, distributing literature for the FPCC. The circulars were stamped with Oswald's name and the address of the Committee's chapter office on 544 Camp Street, New Orleans. Oswald went under the name of Osborne when he ordered and purchased the FPCC literature (*below*).

5. Dallas Municipal Archives and Records Center, City of Dallas, Texas, 143E.

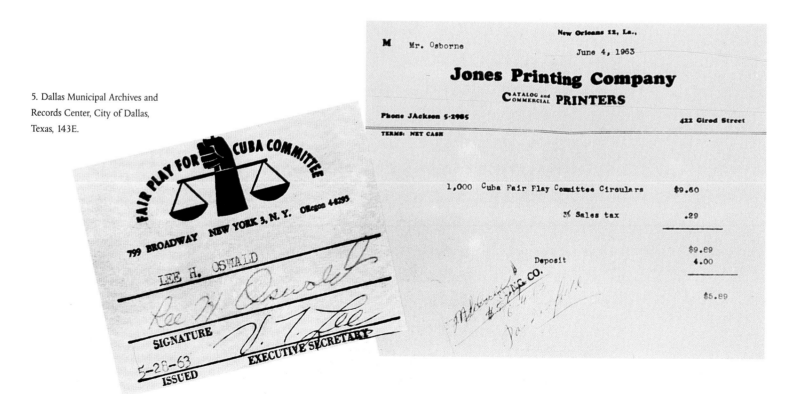

Oswald and Friends

While in New Orleans Oswald connected with David Ferrie and Guy Banister, both active in anti-Castro activities. Oswald's pro-Castro Fair Play for Cuba Committee office on Camp Street was in the same building and on the same floor as Banister's office, though the entrances were around the corner from each other. Guy Banister's offices were the frequent meeting place for anti-Castro exiles who were supported, recruited, and trained in military operations by Ferrie, Banister, and Shaw. Oswald mingled freely with these men and had ample opportunity to observe their activities.

A 1962 mug shot of David Ferrie (*left*), who had a record of prior arrests in New Orleans.

While Lee Harvey Oswald was still in the Soviet Union, FBI Director J. Edgar Hoover wrote a memo, dated June 3, 1960, (*above*) about him stating that, should Oswald return, the Bureau should be careful to make sure of Oswald's true identity. The Director did not want to make the mistake of letting an "imposter" back into the United States. This memo signifies that Hoover was aware of Oswald's existence and activities within the Soviet Union well before the assassination of John Kennedy.

The intelligence community appeared to want Oswald to create a pro-Castro cover story for himself, perhaps to simplify his obtaining a visa to enter Cuba for undercover work. What was really behind this ruse? Perhaps Oswald was acting as a double agent, informing on the CIA to the FBI. The Agency then double-crossed him, positioning Oswald as the crucial missing link between Fidel Castro and the assassination of the President.

The CIA was aware of at least one imposter using the name Lee Harvey Oswald. The photographs of the same man (*right*), posing as Oswald, were taken by the CIA on two separate occasions at the Cuban and Soviet embassies. This man had traveled to Mexico City and made a memorable scene at the Cuban Consulate there. When the House Assassinations Committee conducted its investigation, the Consul testified and recalled the event. When shown a photograph of Oswald on his visa application form, the Consul stated, "This gentleman was not, is not, the person or the individual who went to the Consulate. . . . The man who went to the Consulate was a man over 30 years of age and very, very thin-faced. . . . He was blond, dark blond."

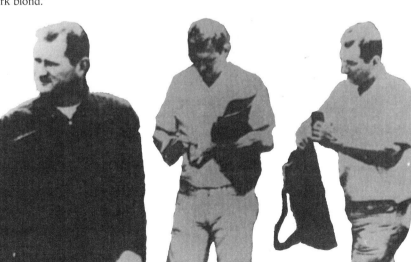

David Ferrie, while serving in the Civil Air Patrol. Oswald knew Ferrie from their days together in the patrol. Through Ferrie, Oswald met Guy Banister, which led to another dangerous and powerful connection with the New Orleans underworld of mobster Carlos Marcello. Ferrie, Banister, and Marcello were involved in the CIA's anti-Castro campaigns, all of which John Kennedy abhorred.

Guy Banister, a former FBI operative, had a close association with David Ferrie. Banister's secretary, Delphine Roberts, claimed to have seen Oswald and Ferrie in Banister's office at 531 Lafayette Street. (The building that housed Oswald's and Banister's offices had two separate entrances, one at 544 Camp Street and one on Lafayette Street.)

Dallas FBI agent **James Hosty** had been assigned by the Bureau to keep tabs on Oswald. It was Hosty who destroyed a warning note that Oswald had hand-delivered to the FBI only days before the assassination. When Oswald was arrested on the afternoon of November 22, he had Hosty's telephone number on a piece of paper in his pocket.

Only hours after the assassination, Clay Bertrand (also known as Clay Shaw) asked New Orleans lawyer **Dean Andrews** to defend Lee Harvey Oswald. Andrews also worked for New Orleans Mafia boss Carlos Marcello.

High-ranking CIA agent **David Atlee Phillips** (*top*) often used the alias Maurice Bishop. Cuban exile leader Antonio Veciana, who knew Phillips, testified to that fact before the House Assassinations Committee. He also stated that Phillips — or Bishop — was involved with Oswald during his stay in New Orleans. The drawing of "Bishop" (*above*) was made for the House Assassinations Committee based upon Veciana's description.

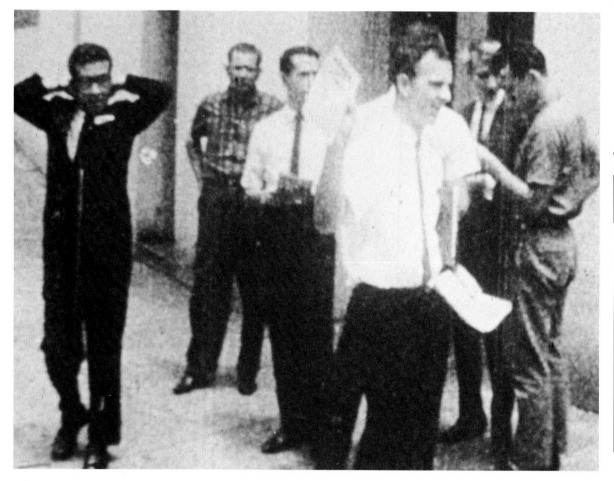

H S C A

MYSTERIOUS
Death Project

Within ten days after the final Warren Commission hearings in 1964, both Guy Banister and his partner, Hugh Ward, suddenly died: Banister was found dead of a gunshot; Ward died while piloting an airplane, which crashed in Mexico.

The Investigation Begins

Jim Garrison, tipped off by informant Jack Martin, brought David Ferrie in for questioning soon after the assassination in Dallas. Martin, a private investigator who worked with Guy Banister, knew Ferrie and had observed the goings-on at the Camp Street offices. He had information that Ferrie had taken a mysterious "hunting" trip to Texas (in the middle of a violent electrical storm) on November 22. Garrison's questioning led to an FBI investigation (of doubtful veracity) that eventually exonerated Ferrie. The case appeared closed for three years until Garrison, as a result of a conversation about the Warren Report with Louisiana Senator Russell Long, reopened his investigation.

Facing a woefully underfunded project, Garrison gladly welcomed volunteer workers to his special investigative team.

Former CIA case officer William Wood volunteered his services to Garrison's investigative team. Wood, who claimed to fully support the aims of the fledgling investigation, had been working as a newspaperman in Austin, Texas, after leaving the agency. After checking his background, Garrison wel-

comed him to his staff, but decided that Wood should use the alias "Boxley." Wood's CIA connection would have been of considerable interest to the news media, which had begun to take notice of Garrison's work on the Kennedy assassination.

Jim Rose, another volunteer, was another former CIA employee who had worked in the Florida anti-Castro guerrilla training camps run by the CIA during the early 1960s. "Boxley" and Rose knew each other, and it was on "Boxley's" recommendation that Garrison accepted Rose's help.

Jim Garrison called one of the President's autopsists, Dr. Pierre Finck, to testify at the Shaw trial. Finck informed the court that some powerful, high-ranking officers had kept him (and the other attending physicians) from performing the autopsy in accordance with proper military procedure. Finck also stated for the court that the bullet that had caused the wound in the President's back did not pass through his body. During the trial, Garrison's team presented evidence proving the single bullet theory invalid.

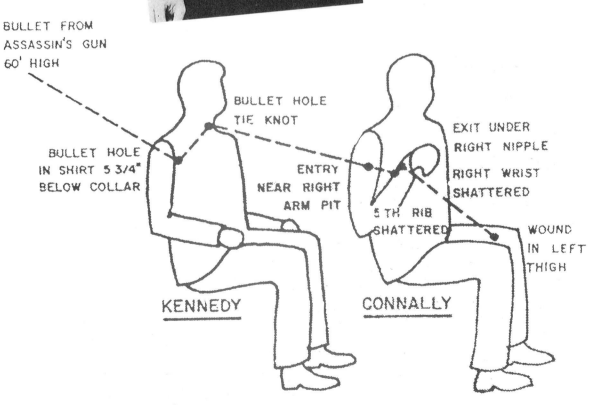

BULLET FROM ASSASSIN'S GUN 60' HIGH

BULLET HOLE TIE KNOT

BULLET HOLE IN SHIRT 5 3/4" BELOW COLLAR

ENTRY NEAR RIGHT ARM PIT

EXIT UNDER RIGHT NIPPLE

RIGHT WRIST SHATTERED

5TH RIB SHATTERED

WOUND IN LEFT THIGH

KENNEDY

CONNALLY

THE REMARKABLE PATH OF THE PRISTINE BULLET ACCORDING TO WARREN COMMISSION

Guy Banister, along with Oswald's other "friends" in the intelligence network, probably could have influenced Oswald to obtain the Mannlicher-Carcano rifle — if he, indeed, did purchase it. The rifle was signed for (in printing) by an A. Hidell, Oswald's known alias, but this "signature" could have been forged.

The Warren Commission had known that Oswald had been trained as an intelligence agent, but suppressed this in its final report. When the House Assassinations Committee later examined Oswald's background, investigators discovered that many of his military service records had vanished.

In 1968, Attorney General Ramsey Clark tried to block Garrison's inquiries into the medical evidence, convening a confidential panel of four doctors who might present information contrary to the autopsists' testimonies. He showed them the alleged

autopsy photos and X-rays. The physicians found, to their amazement, that the President's head wound had "traveled" four inches toward the top of the head from the baseline, where the autopsists had originally observed it.

The day of the assassination, Jack Martin informed the New Orleans police and the FBI that Oswald and Ferrie knew each other and had shared certain activities. This information probably could have been verified in Ferrie's original testimony to the FBI; however, the National Archives later reported that Ferrie's statement, which had been transcribed from the FBI's report for Commission Document Number 205, was missing.

At his trial, Clay Shaw testified that he did not know — and had never met — David Ferrie. These photographs, which show Ferrie and Shaw together at parties, prove that he was lying.

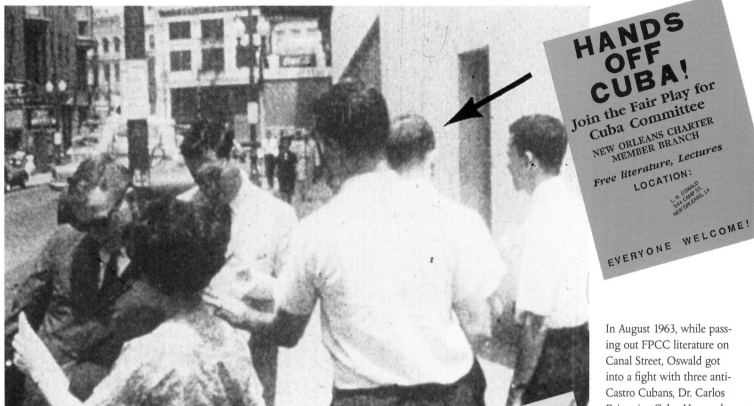

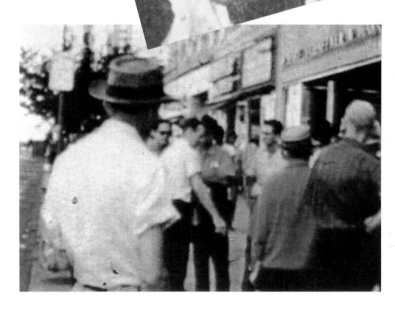

Above: Live film footage, taken by TV station WDSU, New Orleans, shows Clay Shaw, wearing a white suit, walking toward Oswald (indicated by arrow), who is handing out leaflets. Shaw looks over at Oswald, then enters his office building. The arrows in the photo on the right point to Oswald and to the door through which Shaw entered the building. In 1975, I showed this film to Jim Garrison, who declared that he wished he'd had possession of this footage during Shaw's trial. He knew that the man who approached Oswald was undeniably Clay Shaw because of Shaw's distinctive gait, which Garrison described as the "combination of a limp and a swish."

In August 1963, while passing out FPCC literature on Canal Street, Oswald got into a fight with three anti-Castro Cubans, Dr. Carlos Bringuier, Celso Hernandez, and Miguel Cruz. The four were arrested for disturbing the peace and taken to the police station. Oswald asked to see an FBI agent; soon one arrived to question him. Oswald was later released. Could Oswald have identified himself to the agent as an operative, which would have secured his speedy release?

Above: Lee Oswald at the New Orleans police station just after his arrest for brawling with anti-Castro Cuban exiles. Local TV station WDSU was on hand to film his departure from the station.

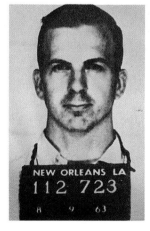

The Trial

Jim Garrison brought Clay Shaw to trial in connection with the President's assassination and was able to show the Zapruder footage for the first time to a stunned court. However, extradition of a key witness was denied; others were mysteriously injured or killed before they could testify, or broke down on the witness stand. Several of Garrison's staff were informers to both the FBI and CIA, and they regularly leaked files and information to the Shaw defense attorneys. Shaw was acquitted, but could have been retried on perjury charges. The jury felt that Shaw was lying on many counts, but a new trial was blocked by the federal authorities.

William Newman, Jr., of Dallas, was the first witness called by Garrison in the Shaw trial. He told of shielding his children with his body during the volley of shots in Dealey Plaza, and of shots from the Knoll.

Former CIA man Victor Marchetti knew that his superior, Director Richard Helms, was worried about Garrison's investigation. Ferrie and Shaw, under contract to the CIA in regard to its Cuban paramilitary operations, were Garrison's prime targets. During a high-level meeting, Helms expressed his concern, saying, "What are we doing in New Orleans to protect our man Shaw?"

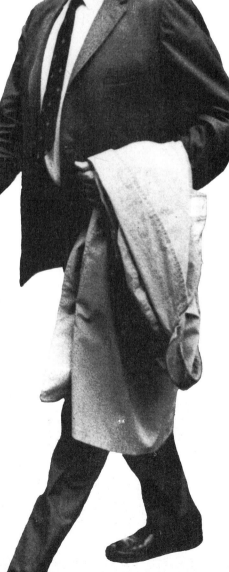

Above: Clay L. Shaw

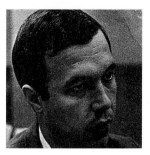

Vernon Bundy testified for the state of Louisiana in the Clay Shaw trial. He stated that he had seen Clay Shaw conversing with Lee Harvey Oswald on the New Orleans lakefront during the summer of 1963. Bundy, a heroin addict, had been giving himself a "fix" at the time he had seen the two men.

Perry Russo, an acquaintance of David Ferrie's, testified that in September 1963, while he was at a gathering in Ferrie's apartment, he overheard Clay Shaw discussing the Kennedy assassination plot.

During the investigation and before the trial, Philadelphia attorney Vincent Salandria, who was a vocal opponent of the Warren Commission's single bullet theory, came to Garrison's office to observe the investigative proceedings. When Salandria arrived, Bill Boxley (see page 139) was in the middle of relating information about some evidence he had discovered during a recent trip to Dallas. When the meeting broke up, Salandria asked Garrison if he could review Boxley's notes and memoranda on the investigation. After doing so, Salandria told Garrison, "I'm afraid your friend, Bill Boxley, works for the federal government." Garrison later wrote: "Boxley's memos and summaries, each impressive in its own right, did not add up when evaluated as a whole. It was embarrassingly apparent that Boxley's material had been designed, first, to intrigue me and, second, to lead nowhere at all."[6]

6. James Garrison: *On the Trail of the Assassin.*

HSCA
MYSTERIOUS Death Project

The circumstances of Clay Shaw's death on August 14, 1974, were extremely odd. One of Shaw's neighbors witnessed some (unidentified) men carrying a stretcher, which held a sheet-covered body, into Shaw's carriage house, through the front door. The neighbor, thinking this an unusual sight, called the coroner, who immediately dispatched investigators to Shaw's home. When they arrived, the men — and the body — had vanished. Further inquiries one day later revealed that Shaw already had been buried in his home town of Kentwood.

H S C A
MYSTERIOUS
Death Project

Robert Perrin was married to Nancy Perrin Rich, who was an employee of Jack Ruby. After Perrin died by arsenic poisoning, Mrs. Perrin stated that her boss, Jack Ruby, had been involved in the smuggling of arms to anti-Castro Cuban exiles.

H S C A
MYSTERIOUS
Death Project

Dr. Nicholas Chetta, New Orleans coroner, died of an alleged heart attack in May 1968. Chetta was to have been one of Jim Garrison's key witnesses in the Shaw trial. He had been present at the autopsies of David Ferrie and Robert Perrin, two of Garrison's key witnesses in the trial.

The long-suppressed Zapruder film was shown publicly for the first time at the Shaw trial. The public at large would not have the opportunity to see this footage for six more years.

The oddity of the well-groomed tramps (*left*) went virtually unnoticed with respect to the Kennedy case until an assassination researcher brought them to Jim Garrison's attention.

In the mid-1970s, other researchers tried to identify the men, who, according to the Dallas arrest records, were identified as Gus Abrams, Harold Doyle, and John Gedney. There are those who conjecture that the tallest "tramp" could be convicted killer Charles Harrelson or former CIA agent Frank Sturgis. Some say that the older, shortest man is Watergate burglar E. Howard Hunt. The third man is reputed to be an individual, nicknamed "Frenchy," who is the mirror image of the face on the original wanted poster for "Eric Starvo Galt," the name of the original suspect in the murder of Dr. Martin Luther King, Jr. This photo of the tramps in Dealey Plaza is typical of the seven photos taken of the men: In all but two of the photos, the shortest "tramp" is obscured from the camera's eye, as if he is trying to hide himself.

H S C A
MYSTERIOUS
Death Project

Garrison secured Dealey Plaza witness Richard Carr to testify at the Shaw trial. The day before his testimony, Carr found dynamite wired to the ignition of his car; however, he did testify. Since the assassination, Carr had received numerous threats and suffered attacks on his life (he shot and killed one of his attackers). Carr was stabbed to death in Atlanta in the 1970s.

CLASSIFICATION

PROCESSING ACTION

MARKED FOR INDEXING

X NO INDEXING REQUIRED

ONLY QUALIFIED DESK
CAN JUDGE INDEXING

MICROFILM

Chiefs, Certain Stations and Bases

Document Number 1035-960

for FOIA Review on SEP 1976

2 Countering Criticism of the Warren Report

IN REQUIRED . REFERENCES

CONTINUATION OF
DISPATCH

a. To discuss the publicity problem with liaison and friendly elite contacts (especially politicians and editors), pointing out that the Warren Commission made as thorough an investigation as humanly possible; that the charges of the critics are without serious foundation, and that further speculative discussion only plays into the hands of the opposition. Point out also that parts of the conspiracy talk appear to be deliberately generated by Communist propagandists. Urge them to use their influence to discourage unfounded and irresponsible speculation.

b. To employ propaganda assets to answer and refute the attacks of the critics. Book reviews and feature articles are particularly appropriate for this purpose. The unclassified attachments to this guidance should provide useful background material for passage to assets. Our play should point out, as applicable, that the critics are (i) wedded to theories adopted before the evidence was in, (ii) politically interested, (iii) financially interested, (iv) hasty and inaccurate in their research, or (v) infatuated with their own theories. In the course of discussions of the whole phenomenon of criticism, a useful strategy may be to single out Epstein's theory for attack, using the attached Fletcher Knebel article and Spectator piece for background. (Although Mark Lane's book is much less convincing than Epstein's and comes off badly where contested by knowledgeable critics, it is also much more difficult to answer as a whole, as one becomes lost in a morass of unrelated details.)

4. In private or media discussion not directed at any particular writer, or attacking publications which may be yet forthcoming, the following arguments should be useful:

a. No significant new evidence has emerged which the Commission did not consider. The assassination is sometimes compared (e.g., by Joachim Joesten and Bertrand Russell) with the Dreyfus case; however, unlike that case, the attacks on the Warren Commission have produced no new evidence, no new culprits have been convincingly identified, and there is no agreement among the critics. (A better parallel, though an imperfect one, might be with the Reichstag fire of 1933, which some competent historians (Fritz Tobias, A.J.P. Taylor, D.C. Watt) now believe was set by Van der Lubbe on his own initiative, without acting for either Nazis or Communists; the Nazis tried to pin the blame on the Communists, but the latter have been much more successful in convincing the world that the Nazis were to blame.)

 overvalue particular items and ignore others. They tend

SABOTAGE AND SUBTERFUGE

Opposite: The actual text of the influential CIA document Number 1035-960, which gives a four-page outline for the manipulation of the press — an activity that the Agency commonly refers to as making use of their "propaganda assets." Other significant passages include: "From the day of President Kennedy's assassination on, there has been speculation about the responsibility for his murder. Although this was stemmed for a time by the Warren Commission Report . . . there has been a new wave of books and articles criticizing the Commission's findings. . . . We do not recommend that discussion of the assassination question be initiated where it is not already taking place. Where discussion is active, [business] addresses are requested . . . to employ propaganda assets to [negate] and refute the attacks of the critics. Book reviews and feature articles are particularly appropriate to this purpose. . . ."

"IN RECENT YEARS . . . forces have developed in our government over which there is no control and these forces have an authoritarian approach to justice — meaning, they will let you know what justice is." — Jim Garrison, from the closing statement at the trial of Clay Shaw.

After the Garrison debacle in 1969, the news media came down hard on him and other critics of the Warren Report. The tandem topics of assassination and conspiracy were unpopular subjects in the press, and no one would report on the JFK killing (or the possibility of conspiracy in the murders of Martin Luther King and Robert Kennedy in 1968; Robert Kennedy's murder has never been examined in a federal investigation), other than to oppose current criticism of the Warren Commission investigation. The CIA network reinforced this silence and protected the Commission's findings by cultivating a carefully detailed policy outlining the use of media "propaganda assets to negate or refute" critical

John Kennedy with Dr. Martin Luther King, Jr. Both men strongly opposed U.S. involvement in Vietnam, arousing anger within the highest echelons of the military-industrial-intelligence complex.

discussions of the Kennedy assassination (see CIA document #1035-960 on page 144).

With the advent of the Nixon presidency, a wave of civil unrest gathered force in conjunction with U.S. involvement in Vietnam, a situation that John Kennedy had sought to diffuse. Amid these tensions, any proposed investigation into the deaths of John Kennedy, Martin Luther King, and Robert Kennedy foundered.

America suddenly woke up to a harsh reality with the breaking of the Watergate scandal in 1973 and President Nixon's eventual resignation the following year. Conspiracies created and sanctioned by the government could — and did — exist.

Beginning in 1969, I had been secretly working for five years on enhancing the Zapruder film of the JFK assassination. I had shared my work with a small handful of assassination researchers, but I was afraid of making this research public information. That all changed in early 1975.

The Assassination Information Bureau (AIB), a Boston-based group dedicated to increasing public awareness of the Kennedy assassination conspiracy, held a symposium in February on "The Politics of Conspiracy." I presented my optical enhancement of Zapruder's film at the press conference that opened the symposium, and the news media picked up the story.

Social activist Dick Gregory attended the symposium and suggested we collaborate on bringing the film to a wider audience. With the additional help of Robert Saltzman, a fellow assassination researcher, we held a

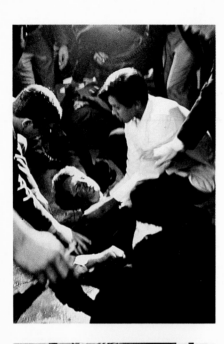

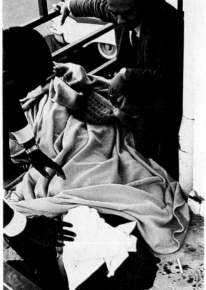

The tragic aftermath left by two other assassins: the deaths of Robert Kennedy and Martin Luther King, Jr. There is a body of evidence that suggests conspiracies were behind both of these killings as well.

April 4, 1968
Dr. Martin Luther King, Jr., is assassinated at the Lorraine Motel in Memphis, Tennessee.

June 4, 1968
Senator Robert F. Kennedy is fatally shot in the back of the head at a Los Angeles hotel shortly after winning the California primary election. His alleged assassin, Sirhan Sirhan, fired upon Kennedy only from the front.

August 29, 1968
Outside the National Democratic Convention in Chicago, more than 100 anti-war demonstrators (including elderly persons, children, and reporters) are punched, beaten, gassed, and maced by Mayor Richard Daley's riot police.

November 30, 1969
Reports are made public of a massacre in the village of My Lai in South Vietnam. Under the orders of Lt. William Calley, more than 500 unarmed men, women, and children were slaughtered within 15 minutes on March 16, 1968.

May 18, 1970
At Ohio's Kent State University, National Guardsmen fire into a crowd of students protesting the Vietnam War, killing four and wounding eight others.

May 15, 1972
Presidential candidate George Wallace is seriously wounded in an assassination attempt while campaigning in Laurel, Maryland.

June 17, 1972
Five men, including E. Howard Hunt and Frank Sturgis, break into the Democratic National Committee headquarters on the sixth floor of the Watergate Hotel in Washington, D.C.

November 7, 1972
Richard Nixon is elected to a second term as President of the United States.

March 29, 1973
The U.S. ends its involvement in Vietnam, after more than 58,000 American lives were lost and $220 billion spent.

October 10–12, 1973
Nixon's Vice President Spiro Agnew resigns under charges of tax evasion. (Agnew was disbarred in Maryland on May 2, 1974.) Two days later, Nixon appoints former Warren Commission member Gerald Ford as his Vice President.

March 15, 1974
A federal grand jury concludes that President Nixon was a co-conspirator in the Watergate break-in and cover-up. In April, Nixon is ordered to submit more than $500,000 in unpaid back income taxes. Less than one year later, Nixon aides Bob Haldeman and John Erlichman and former U.S. Attorney General John Mitchell are sentenced to prison for their involvement in the Watergate break-in.

August 8, 1974
Rather than face his impending impeachment, Richard Nixon resigns the presidency. One month later, President Ford grants Nixon a full pardon.

January 15, 1975
President Ford creates the Rockefeller Commission to investigate the illegal domestic intelligence activities of the CIA, appointing Vice President Nelson Rockefeller as Chairman and former Warren Commission assistant counsel David Belin as Director.

November 20, 1975
A Senate Select Committee reveals publicly that the CIA had plotted the assassinations of at least five foreign leaders.

press conference in Chicago on February 3, 1973.

We hoped to present this enhancement to the Rockefeller Commission as possible evidence of the government's involvement in the Kennedy killing. The initial presentation was made to the Commission's Executive Director, David Belin, in Washington, D.C., on February 4, 1975. Before we began, government agents came into the room, went to the window, and covered it with a heavy steel shutter. They locked it and left. A minute later, Belin walked into the room.

As I ran the film, Belin sat straight up in his seat. When the film reached the moment of the shot to Kennedy's head, he jumped up and shouted, "Neurospasm, neurospasm!"

Belin then showed me an unsolicited letter he had received from a physician, submitted as evidence to the Commission. The letter made the hypothesis that a neuromuscular reaction, or neurospasm, might have been the reason that the President was pushed rearward in his seat. Although the characteristic stiffening of a body in the grip of a neurospasm was not present in the President (as corroborated on film), Belin was desperately grasping at this new straw. To believe this theory would be to discount the lethal frontal shot to the President's head — and the presence of more than one assassin.

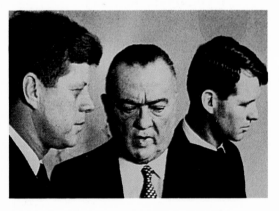

FBI Director J. Edgar Hoover was a formidable opponent within the Kennedy administration. Upon taking office, the President did not make a new appointment to head the Bureau, but his longer-term plans included Hoover's eventual resignation.

I was asked back a few weeks later to present formal testimony to the Commission. I agreed, with the stipulation that I would be able to review the transcript of my testimony for accuracy before it was placed in evidence. The Commission assented, but I was never permitted to review the transcript. State-

ments were attributed to me that I had never made, and critical portions of my testimony had been severely altered and their meaning distorted.

Another result of the February 3 press conference was my appearance and the airing of the Zapruder film on Geraldo Rivera's "Goodnight America" on March 6. Public reaction was climactic — with outrage. The millions of viewers who had seen the telecast, including a great many members of Congress and their families, wanted to know why they had been denied access to the Zapruder film for the last 11 years.

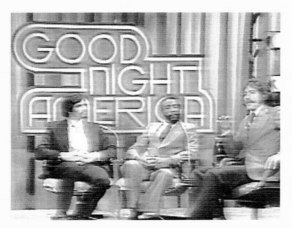

The historic segment of "Goodnight America," which included the first publicly televised showing of Zapruder's film. From left, myself, Dick Gregory, and Geraldo Rivera.

I was invited to present my photographic evidence in March at the University of Virginia by a group of students who had seen the telecast. Some were the sons and daughters of members of the Virginia congressional delegation. The delegation then asked me to present my evidence for them in the U.S. House of Representatives, which I did on April 15. A few days later, Congressman Thomas N. Downing introduced a resolution to reopen the investigation of the Kennedy assassination.

The Road to Watergate

Richard Nixon was no stranger to the clandestine workings of U.S. intelligence operations. Newly graduated from Duke University in 1939, he applied to the FBI for a position as a special agent, but was rejected. However, as Vice President under Eisenhower, Nixon was chair of "Special Group 54-12," which coordinated the actions of the CIA and military intelligence. Nixon also served as the CIA's White House action officer for the Bay of Pigs invasion, run by CIA operative E. Howard Hunt. This familiarity with the "invisible" (intelligence) aspect of government led Nixon toward the Watergate incident, which caused his eventual downfall. In the face of Nixon's resignation from office, the public's trust in government deteriorated and Gerald Ford (who was *appointed* as Vice President by Nixon) assumed the presidency. Ford promptly pardoned his predecessor.

The notorious White House taped conversations helped hasten Richard Nixon's downfall. One of the most damning (dated June 23, 1972) includes the following comments from the former President:

". . . this Hunt, that will uncover a lot of things. You open that scab, there's a hell of a lot of things. . . . This involves these Cubans, Hunt, and lot of hanky-panky. . . . Just say [tape unintelligible] . . . very bad to have this fellow Hunt, ah, he knows too damned much, if he was involved. . . . If it gets out that this is all involved, the Cuba thing, it would be a fiasco. It would make the CIA look bad, it's going to make Hunt look bad, and it is likely to blow the whole Bay of Pigs thing which we think would be very unfortunate — both for the CIA and for the country. . . ."

Nixon resigned within days after this tape was discovered and brought to light in August 1974.

Three of the notorious "Watergate Seven"— Virgilio Gonzalez (left), Frank Sturgis (second from right), and Eugenio Martinez (right)—with attorney Henry Rothblatt and Bernard Barker. Gonzalez, Sturgis, and Martinez were accused of bugging the headquarters of the Democratic National Committee in June 1972.

The probability that Nixon and his henchmen would be prosecuted for their involvement in the Watergate break-in became more of a reality by March 1973. Nixon knew he would have to select a special prosecutor for the hearings. Charles Colson, who had been involved in the activities of the Committee to Re-elect the President (CREEP), tried to persuade J. Lee Rankin, former chief counsel for the Warren Commission, to take the position.

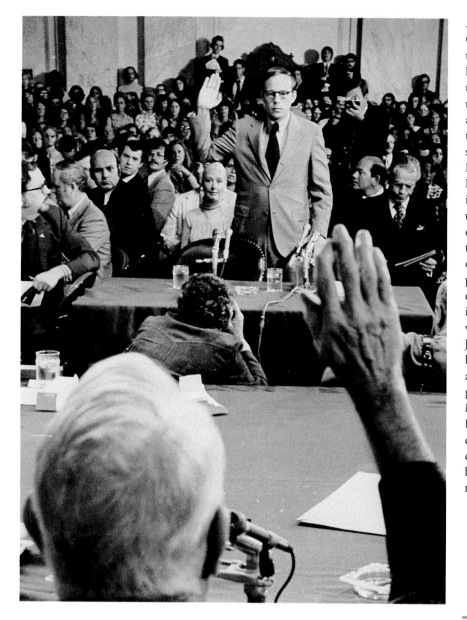

John Dean (*right*), who served as legal counsel to President Richard Nixon, related solid evidence of Nixon's misconduct while in office. These revelations contributed to the demise of the Nixon presidency.

After Howard Hunt quit the CIA and went to work for the Nixon administration, he kept up his close association with the Agency and its resources, using them to the advantage of the administration. When Hunt (who sometimes used the alias Edward Hamilton, as did Frank Sturgis) became involved in CREEP, he naturally used his power and connections within the intelligence network on behalf of the presidential campaign. After a crucial strategy meeting in March 1972 in Key Biscayne, Florida (at which Attorney General John Mitchell agreed to keep the Democratic party's activities under watch), the group decided to use the Miami Beach Fontainebleau Hotel as their home base during the Democratic convention. Rooms were booked there under the name of Edward Hamilton.

Senator Sam Ervin, Chairman of the Watergate hearings.

Dr. Daniel Ellsberg (*above*) made public the infamous (and classified) Pentagon Papers, which revealed the government's well-kept secrets about the war in Vietnam.

The day the Watergate burglars were captured, Frank Sturgis had in his possession a complete complement of fake identification papers, which included a Mexican visa in the name of Edward Hamilton. On that same night in Miami a man showed up at the Fontainebleau Hotel wanting to change the name on the room reservations that had been reserved for Edward Hamilton.

H S C A

MYSTERIOUS
Death Project

Dorothy Hunt, wife of Watergate burglar E. Howard Hunt, died in an airplane crash near Chicago. Research that has been conducted on the events of the Watergate break-in indicates that Mrs. Hunt intended to reveal sensitive information about the burglary plot. When she died, she was alleged to have had incriminating documents and a large sum of money in her possession.

The Appearance of Inquiry

Gerald Ford appointed his own vice president, Nelson Rockefeller, to head the Rockefeller Commission's investigation of domestic intelligence activities. This Commission was created to quiet the rumors of CIA conspiracy and to give the appearance that Ford's administration was looking into the rumors of illegal activities on the part of the CIA and other governmental intelligence agencies.

At a White House luncheon with editors of *The New York Times,* President Ford told them he had chosen the Rockefeller Commission members very carefully because, he said, "there was danger that the Commission would trip over matters a lot more sensitive than domestic surveillance." "Which matters?" asked *Times* editors. "Off the record, like assassinations," replied Ford.[7]

Former Warren Commission assistant counsel David Belin was appointed as executive director of the Rockefeller Commission by his old friend and associate Gerald Ford. Belin, in earlier years, had served as chairman for the campaign organization Lawyers for Nixon-Agnew. Ironically, this new assignment for the Rockefeller Commission required that Belin investigate charges against Nixon's intimate associates.

Under the umbrella of the Senate Select Committee on Intelligence Activities, chaired by Senator Frank Church (*bottom right*), the 1975 Schweiker-Hart Subcommittee was responsible for one of the most straightforward investigations into the murder of President Kennedy. Senators Richard Schweiker (*bottom left*) and Gary Hart hired independent investigators to work on the case and kept the investigation's activities out of the press. When the final report was released on June 23, 1976, it stated that the Subcommittee had experienced substantial interference by U.S. intelligence agencies and the administration during its investigation. The report also reflected the Subcommittee's belief that a conspiracy to kill the President had existed.

ROCKY AND HIS FRIENDS

It seemed like old home week, with Warren Commission alumni Ford and Belin investigating themselves for the Rockefeller Commission.

7. Robert Groden: "The Rockefeller Commission: The Second JFK Whitewash," *Argosy,* October 1977.

During the House Assassinations Committee investigation, strange interconnections of the conspiracy began to surface. One story was about Marita Lorenz, a former CIA operative, who claimed she had traveled by car to Dallas with Lee Harvey Oswald, Frank Sturgis, and Cuban exiles Orlando Bosch and Pedro Diaz Lanz, and that they had taken rifles with telescopes on the trip. Apparently, these men were part of a group called Operation 40, a guerrilla group formed by the CIA in the 1960s as part of the preparations for the Bay of Pigs invasion. Oswald, according to Lorenz, had visited a Cuban training camp in the Florida Everglades; Lorenz had also seen him at a pre-trip meeting in the home of Orlando Bosch.

Lorenz said Operation 40 was considered an "assassination squad," made up of anti-Castro Cubans and their American supporters. She said the group's activities included plans to assassinate Fidel Castro and President Kennedy, whom they blamed for the failed Bay of Pigs operation.

Marita Lorenz had lived with Fidel Castro (*right*) in Havana in 1959, when Frank Fiorini (also known as Frank Sturgis) met and recruited her for the CIA. Lorenz said she later escaped from Cuba, but was sent back on two separate missions, one of which was to steal certain documents from Castro's quarters in the Havana Hilton; her second assignment was to kill him. When Lorenz made the story of the Dallas trip public, Frank Sturgis told reporters that as far as he could recollect, he had never met Lee Harvey Oswald.

In the mid-1970s, shortly after the news of the Dallas trip had appeared in the press, Sturgis paid a visit to Lorenz (apparently to threaten her) and was subsequently arrested in her apartment building.

Frank Fiorini, aka Sturgis, in Cuba. At this time Fidel Castro and Che Guevara were posing a serious threat to the Batista regime.

This letter attributed to Lee Harvey Oswald was addressed only to a "Mr. Hunt." It is unknown whether the addressee was CIA man E. Howard Hunt or Dallas industrialist H. L. Hunt.

Nov. 8, 1963

Dear Mr Hunt,
I would like information concerning my position I am asking only for information I am suggesting that we discuss the matter fully before any steps are taken by me or anyone else
Thank You
Lee Harvey Oswald

The Miami Tape

The morning of Saturday, November 9, 1963, right-wing union organizer Willie Somersett was preparing for a breakfast meeting with his old friend Joseph Milteer. Milteer showed up early for the appointment, while Somersett was engaged in setting up the tape machine that would record their meeting. The two men then discussed John Kennedy's campaign visit to Miami, which was scheduled for the following week. Milteer, who abhorred John Kennedy and his liberal policies, spoke freely of his hatred for the President, not realizing that the conversation was being taped. Somersett, an undercover informant for the Miami police and the FBI, turned in the tape to the Miami Police Department the following day.

Joseph A. Milteer (*top*) and Willie A Somersett.

After Miami Police Chief Walter Headley and Detective Sargeant Sapp listened to the tape of the Milteer-Somersett meeting, they alerted the Secret Service (as did the FBI, who received the information directly from Somersett), who had been planning a presidential motorcade for the President's visit to Miami on November 18. The motorcade plan was canceled.

Somersett: . . . I think Kennedy is coming here on the 18th . . . to make some kind of speech . . . I imagine it will be on TV.
Milteer: You can bet your bottom dollar he is going to have a lot to say about the Cubans. There are so many of them here.
Somersett: Yeah, well, he will have a thousand bodyguards. Don't worry about that.
Milteer: The more bodyguards he has, the easier it is to get him.
Somersett: What?
Milteer: The more bodyguards he has the more easier it is to get him.
Somersett: Well, how in the hell do you figure would be the best way to get him?
Milteer: From an office building with a high-powered rifle. How many people does he have going around who look just like him? Do you know about that?
Somersett: No, I never heard he had anybody.
Milteer: He has about fifteen. Whenever he goes anyplace, he knows he is a marked man.
Somersett: You think he knows he is a marked man?
Milteer: Sure he does.
Somersett: They are really going to try to kill him?
Milteer: Oh, yeah, it is in the works. . . .
Somersett: . . . Hitting this Kennedy is going to be a hard proposition, I tell you. I believe you may have figured out a way to get him, the office building and all that. I don't know

how the Secret Service agents cover all them office buildings everywhere he is going. Do you know whether they do that or not?
Milteer: Well, if they have any suspicion they do that, of course. But without suspicion, chances are that they wouldn't. You take there in Washington. This is the wrong time of the year, but in pleasant weather, he comes out on the veranda and somebody could be in a hotel room across the way and pick him off just like that.
Somersett: Is that right?
Milteer: Sure, disassemble a gun. You don't have to take a gun up there, you can take it up in pieces. All those guns come knock down. You can take them apart. . . . Well, we are going to have to get nasty . . .
Somersett: Yeah, get nasty.
Milteer: We have got to be ready, we have got to be sitting on go, too.
Somersett: Yeah, that is right.
Milteer: There ain't any countdown to it, we have just got to be sitting on go. Countdown, they can move in on you, and on go they can't. Countdown is all right for a slow prepared operation. But in an emergency operation, you have got to be sitting on go.
Somersett: Boy, if that Kennedy gets shot, we have got to know where we are at. Because you know that will be a real shake . . .
Milteer: They wouldn't leave any stone unturned there. No way. They will pick up somebody within hours afterwards, if anything like that would happen, just to throw the public off.
Somersett: Oh, somebody is going to have to go to jail, if he gets killed.
Milteer: Just like Bruno Hauptmann in the Lindbergh case, you know.[8]

Joseph Milteer and Willie Somersett held their next meeting in Jacksonville, Florida, on November 23, 1963. When Somersett returned to Miami, he dutifully reported back to the Miami police. He told them that Milteer had admitted his connection with an international underground organization, which was building a propaganda campaign to blame Zionist Jews for the murder of the President. Somersett revealed that Milteer was enthusiastic about this plan and pleased with the success of the assassination plot. Somersett told the police that "he [Milteer] was very happy about it and shook hands with me. He said, 'Well, I told you so. It happened like I told you, didn't it? It happened from a window with a high-powered rifle. . . . That is the way it was supposed to be done, and that is the way it was done.'"

8. Robert Groden: "The JFK Evidence that Nobody Wanted to Reveal," *Argosy,* August 1977: 131.

The Milteer File

As part of its watch on the radical right, the FBI kept surveillance of Joseph Adams Milteer. Two weeks before the assassination, Milteer probably knew of a plan within the "patriot underground" to eliminate John Kennedy. The FBI, though now aware of Milteer's dangerous knowledge of a possible assassination plot, merely updated its Milteer file on November 10, 1963, noting that "Milteer reportedly said . . . the job could be done from an office . . . using a high-powered rifle. The U.S. Secret Service was advised of the foregoing information."

MM 89-35
FPG:ggr/da
1

Re: Threat to Kill President
KENNEDY by J. A. MILTEER,
November 9, 1963

On November 10, 1963, a source who has furnished reliable information in the past and in addition has furnished some information that could not be verified or corroborated, advised SA LEONARD C. PETERSON that J. A. MILTEER on November 9, 1963, at Miami, Florida, made a statement that plans were i the making to kill President JOHN F. KENNEDY at some future date; that MILTEER suggested one JACK BROWN of Chattanooga, Tennessee, as the man who could do the job and that he (MILTEER) would be willing to help. MILTEER reportedly said that he was familiar with Washington and that the job could be done from an office or hotel in the vicinity of the White House using a high-powered rifle.

U. S. Secret Service was advised of the foregoing information.

119

URGENT 1:45 AM EST 11-17-63 HLF

TO ALL SACS

FROM DIRECTOR 1 PAGE

THREAT TO ASSISINATE PRESIDENT KENNEDY IN DALLAS TEXAS NOVEMBER TWENTYTWO DASH TWENTYTHREE NINETEEN SIXTYTHREE. MISC INFORMATION CONCERNING.

INFO HAS BEEN RECEIVED BY THE BUREAU BUREAU HAS DIXGXXXXXXIXXXXXXXXX DETERMINED THAT A MILITANT REVOLUTIONARY GROUP MAY ATTEMPT TO ASSINATED PRESIDENT KENNEDY ON HIS PROPOSED TRIP TO DALLAS TEXAS XXXXXXXXXX NOVEMBER TWENTYTWO DASH TWENTYTHREE NINETEEN SICTYTHREE.

ALL RECEIVING OFFICE SHOULS IMMIDIATELY CONTACT ALL CI'S; PGIS LOGICAL RACIAL AND HATE GROPUP INFORMANTS AND DETERMINE IF ANY BASIS FOR THREAT. BHRGEU SHOULS BE KEPT ADVISED OF ALL DEVELOPEMENTS BY TELETYPE. SUBMI Y FD THREE ZERO TWOS AND LHM OTHER HOFFICE HAVE BEEN ADVISED

END AND ACK PLS

MO.....

DL.....

NO.....

MT TI TU CLR..@

MM 89-35
2.

Birmingham, Alabama, which occurred on September 15, 1963. Regarding SHELTON, MILTEER said SHELTON was against violence and could not be depended upon.

A characterization of the United Klans of America, Inc., Knights of the Ku Klux Klan (United Klans), follows. Sources therein have furnished reliable information in the past.

MILTEER related that MARTIN LUTHER KING and Attorney General ROBERT KENNEDY are now unimportant. He stated their next move would be against the "Big Jew" noting that there is a communist conspiracy by the Jews to overthrow the United States government.

MILTEER arrived in Columbia, South Carolina, about midnight and registered at the Wade Hampton Hotel, Columbia, South Carolina. On the morning of November 24, 1963, MILTEER advised that they did not have to worry about LEE HARVEY OSWALD getting caught because he "doesn't know anything" and that the "right wing" is in the clear. MILTEER further related that, "The patriots have outsmarted the communists and had infiltrated the communist group in order that they (communists) could carry out the plan without the right wingers becoming involved."

Later, on the morning of November 24, 1963, four individuals arrived at the Wade Hampton Hotel and conferred with MILTEER. These individuals included BELTON MIMS and A. O. BOLEN, members of the Association of South Caroling Klans; JACK HENDRICKS described as a white male, 35, 5' 7", from Denmark, South Carolina, and WILL ULMER, from Orangeburg, South Carolina. ULMER, was described as a white male, 35, 155 pounds, yellow complexion, large eyes.

121

This telex (*left*) was sent via AIRTEL to Special Agents-in-Charge (SACs) in FBI offices throughout the nation. Agent William Walter made the copy of it (reproduced here). The original memo has disappeared from the FBI's files.

MM 89-35
1.

Re: THREAT TO KILL PRESIDENT KENNEDY
BY J. A. MILTEER, MIAMI, FLORIDA,
NOVEMBER 9, 1963

On November 10, 1963, a source who has furnished
reliable information in the past and in addition has
furnished some information that could not be verified or
corroborated, advised SA PETERSON as follows:

On November 23, 1963, J. A. MILTEER was in the
Union Train Station, Jacksonville, Florida, and at about
4:25 p.m. on that date stated he was very jubilant over the
death of President KENNEDY. MILTEER stated, "Everything rant
true to form. I guess you thought I was kidding you when I
said he would be killed from a window with a high-powered
rifle." When questioned as to whether he was guessing when he
originally made the threat regarding President KENNEDY,
MILTEER is quoted as saying, "I don't do any guessing.

On the evening of November 23, 19563, MILTEER
departed Jacksonville, Florida, by automobile en route to
Columbia. South Carolina. During this trip, MILTEER stated
that he had been in Houston, Ft. Worth, and Dallas, Texas,
as well as New Orleans, Louisiana, Biloxi and Jackson,
Mississippi, and Tuscaloosa, Alabama. MILTEER said he was
acquainted with one R. E. DAVIS of Dallas, Texas, whom he
described as a "good man," but did not indicated he was
personally acquainted with DAVIS. MILTEER did not indicate
on what dates he was in the above cities, except for
Tuscaloosa, Alabama.

MILTEER related that he was in Tuscaloosa,
Alabama, and contacted ROBERT SHELTON of the United Klans of
America, Inc., Knights of the Ku Klux Klan (United Klans), on
the evening prior to the bombing of the 16th Streert Baptist
Church,

120

The Federal Bureau of Investigation has requested that
certain pages of this document not be disclosed. This
request was incorporatewd in a letter of August 13,
1965, to Dr. Wayne C. Grover, Archivist of the United
States from Norbert A. Schlei, Assistant Attorney
General, Office of Legal Counsel, Department of
Justice.

Commission Document Number: 1347

Pages Withheld: 121

MM 89-35
3.

A characterization of the Association of South
Carolina Klans follows. Sources therein have furnished
reliable information in the past.

After their arrival, MILTEER stated that there
was no point in discussing President KENNEDY, and again
stated, "We must now concentrate on the Jews." MILTEER ad-
vised that he was preparing a pamphlet which he wanted to
disseminate throughout the country. Prior to concluding
their discussion, information was received that JACK RUBY had
killed LEE HARVEY OSWALD. In view of this, MILTEER said he
would have to alter the information he was setting out in his
pamphlet.

The source advised that based on his contact with
MILTEER, he could not definitely state whether MILTEER was
acquainted with either RUBY OR OSWALD.

122

MM 89-35
FPG:ggr
1

Re: Threat to Kill President KENNEDY
by J. A. MILTEER, Miami, Florida,
November 9, 1963

J. A. MILTEER is also known as JOSEPH ADAMS
MILTEER. He was born February 26, 1902, at Quitman, Georgia,
and lives at Quitman and Valdosta, Georgia. He reportedly is
a wealthy bachelor who inherited an estimated $200,000 from
his father. He is reported to have no family, no employment
and to spend a gerat deal of time traveling throughout the
Southeastern United States. He has been unsuccessful in city
politics in Quitman and publishes a weekly pamphlet critizing
the operation of the Quitman City Government. MULTEER has
associated himself with the Constitution Party of the United
States and attended a convention of this party held at
Indianapolis, Indiana, during October, 1963. He was repri-
manded by this party for describing himself as being the party
regional chairman for the Southeastern states. MILTEER re-
portedly became disillusioned with the Conssssstitution Party
of the United States and has attempted to form a party known
as the Constitutional American Parties of the United States.
MILTEER allegedly intends to use the Constitutional American
Parties of the United States as a front to form a hard core
funderground for possible violence in comatting integration.

123

1

DL 89-43
PEW/as

The interview of JOSEPH ADAMS MILTEER, as well as
additional information regarding him, is contained on pages
24-26 of the eport of Special Agent CHARLES S. HARDING,
Atlanta, Georgia, dated December 1, 1963, in the case entitled
"LEE HARVEY OSWALD; INTERNAL SECURITY - RUSSIA".

FBI memoranda from their files on Joseph Milteer. Although the Warren Commission had reviewed these documents during its investigation, they never acknowledged them publicly. The Commission eventually concealed them within the National Archives. Note that the FBI specifically withheld page 121 from the Commission (*near left*). Page 121 became available from the National Archives when it was declassified years later.

Mobsters, Burglars, and Other Rogues

John Kennedy mounted an ambitious campaign to challenge the dictums of the Cold War with the Soviet Union and to curb the Pentagon's activities in southeast Asia. Attorney General Robert Kennedy resolved to strengthen the integrity of the Department of Justice by dismantling the Mafia's sphere of influence upon the various agencies of government and business. Such a broad atmosphere of change directly threatened the entrenched (and often intertwined) agendas of the FBI, the CIA, the Pentagon, and the Mob. The Kennedy administration thus made an insidious "rogues' gallery" of enemies — many of whom continued to influence the office of the presidency long after John Kennedy's death.

Sam Giancana
Chicago mobster Sam Giancana had claimed to have influenced his city's crucial vote on Kennedy's behalf during the 1960 presidential election. When the Kennedy brothers later went after the Mafia's (illegal) business interests within the United States, Giancana felt he had been betrayed.

John Roselli
Mafia figure John Roselli, through his connection with the CIA, had let the story of the assassination leak out.

Charles Marcello
Crime boss Carlos Marcello was a prime target of the Kennedy brothers' war on organized crime. Deported to Guatemala, he eventually was flown back into the United States by CIA contract operative David Ferrie.

Santos Trafficante
A Mafia chieftain based in Florida, Trafficante was called to testify before the House Assassinations Committee about his possible connection to the assassination. He told the Committee that he had been approached by the CIA in the 1960s. He was contacted secondhand through John Roselli, who informed him about the agency's proposed assassination plots against Castro.

James Hoffa
Teamster leader Jimmy Hoffa had hated the Kennedys since his inquisition at the McClelland Committee hearings on organized crime. Persistently questioned as to his mob activities and connections by Bobby Kennedy, Hoffa vowed that he would break Kennedy's back.

Robert Maheu
One-time CIA operative and FBI man Robert Maheu was a top aide of businessman Howard Hughes in Las Vegas. In 1959, prior to the Bay of Pigs incident, Mafia figures Sam Giancana and John Roselli met with Maheu to assemble an assassination team to eliminate Fidel Castro, who had paralyzed the Mob's profitable gambling and prostitution operations in Cuba. This plan fit perfectly with the CIA's agenda to invade Cuba.

Frank Sturgis
Sturgis, with a long career in the CIA's undercover operations network, was deeply involved with the Mob, especially the dangerous Florida chiefs, Santos Trafficante and Meyer Lansky.

E. Howard Hunt
E. Howard Hunt, one of the seven Watergate burglars, had long been a top CIA henchman and was involved with the CIA anti-Castro group, the Cuban Revolutionary Council, in the 1960s. He put his experience and intelligence connections to work for the Nixon administration.

John Mitchell
Attorney General under Richard Nixon, John Mitchell gave orders in November 1970 to the Justice Department not to release the ballistics evidence in the Kennedy case. The particular information he was trying to suppress was the FBI's (secret) spectrographic analysis of the recovered bullets and fragments from the shooting. This incident was in response to assassination researcher Harold Weisberg's suit to obtain information on the medical evidence.

Bernard Barker
Another of the Watergate burglars, former CIA agent Bernard Barker had been, like Howard Hunt, a member of the Cuban Revolutionary Council. Prior to the Bay of Pigs operation, Barker had worked for the Cuban police as a consultant on counter-insurgency strategy as part of the CIA's efforts to depose Fidel Castro.

Eugene Hale Brading
Eugene Hale Brading, who was arrested in Dealey Plaza, gave a false name (Gene Braden) to the Dallas authorities, and was later released. Reportedly, Brading, who had a police record dating to the 1940s, was in the Los Angeles Ambassador Hotel when Senator Robert Kennedy was assassinated in 1968. Brading is the only known criminal (with connections to the Mafia) to have been present during both assassinations.

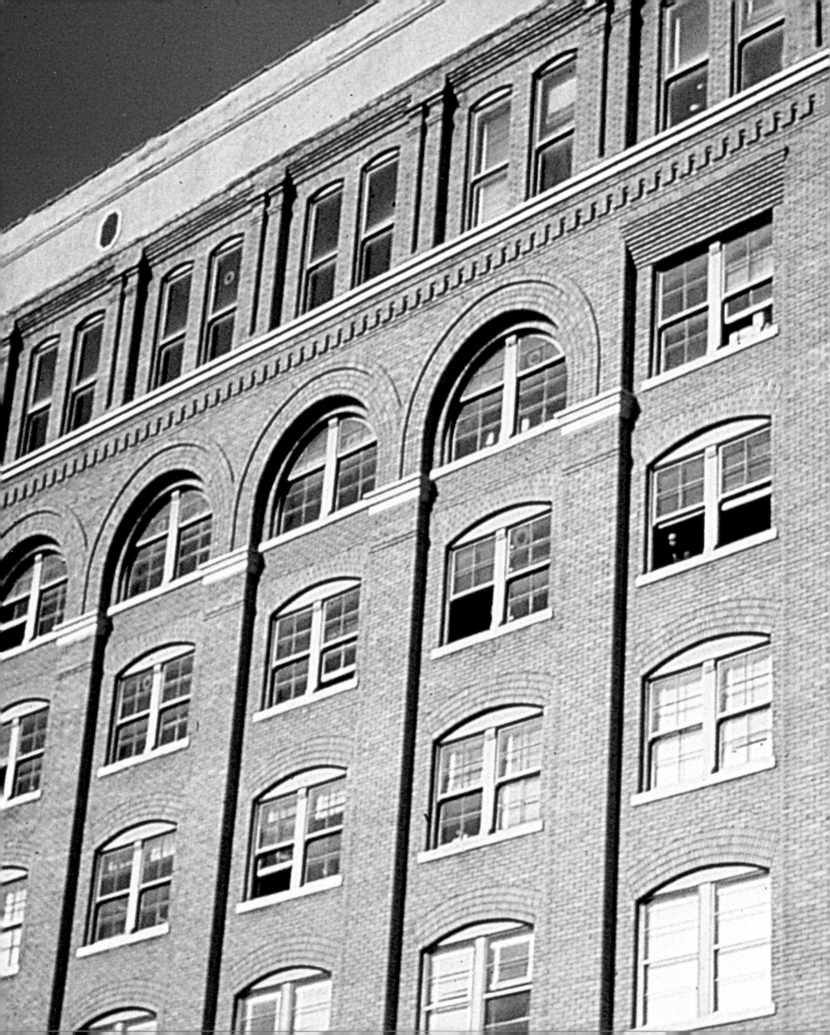

HOUSE ASSASSINATIONS COMMITTEE

The House Select Committee on Assassinations (HSCA) was the fifth, and final, entity to investigate the assassination of President Kennedy. The chain of events that led to the Committee's formation are a testimony to the more positive aspects of a conspiracy — in this instance, a collaboration not to conceal, but to reveal, the truth about the killing.

Congressional support for the committee was not universal, with opposition to the investigation at the outset from Warren Commission loyalists. During its short two years the 12-member Committee had three chairmen and three directors. This turnover was a clear reflection of the chaotic infighting and CIA tactics of obstruction that hampered the HSCA investigation.

The first director, Philadelphia prosecutor Richard A. Sprague, resigned after the Committee Chairman, Congressman Henry Gonzalez, attempted to fire him. Then Director Robert Tanenbaum resigned rather than participate in what he felt was a cover-up. The Committee's agenda was to try to solve the mystery behind the assassination; both of the men treated the case as a criminal investigation.

Opposite: The facade of the Texas School Book Depository building, photographed 30 seconds after the shooting. A figure stands in the sixth floor window (on the extreme right), which frames the sniper's nest. It is not possible that this mysterious individual is Lee Harvey Oswald, who, by eyewitness reports, was on the second floor in the lunchroom 42 to 60 seconds later.

The original legislation introduced by Congressman Tom Downing stipulated that the Committee would investigate the deaths of John Kennedy and Dr. Martin Luther King, Jr. Congressman Henry Gonzalez felt a conspiracy could have been responsible for the assassination of Robert Kennedy, and he wanted this murder investigated as well. But this was not to be; the death of Senator Kennedy has yet to be examined in any federal investigation.

The initial plan for the Committee's work was to have evolved out of the new evidence shown by the enhanced version of the Zapruder film; the scope of their analysis should have examined the assassination and the oppressive manner in which the Warren Commission had conducted its investigation. This crucial work was never accomplished during the Committee's tenure.

Congressman Richardson Preyer: From the Zapruder film and your analysis of that, is it your opinion that the first shot that hit President Kennedy also hit Governor Connally? I wasn't quite clear on your description of that.

Robert Groden: It would appear photographically that analysis of the film would show that the two men were struck by at least two, if not more, separate nonfatal shots prior to the head shot.

RP: Would you say that, again, each man was hit by at least two shots?

RG: No. More than the single bullet was involved in the actual nonfatal wounding of both men.

RP: But, you are not giving your opinion as to whether the shot which hit President Kennedy in the throat, the first shot, whether that was the shot that hit Governor Connally or not?

RG: I do not believe that they are the same bullet. I severely question that particular conclusion.

RP: Have any questions been raised about the Kennedy autopsy photographs?

RG: The autopsy photographs also came under a great deal of challenge by the Warren Commission critics, in that the reports dealing with the autopsy photographs from different groups going into the Archives to view them gave such markedly different results, at least verbal results, as described in relationship to each other and to the medical personnel at Parkland Hospital, who seem to describe totally different wounds than those seen in the photographs described.

RP: Fine.

With the advent of the Committee's third director, Cornell University law professor G. Robert Blakey, that agenda changed. The HSCA's primary aims became to write a politically acceptable report and to keep the investigation under budget. With the tracking and development of new evidence no longer a priority, the Assassination Committee's investigation was doomed.

The Committee used the Warren Commission findings as its yardstick to authenticate — or eliminate — much of the evidence under its scrutiny. Their policy was to take each piece of evidence as an independent entity to be compared with the preconceived conclusions of the Warren Report, rather than to conduct a new investigation of any questionable evidence from the Warren Commission findings.

A huge hurdle the House Committee faced was obtaining cooperation from the CIA, which knew that the Committee was empowered for only two years. All they had to do was stall on the delivery of files and documents until time ran out. The strongest indictment of the CIA as accessories after the fact in the President's murder is their stonewalling of the Committee's investigation in this manner. Director Blakey, claiming that the CIA was cooperative in giving him all the information he had asked for, stated, "I've worked with these people for 20 years. You don't think they'd lie to me, do you?" Lied to or not, Blakey had not asked the CIA for all the information and documentation they had (especially on Lee Harvey Oswald).

The most notable act of suppression during the Committee's investigation was the decision to keep hidden my discovery of the forged autopsy photographs. I discovered the forgeries when I examined this photographic evidence in my role as staff photographic consultant. I conducted tests on the photos by making

My research on the autopsy photographs and the backyard photographs of Lee Harvey Oswald proved that they were forgeries. However, Director Blakey did not permit me to bring this to the attention of the Committee's panel of medical experts. These physicians were associates of Maryland Medical Examiner Russell Fisher and of the President's original autopsists. The Committee, in its final report, did publish a statement corroborating my findings, but only after they realized the overwhelming indications of conspiracy that turned up in the analysis of the acoustical evidence.

successive generations of prints, which brought out a clearly visible matte line where another picture had been inserted to cover a large hole in the back of the President's head. The official pictures are composites.

I made a formal report of my findings in the form of a confidential memorandum to Director Blakey, but I was not permitted to raise the issue of forgery in front of the photographic panel or the other Committee members. One week after I had submitted my memo regarding the forgeries, Regis Blahut, a CIA agent on assignment to the Committee, opened the Committee safe without permission (though it was unlocked) and secretly examined the photos, specifically the one of the back of the head.

I asked the responsible members of the Committee to allow the Dallas doctors to review the autopsy photographs for accuracy. My requests were ignored or denied for the entire life of the investigation.

This obvious lack of action and the HSCA's refusal to consider an exhumation of the President's body were inexcusable. In some areas of its probe, the Committee could claim that they had not known the significance of pursuing certain lines of investigation. With others, they might have chosen to disbelieve evidence. In the case of the forged autopsy photographs, they chose the way of suppression.

Regis Blahut, in the act of removing the photo album from the Committee's safe, was startled upon hearing someone approaching the office. He had taken the forged photo of the back of the President's head out of its plastic sleeve, but in his haste to leave the office undiscovered, he simply pushed the photo back into the album and returned the book to the safe. Later, when staff members found the photo lying loose within the album, they called the police, who dusted the photo for fingerprints and identified them as Blahut's.

My wife, Christine, and I testify before the House Assassinations Committee. The Committee promised that I would be back, to present essential photographic and medical evidence. However, I was never called back, and the testimony was never taken.

The Committee

By a 280–65 vote, Congress approved Thomas Downing's resolution to launch investigations into the John Kennedy and Martin Luther King assassinations. This vote reflected strong support, but it mirrored an element of resistance from some congressional factions. A number of individuals who were initially opposed to the idea later vied for appointment to the 12-member House Select Committee on Assassinations (among them, Congressmen Sam Devine and John Anderson). Such subterfuge was not for Representative B. F. Sisk, who argued outright against the resolution and said, "For God's sake, if you have any respect for the dollars of the taxpayers, let's vote this resolution down."

G. Robert Blakey

A professor of law from Cornell University, Blakey was a veteran employee of the Department of Justice. As the final director and chief counsel, he never intended to look for evidence of a conspiracy. Bolstered by Committee member Judge Richardson Preyer, he ran the Committee in an atmosphere of secrecy, and his first action was to veto further press conferences. Blakey's experience in dealing with organized crime led him to favor the premise that the Mafia was responsible for John Kennedy's death.

Richard Sprague

The Committee's first director and chief counsel, Richard Sprague assumed a strong control over the investigation, wanting to treat it as he would any homicide case. Meanwhile, Sprague was under attack from some members of the press. Chairman Gonzalez, who wanted Sprague out, tried to fire him.

Thomas Downing

Interviewed by the Associated Press, Chairman Downing stated, "I am convinced there was a conspiracy involved. I do not know the identity of the conspirators or their motives. That should be investigated in depth. The Warren Commission which investigated Kennedy's death concluded that Lee Harvey Oswald was the sole assassin of the President. . . ."

Downing instigated research into the "mysterious deaths" of numerous witnesses and persons involved in the Kennedy killing.

Opposite page: From the final report of the House Assassinations Committee. Their findings stated there was a 95 percent chance that a conspiracy to kill John Kennedy and Dr. Martin Luther King, Jr., had existed.

Henry Gonzalez

Congressman Henry Gonzalez, the Committee's second chairman, was pessimistic, though realistic, about the efficacy of the Committee's work. He realized that powerful realms of influence, outside Washington-based political circles, were at work, hidden within agendas of various conservative special interest groups and the intricate manipulations of the CIA. Upon his departure he said the Committee was "a put-up job and a hideous farce that was never intended to work."

Louis Stokes

Stokes, who took over from Gonzalez, worked briefly with Director Richard Sprague before Sprague resigned. Stokes, discussing the Committee's final report, said, "[the Committee] did not find any *official* involvement [by U.S. intelligence agencies] in the assassinations." (Emphasis added.) He also stated that the Committee was unanimous in its belief that President Kennedy died as a result of a conspiracy.

HSCA Timeline

September 17, 1976: The Committee is voted into existence by Congress
December 1976: Chairman Downing retires
January 1, 1977: The Committee dissolves and is reformed
March 1977: Chairman Gonzalez resigns
March 1977: Director Richard Sprague resigns
April 1977: Director Tanenbaum resigns
September 9, 1978: First formal hearing to investigate the death of JFK
December 31, 1978: The Committee adjourns
July 17, 1979: The Commitee's final report is released

H S C A
MYSTERIOUS Death Project

New Orleans FBI agent Regis Kennedy was on loan to the Dallas FBI office during the investigation. The Monday following the killing, Kennedy went to see Beverly Oliver at the Colony Club, where she worked, and confiscated her film of the assassination. When the House Assassinations Committee later tried to locate Kennedy they found that he had died.

H S C A
MYSTERIOUS Death Project

William Sullivan, one of J. Edgar Hoover's top three men in the Bureau, was shot in an alleged hunting accident. New Hampshire State Fish and Game officials announced to the press that someone had mistaken Sullivan for a deer on Wednesday, November 9, 1977. Sullivan was one of a small group of top FBI men who died during a six-month period in 1977.

SUMMARY OF FINDINGS AND RECOMMENDATIONS

I. FINDINGS OF THE SELECT COMMITTEE ON ASSASSINATIONS IN THE ASSASSINATION OF PRESIDENT JOHN F. KENNEDY IN DALLAS, TEX., NOVEMBER 22, 1963

A. Lee Harvey Oswald fired three shots at President John F. Kennedy. The second and third shots he fired struck the President. The third shot he fired killed the President.

 1. President Kennedy was struck by two rifle shots fired from behind him.

 2. The shots that struck President Kennedy from behind him were fired from the sixth floor window of the southeast corner of the Texas School Book Depository building.

 3. Lee Harvey Oswald owned the rifle that was used to fire the shots from the sixth floor window of the southeast corner of the Texas School Book Depository building.

 4. Lee Harvey Oswald, shortly before the assassination, had access to and was present on the sixth floor of the Texas School Book Depository building.

 5. Lee Harvey Oswald's other actions tend to support the conclusion that he assassinated President Kennedy.

B. Scientific acoustical evidence establishes a high probability that two gunmen fired at President John F. Kennedy. Other scientific evidence does not preclude the possibility of two gunmen firing at the President. Scientific evidence negates some specific conspiracy allegations.

C. The committee believes, on the basis of the evidence available to it, that President John F. Kennedy was probably assassinated as a result of a conspiracy. The committee is unable to identify the other gunman or the extent of the conspiracy.

 1. The committee believes, on the basis of the evidence available to it, that the Soviet Government was not involved in the assassination of President Kennedy.

 2. The committee believes, on the basis of the evidence available to it, that the Cuban Government was not involved in the assassination of President Kennedy.

 3. The committee believes, on the basis of the evidence available to it, that anti-Castro Cuban groups, as groups, were not involved in the assassination of President Kennedy, but that the available evidence does not preclude the possibility that individual members may have been involved.

 4. The committee believes, on the basis of the evidence available to it, that the national syndicate of organized crime, as a group, was not involved in the assassination of President Kennedy, but that the available evidence does not preclude the possibility that individual members may have been involved.

The Cover-up Resumes

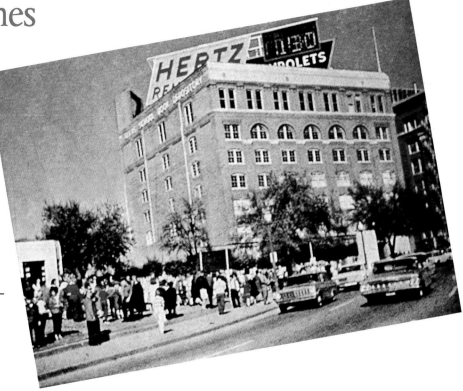

The first three months of the Committee's investigation were beset by opposition from Capitol Hill critics, infighting between Chairman Henry Gonzalez and Chief Counsel Richard Sprague, and bad press. Though nearly derailed within four months after its first session, the Assassinations Committee sat for two years, during which time perhaps a total of six months of hard investigation was achieved. The Committee, guided by the Warren Report findings, took Oswald's culpability as the "lone assassin" as a given. This flawed premise set the tone for an equally faulty investigation. There was too little strength on the Committee — some of the members being younger and less powerful congressmen — to counter the effects of subsequent CIA stonewalling and subterfuge. While the battle between Sprague and Gonzalez raged on, time was running out and key witnesses were disappearing.

Edwin Lopez, an investigator for the Committee, concentrated on researching the Cuban and New Orleans connections in the Kennedy case. Said Lopez, "The CIA was stalling [the committee]. They knew we had a very limited lifetime [and] they were prepared to wait us out."

Robert Tanenbaum was briefly the Committee's director and its chief counsel, succeeding Richard Sprague. Realizing that the Committee's report would be another cover-up, Tanenbaum resigned.

Gaeton Fonzi, another HSCA investigator, went to interview George DeMohrenschildt. DeMohrenschildt died, reportedly from a self-inflicted gunshot wound, while Fonzi was en route for the interview. Of his work for the Committee, Fonzi said, "We were not allowed to follow up many strong leads that needed to be pursued."

A diary, supposedly kept by Lee Harvey Oswald, was found in his belongings and used as evidence. The Committee had the diary analyzed by handwriting experts in 1978: The experts told them that it had been written without a perceptible break in time sequence, in one or two sessions. The Committee felt that Oswald most likely did write the diary, but thought it odd that he wrote about events (and ascribed dates to them) in a time frame before they actually happened. George DeMohrenschildt, Oswald's close friend, said of him: "Lee's English was perfect, refined, rather literary. . . . He sounded like a very educated American. But to know Russian as he did was remarkable. . . ."

The real Oswald probably never journeyed to Mexico City. Just as the Committee was beginning its investigation into the JFK case, David Atlee Phillips, who had been head of the FBI station in Mexico City, made public the story that (despite the Cuban Consul's assertion that the man he had met in Mexico City did not even resemble Oswald) he had seen the transcripts and heard the tapes of Oswald's conversation while at the Embassy. When this story reached the press, the CIA destroyed this evidence.

Left: Oswald in the foreground during Marine Corps training. This is the only known legitimate photograph of Oswald holding a rifle.

When he returned to the United States from the Soviet Union in 1962, Oswald went to work for Jaggars-Chiles-Stovall Inc., a firm that engaged in high-level security work for the government. Oswald had no trouble regaining a passport as a U.S. citizen, which he received within 24 hours of his application. When examining the Warren Commisson evidence about

Oswald, the Committee found a memo that discussed Oswald's discharge from the armed services, which he had requested well before it was due to be issued. Oswald had the discharge in under two weeks. The Warren Commission document surmised that he had obtained the discharge in a fraudulent manner.

Right: Oswald in death posed no more threat to the conspirators.

Above and center left: Oswald as a marine. Many of the records pertaining to Lee Oswald's military service were destroyed. Military intelligence and the CIA both had personnel files on him, which they produced for the Committee to examine, but the files were incomplete or empty and insubstantial—at least 37 documents were missing.

An Overview of the Hearings

Richard Sprague was replaced briefly by Robert Tanenbaum, then by G. Robert Blakey, who called a press conference and stated that no more conferences would be held. An ominous secrecy surrounded the Committee's work for the next 18 months. The Committee then came into public view, announcing a series of short public hearings. They were originally planned and designed to find no evidence of conspiracy, despite the eyewitness, photographic, and medical evidence presented. However, hard evidence presented in the enhanced Zapruder film was reinforced by the introduction of the acoustic evidence contained in the Dictabelt recording of the gunshots. The Committee could not suppress this information, as they did the discovery that the original autopsy photographs had been falsified. After I reported my initial findings, this medical and photographic information was stringently restricted by Blakey, and the Committee's panel of medical experts denied the validity of the medical photo evidence.

George DeMohrenschildt
An exiled Russian count who made his home outside Dallas, DeMohrenschildt had become friends with the Oswalds. He liked and respected Lee Oswald. A highly educated man, DeMohrenschildt was involved in the oil business and was also linked to the intelligence community. He and Oswald had many interests in common, such as literature, Russian life and culture—and the intrigues of the intelligence circles. Shortly before his death, DeMohrenschildt wrote of Oswald: "Lee is innocent of Kennedy's assassination . . . he was rather an admirer of Kennedy's."

In Gerald Ford's *Portrait of the Assassin,* he stated that Dallas police and sheriff's deputies were originally "mistaken" as to the type of rifle they found on the sixth floor of the Depository. This pattern of alleged initially mistaken information has, interestingly, been attributed to the original statements of the autopsists, the Dallas doctors, Jacqueline Kennedy, and many Dealey Plaza witnesses.

Knowing that it would provide indisputable answers to nearly all the medical questions, the Committee would not consider an exhumation of the President's body, even after I told them about the forged autopsy photographs and the contradictions between the locations of the wounds and the bullet trajectories.

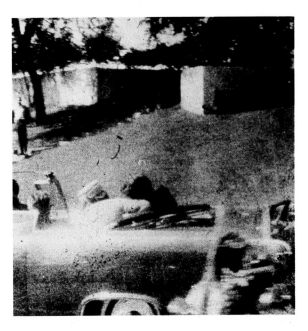

The Moorman Polaroid (*right*) shows that the retaining wall was a perfect spot for a sniper. The detail on page 173 shows a possible sniper.

Left: government agents measure the height of the "sniper's nest" window frame. It measured approximately 12 inches from the floor.

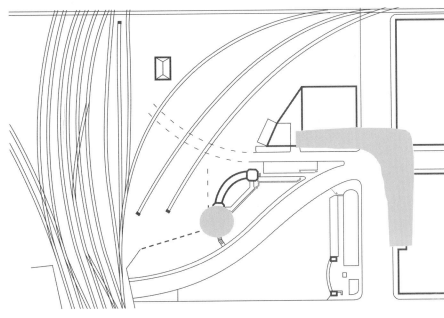

Late in its investigation, the Committee turned its attention to the Dallas police Dictabelt recording from November 22, 1963. The tape had captured impulses that could only be the sounds of gunshots. Though Officer W. B. McLain's motorcycle engine had all but obliterated the sounds of the shots (due to his open microphone), acoustics experts had been able to isolate and identify at least six impulses. Director

Blakey had not wanted to find any evidence of a conspiracy; he had wanted only to produce a politically acceptable report. However, he knew, to his dismay, that this acoustical evidence of conspiracy could not be suppressed. The Committee staff called this turn of events "Blakey's problem."

The highlighted portions in this diagram (*above*) of Dealey Plaza show the areas from which the gunshots could have actually originated.

Left: The view from the other side of the retaining wall, looking east on Elm Street. A sniper here would have a clean view of the motorcade.

The Backyard Photos

Early in 1963, Lee and Marina Oswald lived in a house on Neely Street in Dallas. Mrs. Oswald supposedly took one or two photographs of her husband holding a rifle in the backyard of this house. These photos, when later discovered and then circulated in the press (leaked to the press by the Warren Commission), helped solidify in the minds of the public a portrait of Oswald as the dangerous lone assassin. The rifle Oswald held was thought to be the one he used to assassinate John Kennedy; the pistol was supposed to be the weapon used to kill Officer J. D. Tippit. He also held two socialist newspapers, *The Militant* and *The Worker.*

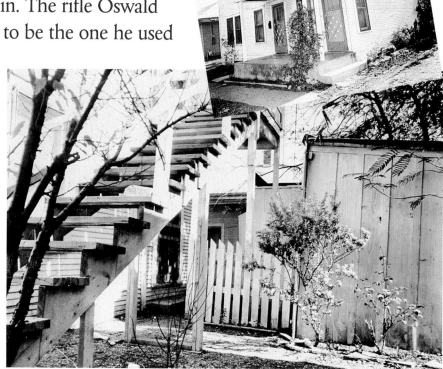

The backyard photos were subjected to careful analysis by photography experts before and during the Committee's work and were found to be composite pictures: photos of Oswald's head pasted atop someone else's body. The Committee, however, claimed that they were genuine.

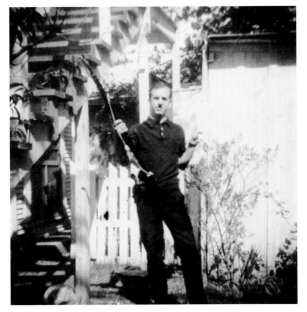

The day after the assassination, a search of the garage at Ruth Paine's house in Irving, Texas, yielded two "backyard" photographs. They both appeared to be of Lee Harvey Oswald in the backyard of the Neely Street house (the backgrounds in the photos were identical), and they were the only "solid" evidence linking him to the rifle and pistol.

The shadows cast in the backyard pictures were analyzed extensively. Although the photos revealed shadows across the face and on the ground that were at odds, indicating the sun's position at two completely different times of day, the Committee's panel of photographic experts concluded that there was "no evidence of fakery in any of the backyard picture materials."

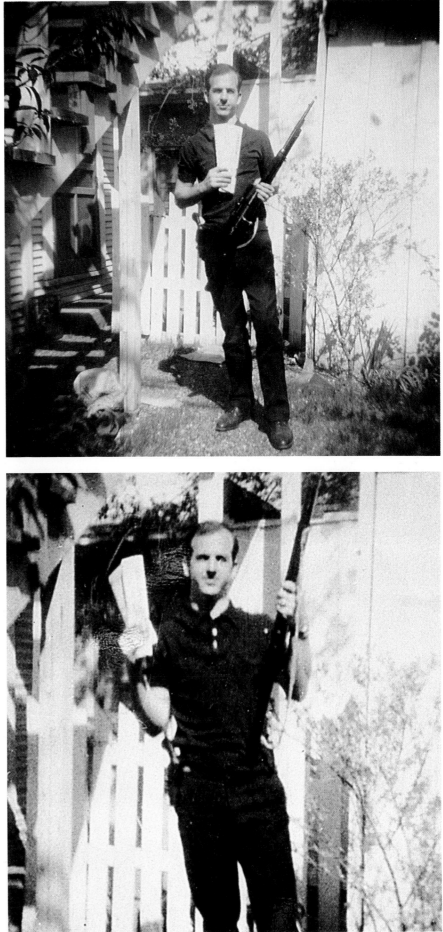

During the 1976 Schweiker-Hart assassination investigation, the third photograph was found in the possession of Geneva Dees, the widow of Officer Roscoe White. White, who had been a photographic technician for the Dallas police, had probably been involved in making the re-enactment photos seen on this page. There was, reputedly, a fourth photo found by Oswald's mother, Marguerite. She destroyed it. The picture showed "Oswald" holding the rifle over his head in both hands.

Marina Oswald has stated that when she took the first photos of her husband she was standing by the steps. The steps appear in the background. If she was standing by the steps, how could they be in the photo?

In a second group of photographs, the steps were on the right side of the pictures. The three known photos show the steps on the left.

A third backyard photograph (*bottom*) also existed, which had been found in the search of Ruth Paine's house and garage— and was pocketed by Dallas policeman Roscoe White. This photograph, which supposedly remained in the possession of the Dallas Police Department, was kept under wraps and never submitted to the Warren Commission as evidence. Marina Oswald, when shown the other two photographs during her testimony to the Warren Commission, initially stated that she had taken only one photo, not two (or three).

The "missing" photograph (*bottom*), from which Dallas police created their test photographs (*above*), was discovered by the Schweiker Committee during its investigation in 1976 (see page 151). The most alarming aspect of these photos is that they were created and planted before the assassination in order to frame Oswald.

Top left: The re-creation of one of the backyard photographs, showing an agent standing in a pose similar to Oswald's.

Top right: A backyard photograph that appears to be a composite.

Left: This photograph, known as "the ghost of Lee Harvey Oswald," shows a cut-out of where Oswald's figure would appear in the creation of the third backyard photograph. This photo was only recently found in the Dallas Municipal Archives.

Below: Part of researcher Jack White's analysis of the shadow disparities in one of the backyard photos. Jack White observed that the shadow under "Oswald's" nose is vertical, but the shadow on his neck only a few inches down falls diagonally to the left. In other words, the sun was at two different positions.— an impossibility.

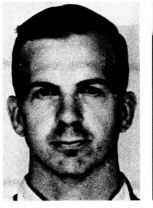

A chin transplant: When Oswald was arrested and the mug shots taken, he had a pointed chin with a slight cleft in it, as appears in all other photos taken of the real Oswald. However, these backyard composites show a man with a square chin and no cleft.

IF SUN IS IN POSITION TO CAST A SHADOW OF NOSE DIRECTLY TO CENTER OF MOUTH, THEN CHIN SHOULD CAST A SHADOW TO CENTER OF NECK, WITH AS MUCH LIGHT ON RIGHT SIDE OF NECK AS ON THE LEFT.

During the Committee's investigation, new evidence was found in many of the photographs and films of the assassination. While repeatedly reviewing the frames and still pictures of the killing — including the photographic evidence of eyewitnesses Zapruder, Nix, Moorman, Betzner, Willis, and Bronson — I stabilized, enlarged, and analyzed the photographic evidence of the shooting. The enhanced frames of Zapruder's film made the details of the gruesome sequence clear, enabling researchers to ver-

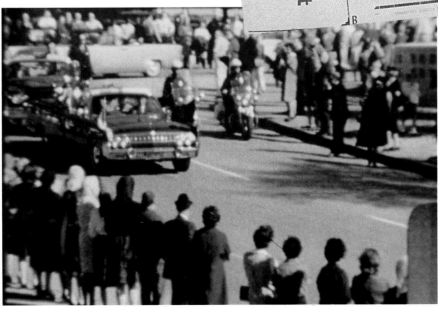

ify more than three shots and deduce their direction.

The Zapruder film is, perhaps, the most crucial piece of documentary evidence that exists in the Kennedy case. The selected frames from the film shown over the succeeding pages begin here at frame #139, as Kennedy's limousine turns onto Elm Street, and finish with frame #416, which indicates the possible presence of a gunman on the Grassy Knoll.

The Acoustic Evidence

For the first time during any investigation into Kennedy's death, the Dictabelt recording of the gunshots was subjected to a series of scientific tests, which confirmed that *at least* four shots were fired. The acoustical experts who had analyzed the tape presented their evidence, which claimed a "virtual certainty" that a second gunman had shot at the President, with the shots originating from the Grassy Knoll. In 1979, the Committee requested that the Justice Department complete the tests. They have done nothing to this day.

Two photos of Officer McLain (left) show him just before, and moments after, he reaches down with his left hand toward the police radio. The acoustics tape was recorded from this motorcycle microphone that was positioned eight cars to the rear of President Kennedy's car. The sounds of all the shots, which were hidden by the sound of McLain's motorcycle engine, were — nonetheless — recorded on the Dallas Police Department's Dictabelt tape.

When experts studied the Dictabelt tape recording, they created a range of echo types in Dealey Plaza with which to compare the recorded gunshots. Dealey Plaza was closed off. Then, using gunmen firing live rounds into sandbags, scientists employed an array of microphones to determine the precise location and sequence of each shot. The test results proved that it was McLain's microphone that was left open.

Officer McLain (*above*) testified to the Committee that he had been about 150 feet behind the President during the shooting. Acoustical analysts found that McLain's open microphone was 154 feet behind the limousine at the moment the third shot was fired. Photographs taken at that moment verify this position. Two experts, Drs. Mark Weiss and Ernest Aschkenasy, ascertained from their analysis that the jammed microphone was on the left side of the motorcycle, pointed downward.

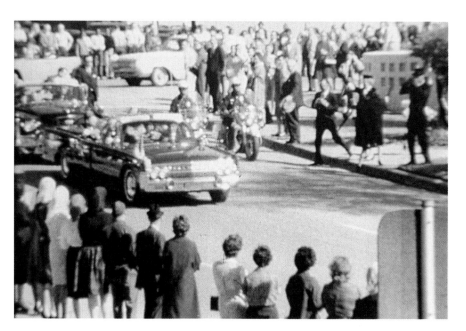

Along with Mark Weiss (*right*) and Ernest Aschkenasy, I worked on the acoustical evidence, synchronizing the sounds of the gunshots to the Zapruder film, using the last two auditory impulses as the synchronization point for the fatal head shot. When testing was complete, all of us came to the same conclusion: The audio recording revealed four shots that were verifiable, with at least two more sounds that appeared to be additional gunshots. It was clear to us all that the head shot came from the front.

Dr. Mark Weiss, of New York's Queens College, shows where the second gunman was positioned on the Grassy Knoll, based upon his studies of the acoustical data. This revelation underscored the statements of numerous eyewitnesses in Dealey Plaza.

When acoustic scientists Weiss and Aschkenasy, and James Barger of Bolt, Beranek and Newman, conducted their tests and gave testimony on the results, they were unaware that Moorman's photograph existed. The detail (*right*) shows a man at the exact spot, eight feet west of the corner of the stockade fence, where they had indicated that someone could have stood and fired a gun.

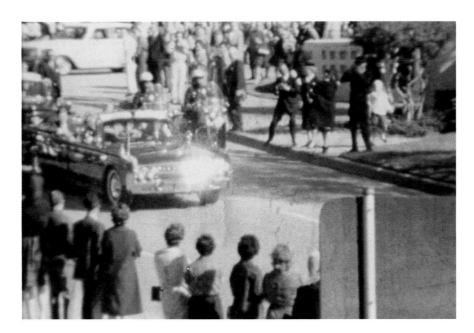

Right : Ernest Aschkenasy, left, and Mark Weiss testified before the House Assassinations Committee and explained that to a 95 percent (or greater) certainty, there were at least four shots fired from at least two points in Dealey Plaza.

The firm of Bolt, Beranek and Newman took the analog (straight audio) recording and transformed its sounds into digitized wave forms to make a visual re-creation of the shots. They filtered out background noise (from the motorcycle's engine), then analyzed the tape for other notable sequences of impulses that could have been caused by gunfire and resultant echoing. Analysts were able to isolate at least six sequences and identified a probable seventh, implying there was at least a second gunman — and a conspiracy.

Experts, using the Dictabelt recording to measure the time span in which the gunshots were fired, were able to match the auditory impulse patterns to the Zapruder frames based on the President's and John Connally's reactions to the shots. James Barger, of Bolt, Beranek and Newman, displays acoustic wave forms showing shot impulses (*above*).

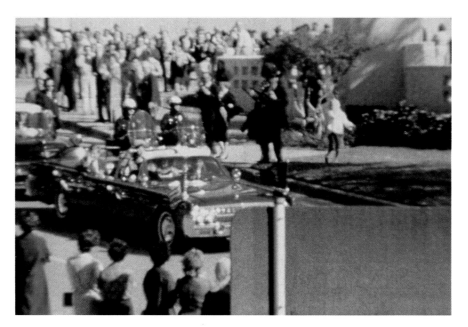

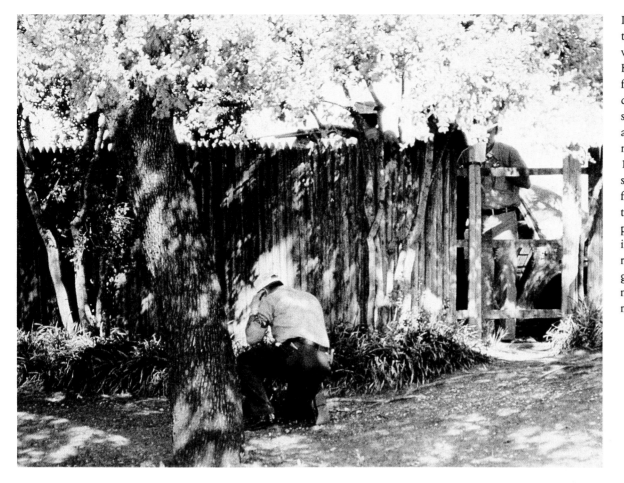

In a re-enactment done for the Committee, a gunman was placed on the Grassy Knoll behind the stockade fence. This position was derived from eyewitnesses' statements (scientists were as yet unaware of the Moorman photograph on page 167, which showed a possible gunman behind the fence). Test shots fired from this position produced echo patterns that proved that the impulses on the Dictabelt recording could be gunshots from this location, not backfire noise from a motorcycle.

The Dictabelt recording picked up the sounds of a carillon from a nearby bank. The bell was still sounding for at least seven seconds after the last shot was heard on the tape.

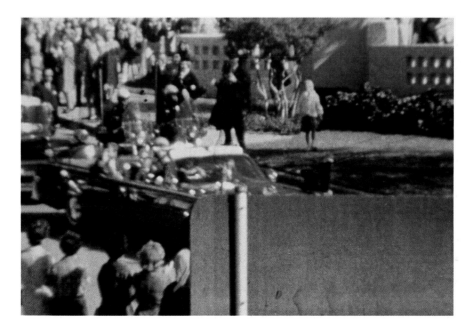

The Ballistic Evidence

The FBI ran spectrographic analysis tests on the ballistic evidence, and the Warren Commission made every effort to suppress the results. Had the findings stated conclusively that the fragments found in former Governor Connally were the same as those taken from the "magic bullet," from Kennedy's head, and from the floor of the limousine, the government would have featured those results in the first chapter of its report. Assassination researcher Harold Weisberg finally got the test results after a long suit, and they were inconclusive. J. Edgar Hoover reported on the tests, and disingenuously stated that the composition of the fragments was "similar" and that "no significant differences were found."

Spectrographic analysis can show ballistics material to be similar or dissimilar. If test results on two bullets, or bullet fragments, show similarity, then this could indicate that the material came from the same bullet — or the same series of bullets being tested. Any dissimilarity indicates that the fragments being compared cannot have come from the same bullet or the same series.

The Committee stated in its report that Dallas Deputy Sheriff Luke Mooney found three rifle shells and a 6.5 Mannlicher-Carcano rifle on the sixth floor of the Depository. However, Dallas Deputy Sheriff Weitzman, who had an extensive knowledge of firearms, signed an affidavit that the gun found in the Depository was a 7.65 Mauser, a German-made gun. It is unlikely that he would have confused the Mauser with the Mannlicher-Carcano, an Italian-made gun. The Committee's report concludes that "over the years skepticism has arisen as to whether the rifle found . . . is the same rifle that was delivered to the Warren Commission and is presently in the National Archives."

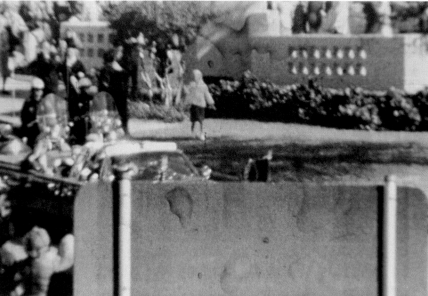

The Ballistics Inventory

Bullets

3 rifle shells in the 6th floor sniper's nest
1 bullet in the Mannlicher-Carcano rifle
1 "pristine" bullet found at Parkland Hospital
1 intact bullet found in Dealey Plaza; traces of lead in the curbing
Bullet fragments in the front seat of the President's car and under the jumpseat, and scrapings in the car's windshield

Guns Reportedly Found in the Depository

6.5 Mannlicher-Carcano (sixth floor), the official murder weapon
British Enfield .303 (7th floor or roof)
7.65 Mauser (sixth floor)

Both the Enfield and the Mauser subsequently disappeared.

Commission exhibit No. 569 was not tested. It was a copper bullet jacket minus the interior lead. Faced with such harmless evidence, the Committee decided that the bullet could have been fired from the Mannlicher-Carcano rifle, but they could not prove this.

Left: This metal cannister contains the scrapings of metallic material taken from the windshield of the President's car. The glass was cracked, but not shattered, by a bullet or fragment.

The curb section (*below*) was taken from the south curb of Main Street in Dealey Plaza, and shows the point where the bullet struck. The FBI removed this section of curbing from the Plaza approximately five months after the shooting to examine it for fragments or traces of metal. This section of concrete was splintered by the bullet's ricochet, and caused a cheek wound on bystander James Tague.

The portion of the curb where the bullet struck was repaired. When the FBI ran tests on that section of curb, they most likely analyzed the new patch of paving material on the curb, rather than the old concrete that the bullet struck. Their analyses did turn up traces of lead, but not copper (which would indicate that there was another nonjacketed bullet — simply a lead bullet — that struck the curb, and that it was was fired from a gun other than the Mannlicher-Carcano). From those results, the FBI concluded that the damage must have been caused by a fragment of the bullet, not the bullet itself, which could have been fired from the Mannlicher-Carcano. It is unlikely that a bullet fragment striking the curb would carry enough force to make a deep gouge in the concrete, causing pieces of paving, lead, and metal to scatter and wound Tague.

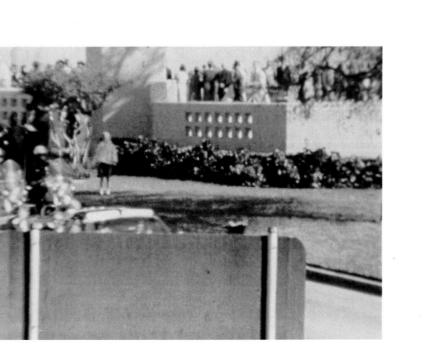

The Head Wound

The autopsy findings and the discovery of the forged photos were never shared with the original physicians or other medical personnel who first attended the President at Parkland Hospital. At the Committee's direction, this evidence was kept away from those who could corroborate it. Blakey's fears that this newly discovered evidence of conspiracy would surface were well founded, especially when medical expert Dr. Cyril Wecht, a leading forensic pathologist, voiced his doubts: "I have raised some questions concerning the head wound and the possibility of a second shot fired in synchronized fashion from the right side, or lower right rear, synchronized with the head shot that struck the President in the back of the head." He told the Committee that an examination of the President's brain would verify the evidence, but he had discovered that it was missing from the National Archives.

The Warren Commission and the House Assassinations Committee claimed that only one bullet went through the President from behind, traveled through Governor Connally's body, and buried itself in the Governor's left thigh. Yet the bullet remained intact! Still another bullet (according to the lone assassin theory) was fired from the same gun and struck the President in the skull (a thinner, more fragile bone material), but this supposedly identical bullet shattered into fragments.

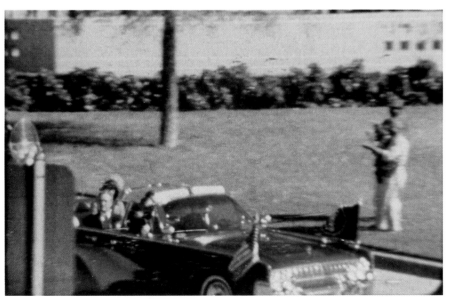

My visual inspection of the autopsy photographs and X-rays reveals evidence of forgery in at least four of the photographs showing the back of the head. Within the circumference of the President's head, there is an irregular line. Within this line, the hair appears black and wet. On the outside of the line it is auburn and completely dry. In later generations of these photographs, a large degree of contrast buildup becomes apparent at the line's edge and the line becomes clearly defined. This phenomenon is characteristic of crop lines in matte insert processes used for retouching and recomposition of photographs. The top left photograph is a forgery, a composite manufactured to eliminate evidence of an exit wound in the rear of the President's head. The only method that could have been used to create the composite is known as "soft edge matte insertion" (see page 85). On the bottom left is HSCA's drawing, which adds an entrance wound to the top rear of the head. The bottom right illustration is the Warren Commission's drawing of the same area and alleged wound positions. Note the differences. The top right depiction is a computer-generated drawing that shows what all the witnesses actually saw.

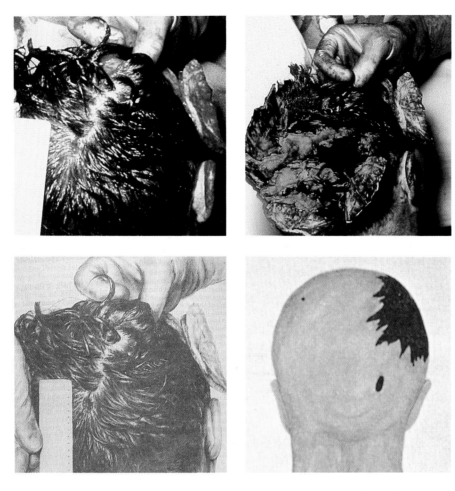

During the Committee's investigation, the President's autopsist, Dr. Humes, was shown the photographs and X-rays of the wounds. Dallas County Medical Examiner Dr. Charles Petty and HSCA panelist Dr. Joseph Davis interviewed Humes:

"*Dr. Charles Petty:* I am now looking at X-ray No. 2. Is this the point of entrance [the cowlick area at the rear of the head] that I'm pointing to?
Dr. James Humes: No.

CP: Then this is the entrance wound. The one down by the margin of the hair in the back?
JH: Yes, sir.
JD: Well, in terms of the inshoot, my impression when I first looked at those films was that the inshoot was higher.
JH: No, no, that's no wound [indicating the "new" bullet hole in the cowlick area]."

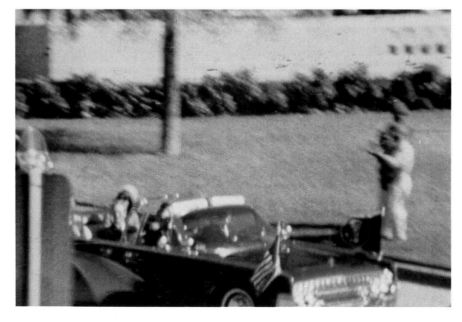

The Committee concluded that the doctors at Parkland Hospital were wrong about the existence of a large wound in the back of the President's head because this wound did not appear in any of the photographs the Committee had seen. Their report stated, "In disagreement with the observations of the Parkland doctors are the 26 people present at the autopsy. All of those interviewed who attended the autopsy corroborated the general location of the wounds as depicted in the photographs; none had differing accounts." In reality, fewer than six people present at the President's autopsy had seen the X-rays and photographs, and they did not vouch for their accuracy. Several autopsy witnesses openly state that the photos are false. The "none had differing accounts" is purely false!

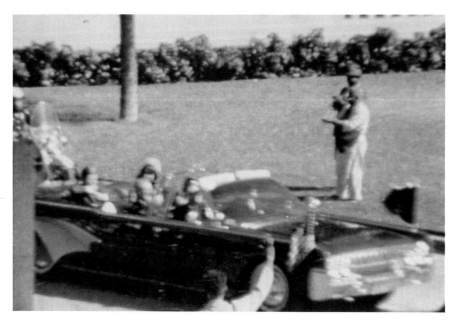

This sketch by one of the autopsists, Dr. J. Thornton Boswell, shows the top of the President's head. The back of the head shows massive fracturing. Boswell wrote on the drawing that an area of 10 x 17 cm was missing from the skull, extending into the occipital region. Dr. Boswell's drawing shows different wounds from those of the official photos.

Nurse Margaret Henchliffe also sketched a picture of the President's wounds as she had observed them. What she drew was a representation of a large, gaping hole in the occipital region that extended somewhat into the parietal area. She added that the President also had an entry wound in his throat.

Dr. Paul Peters assisted the Parkland Hospital medical team when the President was brought in. In an interview with reporters, Peters stated that the large wound was in both the occipital and parietal areas of the head. When he was later shown the "official" (faked) picture, Peters said, "I don't think it's consistent with what I saw."

The Committee's artist's conception of the President's brain during the autopsy shows about half the brain missing. Yet the autopsy report states that the brain weight exceeded the maximum weight of a full, intact brain.

Parkland Hospital doctor Robert Grossman gave his description of the wounds, saying that there were two large holes in the President's head, one of which was located squarely in the occiput and was too big to be a bullet entry wound.

Dr. Ronald Coy Jones was, in 1963, Parkland Hospital's chief surgical resident. When he first testified to the Warren Commission, he told Arlen Specter that "there was a large defect in the back side of the head as the President lay on the cart with what appeared to be some brain hanging out of this wound with multiple pieces of skull noted next to the brain and with a tremendous amount of clot and blood."

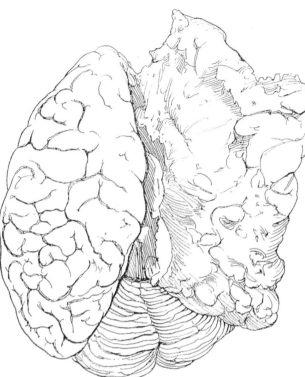

Dr. James Humes, the President's autopsist, was "authorized" by the President's physician, Admiral George Burkley, to destroy his original autopsy notes. Burkley "accepted" written proof that this order had been carried out. He also required that Humes give over any remaining materials relating to the autopsy, and asked him to submit yet another written affidavit. Humes wrote: "I, James J. Humes, certify that all working papers associated with Naval Medical School Autopsy Report A63-272 have remained in my personal custody at all times. Autopsy notes and the holograph draft of the final report were handed to Commanding Officer (J. H. Stover, Jr.), U.S. Medical School, at 1700, 24 November 1963. No papers relating to this case remain in my possession."

The driver of the limousine, William Greer, said: "His head was all shot, this whole part was all . . . blood like he had been hit." The Commission's examiner asked if the part of the head that was gone was "the top and right rear side of the head?" "Yes, sir; it looked like that was all blown off."

Another Secret Service agent, Roy Kellerman, was shown a picture of a head, indicating the rear portion: "Yes." "More to the right side of the head?" "Right. This was removed." "When you say, 'This was removed,' what do you mean by this?" "The skull part was removed." "All right."

Representative — later President — Gerald Ford asked him, "Above the ear and back?"

"To the left of the ear, sir, and a little high; yes. About right here." "When you say 'removed,' by that do you mean that it was absent when you saw him, or taken off by the doctor?" "It was absent when I saw him."

"Fine. Proceed."

"Entry into this man's head was right below that wound, right here," Kellerman said. "Indicating the bottom of the hairline immediately to the right of the rear about the lower third of the ear?" "Right. But it was in the hairline, sir." "In his hairline?" "Yes, sir." "Near the end of his hairline?" "Yes, sir." "What was the size of that aperture?" "The little finger." "Indicating the diameter of the little finger." "Right."

"Now, what was the position of that opening with respect to the portion of the skull which you have described as being removed or absent?"

"Well, I am going to have to describe it similar to this. Let's say part of your skull is removed here; this is below."

"You have described a distance of approximately an inch and a half, 2 inches, below."

"That is correct; about that, sir."

— from the Warren Commission proceedings

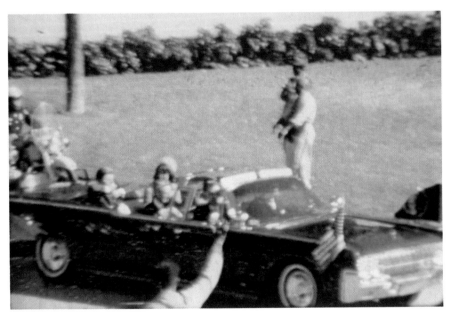

The X-Rays

The X-rays of the President's head were also forged. They show that the areas encompassing the entire front of the forehead to above the ear, and from the extreme top of the head down to the temporal area, are missing. This damage does not appear in the faked autopsy photographs, which show that particular portion of the President's head to be intact. The two sets of faked evidence do not match. The X-rays and photographs, both supposedly taken at the same time during the autopsy, neither reflect each other nor correspond with the wounds observed on November 22, 1963, by hospital personnel and eyewitnesses.

Floyd Riebe, a photographer at Bethesda, shows very clearly where the President's skull was missing.

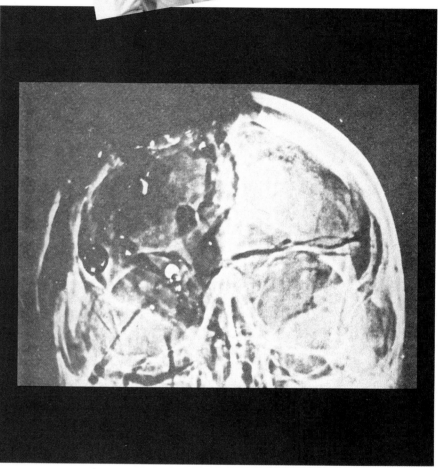

Technician Jerrol Custer took the X-ray pictures on the night of the autopsy. These X-rays, purportedly of the President's head, do not depict the true nature of the President's wounds. Custer has stated that the pictures shown here are not the X-rays he took that night. The first review of the X-rays (after the autopsy) was done by the Ramsey Clark Panel in 1968, which gave any conspirators nearly four years in which to alter or make any substitutions.

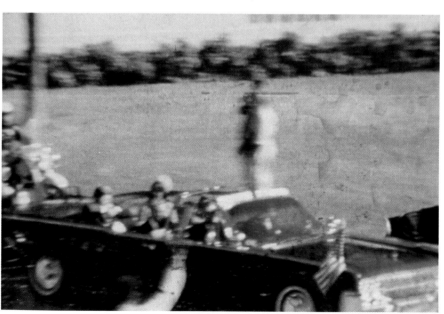

The autopsy report stated that the X-rays of the President's skull and brain revealed 30 to 40 minuscule fragments of metal—as well as two larger fragments measuring 7 x 2mm and 3 x 1 mm, respectively—that appeared in the right cerebral cortex. Yet when Attorney General Ramsey Clark's panel of experts reviewed the X-rays in 1968, they noted two very large fragments embedded in the skull. Had this material been present in the President's skull at the time of the autopsy, it would have been noted and removed, and certainly would not have been missed in a review of the pictures.

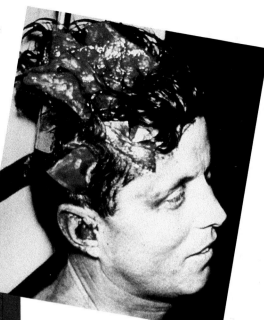

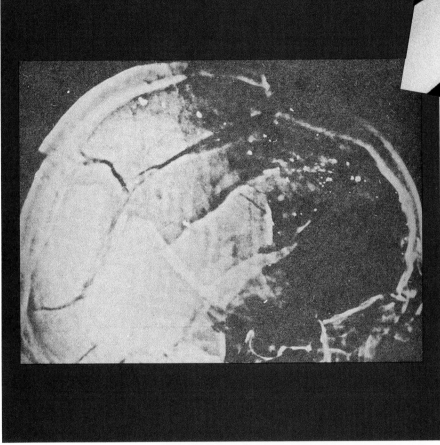

After the discrepancies concerning the medical evidence came to the Committee's attention, they contrived three possible explanations for the mismatched data. They assumed that if the Parkland doctors' original statements were correct, the autopsy photographs and X-rays had been tampered with (but they did not know who was responsible); the body itself could have been altered to show different wounds; or the photographs and X-rays were of someone other than the President. However, the Committee never considered any of these possibilities.

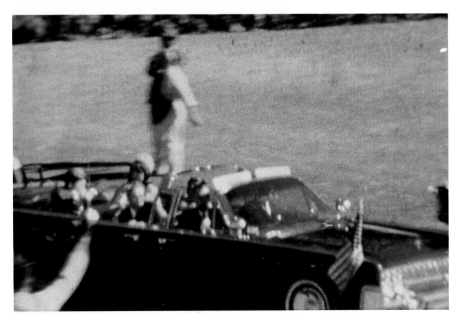

Figure in the Dal-Tex Window

Across the street from the Book Depository, a man was sitting on a step of the Dal-Tex Building fire escape. Seconds after the first volley of shots occurred, Kennedy was hit in the throat and back, Connally in the back. The man on the fire escape, who moments before had been in a normal sitting posture, had now fallen off the step and was supporting himself with his arms. Why this sudden startled reaction? Careful examination of the Altgens photograph (see page 31) reveals an unidentified, dark-complected man leaning out of the window just below the fire escape, his left arm visible on the sill, his right arm in shadow. This window provided a perfect vantage point for at least two gunshots: the one that missed, striking the south curb of Main Street, and the shot that struck the President in the back.

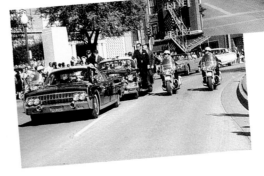

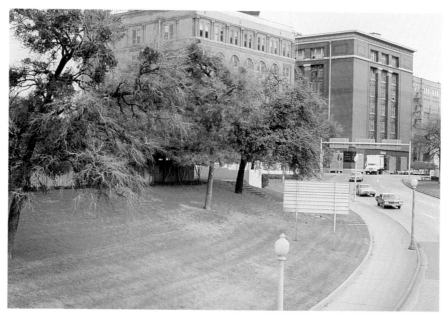

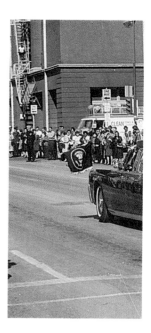

Before the shots, the man sits, apparently calm, watching the motorcade. After the shots, the man, startled, looks as if he has lost his balance and has fallen forward. Directly below him, framed in the window (which looks out from a

broom closet), is the figure of a man. Was it the close proximity of gunshots that startled the man on the fire escape? The figure is isolated and enhanced in this rendering by Ed Chiarini.

In the seconds preceding the exposure of this photograph, four gunshots have already been fired.

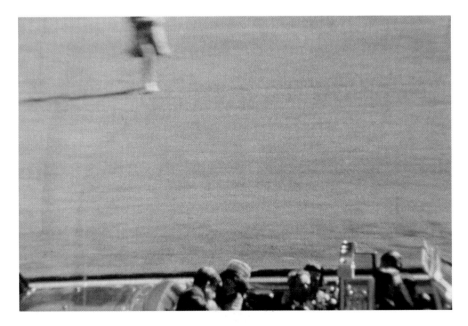

Billy Nolan Lovelady

In Ike Altgens' fifth photograph, there is a man standing in the doorway of the Book Depository. His extraordinary likeness to Lee Harvey Oswald is uncanny. If Oswald were standing in the doorway, how could he have been in the sixth floor "sniper's nest" firing upon the motorcade? Federal investigators later claimed that the man in the doorway was Book Depository employee Billy Lovelady. Although earlier research had indicated that the man in the doorway was Oswald, my work with the House Assassinations Committee produced evidence to the contrary.

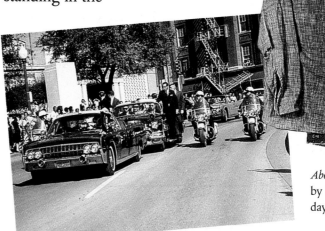

Above: The shirt worn by Lee Oswald on the day of the assassination.

While examining the photographic material for the Committee, I applied a technique I had developed to the original Altgens negative. I was able to prove that, contrary to my own original opinion, the man was not Oswald, but a remarkable look-alike, Billy Lovelady. Lovelady's testimony verified that he—not Oswald—was standing in the doorway at the time of the shooting. This is confirmed by other photographic evidence.

Billy Lovelady so strongly resembled Lee Oswald that about one week before the assassination, Lovelady's wife came down to the Depository to visit her husband, saw Oswald from across a room, and called out to him thinking he was her husband.

I interviewed Billy Lovelady in 1976. Lovelady took out the shirt he had worn in Dealey Plaza (he had packed it away for safekeeping) and put it on for the first time in years.

Above: The FBI photographs. When the FBI called Lovelady to come down and be photographed, they told him not to bother to wear the same shirt. When they released the photograph, they stated that it was the same shirt, creating the controversy over whether it was Oswald or Lovelady in the Depository doorway.

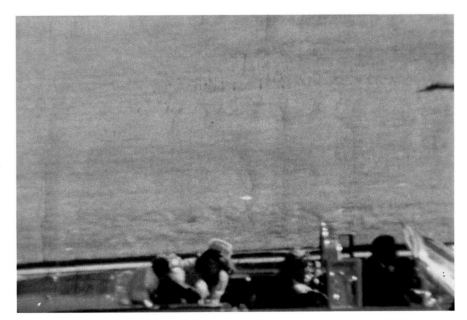

Umbrella Man

The significance of Umbrella Man has been a mystery for nearly 30 years. One of hundreds of bystanders in Dealey Plaza, this man stood parallel to the exact Elm Street location where the President was shot in the back. Though the weather that day was sunny and warm, he alone held an open, black umbrella. Was the umbrella some sort of visual signal, a communications device? A weapon? Two things are certain: The morning's rainfall had given way to hot sunshine, and it was not the custom in Dallas for men to carry parasols against warm weather.

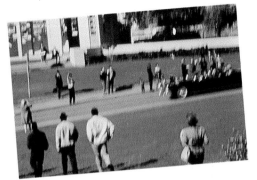

Witt, unaware that he had been the subject of a 15-year search, testified that he disliked the Kennedy family and that he held an open umbrella in Dealey Plaza to taunt Mr. Kennedy. The umbrella was supposed to remind Kennedy that his father, Joseph, had sympathized with former British Prime Minister Neville Chamberlain's attempts to appease Germany before the start of World War II (Chamberlain's trademark had been an umbrella).

A recognizable picture of Umbrella Man's face was released to the press by the House Assassinations Committee. Someone recognized him as Louis Steven Witt, and he was sought for his testimony.

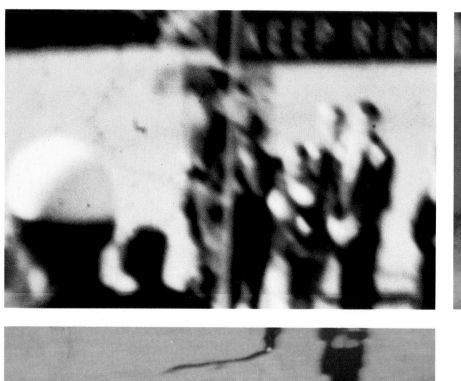

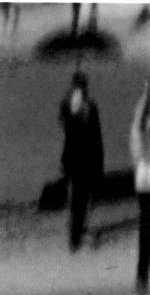

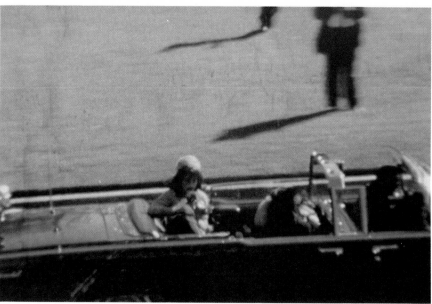

Just after the shooting, an apparently unfazed Umbrella Man folds his umbrella and sits down with an associate. After a few moments, they separate and wander off.

A Committee aide showed the (supposed) infamous umbrella to the Committee. While she was trying to raise it, the umbrella turned inside out. This helped to make a mockery of any theory that Umbrella Man had been a conspirator. The possibility of investigating the true significance of Umbrella Man was lost when the HSCA ridiculed the issue. Louis Seven Witt is seen below the umbrella.

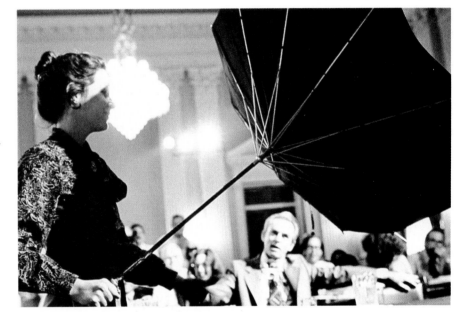

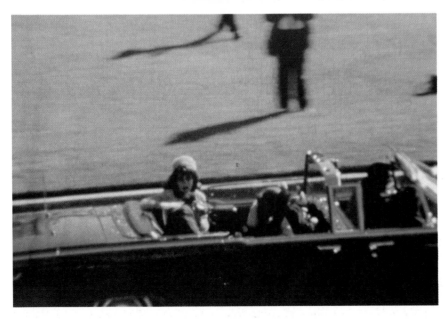

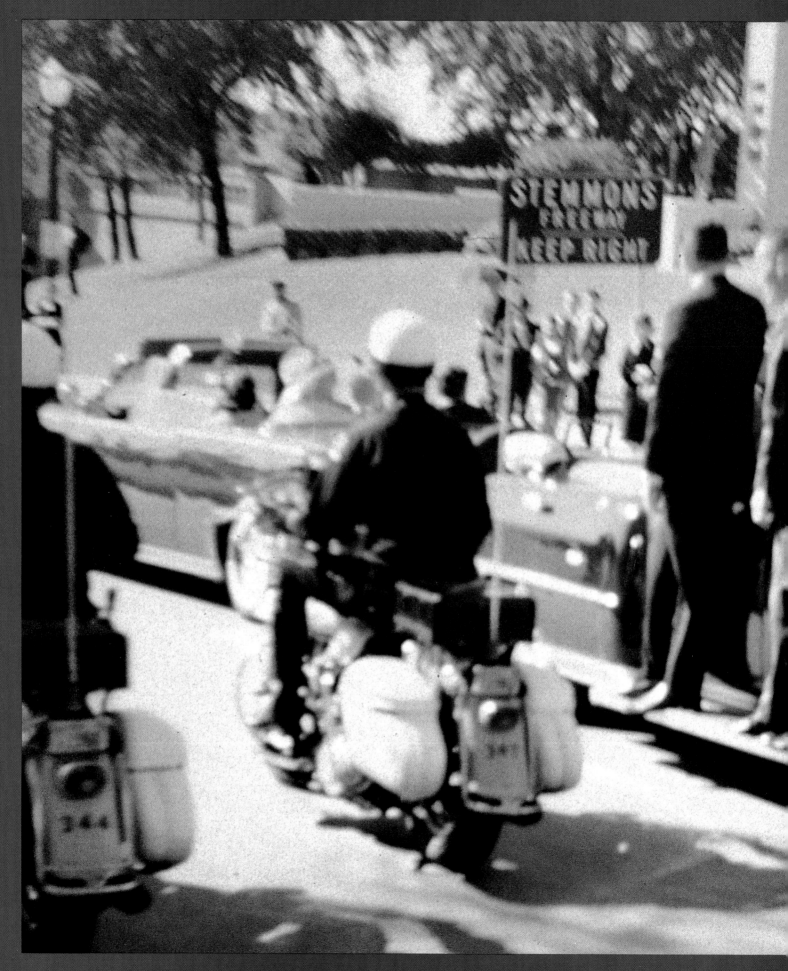

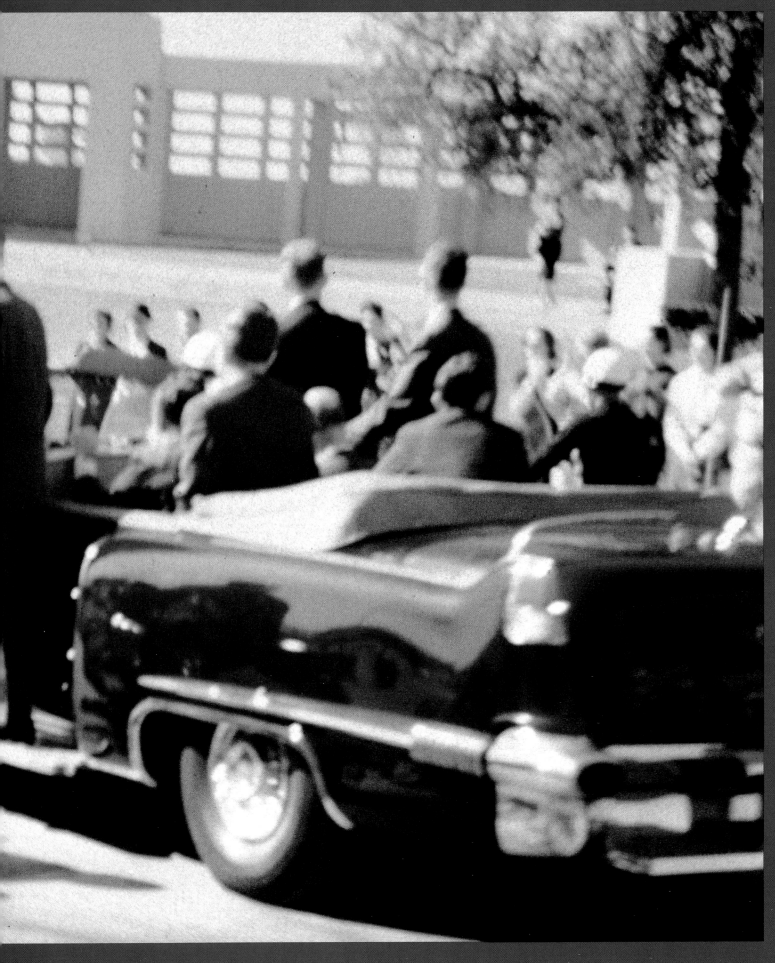

Black Dog Man

A cement wall juts out from the Grassy Knoll just east of the stockade fence. At the time of the shooting, a man stood behind this wall. As the Committee examined and analyzed the photographs of the assassination scene, they saw that many of the eyewitnesses' photos had captured the strange presence of this man. The Committee dubbed him the Black Dog Man because in photographs he resembles, from the waist up, a black dog sitting atop the wall. In reality, he was crouching behind the retaining wall, perhaps to fire upon the President.

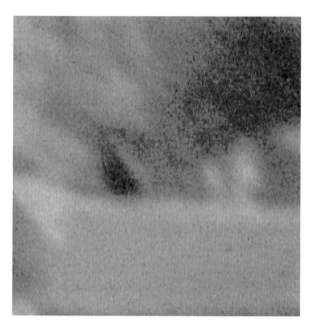

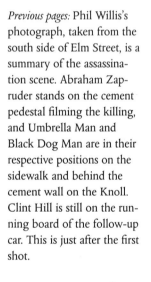

Previous pages: Phil Willis's photograph, taken from the south side of Elm Street, is a summary of the assassination scene. Abraham Zapruder stands on the cement pedestal filming the killing, and Umbrella Man and Black Dog Man are in their respective positions on the sidewalk and behind the cement wall on the Knoll. Clint Hill is still on the running board of the follow-up car. This is just after the first shot.

In the enhancement of the same photo (*top right*), we see the Black Dog Man in greater detail. Although the picture is blurred, you can still see some of the skin tone of the man's face. He is wearing a dark brown raincoat.

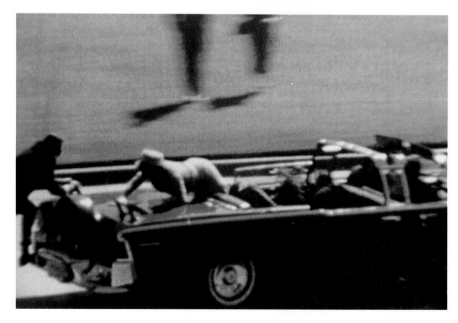

A detail from Moorman's photograph (see page 34) also verifies the existence of Black Dog Man.

A frame from Marie Muchmore's film (*left*) shows the retaining wall as the presidential car passes by. This was filmed less than one second before the firing of the fatal head shot. Black Dog Man is visible at the top of the wall. After enlarging the area over the wall, a more obvious human shape is revealed. Note the skin tone on the left and the metallic reflection on the right, which could be from a weapon.

The Orville Nix film (*top left*) shows the President at the exact moment of the head shot. The area behind the wall is in deep shadow, but after enlarging this area, the shape of Black Dog Man appears. If you look closely, you can see a flash to the extreme right of the figure (when the shot was fired), the position of Black Dog Man's left hand.

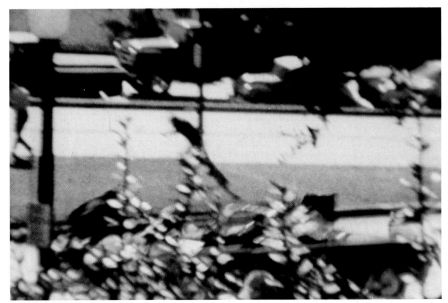

A detail of a later photo (*below*) shows the Coca-Cola bottle left on the wall by Black Dog Man. The bottle was probably discarded.

In a re-enactment of sorts, assassination researcher Gary Shaw crouches in the spot where Black Dog Man stood during the shooting. This is the point of cover nearest to the President that an assassin could have assumed to fire the fatal head shot. The car's position at the right of the wall is the approximate location of the presidential limousine. Any gunman stationed there would have had an unobstructed view to fire upon the President.

As shown in the diagram below, Zapruder stood on a cement pedestal and panned his camera down the length of Elm Street following the Presidential limousine. Zapruder panned across the retaining wall as the President's car disappeared behind the stockade fence.

Abraham Zapruder (*right*), wearing a hat, climbed down from the pedestal and immediately returned to his office in the Plaza to telephone the FBI. He told them that he had just filmed the murder of the President.

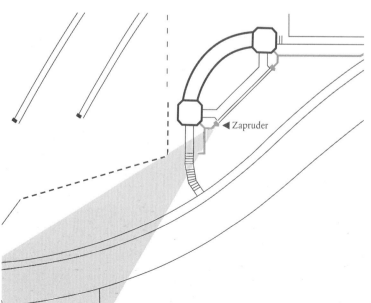

◄ Zapruder

Six seconds after the shot to the President's head, the top of Black Dog Man's head appears at the lower edge of the Zapruder film for several frames, the clearest of which is #413. (*blown up below*). It appears (note drawing at right) that he is wearing a hat or helmet, but the white areas creating that illusion are reflected light shining off the leaves of the pyracantha tree that obstructed Zapruder's view.

Left: The FBI's recreation of the view from Zapruder's position just prior to the disappearance of the Presidential limousine.

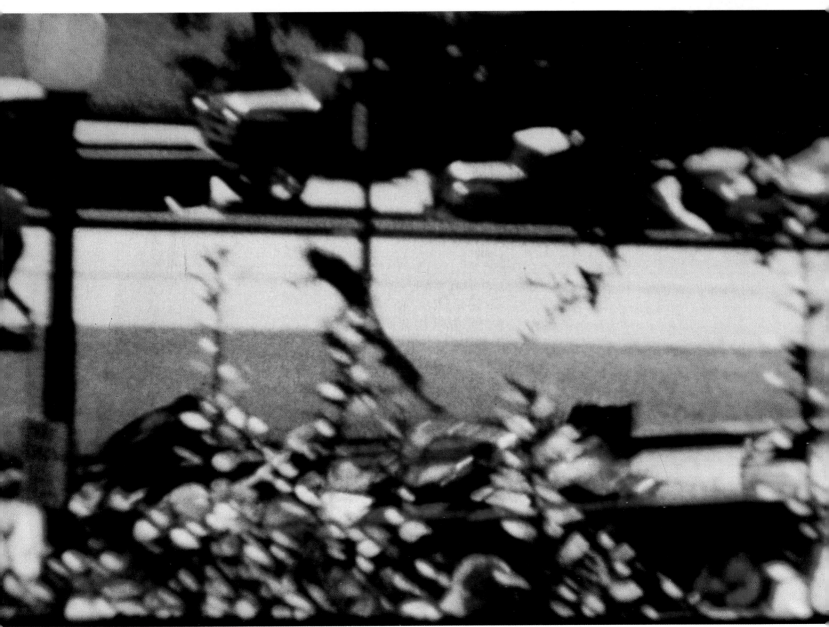

The Right Wing Keeps Watch

Joseph Milteer traveled a great deal throughout the southeastern United States, using his memberships in various ultra-right-wing groups to work against ideals and causes he considered abhorrent. In Dallas on the morning of the assassination, Milteer telephoned Willie Somersett in Miami and told him, in effect, "I don't think you will ever see your boy Kennedy in Miami again." Two hours after that telephone call, the President, with Joseph Milteer watching in Dealey Plaza, was assassinated.

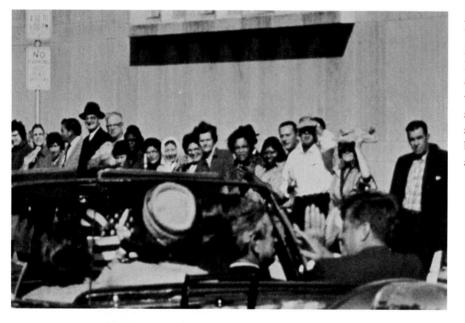

Milteer stood on Houston Street, next to eyewitnesses Carolyn Walther and Pearl Springer. While the crowd about him called out greetings to the President, Milteer stood silently, his right arm held up at a 90 degree angle. Then the first shots were fired. As pandemonium erupted in the Plaza, Milteer quietly disappeared into the crowds.

Above: A telegram from Willie Somersett to Joseph Milteer. The two men had known each other since childhood. It is unknown why Somersett, who had such a long-standing friendship with Milteer, would become an informant against his associate.

Joseph Milteer was a sour-looking observer in Dealey Plaza on November 22, and a comparison of the blow-up from the above photograph with a family portrait leaves no doubt that he was part of the crowd on Houston Street.

tement that plans were in the making to kill President
N F. KENNEDY at some future date; that MILTEER suggeste
JACK BROWN of Chattanooga, Tennessee, as the man who
ld do the job and that he (MILTEER) would be willing to

New Orleans Assistant District Attorney James Alcock learned of Milteer's call from Dallas from Somersett himself in 1968.

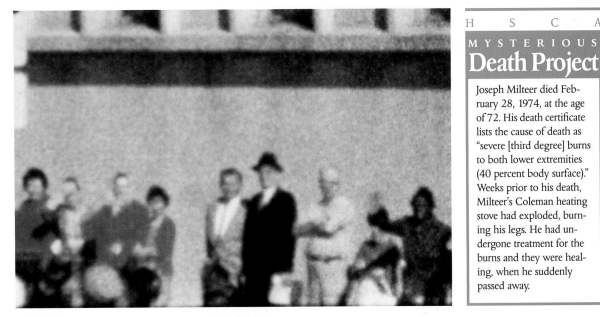

Below: Milteer lost no opportunity to promote his right-wing ideologies.

Joseph Milteer died February 28, 1974, at the age of 72. His death certificate lists the cause of death as "severe [third degree] burns to both lower extremities (40 percent body surface)." Weeks prior to his death, Milteer's Coleman heating stove had exploded, burning his legs. He had undergone treatment for the burns and they were healing, when he suddenly passed away.

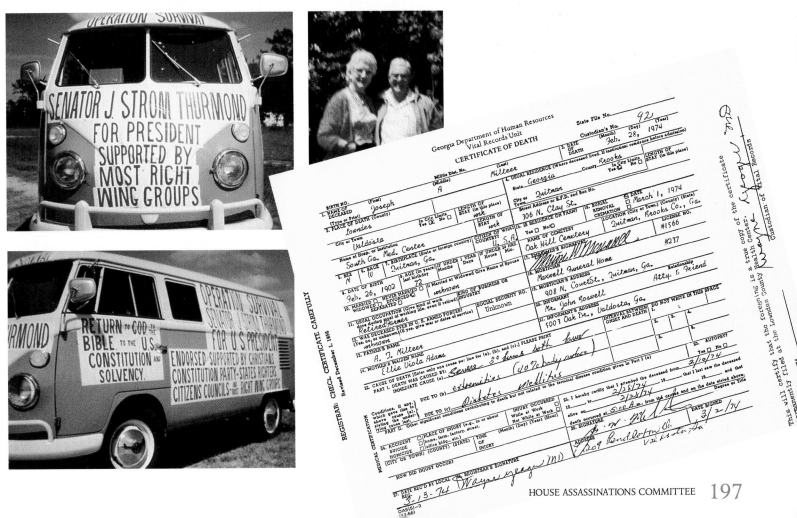

The Death List

Jacqueline Hess, HSCA chief of research, researched the "mysterious" deaths that had befallen many of the witnesses and participants in the assassination. An article in the London *Sunday Times* said the odds were 100,000 trillion to one that so many witnesses would die so soon after the assassination, but Hess claimed, "We had thus established the impossibility of attempting to establish . . . any meaningful implications about the existence or absence of a conspiracy." The Committee eventually decided that "our final conclusion on the issue is that the available evidence does not establish anything about the nature of these deaths which would indicate that the deaths were in some manner, either direct or peripheral, caused by the assassination of President Kennedy. . . ."

H S C A

MYSTERIOUS
Death Project

Marilyn M. Walle, a dancer whom Jack Ruby had hired on the day the President was killed, had planned to write a book about John Kennedy's assassination. She was shot to death on September 1, 1966. Her husband was convicted of murdering her.

H S C A

MYSTERIOUS
Death Project

CIA executive John A. Paisley died while sailing on Chesapeake Bay. Calvert County, Maryland, Coroner Dr. George Weems later testified, to the anger of his superior, Maryland Medical Examiner Dr. Russell Fisher, that he believed Paisley had been the victim of foul play. Fisher claimed the death was a suicide and angrily denied that Paisley had been murdered.

H S C A

MYSTERIOUS
Death Project

Maurice B. Gatlin, Sr., supposedly fell out of a window to his death in Panama in 1964. An associate of Guy Banister, he was involved with the CIA and served as legal counsel to the Anti-Communist League of the Caribbean. He once claimed he held a large sum of CIA money for a right-wing group that wanted to assassinate French President Charles DeGaulle.

H S C A

MYSTERIOUS
Death Project

Harold Russell, who saw a man leaving the scene of J. D. Tippit's murder, believed that his life was in danger because of what he had seen. At a party in February 1967, Russell became extremely agitated, thinking that he would be killed at any moment. His friends called the police, who tried to reason with him. One of the officers struck Russell, who died soon afterward.

H S C A

MYSTERIOUS
Death Project

Teresa Norton, also known as Karen Bennett Carlin and "Little Lynn," worked as a stripper in Jack Ruby's Carousel Club. On November 24, 1963, she apparently called Ruby from out of town, telling him that she desperately needed funds. Ruby went downtown to wire her money, then went to the nearby police headquarters and killed Lee Harvey Oswald. Could Norton's telephone call have been made to provide a reason for Ruby to be in the vicinity of the police station? Norton was supposedly shot to death in Houston in August 1964 — though no death certificate exists. At present, it is uncertain whether Norton is alive or dead.

H S C A

MYSTERIOUS
Death Project

John Crawford, a close friend of Jack Ruby, and five other persons died in 1969 while Crawford piloted a plane on a night flight. The investigation of the accident revealed that Crawford had left on the trip suddenly. His passengers also left hurriedly. The keys were still in their cars at the airport, and one woman left her purse in the front seat of her car.

H S C A

MYSTERIOUS
Death Project

Lee Oswald's landlady, Earline Roberts, died on January 9, 1966, when her heart failed. Roberts had claimed that an "Officer Alexander" sometimes came to the house to see Oswald. This was, perhaps, Dallas Assistant District Attorney Bill Alexander, who had known Jack Ruby well and had met with Ruby the day before Oswald was murdered.

H S C A

MYSTERIOUS
Death Project

Mrs. Earl Smith, an intimate friend and confidante of former reporter Dorothy Kilgallen (see page 111), died of unknown causes only two days after Kilgallen herself died of an alleged barbiturate overdose.

H S C A

MYSTERIOUS
Death Project

Mafia figure Charles Nicoletti was shot in the head three times March 28, 1977, while in his car, which was set on fire. Nicoletti, Sam Giancana, and John Roselli died violent deaths before they could testify before the House Assassinations Committee about the connection between the CIA's assassination plots against Fidel Castro and the killing of John Kennedy.

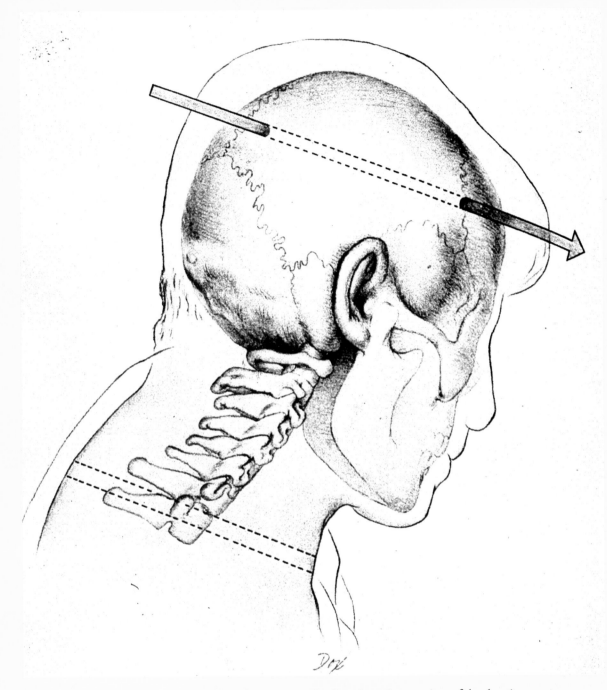

Both the Warren Commission and House Assassinations Committee versions of the shooting include a bullet traveling on a left-to-right trajectory through the President's head. The book depository was always to the right rear of the President. For the bullet to have come from anywhere in the depository, its trajectory would have to have been from right-to-left. Either the official version of the trajectory is completely wrong, or the head shot could not have come from the depository. In fact, the entrance and exit points were the opposite of what is shown in this Assassinations Committee illustration.

A CONSPIRACY
OF SILENCE

There were two conspiracies involved in the killing of the President. The first was responsible for the design and execution of a murder. The second covered up evidence and silenced witnesses: Both the Warren Commission and the House Assassinations Committee investigations deliberately chose to distort and suppress the damning evidence of conspiracy shown in the autopsy photos. Many individuals may have taken part in the cover-up unwittingly. But the premeditated acts of distortion and forgery in connection with the medical evidence make it obvious that many of these "accessories after the fact" knew exactly what they were doing.

After 30 years of research and five investigations, the assassination of John Kennedy is still under scrutiny, though not by any federal body. (The killing of Robert Kennedy has yet to be investigated.) The files from the House Assassinations Committee investigation are locked away, inaccessible to the public until the year 2029. In spite of this impasse, there are individuals outside the government purview for whom the case is not closed. Their efforts to clarify the events of the assassination and cover-up are reflected in

Opposite. An extreme enlargement of a portion of Mary Ann Moorman's photograph shows a distinct image of a man in uniform, especially when the shadowy shapes are colored in as in the illustration above.

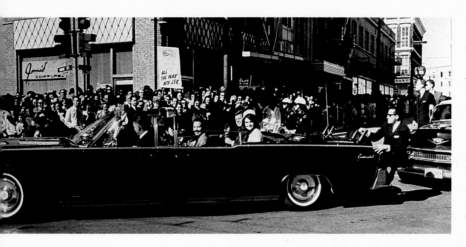

research, articles, books, and film. This work is a potent reminder that we have an ongoing responsibility to examine and monitor our affairs of state.

Those who conspired to kill John Kennedy were successful in doing so, but the conspirators' efforts to cover up the crime were less successful. The premature silencing of Oswald and the start-up of the Warren Commission investigation temporarily mollified a nation vulnerable and stunned by the assassination; the American public had no choice but to trust that their government would bring John Kennedy's assassin to justice. The killings of Dr. Martin Luther King and Robert Kennedy presaged the slow erosion of public trust that resulted from the Johnson and Nixon administrations and culminated with the Watergate scandal. Persistent Warren Commission critics were finding evidence of conspiracy and were working to expose government intelligence and media in the cover-up through the CIA's manipulation of "propaganda and media assets."

This powerful collusion, a conspiracy of silence and suppression that plagued the Garrison and House Assassinations Committee investigations, is the shadow enemy we are fighting — and must continue to fight. Important evidence is still being suppressed or obscured through governmental stonewalling and through misinformation and disinformation tactics.

This book contains a great deal of

On May 27, 1977, the President of CBS News, Richard Salant, confirmed that CBS had connections with the CIA that had been formed back in the mid-1950s. Salant further stated that these ties had been forged by CBS Chairman William Paley and Sig Mickelson, Salant's predecessor. Salant also stated that, as a matter of routine form, any CBS foreign correspondents returning to the United States after assignment were traditionally "debriefed" by (then) CIA Director Allen Dulles. In February 1976, prior to the formation of the House Assassinations Committee later that year, CIA Director George Bush called a meeting with Paley and Salant to gain support for the CIA's policy of "burying the past." One of the CBS executives told Bush, "we protect ours, you protect yours," when dealing with CIA contacts within the CBS news organization, as well as with those stringers working for other national publications.

At present, the government still refuses to exhume the President's body to discover the true nature of his wounds, perhaps afraid of how such an examination might point to conspiracy. The whereabouts of the President's brain and skull fragments, which are missing from the National Archives, remain unknown.

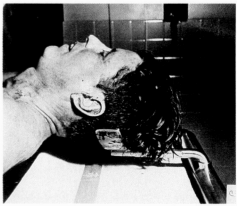

new and relevant evidence in the Kennedy case (some of the newest revelations appear in this chapter), but there is important and unseen information waiting to be examined. The President John F. Kennedy Assassination Act of 1992 was enacted as a result of public outcry following the release of the movie *JFK*. The Act requires any federal agency holding unreleased documents relating to the assassination to catalogue and transfer them to the National Archives. By June 1993, this review body still had not been appointed, partly because former President (and CIA Director) George Bush left office with the needed records in his possession.

It is our collective responsibility to not, even unwittingly, participate in a continuing cover-up. The danger of this is insidious and subtle. It is unlikely that anyone who was actively involved in the assassination is now in a position of real power, but the legacy of the assassination remains. As key participants in the cover-up pass away and memories of the assassination fade, we must continue to keep watch, insisting on accountability from our elected officials and institutions.

Governor Connally's damaged wrist. Shortly after his death in May 1993, articles quickly appeared in the press calling for a thorough autopsy examination of the Governor's body. This analysis, which potentially could have uncovered evidence refuting the Warren Commission and House Assassinations Committee reports, was not performed. Connally was buried immediately.

Uniform Man

A Polaroid photo taken by Dealey Plaza witness Mary Ann Moorman shows the President within half a second after being shot in the head. In the background are several ambiguous shapes, one of which appears to be a man in a police uniform standing behind the stockade fence at the top of the Grassy Knoll. Ruth Stapleton, sister of former President Carter, was the first to identify one of the shapes as a man. Though he appears to be dressed in the uniform of a Dallas policeman, the "officer" wore no hat. This man was discovered independently years later by Fort Worth researchers Jack White and Gary Mack, who named him Badge Man (see page 200).

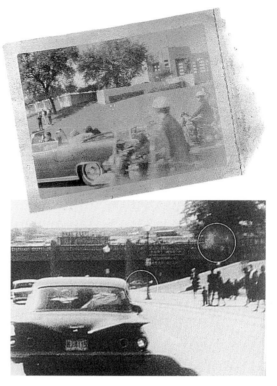

An NBC film shows what could well be a haze of gunsmoke (circled) from an assassin's rifle. The other circled area shows the President's limousine disappearing under the railroad bridge.

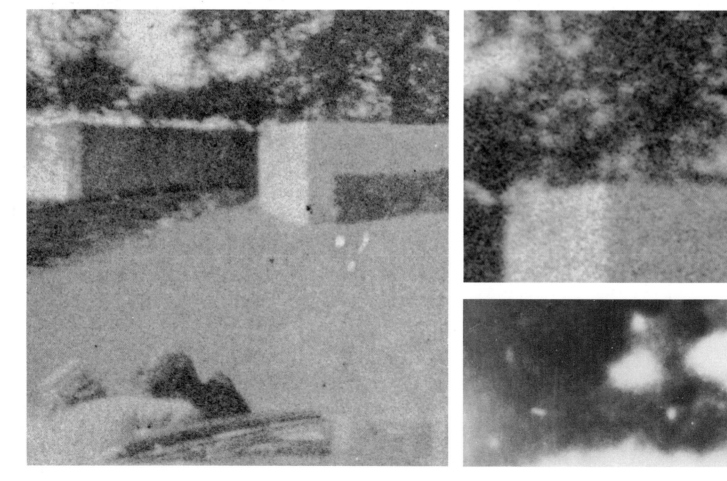

The Speaker Speaks Out

Five years after John Kennedy was killed, Thomas ("Tip") O'Neill had dinner with two men, Kenneth O'Donnell and Dave Powers, who had been close friends of the President and had ridden in the motorcade with him. During their conversation, O'Neill was surprised to hear O'Donnell and Powers recall that they had both heard shots come from behind the stockade fence on the Grassy Knoll. O'Neill said to O'Donnell, "That's not what you told the Warren Commission." Replied O'Donnell, "You're right. I told the FBI what I had heard, but they said it couldn't have happened that way, and that I must have been imagining things. So I testified the way they wanted me to. I just didn't want to stir up any more pain and trouble for the [Kennedy] family." Powers also altered his testimony in accordance with the FBI's wishes. Astounded, O'Neill declared, "I can't believe it! I wouldn't have done that. . . . I would have told the truth."[9]

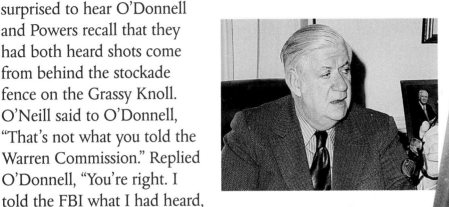

9. Thomas O'Neill: *Man of the House*, p. 211.

Dave Powers was standing in the follow-up car behind the President, taking 16 mm footage of the motorcade (*below*). He claimed to have run out of film just before the procession reached Dealey Plaza. None of his film has ever been shown publicly.

Long saddened by the assassination of a respected colleague, O'Neill was skeptical, even hostile, about the efficacy of the House Assassinations Committee investigation.

Kenneth O'Donnell stands next to the President (*below right*) and Dave Powers, wearing a hat, walks with the President (*bottom right*).

When O'Neill assumed his position as Speaker of the House in 1977, the Committee was just beginning to show the effects of the continued fighting between Henry Gonzalez and Richard Sprague. O'Neill, though disgusted by the bad press the Committee was receiving, demanded that Gonzalez improve the Committee's performance.

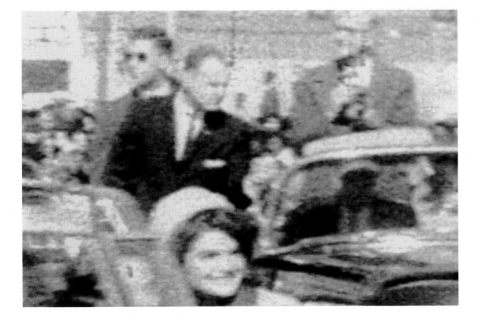

Bronson/Hughes Evidence

Bystander Charles Bronson was in Dealey Plaza on the southwest corner of Main and Houston Streets. Six minutes before the shooting, an unidentified man had an epileptic seizure on the corner of Elm and Houston. Bronson, thinking this incident interesting, filmed it with his 8 mm camera and inadvertently photographed the sixth floor of the Depository. His film caught the movements of figures in the alleged sniper's window and two adjacent windows on the sixth floor. Robert Hughes filmed the motorcade from Main and Houston Streets as it turned onto Elm. His film also revealed movement in those same windows.

Lee Harvey Oswald had no way of knowing the motorcade was late. If he had planned the assassination, he would have been on the sixth floor getting in position to fire at least six minutes before the shooting. He was sitting in the lunchroom at 12:20 p.m.

John Powell, a prisoner in the sixth floor of the county jail, said he and other inmates clearly saw two men in the sniper's window opposite them.

Immediately following the assassination, Bronson called the FBI and told them about the film he had taken. They later reviewed it and told him that his footage did not contain any important information. In 1978, assassination researcher and journalist Earl Golz discovered an FBI memorandum about the Bronson film and was able to borrow this film from Bronson. Later, I optically enhanced the film, which yielded evidence of movement in three of the sixth floor windows.

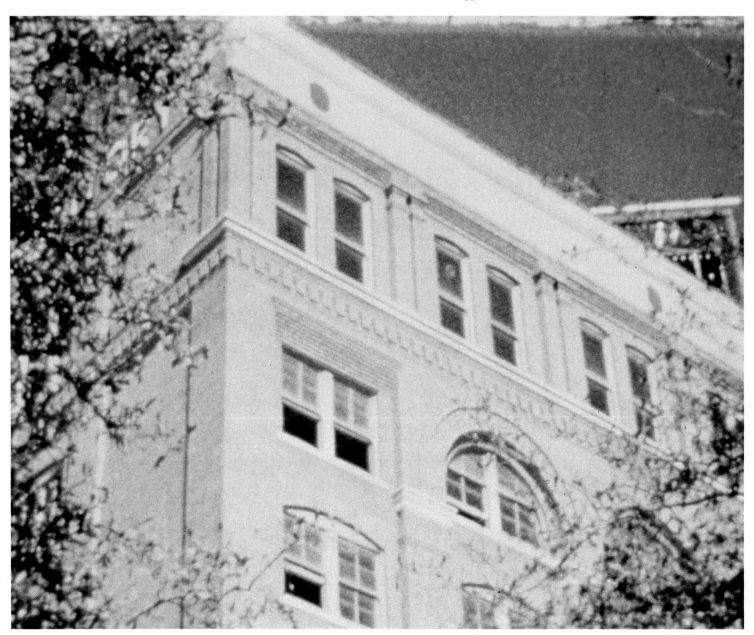

Blowups of the Hughes frames (*above left and center*) confirm that there were people on the Depository sixth floor as the motorcade passed.

ASSASSINATION MYTHS, #5

An unusual myth around the assassination is that there was a Secret Service agent in the follow-up car who, upon hearing the gunfire, stood up and accidentally fired his automatic rifle. He shot the President in the back of the head, killing him, and this was later covered up by the Secret Service. Bronson's film shows that nobody in the follow-up car slipped, made a sudden movement, or fired a gun.

Several bystanders recall seeing activity in the sixth floor "sniper's" window, and this picture (*above right*) clearly shows a person's arm just seconds after the shooting.

The Figure in the West End Window

Dallas Morning News photographer Tom Dillard took a photo of the Depository that caught the building's sixth floor windows. Dillard, riding in a motorcade press car (eight cars behind the President's), snapped the picture 15 seconds after the last gunshot was fired. This photo, widely published since the assassination, has always been reproduced with the left side (which shows the west end windows) cropped off. The uncropped version is shown here and includes the sixth floor west end windows (*below*). In one of them is the figure of a heavyset man wearing a white T-shirt. A shot fired from this window would match either of Governor Connally's wounds, explaining how the Governor was hit on such a sharp right-to-left trajectory at a steep, downward angle.

Eyewitness Howard L. Brennan watched the motorcade from a concrete wall at the southwest corner of Elm and Houston Streets. He had a clear view of the Depository Building while waiting for the motorcade to arrive. Brennan noticed a man at the southeast corner window of the sixth floor of the Depository and observed that he left the window "a couple of times."

After the shooting, Brennan said that he saw a pipe-shaped object (which could have been the barrel of a rifle) being withdrawn slowly back inside the window. Moments later, the alleged gunman appeared in the window, looking out, according to Brennan, as if to "admire his handiwork."

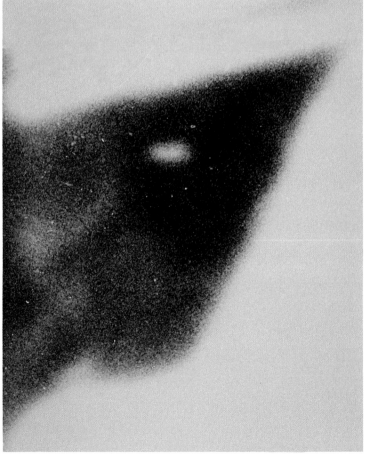

Another witness, Amos Lee Euins, also was facing the Depository. He stated, "I seen this pipe thing sticking out the window. And I wasn't paying too much attention to it. Then, when the first shot was fired, I started looking around. . . . I looked up at the window, and he shot again."

Since the entire sixth floor of the Depository is one large room, anyone looking out the west end windows would have been aware of shots being fired from the alleged "sniper's nest," even though it was at the opposite (east) end of the floor.

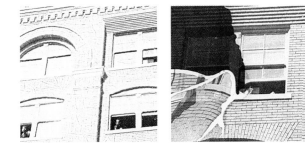

The House Committee's photographic panel ruined both of Tom Dillard's negatives of the Depository facade *(left)* when they left a radioactive enhancement substance on the photos for a year rather than the maximum of a few hours allowable. Note the effect on the photographs.

Following extensive work on the negatives and despite the grainy quality of the enlargements, the shape and features of a man in the window become visible — the hairline, the forehead, the eyes, nose, mouth, and shoulders. The white spot over his left shoulder is a light fixture.

Brennan, who was nearsighted, was not wearing his glasses that day. Yet he was the Warren Commission's key witness for placing Lee Harvey Oswald in the sixth floor southeast window. Brennan later failed to pick Oswald out of the police

lineups, and when quizzed as to why he could not identify Oswald, he intimated that he was afraid of Oswald's Communist friends. No public announcement had yet been made about Oswald's supposed Communist leanings.

This artist's rendering *(below right)* of the man's features add clarity to graininess of the enhanced photograph. The man is clearly not Lee Oswald. He is heavier, with a flat-top crew cut.

Project X

A recent controversial project was Oliver Stone's film *JFK,* the most accurate and influential depiction of the evidence in the Kennedy assassination since the Zapruder film was shown on "Goodnight America." As a consultant to the film, I met Mr. Stone for the first time in Dallas and was impressed with his personal commitment to the project. The name Project X was given the film in order to deflect the possible curiosity and intervention of various government agencies and the press. Early on in the project, an assassination researcher fraudulently obtained a first-draft copy of the script and sent it to another researcher, who gave it to journalist George Lardner. This security breach resulted in Lardner's attacking the film in the press.

Below: Lovita Irby's photograph of me advising on the set of *JFK.*

Putting me through an intensive questioning and interview process, Oliver Stone sifted through fact and theory, which he shared with the film's personnel, from production crew to actors. All staff were required to view the optically enhanced Zapruder film, which Mr. Stone used to re-create the setting in Dealey Plaza.

In the re-enactments, we were able to test out all the theories as to the nearly two dozen possible firing points in Dealey Plaza. Mr. Stone and his assistants were able to obtain access to places that researchers had been theorizing about for decades: We could observe the trajectory of a shot from the second floor of the Dal-Tex Building; check other possible trajectories by positioning a rifle on the roof of the County Records Building; and after replacing the Stemmons Freeway sign in its original position for the first time since 1963, we could confirm the viability of the two shots from the Grassy Knoll.

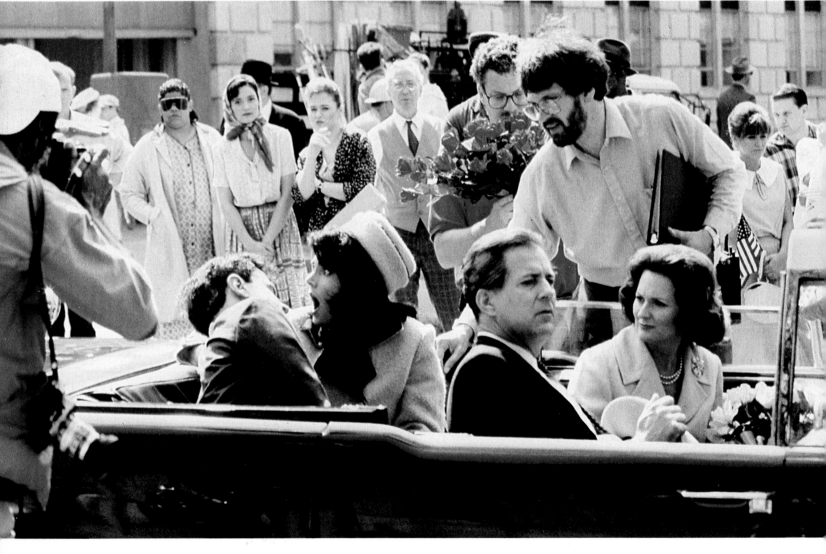

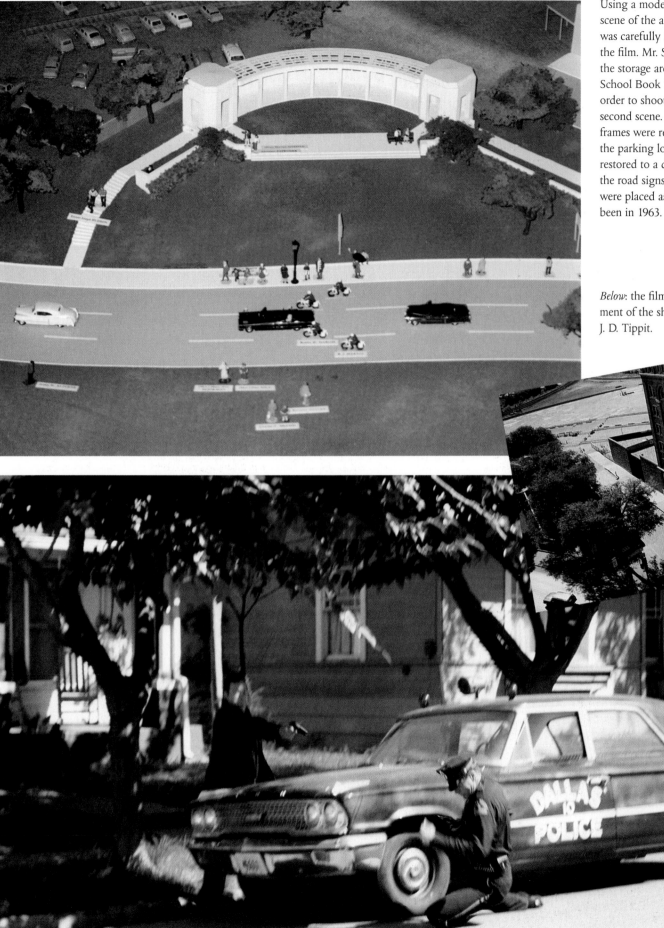

Using a model, the original scene of the assassination was carefully re-created for the film. Mr. Stone rebuilt the storage area of the Texas School Book Depository in order to shoot a single, five-second scene. The window frames were repainted and the parking lot behind was restored to a dirt surface. All the road signs in the Plaza were placed as they had been in 1963.

Below: the film's re-enactment of the shooting of J. D. Tippit.

JFK: The Movie

Years of research and an accumulation of facts, connections, and theory came to life in the making of *JFK*. When the filming began, Oliver Stone started with the events at Dealey Plaza — the most exacting and complex of all of the film's re-enactments. The geography of Dealey Plaza was revived, from the replanting of the original types of foliage to moving the Plaza lightposts back to their original locations. Mr. Stone had the railroad tracks in the yard behind the Depository meticulously replaced. He even found replicas of all the vehicles in the original motorcade. Like stepping through a time warp, witnessing this re-creation was eerie and enlightening: Even though seven shots were fired in the Plaza during most of the takes, only three or four shots could be heard, depending upon where you were standing. It was now clear why some of the Dealey Plaza witnesses reported hearing only three shots.

Opposite: On the set of *JFK* with the painstaking re-creation of Dealey Plaza used to film the courtroom scene during Clay Shaw's trial.

The re-creation of Jefferson Boulevard. The Texas Theatre, where Oswald was arrested, is down the block, at left. The original Hardy shoe store, where Johnny Calvin Brewer originally saw Lee Oswald, was farther down the boulevard to the right.

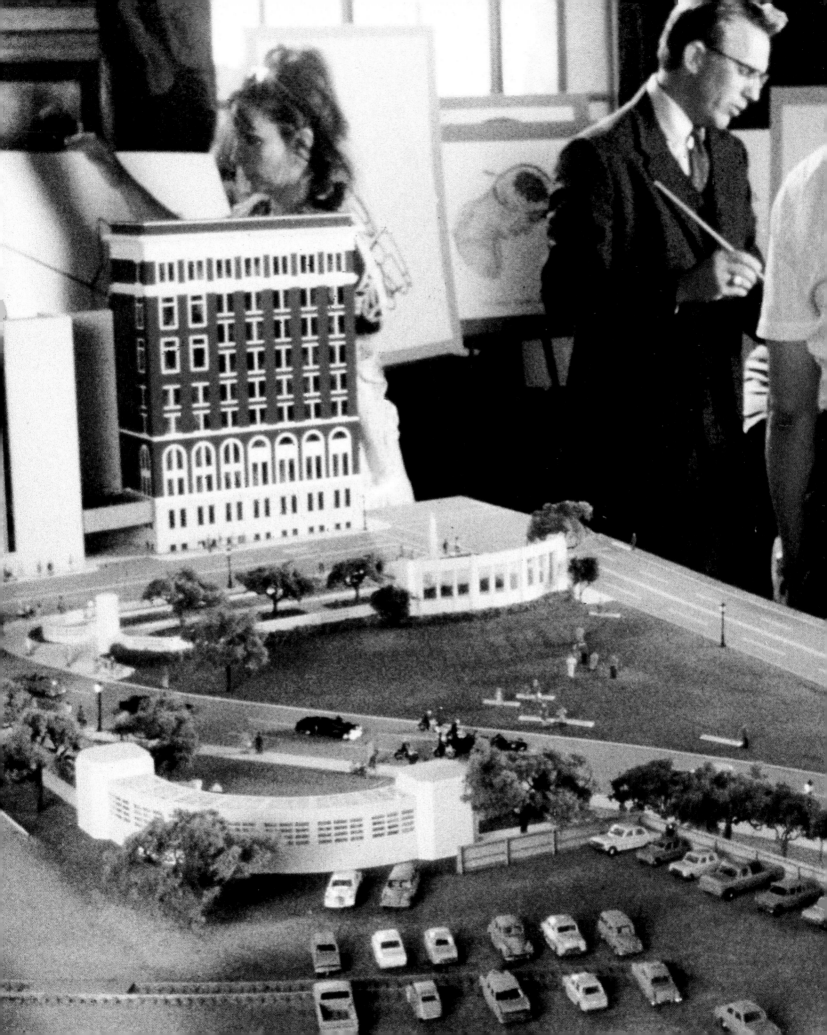

I played a number of cameo roles in the movie; I portrayed the projectionist who showed the Zapruder film in the courtroom at the Shaw trial and two doctors at Parkland Hospital.

While the movie was in the first week of filming, it was attacked in the press by journalist George Lardner of the *Washington Post.* Lardner had originally ridiculed Garrison's investigation back in the late 1960s. Twenty-two years after Clay Shaw's acquittal, it appears that Garrison's investigation, as described in *JFK,* brought forward much of the truth about the conspiracy. Though this realization is perhaps embarrassing to Garrison's longtime critics in the press, it is one that may help safeguard our future against other deadly conspiracies, including acts of collusion within the media.

When trying to obtain permission to work in Dealey Plaza, Mr. Stone came up against resistance from Dallas officials. They had originally voted against allowing him to photograph from the sixth floor of the Depository.

Below: I examined angles and trajectories using the meticulous scale model constructed to test and check the story boards.

Opposite: National Security Action Memorandum #273: The first directly political result of the Kennedy assassination—the almost immediate reversal of John Kennedy's plan to withdraw troops from Vietnam, which he had outlined to his staff on October 5, 1963 (see page 1). Johnson's memorandum was written and enacted only one month and twenty-one days after President Kennedy had made this internal announcement to his staff—and four days after the assassination.

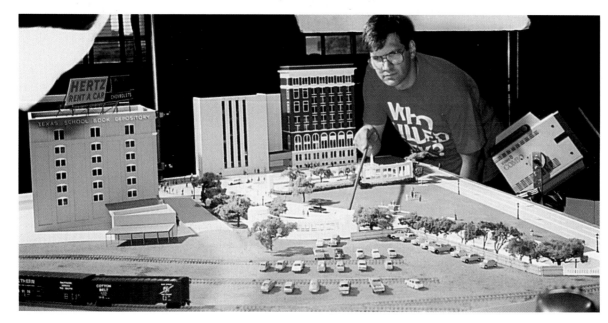

The Vigil Continues

When I lecture on the Kennedy assassination, I am asked questions about the "who" and "how" of the murder and cover-up. The most startling question has been: "After all this time, does the JFK assassination really matter?" Of course it does! Those directly involved in the crime and cover-up might never be brought forward or confess as a result of any further investigations. But that is, perhaps, of secondary importance. We must be vigilant and take as our primary responsibility a careful scrutiny of the past, taking those measures necessary to ensure that history does not repeat itself.

THE WHITE HOUSE
WASHINGTON

November 26, 1963

~~TOP SECRET~~

NATIONAL SECURITY ACTION MEMORANDUM NO. 273

TO:
The Secretary of State
The Secretary of Defense
The Director of Central Intelligence
The Administrator, AID
The Director, USIA

The President has reviewed the discussions of South Vietnam which occurred in Honolulu, and has discussed the matter further with Ambassador Lodge. He directs that the following guidance be issued to all concerned:

1. It remains the central object of the United States in South Vietnam to assist the people and Government of that country to win their contest against the externally directed and supported Communist conspiracy. The test of all U. S. decisions and actions in this area should be the effectiveness of their contribution to this purpose.

2. The objectives of the United States with respect to the withdrawal of U. S. military personnel remain as stated in the White House statement of October 2, 1963.

3. It is a major interest of the United States Government that the present provisional government of South Vietnam should be assisted in consolidating itself and in holding and developing increased public support. All U. S. officers should conduct themselves with this objective in view.

4. The President expects that all senior officers of the Government will move energetically to insure the full unity of support for established U. S. policy in South Vietnam. Both in Washington and in the field, it is essential that the Government be unified. It is of particular importance that express or implied criticism of officers of other branches be scrupulously avoided in all contacts with the Vietnamese Government and with the press. More specifically, the President approves the following lines of action developed in the discussions of the Honolulu meeting of November 20. The offices of the Government to which central responsibility is assigned are indicated in each case.

(page 1 of 3 pages)

~~TOP SECRET~~

DECLASSIFIED 5-23/78

The Disbelievers

Soon after the Warren Commission Report was released in 1964, a small handful of individuals who had been independently researching the Kennedy assassination became concerned over the Commission's findings. These first "disbelievers," alarmed about the disparity between the Report's conclusions and the solid evidence already uncovered in the case, created a movement to reopen the investigation. Their driving force has always been a quest for the truth, and their work at times has been difficult and dangerous: There are those who believe that the facts about the Kennedy assassination should remain hidden at all costs.

Three decades after the President's death, the assassination research community has grown to include thousands of individuals who carry on the work started by the original group of Warren Report critics. Over the years, this community has accomplished much, patiently and consistently compiling and organizing a vast cache of evidence overlooked or altered by the Warren Commission. They have uncovered the testimonies of those witnesses the government did not want in the public record, and they have discovered long-suppressed documents that were secreted within the National Archives and various federal agencies, as well as other locations.

Though the absence of formal funding hampers our work, perhaps the most overwhelming impediment is the government's interference in the form of stonewalling and disinformation tactics. The government maintains a long reach of influence over its "propaganda assets," and the community has seen the appearance of new "critics" who are, in fact, disinformation generators attempting to discredit the legitimate critical community with false accusations and false "evidence." We have no means to regulate those who purport to be serious critics, nor is there an open forum to challenge all of the disinformation and misinformation. Let the buyer beware, for not everyone who says the assassination and its cover-up was the result of a conspiracy is a champion of the truth.

Organizations

The JFK Assassination Information Center
110 S. Market Street
Dallas, Texas 75202
(214) 653-0457
Contact: Larry Howard, Director

This organization, based in Dallas, Texas, is an excellent place to obtain information about current and past assassination research. The Center's resources include an ongoing newsletter, an extensive publications library, a collection of audio-visual materials, and museum exhibits (with a related audio tour) detailing the events of the Kennedy assassination.

The Assassination Archives and Research Center (AARC)
918 "F" Street, N.W.
Washington, D.C. 20004
(202) 393-1917
Contact: Jim Lesar, President

The AARC is a major depository of historical and current information and documentation concerning assassinations that have occurred within the United States.

Newsletters

The Third Decade
State University College
Fredonia, NY 14063
Jerry Rose, Publisher

This 50-page bimonthly newsletter features articles and information presented by the assassination research community. The publication showcases the latest assassination research, theories, and other research resources. Subscription rates are $20 for 1 year, $36 for 2 years, $50 for 3 years. Single copies can be ordered for $4.

Dateline Dallas
The JFK Assassination Information Center
(214) 653-1619
Robert T. Johnson, Editor

A periodic newsletter with up-to-date articles.

Bookstores

There are a small number of bookstores that specialize in books relating to the assassination. The following three stores are among the best:

Handy Books
1762 Avenue Road
Toronto, Ontario M5M 3Y9
Canada
(416) 781-4139

The Last Hurrah Bookshop
937 Memorial Avenue
Williamsport, PA 17701
(717) 327-9338

The President's Box Bookshelf
P.O. Box 1255
Washington, D.C. 20013
(703) 998-7390

Recommended Documentaries

JFK: An Unsolved Murder
KRON-TV, San Francisco, California, 1988
Stanhope Gould, producer; Sylvia Chase, host.

This documentary presents an in-depth discussion of the medical and photographic evidence in the Kennedy case, and includes statements from physician experts and witnesses who were attendant at the President's autopsy. The piece also includes an implausible theory that the President's body was stolen between Parkland and Bethesda Hospitals.

The Men Who Killed Kennedy
Central Independent Television, Birmingham, England, 1988, Nigel Turner, *producer.*

An extensive essay that gives a good overview of all the collected evidence, but overemphasizes a theory that French hit men were employed to kill the President.

Reasonable Doubt
C.S. Films, Inc., Baltimore, Maryland, 1988
Chip Selby, *producer.*

This film presents information that successfully refutes the single bullet theory, but focuses only on that aspect of the assassination.

JFK, The Director's Cut
Warner Home Video, Burbank, California, 1993.

The director's cut of Oliver Stone's film *JFK* is 17 minutes longer than the movie as shown in public theaters.

Who Didn't Kill . . . JFK.
3-G Home Video, Montebello, California, 1990
Jack White, *host.*

This program contains extensive analysis of the "backyard" photographs of Lee Harvey Oswald.

JFK: The Case for Conspiracy
New Frontier Video, Boothwyn, Pennsylvania, 1993

A video documentary with all of the most relevant available visuals relating to the assassination and the medical evidence. Includes Robert Groden's enhanced assassination footage. This is the first tape in a projected series.

Many video documentaires and a catalog are available from ATV Films, 405 Hopkins Court, North Wales, Pennsylvania 19454-1026.

Bibliography

ANSON, ROBERT SAM. *They've Killed the President! The Search for the Murderers of John F. Kennedy.* New York: Bantam Books, 1975.

BLAKELY, G. ROBERT, AND RICHARD N. BILLINGS. *The Plot to Kill the President: Organized Crime Assassinated JFK.* New York: Times Books, 1981.

BLUMENTHAL, SID, AND HARVEY YAZIJIAN, eds. *Government by Gunplay: Assassination Conspiracy Theories From Dallas to Today.* New York: New American Library, 1976.

BUCHANAN, THOMAS G. *Who Killed Kennedy?* New York: Putnam's, 1964.

CRENSHAW, CHARLES A., JENS HANSON, AND J. GARY SHAW. *JFK: Conspiracy of Silence.* New York: Signet Books, 1992.

CURRY, JESSE E. *JFK Assassination File.* Jesse E. Curry, 1969.

DAVIS, JOHN H. *Mafia Kingfish: Carlos Marcello and the Assassination of John F. Kennedy.* New York: New American Library, 1989.

DIEUGENIO, JAMES. *Destiny Betrayed: JFK, Cuba, and the Garrison Case.* New York: Sheridan Square Press, 1992.

EDDOWES, MICHAEL. *The Oswald File.* New York: Clarkson N. Potter, 1977.

EPSTEIN, EDWARD JAY. *Inquest: The Warren Commission and the Establishment of Truth.* New York: Viking Press, 1966.

FENSTERWALD, BERNARD, AND MICHAEL EWING. *Coincidence or Conspiracy?* New York: Zebra Books, 1977.

FLAMONDE, PARIS. *The Kennedy Conspiracy: An Uncommissioned Report on the Jim Garrison Investigation.* New York: Meredith Press, 1969.

FOX, SYLVAN. *Unanswered Questions about President Kennedy's Assassination.* New York: Award Books, 1965.

GARRISON, JAMES. *A Heritage of Stone.* New York: Putnam's, 1970.

———. *On the Trail of the Assassins.* New York: Sheridan Square Press, 1988.

GENTRY, CURT. *J. Edgar Hoover: The Man and His Secrets.* New York: W. W. Norton & Company, 1991. Reprint. New York: Penguin Books USA Inc./Plume, 1992.

GRODEN, ROBERT AND HARRISON EDWARD LIVINGSTONE. *High Treson.* Baltimore: Conservatory Press, 1989. Reprint. New York: Berkley Books, 1990.

HUBBARD-BURRELL, JOAN. *What Really Happened? JKF: Five Hundred & One Questions & Answers.* Spring Branch, Tex.: Ponderosa Press, 1992.

JOESTEIN, JOACHIM. *Oswald: Assassin or Fall Guy?* New York: Marzani & Munsell, 1964.

JONES, PENN. *Forgive My Grief.* 4 vols. Midlothian, Tex.: Penn Jones, 1966-1974.

LANE, MARK A. *Rush to Judgement.* New York: Holt, Rinehart and Winston, 1966.

———. *Citizen's Dissent.* New York: Holt, Rinehart and Winston, 1968. Reprint. New York: Dell, 1975.

———. *Plausible Denial.* New York: Thunder's Mouth Press, 1991.

LEEK, SYBIL, AND BERT R. SUGAR. *The Assassination Chain.* New York: Corwin Books, 1976.

MARCHETTI, VICTOR, AND JOHN D. MARKS. *The CIA and the Cult of Intelligence.* New York: Alfred A. Knopf, 1974.

MARCUS, RAYMOND. *The Bastard Bullet: A Search for Legitimacy for Commission Exhibit 399.* N.p. 1990.

MEAGHER, SYVIA. *Subject Index to the Warren Report and Hearings and Exhibits.* Metuchen, N.J.: Scarecrow Press, 1966.

———. *Accessories After the Fact: The Warren Commission, The Authorities, and the Report.* Indianapolis: Bobbs-Merrill, 1967. Reprint. New York: Vintage Books, 1976.

———, and Gary Owens. *Master Index to the J.F.K. Assassination Investigations: The Reports and Supporting Volumes of the House Select Committee on Assassinations and the Warren Commission.* Metuchen, N.J.: Scarecrow press, 1980.

MELANSON, PHILIP. *Spy Saga: Lee Harvey Oswald and U.S. Intelligence.* New York: Praeger Publishers, 1990.

MILLER, TOM. *The Assassination Please Almanac.* Chicago: Henry Regnery, 1977.

MODEL, F. PETER, AND ROBERT J. GRODEN. *JFK: The Case For Conspiracy.* New York: Manor Books, 1976.

NEWMAN, JOHN M. *JFK & Vietnam: Deception, Intrigue and the Struggle for Power.* New York: Warner Books, 1991.

NOYES, PETER. *Legacy of Doubt.* New York: Pinnacle Books, 1973.

OGLESBY, CARL. *The Yankee and Cowboy War: Conspiracies from Dallas to Watergate and Beyond.* Mission, Kans.: Sheed, Andrews and McNeel, 1976.

———. *Who Killed JFK?* Berkeley, Calif.: Odonian Press, 1992.

O'NEILL, THOMAS ("TIP"). *Man of the House.* New York: St. Martins Press, 1987.

O'TOOLE, GEORGE. *The Assassination Tapes: An Electronic Probe Into the Murder of John F. Kennedy and the Dallas Cover-up.* New York: Penthouse Press, 1975.

POPKIN, RICHARD H. *The Second Oswald.* New York: Avon Books, 1966.

PROUTY, L. FLETCHER. *The Secret Team: The CIA and Its Allies in Control of the United States and the World.* Englewood Cliffs, N.J.: Prentice-Hall, 1973.

ROFFMAN, HOWARD. *Presumed Guilty.* Rutherford, N.J.: Fairleigh Dickinson University Press, 1975.

SAUVAGE, LEO. *The Oswald Affair: An Examination of the Contradictions of the Warren Report.* New York: World Publishing Co., 1966.

SCHEIM, DAVID E. *Contract on America: The Mafia Murder of President John F. Kennedy.* New York: Zebra Books, 1988.

SCOTT, PETER DALE, PAUL HOCH, AND RUSSELL STETLER. *The Assassinations: Dallas and Beyond — A Guide to Cover-ups and Investigations.* New York: Vintage Books, 1976.

———. *Crime and Cover-ups: The CIA, the Mafia, and the Dallas-Watergate Connection.* Berkeley, Calif.: Westworks, 1977

SHAW, J. GARY, AND LARRY R. HARRIS. *Cover-up: The Governmental Conspiracy to Conceal the Facts About the Public Execution of John F. Kennedy.* N.p. 1976.

SLOAN, BILL, WITH JEAN HILL. *JFK: The Last Dissenting Witness.* New York: Pelican Books, 1992.

SMITH, MATTHEW. *JFK: The Second Plot.* Edinburgh and London: Mainstream Publishing, 1992.

STONE, OLIVER, AND ZACHARY SKLAR. *JFK: The Documented Screenplay.* New York: Applause Books, 1992.

SUMMERS, ANTHONY. *Conspiracy.* New York: McGraw-Hill, 1980.

THOMPSON, JOSIAH. *Six Seconds in Dallas: A Microstudy of the Kennedy Assassination.* New York: Bernard Geis & Associates, 1967.

U.S. HOUSE OF REPRESENTATIVES, Select Committee on Assassinations. *The Final Assassination Report.* New York: Bantam Books, 1979.

WEISBERG, HAROLD. *Whitewash.* Vol. 1, T*he Report on the Warren Report.* Hyattstown, Md.: Harold Weisberg, 1965. Reprint. New York: Dell, 1966.

———. *Whitewash.* Vol. 2, *The FBI-Secret Service Cover-up.* Hyattstown, Md.: Harold Weisberg, 1965. Reprint. New York: Dell, 1967.

———. *Whitewash.* Vol. 3, *Suppressed Kennedy Assassination Pictures.* Hyattstown, Md.: Harold Weisberg, 1967.

———. *Oswald in New Orleans.* New York: Canyon Books, 1967.

———. *Whitewash.* Vol. 4, *JFK Assassination Transcript.* Frederick, Md.: Harold Weisberg, 1974.

———. *Post Mortem: JFK Assassination Cover-up Smashed!* Frederick, Md.: Harold Weisberg, 1975.

WILBER, THOMAS. *Medicological Investigation of the President John F. Kennedy Murder.* Springfield, Ill.: Charles C. Thomas, 1978.

ZERBEL, CRAIG I. *The Texas Connection: The Assassination of President John F. Kennedy.* Scottsdale, Ariz.: Wright & Company, 1991.

Index

A

Accessories After the Fact, xii
Acoustical evidence of assassination, 172-75
Agnew, Spiro, 147
Alexander, William, 101
Altgens, Ike, 31, 33, 36, 184-86, 194
Anderson, John, 162
Andrews Air Force Base, 88
Andrews, Dean, 138
Arnold, Carolyn, 18, 64, 94-95
Arnold, Gordon, 32, 36
Aschkenasy, Dr. Ernest, 172-74
The Assassination Archives and Research Center, 216
Assassination Information Bureau (AIB), 146
Assassination myths
 of accidental shooting of Kennedy, 207
 of reaction in the Vice-President's car, 37
 regarding Mrs. Kennedy, 39
 of the Secret Service car door, 14
Autopsy
 disallowal of in Texas, 71
 photos of, 76-85, 160-61, 179-81
 as sham, 73-75, 140
 See also X-Rays

B

Babushka Lady. See Oliver, Beverly
Back wounds
 medical investigation of, 78-79
 Warren Commission report on, 118,125
Backyard photos of Oswald, 122, 168-71
Bagman, 6
Baker, Bobby, 114
Baker, Marrion L., 48, 62, 64, 94
Ballistic evidence
 in Kennedy assassination, 58, 64-66, 176-77
 in Officer Tippit murder, 100
 See also Bullets; Weapons
Banister, Guy, 136-38, 140, 198
Barger, James, 173
Barker, Bernard, 157
Batchelor, Charles, 8, 106
Bay of Pigs, 4, 114-15, 133
Belin, David, 98-99, 131, 147, 151
Bell, Audrey, 87, 128
Benavides, Domingo, 98
Bertrand, Clay. See Shaw, Clay Ellis
Bethesda Naval Hospital, 73
Bissell, Richard, 114
Black Dog Man, 24, 192-95
Blahut, Regis, 161
Blakey, G. Robert, 160, 162, 166-67
Boggs, Hale, 117, 129

Bookstores, for obtaining assassination materials, 216
Boone, Eugene, 64
Boswell, Dr. J. Thornton, 74, 83, 86, 88, 126, 180
Bowers, Lee, 61, 68-69
Boxley, Bill. See Wood, William
Brading, Eugene Hale, 157
Brain, missing evidence of Kennedy's, 82-85,87, 89, 178
Breneman, Chester, 19, 120
Brennan, Howard Leslie, 48, 52, 64, 208-9
Brewer, Johnny Calvin, 10, 212
Bronson, Charles, 165, 206-7
Brown, Jack, 197
Brown, Judge Joe, 93
Bullets
 analysis of fragments, 129
 found in Parkland Hospital, 58, 128
 trajectory of, 89, 129
 See also Ballistic evidence; Gunshots; Weapons
Bundy, McGeorge, 1
Bundy, Vernon, 142
Burkley, Admiral George, 58, 73, 77, 79, 87, 181
Bush, George, 202
Butler, George, 106

C

Cabell, Charles, 114
Cabell, Earle, 3, 107
Cabinet members, at time of assassination, 43
Callaway, Ted, 99
Calley, Lt. William, 146
Carousel Club, 105, 109-10
Carr, Richard Randolph, 62, 143
Carrico, Dr. Charles, 59, 76-77, 87
Carroll, Bob, 99
Castro, Fidel
 assassination plots against, 4, 48, 115, 152
 closing of Mafia operation in Cuba by, 5, 111
CBS, connections with CIA, 202
Chase, Sylvia, 83
Cherami, Rose, 111
Chetta, Nicholas, 143
Church, Frank, 151
CIA
 assassination plots against Castro, 4
 connections with CBS, 202
 manipulation of media by, 144-45
 Oswald's relationship to, 91-92, 113, 118, 130, 140, 152
 response to criticism of Warren Report, xiv
Clark, Ramsey, 89, 129, 140
 panel of experts, 182-83
Clemmons, Aquilla, 97, 99
Clifton, Major General

Chester, 6
Code book, missing from Cabinet plane, 43
Colson, Charles, 150
Committee to Re-elect the President (CREEP), 150
Conforto, Janet Adams, 109
Connally, John 5-6
 gunshot wound to torso, 26-28, 125-27
 gunshot wound to wrist, 36-37, 128, 203
 reaction to first shot, 20-21
 and "single bullet" theory, 126
 suppression of autopsy on, 203
Conspiracy
 acoustical evidence of, 172-75
 House Assassinations Committee verdict on, xiv, xvi, 44
Cooper, John Sherman, 117
Coy, Dr. Ronald, 181
Craig, Roger, 62, 64
Crawford, John, 198
CREEP, 150
Crenshaw, Dr. Charles, 86
Crime, organized. See Organized crime
Cuban Missile Crisis, 4
Curry, Jesse, 4, 8, 9, 52, 103, 105, 107, 124
Curtain rods, 65, 96, 122, 131
Custer, Jerrol, 83, 88, 182

D

Daley, Richard, 146
Dallas
 Kennedy's arrival in, 6-7
 political climate in 1963, 4
Dallas County Government Center, 62
Dallas County Records Building, 16, 70
Dallas Morning News
 Nixon prediction in, 6, 114
 publication of motorcade route in, 16
Dallas Times-Herald, 16
Dallas Trade Mart, 5, 10, 12
Dal-Tex Building, 21, 28, 31, 41, 184-85
Daniels, Napoleon, 106
Dealy Plaza, 5, 16-17
 after the shooting, 47-51
 arrest of "tramps" in, 48, 61, 69-70, 143, 203
 assertion of witnesses in, 32
 Black Dog Man of, 24, 192-95
 geography of, 17-18, 32
 investigation of, 67-68
 lack of Secret Service agents in, 12
 motorcade route through, 8, 10-11, 16
 origination of gunshots in, 167, 172-75

recreation of for film JFK, 210-12
 Umbrella Man of, 24, 188-89
 Uniform Man of, 204
Dean , John, 150
Death certificate, at Kennedy's death, 73
Death Project. See Mysterious Death Project
Decker, Bill, 8, 9, 16, 52
Dees, Geneva, 170
DeMohrenschildt, George, 131, 164, 166
Devine, Sam, 162
Dictabelt recording, 44, 52, 166-67
 as acoustical evidence, 172-75
Dillard, Tom, 208-9
Dobbs House, 98
Documentaries, about the assassination, 217
Downing, Thomas N., xiv, 148, 159, 162
Dulaney, Dr. Richard, 87
Dulles, Allen, 4, 114-16, 202

E

Ellsberg, Dr. Daniel, 150
Elm Street, 9-12, 14, 17, 68
Epileptic seizure victim, 14, 206
Erlichman, John, 147
Ervin, Sam, 150
Euins, Amos, 48, 67, 209
Executive Order No. 11130, xi, 113

F

Fair Play for Cuba Committee, 105, 130-31, 137
FBI
 ignoring of acoustical evidence, 175
 investigation of Kennedy's assassination, 113, 115-16
 Oswald's involvement with, 91-92, 118, 130
Ferrell, Mary, 102, 130,
Ferrie, David, 110, 130, 133-134, 137-141
Films of assassination. See Nix, Orville; Zapruder, Abraham
Finck, Dr. Pierre, 74, 126, 128, 139
Fiorini, Frank. See Sturgis, Frank
Fisher, Dr. Russell, 89, 160, 198
Florer, Larry, 67
Fonzi, Gaeton, 164
Ford, Gerald, 115, 117, 119, 147, 181
 appointment as President, 149
 appointment of Nelson Rockefeller, 151
Forgive My Grief, xiv
Fort Worth, 5-6, 9
Frazier, Buell Wesley, 65, 96, 122, 131

Fritz, Will, 62, 65, 92, 102, 122

G

Garrison, Jim, 40, 133
 criticism of investigation of, 145, 214
 investigation by, xi, xii, 133-35, 139-44
Gatlin, Maurice B., 198
Giancana, Sam, 156, 198
Golz, Earl, 206
Gonzalez, Henry, 159, 162, 164, 205
"Goodnight America," Zapruder film showing on, xiv, 148, 210
Grammer, Billy, 104
Grassy Knoll
 abandoned car found in, 7
 after the shooting, 47-51
 during the shooting, 20, 22, 32
 eyewitness accounts near, 34
 Secret Service stationed at, 47, 51, 54, 60
Graves, L.C., 93
Greer, William, 12, 18
 description of Kennedy's head wound, 181
 reaction to gunshots, 23, 33, 37, 43
Gregory, Dick, xiv, 146
Griffin, Burt, 131
Guevara, Che, 152
Guns. See Ballistic evidence; Bullets; Mannlicher-Carcano; Mauser; Weapons
Gunshots
 first, 20-21
 second, 22-24
 third, 26-27
 fourth, 28-31
 fifth, 32-35
 sixth, 36-37
 acoustical analysis of, 32, 172-75
 tape recording of, 23
 See also Dictabelt recording

H

Haldeman, Bob, 147
Hamilton, Edward, 150
Hargis, Bobby, 32, 47
Harper, Billy, 34, 83
Harper Fragment, 34, 83
Harrelson, Charles, 11
Hart, Gary, 151
Head wound
 autopsy photos of, 76-85, 160-61, 166, 179-81
 investigation of, 80-81
 missing evidence of, 82-85
 and "single bullet" theory, 126
 X-rays of, 182-83
Helms, Richard, 142
Helpern, Dr. Milton, 127
Henchliffe, Margaret, 76, 180
Hess, Jacqueline, xiv, 191, 198

Hicks, Jim, 51
Hills, Clint, 15, 36, 39, 43, 50, 192, 202
Hill, Gerald, 98-99, 101, 176
Hill, Jean, 47
Hoffa, James, 156
Hoffman, Ed, 43, 87
Holland, S.M., 32, 44
Hoover, J. Edgar, 4
 gambling of, 119
 memo about Oswald, 137
 Warren Commission and, 17, 115-16, 121, 128-29
Hosty, James, Jr., 103, 138
House Assassinations Committee
 creation of, xi
 Dictabelt recording and, 166-67, 172-75
 disappearance of Oswald's military records and, 140, 165
 investigation of autopsy photos, 75, 160-61, 166, 179-81
 investigation of Oswald's murder by, 106
 "lone assassin" premise and, 164
 official verdict of, xiv, xvi
 purpose of, 159-61
 refusal to exhume Kennedy's body, 166, 202
 "single bullet" theory and, 178
 summary of findings and recommendations, 163, 201
 Warren Commission findings and, 160, 164
 Zapruder film and, 166
Houston Street, 10-11, 14, 17
Howard, Thomas Hale, 108, 110
Huber, Father Oscar, 58
Hughes, Robert, 206-7
Humes, Dr. James, 74, 77, 81, 83, 86, 89, 126, 179, 181
Hunt, Dorothy, 150
Hunt, E. Howard, 48, 146, 149-50, 157
Hunt, H.L., 124
Hunter, Bill, 110

I

Ingram, Hiram, 108

J

Jaworski, Leon, 117
Jenkins, Dr. Marion, 39, 59
JFK (Oliver Stone), x, 203
 filming of, 214
 recreation of assassination scene in, 210-12
JFK: An Unsolved Murder, 217
JFK, The Director's Cut, 217
JFK Assassination File, 124
Johnson, Lady Bird, 70-71
Johnson, Lyndon, 5, 59
 and conviction of Oswald, 102
 creation of Warren Commission, 113-16
 swearing in as President, 71
Johnson, Tom, 110
Jones, Dr. Ronald, 86
Jones, Penn, xiv

K

Kellerman, Roy, 12
 description of Kennedy's head wound, 181
 reaction to gunshots, 33, 43
Kendall, Don, 6
Kennedy, Jacqueline, 20, 71
 reaction during shooting, 36-39
 testimony to Warren Commission, 38
Kennedy, John Fitzgerald
 Assassination Act of 1992, 203
 Assassination Information Center, 216
 autopsy on, 71, 73-89
 gunshot wound to back, 26, 28-29
 gunshot wound to head, 32-35
 gunshot wound to throat, 22-24
 Operation 40 and, 152
 purpose of trip to Texas, 3
 single bullet theory and, 126
 war against the Mafia, 4-5
Kennedy, Regis, 37, 162
Kennedy, Robert
 assassination of, 145-46, 202
 war against the Mafia, 4-5, 156
Khrushchev, Nikita, 4
Kilduff, Malcolm, 59
Kilgallen, Dorothy, 111, 198
Killam, Hank, 111, 156
Killam, Wanda Joyce, 111
King, Martin Luther
 assassination investigated, 162
 assassination of, 145-46, 202
Kirkwood, Pat, 9
Koethe, Jim, 110, 156
Kupcinet, Irv, 111
Kupcinet, Karen, 111

L

Lake Pontchartrain, 4
Lansky, Meyer, 111
Lardner, George, 140, 210, 214
Lawrence, Jack, 7, 110
Lawson, Winston G., 5, 8
Liddy, G. Gordon, 157
Limousine, Presidential
 acquistion of, 7
 bubbletop removal from, 9, 15
 cleaning out of, 70
 design of, 8
Lone assassin theory, xiv, 21, 29, 115, 121-23, 125-29
Long, Russell, 139
Lopez, Edwin, 164
Lorenz, Marita, 232

Love Field, 5-6, 12
Lovelady, Billy, 92
 resemblance to Oswald, 186-87

M

McClelland, Dr. Robert, 59, 81, 83-84, 87
McCloy, John, 117
McCone, John, 114
McDonald, Nick, 101
McGann, George, 111
McLain, Officer, 47, 167, 172
MacNeil, Robert, 49
Mafia
 President Kennedy's war against, 4-5
 Jack Ruby's connections to, 104, 106, 110, 119
Magic bullet theory, 26, 28, 125-29
Maheu, Robert, 156
Main Street
 gunshot evidence on curb of, 41, 177
 route not taken on, 10, 16
Manhole, gunshot evidence on, 41
Mannlicher-Carcano rifle, 64, 66, 92, 102-3, 122-23, 176-77
 firing time of, 125, 128
 Oswald's purchase of, 140
 See also Ballistic evidence; Mauser rifle; Weapons
Marcello, Carlos, 4, 136, 138, 156
Marchetti, Victor, 142
Markham, Helen, 100
Martin, Frank, 127
Martin, Jack, 127, 139-50
Mauser rifle, 64, 66, 122-23, 176
Media, CIA manipulation of, 144-45
"Media assets," CIA, 145
Medical evidence
 autopsy photos, 76-85, 160-61, 166, 179-81
 eyewitness accounts, 86-88
 fabrication of, 82-85
Medical investigation, 73-89
 Miami Beach Fountainebleu Hotel, 150
Mickelson, Sig, 202
The Militant, 168
Milteer, Joseph, 153-54, 196-97
Mitchell, John, 129, 147, 150, 157
Mob. See Mafia
Mooney, Luke, 101, 176
Moorman, Mary Ann, 50, 165, 175, 193, 195, 201, 204
Motorcade, Presidential
 motorcycle policemen in, 15
 press vehicles in, 9, 11
 route taken by, 8-11
Moyers, Bill, 9
Muchmore, Marie, film taken by, 19, 37, 193
Mysterious Death Project
 anomaly of, 198

creation of, xiv
Banister, Guy, 371
Benavides, Edward, 98
Boggs, Hale, 129
Bowers, Lee, 61
Carr, Richard, 62, 143
Cherami, Rose, 111
Chetta, Nicholas, 143
Conforto, Janet Adams, 109
Craig, Roger, 64
Crawford, Jack, 198
del Valle, Aladio, 140
DeMohrenschildt, George, 166
Ferrie, David, 140
Gatlin, Maurice, 198
Howard, Thomas, 110
Hunt, Dorothy, 150
Hunter, Bill, 110
Ingram, Hiram, 108
Johnson, Clyde, 140
Kennedy, Regis, 162
Kilgallen, Dorothy, 111
Killam, Hank, 111
Koethe, Jim, 110
Kupcinet, Karen, 111
McGann, George, 111
Martin, Frank, 127
Milteer, Joseph, 197
Nicoletti, Charles, 198
Norton, Teresa, 198
Paisley, John, 198
Perrin, Robert, 143
Pitzer, Bruce, 84
Roberts, Earline, 198
Russell, Harold, 198
Shaw, Clay, 142
Smith, Mrs. Earl, 198
Sullivan, William, 162
Underhill, Gary, 157
Walle, Marilyn, 198
Walthers, Buddy, 68
Ward, Hugh, 138
Whaley, William, 94
Worrell, James R., 95
Myths. See Assassination myths

N

National Archives
 documents missing from, 131
 Kennedy's brain missing from, 87, 89, 178, 202
National Security Action Memorandum
 on involvement in Vietnam, 214-15
 on Joint Chiefs of Staff, xv
 on withdrawal from Vietnam, 1
Nelson, Doris, 59
New Orleans, Oswald's time in, 130-31, 136-37
New Orleans Civil Air Patrol, 133, 136
New York Times, 151
Newman, William, Jr., 142
Newsletters, for assassination research, 216

Nicoletti, George, 198
Nix, Orville, film of, 19, 32, 34-35, 193
Nixon, Richard, 6, 114, 117
 and intelligence activities, 149
 presidency of, 146-47
Norton, Teresa, 198

O

O'Connor, Paul, 87, 88
O'Donnell, Kenneth, 4, 205
Oliver, Beverly, 37, 86, 109-10, 111
O'Neill, Frank, 79, 88-89
O'Neill, Thomas ("Tip"), 205
Operation 40, 152
Organizations, for assassination research, 216
Organized crime
 Kennedy's war on, 4-5
 See also Mafia
Oswald, Marguerite, 136, 170
Oswald, Lee Harvey,
 acquaintance with Jack Ruby, 109-10, 111
 alias Alek J. Hiddell, 66, 102, 123, 140
 alleged diary of, 164
 arrest of, 101-3
 backyard photos of, 122, 168-71
 and curtain rods, 65, 96, 122, 131
 involvement with CIA, 91-92, 113, 118, 130, 136-137, 141, 152
 involvement with FBI, 91-92, 118, 137
 marksmanship of, 103
 motive for assassination, 121
 and murder of J.D. Tippit, 97-100
 in New Orleans, 136-37
 note to FBI before assassination, 103
 portrait of, 130-31
 relationship to Clay Ellis Shaw, 134
 resemblance to Billy Lovelady, 186-87
 at Texas School Book Depository, 18, 48-49, 62, 64-65, 121, 131
 trail after assassination, 94-96
 Warren Commission's report on, xi-xii
Oswald, Marina, 121-22, 124, 130-31

P

Paine, Ruth, 62, 96, 123, 131, 169
Paisley, John A., 198
Paley, William, 202
Parkland Memorial Hospital, 14, 39, 43-45, 51, 126

bullet found inside, 58, 128
cleaning of limousine at, 70
eyewitness accounts from, 86-88
Oswald's death at, 108
Perin, Robert, 143
Perry, Dr. Malcolm, 59, 76-77, 86
Peters, Dr. Paul, 87, 180
Petty, Dr. Charles, 179
Phillips, David Atlee, 138, 165
Photographs
autopsy, 76-85, 89
of Oswald, 122, 168-71
Pitzer, Bruce, 84
Police transcript of shooting, 52
Portrait of the Assassin, 117, 166
Powell, John, 206
Powers, Dave, 88, 205
Press, CIA manipulation of, 144-45
Preyer, Richard, 160
Price, John Wiley, 214
Prouty, Colonel Fletcher, 5

R

Randle, Linnie, 131
Rankin, J. Lee, 117, 131, 150
Reasonable Doubt, 217
Riebe, Floyd, 82, 88, 182
Rifle. *See* Ballistic evidence;
Mannlicher-Carcano; Mauser;
Weapons
Rilke, Aubrey, 88
Rivera, Geraldo, 148
Roberts, Delphine, 138
Roberts, Earline, 96, 198
Rockefeller Commission, xi, xiv, 151
Rockefeller, Nelson, 147
appointment as vice president, 151
Rose, Dr. Earl, 71
Rose, Jim, 139
Roselli, John, 156, 198
Rowland, Arnold, 18
Rubenstein, Jacob. *See* Ruby, Jack
Ruby, Jack, 9, 37, 49, 58, 117
acquaintances with Oswald, 109-10, 111
connections to the Mafia, 104, 106, 110, 119
death of, 93
shooting of Oswald, 92-93, 107-8, 198

stalking of Oswald, 104-6
trip to Cuba, 111
Warren Commission and, 119
Russell, Harold, 198
Russell, Richard, 117, 129
Russo, Perry, 142
Ryberg, H.A., 79, 89

S

Salandria, Vincent, 142
Salant, Richard, 202
Saltzman, Robert, 146
Salyer, Dr. Kenneth, 87
Schweiker Committee, 151, 170
Schweiker, Richard, 151
Secret Service
design of route through
Dallas, 8
party in Forth Worth, 9
reaction to gunshots by, 36
stationed at Grassy Knoll, 47, 51, 54, 60
Senate Intelligence Committee, xi
Senator, George, 110
Shanklin, Gordon, 103
Shaw, Clay Ellis, xii, 133-35, 140-42, 214
Shaw, Dr. Robert, 126
Shaw, Gary, 194
Shots. *See* Gunshots
Sibert, James, 79, 88-89
Single bullet theory, xiv, 28-29, 125-29, 139, 178
Sisk, B.F., 162
Six Seconds in Dallas, xii
Smith, Merriman, 43, 45
Smith, Mrs. Earl, 198
Sniper's nest, 48, 62-63, 167, 206-7, 209
Somersett, Willie, 153, 196-97, 201
Sorrels, Forrest, 8, 10, 16
Specter, Arlen, 115, 117, 121, 125-26, 181
Sprague, Richard, 159, 162, 164, 166, 205
Springer, Pearl, 196
Stapleton, Ruth, 204
Stemmons Freeway, 10, 43-45, 49
Stevenson, Adlai, reception of in
Dallas, 3, 6
Stokes, Louis, 162
Stone, Oliver, 210, 212, 214
Sturgis, Frank, 143, 146, 149-50,

152, 157
Sullivan, William, 162
Sunday Times (London), 198
Surveyor's report, to Warren
Commission, 19, 120

T

Tague, James, gunshot wound of, 29, 41, 177
Tanenbaum, Robert, 159, 164, 166
Tatum, Jack, 97, 99
Telephone service loss in
Washington, D.C., 43
Texas School Book Depository, 10, 12, 14, 41
figure in west end window, 208-9
investigation of, 48-50, 62, 64-65
Oswald's employment at, 121, 131
questioning of employees of, 94
re-enactments from, 19
sniper's nest in, 48, 62-63, 167, 206-7, 209
timing of sniper fire from, 12, 17
view of President's car from, 21
Texas Theatre, 94, 99, 101
The Cellar, 9
The Men Who Killed Kennedy, 217
The Third Decade, 216
Thomas, Albert, 71
Throat wound
medical investigation of, 76-77
from second gunshot, 22-24
Tippit, J.D., 94, 96, 97-100, 168, 211
Tomlinson, Darrell, 58
Towner, Tina, 18
Trade Mart, Dallas, 5, 10, 12
Traffficante, Santos, 4, 156
Trajectories, of bullets, 89, 129
Tramps, arrested after shooting, 48, 61, 69-70, 143,
Transcript of shooting, 52
Triangulation style ambush, 28, 49
Truly, Roy, 48, 62, 64, 94

U

Umbrella Man, 24, 188-189, 192
Underhill, Gary, 157
Uniform Man, 204

U.S. House of Representatives
Select Committee on Assas-
sinations (HSCA). *See* House
Assassinations Committee

V

Vaughn, Roy, 106, 109
Virginia Congressional Delegation, xiv

W

Walker, Edwin A., 124
Wallace, George, 146
Walle, Marilyn M., 198
Walther, Carolyn, 196
Ward, Hugh, 138
Ward, Theran, 73, 87-8
Warren Commission
censorship of Mrs. Kennedy's
testimony, 38-39
creation of, xi, 113
findings of, xi-xii
J. Edgar Hoover and, 17, 116
House Assassinations
Committee and, 160
interrogation of Jack Ruby, 93, 119
investigation of Officer Tippit's
death, 97-99
lone assassin theory , xiv, 21, 29, 115, 121-23
magic bullet theory, 26, 28, 125
manipulation of evidence by, 35, 78, 81, 118, 120
members of, 117
Oswald's motive for assassina-
tion and, 121
re-enactments of Zapruder film, 19
single bullet theory, xiv, 28, 115, 117, 125-29, 178
suppression of testimonies
ιv, 67
su. veyors report for, 120
use of evidence by, 21
Warren, Earl, 114-16, 117, 119, 129
Watergate scandal, 146, 149
Weapons
used in Kennedy's assassination, 64, 66, 92, 102-3, 122-23, 176
used to kill officer Tippit, 97-98, 100
See also Ballistic evidence;
Bullets; Mannlicher-Carcano;

Mauser
Weatherford, Harry, 16, 41
Wecht, Dr. Cyril, 178
Weeden, Ronny, 111
Weems, Dr. George, 198
Weisberg, Harold, 157, 176
Weiss, Dr. Mark, 172-74
Weitzman, Moses, xiii, 37
Weitzman, Seymour, 34, 64, 176
West, Bob, 120
Whaley, William, 94, 96
White, Jack, 171
White, Roscoe, 170
Whitewash, xii
Who Didn't Kill . . . JFK, 217
Willis, Marilyn, 87
Willis, Phillip, 6, 24, 35, 86, 194
Windshield, gunshot evidence on, 36, 41
Witnesses, death of. *See*
Mysterious Death Project
Witt, Louis Steven, 188
Wood, William, 139, 142
Worrell, James. R., 95

X

X-Rays
of Kennedy's body, 82-83, 86, 89, 182
See also Autopsy

Y

Yarborough, Ralph, 36, 58
Youngblood, Rufius, 37

Z

Zapruder, Abraham, 19-21, 192, 194
Zapruder film
analysis of, 171
blurring of, 21, 23
first public showing of, xiv, 133, 142
and House Assassinations
Committee, 166
manipulation by Warren
Commission, 35
missing frames from, 24
optical enhancement of, xii-xiv, 146
re-enactments based on, 19
showing on "Goodnight

Credits

Grateful acknowledgment is made to the following for permission to reprint photographs and other illustrative material.

AP/Worldwide: iii, 3, 10*tr*, 12-13, 15*t*, 15*c*, 15*b*, 30-31, 34*b*, 34*c*, 42, 44*b*, 45*t*, 92*tl*, 291*br*, 107*br*, 111*r*, 116*tl*, 114*tl*, 114*tr*, 117*second fr. r*, 117bl, 117*second fr. bl*, 138*bl*, 145, 150*t*, 150*bl*, 150*br*, 151*bl*, 151*br*, 152*tr*, 156*t*, 156*cl*, 156*cr*, 156*bl*, 157*tl*, 162*tr*, 162*bl*, 162*br*, 167*tr*, 173*cr*, 174*t*, 174*c*, 175*t*, 176*tr*, 184*t*, 184*second fr. t* 184*cr*, 185*tl*, 185*tr*, 186*t*, 186*c*, 193*tr*, 194*cr*, 196*c*, 196*bl*, 200, 204*t*, 204*l*, 204*cr*, 204*br*, 205*t*, 205*c*, 205*br*.

Bell Film: Copyright 1980 by F.M. Bell All Rights Reserved: 43*cr*, 45*c*, 47, 48*l*, 50*b*, 61*t*, 61*c*, 187*tl*, 187*tc*, 197*t*, 206.

The Bettmann Archive: 41*cr*, 49, 50*tr*, 59*t*, 77*tl*, 92*br*, 93*r*, 103*l*, 107*tl*, 107*cl*, 107*cl*, 107*bl*, 107*tr*, 114*br*, 115*r*, 116*tr*, 116*b*, 117*tl*, 117*second fr. l*, 117*tc*, 117*br*, 119*c*, 133,138*br*, 142*lc*, 142*tl*, 142*tr*, 142*c*, 149*b*, 156*bl*, 157*bl*, 157*bc*, 162*tc*, 162*second fr. bl*, 172*tr*, 173*t*, 174*t*, 174*c*, 189*c*.

©1978 Charles L. Bronson: 9*t*, 9*cr*, 25, 188*t*, 188*cr*, 207*b*.

R.B. Cutler: 129*t*.

The Dallas Morning News: ix, 6, 70*cl*, 164*t*, 208*t*, 208*bl*, 208*br*, 209*tl*, 209*tr*, 209*c*, 209*bl*, 209*br*.

Dallas Municipal Archive and Records Center: 17*c*, 18*tr*, 41*bl*, 63, 64*c*, 64*b*, 65*t*, 65*b*, 66*second fr. t*, 66*second fr. b*, 67*t*, 73*bl*, 90, 91, 95*tl*, 95*tc*, 95*tr*, 95*br*, 97*c*, 99*c*, 99*b*, 100*cl*, 101*c*, 102*t*, 102*b*, 108*b*, 109*t*, 109*cr*, 109*bl*, 110*r*, 119*t*, 121*t*, 123, 130*t*, 130*c*, 130*b*, 131*br*, 136*bl*, 136*br*, 168*t*, 168*c*, 169*tl*, 169*tr*, 169*c*.

Courtesy the Dallas County Historical Foundation: 5*b*, 48*r*, 62*br*, 69*t*, 93*l*, 98*t*, 143*t*, 202*t*.

Daniel Film: Copyright 1979, 1988, By Jack Daniel All Rights Reserved: 43*b*.

Squire Haskins Photography: 8*bl*, 16*c*.

©1963 by Bob Jackson: 108*t*.

©1988 KRON-TV, San Francisco: 86*br*, 87*tc*, 87*cr*, 87*br*, 88*second fr. tr*, 88*bl*.

Maravilla Production Co., Inc.: 148.

©Jim Murray Film All Rights Reserved: 68*c*, 68*b*.

Nix Film: Copyright 1964 NIX (Copyright renewed 1992 Nix) All Rights Reserved: 14*t*, 18*l*, 32*b*, 35*bl*, 35*bc*, 35*br*, 40*tr*, 40*cr*, 40*br*, 43*l*, 193*tl*, 193*tl* inset.

Stuart L. Reed: 101*bl*.

Rickerby/LIFE Magazine ©Time/Warner: 2.

Photo courtesy of Southwest Film/Video Archives, Dallas, Texas: 64*t*.

Josiah Thompson: 83*r*, 115*l*.

Towner Film: Copyright 1983 by Tina Towner Barnes All Rights Reserved: 13*t* inset, 14*b*, 18*rc*, 46, 50*rc*, 51*b*, 54-55, 54*bl*, 56-57, 56*tl*, 57*tr*, 57*bl*, 194*tl*, 194*lc*.

US News & World Report: 101*br*.

©1991 Warner Bros. Inc., Regency Enterprises V.O.F. and Le Studio Canal+ All Rights Reserved: x, 213, 214*tl*, 214*c*.

Courtesy: WDSU-TV: 138*b*, 141*t*, 141*c*, 141*bl*.

©1964, updated to 2039, Phil Willis: 10*cl*, 10*c*, 20*br*, 24*b*, 50*cl*, 51*cl*, 51*cr*, 67*cl*, 188*c*, 190-191, 192*tr*.

Zapruder Film: Copyright 1967 LMH Co. c/o James Silverberg, Esq. Washington, D.C. 202-332-7978 All Rights Reserved: 19*t*, 20*c*, 20*bl*, 20*br*, 21*t*, 21*bl*, 21*br*, 22*b*, 23*t*, 23*b*, 24*t*, 26*c*, 26*bl*, 26*bc*, 26*br*, 27*t*, 27*c*, 27*cr*, 27*b*, 28*l*, 28*cr*, 28*br*, 29*t*, 32*c*, 33*t*, 35*t*, 35*c*, 37*t*, 37*rt*, 37*rb*, 38, 39*tr*, 39*cl*, 39*br*, 40*tl*, 40*cl*, 40*bl*, 76*t*, 80*t*, 132, 143*bl*, 143*bl*, 171*b*, 172*b*, 173*b*, 174*b*, 175*b*, 176*b*, 177*b*, 178*b*, 179*b*, 180*b*, 181*b*, 182*b*, 183*b*, 184*b*, 185*b*, 186*b*, 187*b*, 188*b*, 189*b*, 192*b*, 193*b*, 195*b*, 210*t*.

The following photographs and illustrative material are part of The Robert J. Groden Collection (All Rights Reserved): xii, 17*b*, 40*l*, 60*t*, 61*bl*, 61*br*, 70*c*, 72, 76*bl*, 77*tc*, 77*br*, 78*bl*, 80*br*, 81*tl*, 81*br*, 82*b*, 83*t*, 83*br*, 84*tl*, 84*b*, 85*tl*, 85*r*, 85*cl*, 85*bl*, 85*br*, 86*t*, 86*cl*, 86*cr*, 86*bl*, 87*tl*, 87*tr*, 87*bl*, 88*tl*, 88*second fr. tl*, 88*tr*, 88*br*, 96*br*, 99*tl*, 100*bl*, 105*cr*, 125*cl*, 128*b*, 139*t*, 164*bl*, 164*bc*, 164*br*, 167*c*, 168*b*, 178*l*, 179*tl*, 179*tr*, 182*t*, 183*t*, 184*cl*, 185*tc*, 187*cr*, 194*b*, 195*tr*, 202*b*, 209*br*, 211*c*, 211*b*, 212*t*, 212*b*, 215*t*

Melanie C. Groden: 211*t*, 214*b*

Codes: *t*: top; *c*: center; *b*: bottom; *r*: right; *l*: left; *tr*: top right; *cr*: center right; *br*: bottom right; *tl*: top left; *cl*: center left; *bl*: bottom left.